The Diffusion
of Classical Art
in Antiquity

THE A.W. MELLON LECTURES IN THE FINE ARTS

DELIVERED AT THE NATIONAL GALLERY OF ART, WASHINGTON, D.C.

John Boardman

The Diffusion of Classical Art in Antiquity

The A.W. Mellon Lectures in the Fine Arts, 1993
The National Gallery of Art
Washington, D.C.
Bollingen Series XXXV · 42

PRINCETON UNIVERSITY PRESS

Copyright © 1994 by the Trustees of the National Gallery of Art,
Washington, D.C.
Published by Princeton University Press, 41 William Street, Princeton,
New Jersey 08540

This is the forty-second volume of the A. W. Mellon Lectures in the Fine
Arts, which are delivered annually at the National Gallery of Art, Washington.
The volumes of lectures constitute Number XXXV in Bollingen Series,
sponsored by Bollingen Foundation.

Library of Congress Cataloging-in-Publication Data

Boardman, John, 1927-
 The diffusion of classical art in antiquity / John Boardman.
 p. cm. — (The A. W. Mellon lectures in the fine arts; 1993)
(Bollingen series; XXXV, 42)
 Includes bibliographical references and index.
 ISBN 0-691-03680-2 (CL)
 1. Art, Ancient—Greek influences. 2. Art, Greek—Influence.
I. Title. II. Series. III. Series: Bollingen series; XXXV, 42.
N5340.B59 1994
709'.38—dc20 94-16269
 CIP

Princeton University Press books are printed on acid-free paper, and meet the
guidelines for permanence and durability of the Committee on Production
Guidelines for Book Longevity of the Council on Library Resources.

Printed in Slovenia

10 9 8 7 6 5 4 3 2 1

10 9 8 7 6 5 4 3 2 1
(Pbk.)

Contents

Preface

MUCH OF THIS BOOK is about the reception of art without understanding; it is about media rather than messages. This may sound unfashionable but in effect it can lead to a better understanding of success and failure in communication through visual experience alone.

Art is a means of communication, and we must judge that the intention of an artist is to communicate with his customer or viewer even if only on a trivial level, or on several different levels for viewers of different character. For successful communication artist and viewer need to share the same culture. A measure of communication is certainly possible without this, and we can respond to some degree to the art of a newly discovered tribe in, say, New Guinea, because we share the common expectations and responses of humanity. But we are unable to respond fully to the artists' intentions, and confronted with extragalactic art, if there is any, we would probably be unable to respond at all. Common culture determines the possibility of intentional communication of ideas through art, but, even without this understanding on the part of the viewer, the visual arts can convey images which may be left to him to interpret as he will in terms quite other than those intended by the artist. We think we can understand the messages of Greek art because we know something of Greek culture from its literature and history and we have faith (possibly misplaced) in interpretations based on a continuous tradition in the west. This book is about Greek art as a medium of communication to non-Greek cultures and it therefore deals more with the responses to images that are sometimes misunderstood and often reinterpreted than with the communication of shared ideas.

It is essentially a study of movement and interaction: the movement of objects by way of gift or trade, the movement of craftsmen through choice or necessity, the response of craftsmen to foreign arts, the movement of images outside the society that created them, and consideration of the reasons for their adoption and survival elsewhere. In all this the role and intentions of the original artist and his society are often remote and certainly less important than the response and intentions of recipients. We look at Greek art from the outside for a change, as a foreign art, and at styles and subjects sometimes long divorced from their origins.

The title uses the word Classical but the text will more often mention Greek than Roman for reasons that will become clear in Chapter One. Romans were intermediaries for Greek art, but so were Persians, and Rome's special contribution to the classical tradition is beyond the scope of a volume devoted to the classical tradition outside the classical world. This is by way of apology. Terminal dates for the discussion of different

areas also differ widely. They are determined in part by the material, in part more arbitrarily. Areas ruled by Imperial Rome and Constantinople are excluded, but there is some consideration of Christian arts in Egypt because the contrast with what went before is so instructive. Willy-nilly some general observations about Greek art itself emerge from such a study, and the final chapter tries to bring some of these together.

The exploration is only partly an extension of the work I undertook for *The Greeks Overseas* over thirty years ago and has been stimulated by a growing interest in the more art-historical end of the archaeological spectrum. It has relied heavily on the resources of the Ashmolean Museum's libraries and the advice and guidance of more expert colleagues. I mention especially Raymond Allchin, David Bivar, Dominique Collon, Sybille Haynes, Harry James, Roger Moorey, who have read chapters; and Jim Harle, Prudence Harper, François Lissarrague, Margaret Root, whom I have also consulted on various points; and not least Herbert Cheng, the Oxford eye surgeon, for the exercise of skills which have made it possible for me to complete this work.

The Andrew W. Mellon lectures in the National Gallery, Washington, in 1993 provided a focus and target. But this is not simply an annotated enlargement of the lectures: these were rather a distillation of the book which was already largely written. I am deeply indebted to the Trustees of the National Gallery and to the Center for Advanced Study in the Visual Arts, especially Henry Millon, for the opportunity to express my views on this subject to an alert audience. The chapters are addressed to a public, academic and otherwise, not expert in each field discussed, and have been written with, I hope, sufficient indication of where to turn for further general or specific information. I have for this reason avoided, so far as possible, the contemporary and surely ephemeral jargon of archaeology and art history, a quite painless self-denial; and I have used those spellings of names most commonly met in recent literature. The abundant endnotes refer often to secondary, accessible sources, but often to primary sources where necessary. The illustrations concentrate on the non-Greek, with a few to indicate the character of local styles. I have seldom shown examples of *what* was influential or being copied, hoping that the classical styles would be familiar to most readers and available to them in other works. My hope is that this will lead those who are accustomed to histories of classical western art into consideration of some of the less usual aspects of its legacy, and to a better appreciation of the achievements of other ancient peoples who encountered it. It has been a chastening and rewarding experience for a classicist to find himself the barbarian, in a study which depends on some appreciation of non-classical arts and culture. I hope it will prove no less for other classicists, that they will enjoy these wider horizons as much as I have done, and begin to judge Greece and Greek art on non-Greek, even non-western terms.

ACKNOWLEDGEMENTS

The author and publishers are deeply indebted to many museums, institutions and scholars named below for illustrations used in this volume, and permission to reproduce them. Details of other sources are indicated in relevant notes to the text references.

Alexandria, Greco-Roman Museum; Berlin, Staatliche Museen; Boston, Museum of Fine Arts; The Brooklyn Museum; Brussels, Musées Royaux; Columbia (Missouri), Museum of Art; Florence, Museo Archeologico Nazionale; Hamburg, Museum für Kunst und Gewerbe; Leiden, Rijksmuseum van Oudheden; London, British Museum, Greek and Roman, Oriental, Western Asiatic, Egyptian Departments and Coin Room; London, Victoria and Albert Museum; Moscow, Pushkin Museum; Motya, Whitaker Museum; New York, Metropolitan Museum of Art; Oxford, Ashmolean Museum; Paris, Bibliothèque Nationale; Paris, Louvre Museum, Egyptian and Oriental Departments; Paris, Musée Guimet; Paris, Musée Rodin; Rome, Vatican Museum; St Petersburg, Hermitage Museum; Toledo Museum of Art; Toronto, Royal Ontario Museum; Trieste, Museo Civico; Washington, Freer Gallery.

Archaeological Exploration of Sardis; Chicago, Oriental Institute; Egypt Exploration Society; German Archaeological Institutes in Cairo, Istanbul, Madrid, Rome; Hirmer Verlag; Oxford, Ashmolean Museum Cast Gallery Archives.

E. Akurgal; P. Bernard; M. Cristofani; A. Di Vita; G. Herrmann; N. Kreitman; O. Lordkipanidze; M. Martelli; M. Mellink; C. Nylander; G. Ortiz; R. Stucky; F. Tissot; M. Treister.

The maps and several other line drawings are by Marion Cox. Photographic work is by R.L. Wilkins and Jennie Lowe. Several photographs are the author's.

LIST OF MAPS

Introduction

T HE POPULAR MODERN VIEW of Greek art and of its influence on the world around us is probably most fairly expressed in terms of the architectural decoration of buildings and interiors; for sculpture in terms of the realistic male and female nude, especially for allegorical or commemorative figures; for painting in terms of explicit mythological narrative. In all these respects the influence can be seen to have passed via Rome, the Italian Renaissance and the Neoclassical movements of the past two centuries. The results are fireplaces and bank façades, war memorials and limbless torsos in art schools, acres of heroic oil painting. What past generations have discerned as features in Greek art worth borrowing or adapting are by no means those which modern scholarship, in archaeology and art history, would necessarily pick out as the most important characteristics of what was, among all the arts of antiquity, a unique and revolutionary idiom. The medium, the physical appearance of Greek art, has proved more important than the message, and it remains a matter of some difficulty for the connoisseur and scholar to unravel the intentions of Greek artists from the skein of assumptions created by our over-familiarity with the appearance of their works and their derivatives.

In this book I try to explore how ancient non-Greek cultures reacted to Greek art, what they thought important and borrowable in it. They were not necessarily in any better position than we are to judge what Greek art was *really* about, nor were they as interested in the question as we are. Their reactions were determined by their needs, their opportunities, and for many, not least, by the idioms of their native arts. So I try to explore the record of Greek art as a *foreign* art introduced to peoples who may have had strong artistic traditions of their own, and who had no extravagant views about the splendours of Greek Art and Greek Thought (many, indeed, probably despised them).

It has been readily assumed that Greek art was an inspiring force, or at least a vital catalyst, in the development of many other arts of antiquity, the Persian, the Etruscan, the Buddhist. This is not a view that this book can always encourage, but each case is treated on its merits, so far as possible, and this is equally not a debunking of the pervasive effect of an influential style created in a very short period of time in a very small geographic area. But this is decidedly not a book about people waiting for something interesting and Greek to happen to them. Most western viewers are ready enough to acknowledge the quality and achievement of Egyptian or Mesopotamian art. The classicist who looks even farther afield, to the east, may well feel humbled by the achievements of more distant cultures.

'Greek' is, in this context, a broad term. It omits the Bronze Age civilizations of the Minoans and Mycenaeans; theirs is a different story barely impinging on what

happened in later centuries. It embraces the beginnings of Greek art in the Iron Age, when the land was open to the profound influences of other ancient cultures. Much of this I explored in *The Greeks Overseas* (1964; lightly revised in 1980) which is a mainly archaeological study, and considers little after 500 BC. The present work includes, naturally, the works and influence of the Classical and Hellenistic periods from the fifth to first centuries BC, but also those elements of Greek art which pervade the art of the Roman Empire, especially in the east where the continuing Greek tradition was strongest and least affected by Roman taste. 'Classical' seems a better word, but it includes Rome, and I exclude the peculiarly Roman contributions to the spread of classical art and civilization. I use the word Greek when I mean Greek, 'classical' when I refer to that general style of art and life devised in Greece and propagated in our era by the Roman Empire, 'Classical' of the arts of fifth/fourth-century BC Greece itself.

The subjects addressed in the following chapters have, most of them, been explored well by others, but not together, not with any deliberate attempt to compare and contrast the responses of different peoples to what is basically a single phenomenon. The approach has to be more archaeological than most art-histories, and therefore, I hope, a shade more objective in so far as any objectivity in such matters can be effectively exercised. It does not attempt to define or categorize in any prescriptive way how artistic or craft influence works between cultures although many common responses will be found; the vastly different circumstances in each period and place preclude observation of more than the broadest patterns. I must also confess to some diffidence about what is meant by 'art' in these contexts. It is probably seldom any conscious expression of an artistic ideal rather than the application of an appropriate artistic technique and idiom to specific problems and functions; and many of the creators of what we shall be studying are probably more justly called craftsmen than artists. In every case, however, these arts are as valid an expression of the society they served as that society's literature, politics or religion.

The matter of the book will be more often determined by travelling objects than by travelling artists. But it is people who observe and make, who buy and sell. 'Human beings are too important to be treated as mere symptoms of the past' (Lytton Strachey). Those who copied or borrowed Greek motifs dictate the course of this story. Their choice depended on their training, their needs, and the needs of the society in which they worked. These are areas difficult to chart. The crafts of antiquity can be judged well enough from surviving products, and the functions of the products are usually apparent. The motivation for decoration or style is a more difficult matter to fathom. In Greece the individuality of artists in matters of choice and production is more readily perceived than in any other ancient culture, where such individuality seems to have been suppressed, or at least never asserted itself to any marked degree. It is more difficult to judge the needs and responses of a courtier or villager in Mesopotamia or Egypt than to understand the manners of Greek society, where details of its politics, religion and everyday life are so much more readily apparent from texts as well as objects. Those more familiar with the cultures compassed in this book can judge better than I what of significance my subject may have borne for their people. Often, I suspect, it was little or nothing, but we are observing a remarkable diffusion of images, if not ideas, and in their new contexts those images had meaning.

Work for this book has led me to consult modern literature devoted to places and periods barely familiar to me hitherto. Consideration of scholarly procedures in these other areas has been instructive, often leaving me satisfied, often dissatisfied with the procedures of classical archaeology and art history. One common feature may be remarked. The sometimes passionate polarization of views and ideologies seems a universal phenomenon in the scholarship of antiquity and especially rife in the last generation of scholars. Many seem more at the mercy of their predispositions than their sources. It is a virus that strikes indiscriminately and is in some individuals of limited effect, but seems epidemic. Greek or Phoenician, Greek or Roman, Phoenician or Aramaean, Seleucid or Parthian, Semitic or Celtic, Sardinian or Etruscan, Etruscan or Roman, Egyptian or Mesopotamian, Hindu or Buddhist, Christian or Pagan, Male or Female; you are expected to take sides. Some seem almost still to be smarting from either Xerxes or Alexander the Great. Sometimes it is very easy indeed to detect motivation – national (determined by geography, or nationality of excavators, sometimes by teacher or university), political, religious, even sexual, and the lunatic fringe is never far away nor mere academic hooliganism. The debates sometimes generate more heat than light and their stimulating effect on new studies and worthwhile new approaches is not always apparent. The more vocal protagonists seem not to realize that they can never win and that progress in such areas of scholarship depends on reasoned readjustment in the light of new evidence or new methods of analysis, and a shade more honesty in assessment of *all* the evidence, which should be allowed to ask the questions and not have questions with answers imposed upon it. At least no blood is shed. I have little doubt that in this book some partisanship will be detected, but I have tried not to preach.

Strachey recounts how Prince Albert visited Italy just before his marriage to Queen Victoria: 'When the Pope (Gregory XVI) observed that the Greeks had taken their art from the Etruscans, Albert replied that, on the contrary, in his opinion, they had borrowed from the Egyptians: his Holiness politely acquiesced.' Politeness is not enough, but it is a good start.

1 · Greek Art

THE ATTEMPT TO OFFER an account of Greek art as it appeared to the non-Greek viewer obliges us to ignore or discount much that would normally be regarded as essential. Since the subject matter of this book largely concerns Greek art as viewed by the non-Greek, the present chapter needs to consider it as a foreign art, involving little more than what was presented to an ancient eye, which is, with important exceptions, the same as what is presented to a modern eye. In this respect at least the exercise becomes relatively easier than any attempt to explain Greek art in terms of Greek intentions and response. And it would of course be wrong to assume that in every case the medium passed without a message. Indeed, in some cases (as in Etruria) the message could be conveyed by Greeks themselves, and not only by Greek craftsmen. Sometimes we may be led to speculate that the message was as important as the medium, and have to consider *how* it could have been passed. Elsewhere the active intervention of Greeks will be seen to be improbable, and artefacts alone (or copies of them, or even copies of copies of them) must be judged the only sources.

There are, however, some general points about the development of Greek art that need to be made, if only to determine some of the essential and observable differences between it and the arts of most other ancient cultures.

Greek art is a chimaera. Greek artists looked forward and backward all the time. Greek craftsmen were no less conservative than most, yet it must have been a feeling for change as much as any concept of the possibility of progress that determined rapidity of development in such a short time. In comparison with the arts of most other ancient peoples, the stylistic development of the arts in Greece was breathtakingly swift. The visible changes in Greek art between the eighth century BC and the fifth are greater than in the history of the arts of any other period or place that I can think of. An awareness of the past, an historical sense if you will, is a prerequisite for any sense of the future and for the possibility of change. The Greeks' historical sensitivity is demonstrated first by their concern with their own myth-history and the uses to which it was put, then by the conscious efforts of their historians, the world's first, to record, explain, and provide cautionary models for the future.

Speed of development and change is an important factor in any study of the effect of Greek art overseas. In every area we are faced by a notable contrast with the development, the manner of production, and appearance of local arts. The answers to the questions why Greek art was the way it was, and why it became so different from that of other ancient cultures, are diverse and confusing. The conservative character of the arts of many of the peoples with whom the Greeks dealt must in no small measure have

been due to differences in society and patronage. An absolute ruler in full control of the wealth of his lands and of its distribution could determine absolutely what should be done by craftsmen whose skills were monopolized by the court. The craftsmen who served the citizens or a subject people might have neither the incentive nor material for significant innovation. In these circumstances they are left little opportunity to determine *how* they might work, or whether they might work in any way other than the traditional. Change and progress can be accommodated most readily in societies where craftsmen are afforded freedom of choice, or where a ruling class positively wills change to secure its survival or comfort, or to demonstrate its superiority over rivals. In an autocracy unchanging idioms in the arts might be held to discourage thoughts of change in other matters. Where the social group is small and where the more influential crafts are not monopolized by a palace or an aristocracy, there is scope for change generated by the craftsman himself.

The Greek city state (*polis*) was not such a novelty in antiquity as is sometimes claimed, but the apparent role of the citizen body in decision-making, incipient democracy, *was* exceptional. This seems to have been true even in those Greek states which, in the seventh and sixth centuries BC, were ruled by tyrants, since their authority was seldom absolute, but to varying degrees dependent on popular assent. The rulers were far more vulnerable to public opinion, local or of neighbours, than any Assyrian King or Egyptian Pharaoh. Herein probably lies the seed for change and development in the arts. One indication of the truth of this may lie in the observation that the most conservative of the Greek arts, architecture, was the very one that depended most on state patronage, and that innovation flowed most freely in the arts sponsored by the individual or family, often even in crafts that are modest in their materials and function, such as pottery. And another clear indication of independence of action by Greek craftsmen is the way in which artists' signatures begin to appear on works of very diverse cost and merit almost as soon as writing is learnt. It is quite exceptional to read the name of any eastern or Egyptian artist in any period.

The fifth century BC represents a watershed in the history of Greek art. In the so-called Geometric and Archaic periods of the eighth to sixth centuries, the arts are not so unlike those of other contemporary cultures, though they only slowly come to be expressed in the monumental forms that can most readily be compared with the arts of the foreigner. The changes that took place are mainly attributable to the influence of the east and, to a lesser degree, of Egypt, and, taking a detached view, we would have to admit that, in all but its fragmented society and virtual lack of conscious nationhood, Greek culture was not all that unlike that of many other peoples to the east; hardly more than an extension into the Mediterranean of manners of life and craft to which easterners had for far longer been accustomed. I find it easier to view Greece before the fifth century as the westernmost extension of the eastern world, than as the easternmost of the western world, which is the way it is generally presented, even by orientalists.

Within the fifth century dramatic developments in sculpture and painting take place in Greece, at the same time that new developments in politics, philosophy, the theatre and literature begin to create the Classical culture which has determined the attitudes and experience of the West thereafter. After the fifth century progress in the arts is steady until Greece is absorbed politically (though never culturally) by Rome. To many

foreign eyes there may not have appeared that much difference between the arts generated in the democracies of the fifth/fourth centuries and those of the succeeding Hellenistic kingdoms.

The modern scholar approaches this record in the hope of understanding the sources and motivation for change, and to explain the function of the artist in the society he served. None of this was of much concern to the non-Greek introduced to Greek art or artists, and in the rest of this chapter I try to define what characteristics of Greek art, in appearance or techniques and in different periods, were likely to have been noticed and therefore to have become possible subjects for assimilation or copying. To what extent the spirit of Greek art was also exportable is a question best reserved for individual instances in the following chapters, and for the Conclusion.

The art of Geometric Greece, mainly for our purposes that of the eighth century BC, depended a little on earlier crafts, a little on contact with the arts of the east. Its superficial geometricity is important, both because it is more emphatic than that of other cultures and because it betrays an interest in proportion and pattern that remains a vital element in Greek design long after the swastikas and meanders were abandoned. But it was the dominance of the swastikas and meanders which must have seemed one of the more obvious characteristics of Greek art of the period, even in areas where such patterns were familiar but not relatively so important. The accompanying Greek Geometric figure style of simple, angular silhouette was not novel but the formulaic composition of figures and the symmetrical patterns of the multi-figure scenes were. The style travelled on minor objects of metal and especially on pottery, but, as we shall see, not all foreigners were as obsessed as the Greeks were by pottery as a field for elaborate decoration. It was not a style in any way natural to pottery or metal decoration as much as it was to basketry and weaving. This is why it is not all that unlike the decorative styles of some other cultures at a comparable stage of craft development.

The orientalizing period of Greek art had its roots well in the Geometric period but was most fully expressed in the seventh century. It derives mainly from contact with the east, then Egypt, and the results are superficially so similar to their models in general appearance that they could have had nothing to offer in return to lands where the styles were born. The subtle translation of foreign forms in Greece itself, their submission to Greek views of proportion and pattern, and their conversion to the service of a developing art of narrative, would probably have gone unobserved and unappreciated overseas, for all that they lie at the heart of future developments in Greece. Only the artistically naive could have found inspiration in them; but a few did.

The sixth century saw the development of monumental sculpture and architecture, both in varying degrees dependent on foreign forms but expressed in an unmistakable Greek manner. Architecture cannot travel, and major sculpture travels little, but architects and sculptors moved freely enough within the Greek world, and could as easily travel outside it, carrying both design and, more importantly, new techniques. The development of the main architectural orders, Doric and Ionic, for columns and entablature, served specifically Greek types of building (mainly temples) and the Ionic presented the old orientalizing patterns in a new form at a new scale. Their monumental

architecture was perhaps the most striking and original achievement of Archaic Greek artists. In the minor arts much still depended on the example of the east, even in arts at which the Greeks were soon to excel, such as gem-engraving, where the Greek inevitably adopted from Phoenicia the foreign scarab form for his stones. Painted clay vases and, possibly, painted wooden panels could and did travel easily and in numbers. The figures upon the vases had progressed from the outline styles of the seventh century to the silhouette styles of 'black figure'.[1] There was nothing in the figure work to catch the eye of any foreigner whose own artists worked to a similar effect though in a different technique and different media. The content of the Greek decoration was far more likely to impress, with carefully composed scenes of myth-narrative, cult and genre, concentrating on the human figure and demoting geometric pattern and orientalizing floral to subsidiary ornament.

To the end of the sixth century forms and techniques in Greek art remained obviously dependent on what had been learned from others, although the idiom and expression, in various media, were already quite distinctively Greek. Progress had been steady but not, by the standards of what was to follow, swift. In some respects the orientalizing arts adapted by Greek craftsmen seem to have resisted change as effectively as they did in their various eastern homelands. I think especially of the so-called Daedalic sculpture, with its rigidity of posture and simple pattern-formulae of features, body and dress; and of linear drawing, most familiar to us from pottery decorated in the black figure technique, but equally visible in incised metalwork. They were styles long familiar in the east and Egypt, though the Greeks created new narrative compositions for the figures. These were wedded to the profile view, to a strongly conceptual, formulaic treatment which, for all the detail in which it was often expressed, was barely influenced by deliberate reference to live forms; nor need it have been, to answer its function, but the desire to express much more, a desire implicit in the new styles of Greek lyric and narrative poetry, and (by the end of the sixth century) in the new structuring of some Greek societies, meant that there had to be either change, or the relegation of the figurative arts to a function little better than decorative. The challenge was met, and Greek artists found it possible to express, in their own idiom, a view of their society no less effective than that of their poets.

There is of course nothing magic about the year 500 BC. Shortly before that date Athens had thrown off the rule of a minor dynasty of *tyrannoi* (not, in our terms, necessarily tyrannical) and replaced it with an incipient democracy that tried to codify that principle of decision-taking by popular assent which, to varying degrees, had been apparent in earlier Greek society, even the Homeric. But Athens is not Greece and there is no question of a sudden surge to Power for the People in all the Greek city states. In the fifth century, however, Athens' role in repelling the Persian invasions left her in a position of leadership for a substantial proportion of Greek states on both sides of the Aegean; and the Persian Wars themselves represented an important stage in the Greeks' own consciousness of their Greekness. Neither democracy nor a common threat which was met by more-or-less concerted action could separately or together account for all the changes in the current of Greek art, yet both probably made their contribution, the former by giving freer vein to individual invention, the latter by providing a new motivation, new resources, and new functions for the monumental arts. This is an

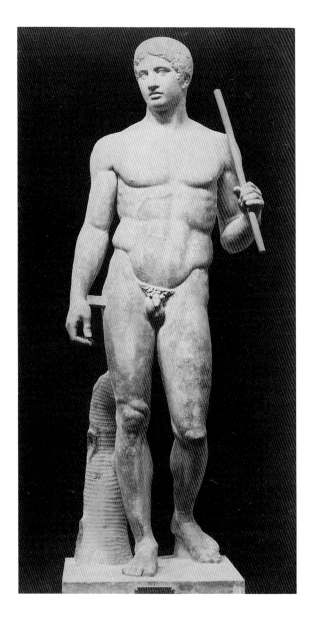

1.1 Copy of Polyclitus' Doryphoros: the Canon (Naples)

appallingly simplistic explanation of a very complex phenomenon but I think it embodies much of the essence of what contributed to change, and in the terms of our subject it is the effects rather than the causes that are important.

The Classical art of fifth- and fourth-century Greece is well expressed for us in the sculpture and architecture of the Acropolis at Athens, in a few but precious and fine original bronze sculptures, in figure-decorated pottery and metalwork, in reports of the appearance of major painting on walls and panels, and, towards the end of the period, in a better view of the luxury arts from the finds in Macedonian graves. The visitor to Greece saw much more and of yet finer quality and range. But what could he, or a foreign viewer exposed to exported artefacts, discern of novelty in it?

One characteristic was surely emphasis on the human figure in more than simply narrative contexts, and often used to indicate the appearance and presence of divinity. Another was the nudity of many male figures, a matter of pride to the Greeks but generally of shame to most non-Greeks. The reasons for the importance of the male nude lay in everyday Greek life and athletics, and in Greek views about the central importance of the human in both political and religious life, factors not inevitably conveyed by their arts except to Greek eyes.[2] In Greek art dress or undress were not as important signals of wealth and status as in other lands.

An accompanying characteristic was a degree of realism that seemed to wish to counterfeit nature rather than express natural forms through traditional formulae. This must have been startling, and the fact that the pursuit of realism for its own sake was only one aspect of this visual revolution in the history of art would have escaped the casual non-Greek viewer. Moreover, the figures were used to express more than presence and action; they expressed emotion and ethos through more than formulaic pose and gesture. Greek sculptors and painters wrote treatises on principles of proportion,[3] and considerations of proportion and composition remain of paramount importance in Greek design. Some perceptive foreign craftsmen may have understood something of this, but their traditions were differently founded. Quite different principles of composition, based on measurement rather than proportion, had long been exercised by Egyptian artists, though these too for a while had their effect in Archaic Greece. Elsewhere the artefact or figure was a self-sufficient entity; in Classical Greece its circumambient space and interrelationships with other figures or objects became just as vital considerations affecting appearance and design.

The last paragraph, I believe, expresses the general view about the role of realism in Classical Greek art, but it may be understated. We piously affirm the importance of proportion and design, and are backed by the record of artists' treatises on their crafts and the importance of *symmetria*, the commensurability of parts. But Polyclitus' figures must have looked like real men, realistically painted and equipped, for all that we know them only from bleached marble copies, propped up by tree trunks [1.1].[4] How much of the *symmetria* would have been apparent in antiquity? We seek it out through mathematical exercises, generally on copies and with no very great success, but to the Greek or non-Greek viewer this was the first true *trompe l'oeil* art, and in sculpture a majority of the figures are man-size, a little bigger for heroes, much bigger if need be for gods.[5] We read about its effect in paintings, where birds pecked at painted grapes, or a rival artist tried to draw back a painted curtain, but we have been denied the survival of any examples and begin to glimpse it only with a few late-fourth-century figures on Macedonian tombs, in the great landscape hunt on Philip II's tomb at Vergina, and later in copies on Roman walls and floors, in paint or mosaic.

We can in a way adjust to the idea of realistically coloured and shaded painting in antiquity, because what little has survived is in this form, and this is what we have become accustomed to from Pompeii and the painting styles of the Renaissance on. But in sculpture we have become so used to white marbles and black bronzes that, for all our knowledge of the way they were originally finished, we shrink from admitting that their prime effect must have been sheer realism. In the Classical period the marbles, flesh and dress, were realistically painted, and it is likely that the bronzes did not fall short of

achieving the same effect.[6] Architectural mouldings, and even walls and columns were painted or at least tinted. Classical Greece was not austerely white, bare and angular; it was warm, bright and illusionistic, a proper setting for the shattering realism of Greek prose and poetry, theatre and thought. This is worth remembering when we speculate about the effect of Classical art on the non-Greek and his motivation for copying or not. For one thing, it must have been extremely difficult to achieve and so discouraged emulation, while inept or mechanical copies would (and did) debase the effect. Moreover, there is nothing essentially right about realism in art, and many would have rejected its appeal with very good reason. It is, in a way, an artistic cul de sac, and some might judge its pursuit in the arts by Classical Greece 'one of the outstanding failures of Greek thought'![7]

The narrative scenes of myth in Classical art were presented in a manner already well-established in earlier years but with deeper sophistication, which probably also went unappreciated outside Greece, although its expression was not confined to the immobile, monumental arts. The propaganda of democracy, of power, of rationality, needs more explanation than the images through which it was conveyed, and much of it surely still eludes even the most imaginative of modern commentators. Beside the scenes of men acting as gods or heroes there was a range of genre and domestic subjects, generally unfamiliar to foreign figure arts that mainly expressed the trappings of state power and state religion. The closest we get to such matter is in Egyptian art, where they were expressed in the provision through images of a full afterlife for the royal or courtly dead, and not only for the attention of the living.

Finally, there is the Classical contribution to ornament. The architectonic character of much Greek art, from major architecture to the design of everyday objects, involved the articulation of parts – frames, mouldings, handles – decorated with developed versions of patterns which were either abstract (the old meanders, Greek key, were never forgotten) or floral, or a combination such as the formalized leaf patterns that became egg-and-dart. In the fourth century new confections of pattern and botany, involving acanthus, the vine, various creepers (convolvulus) and blossoms, begin to inform the arts at all scales. Such ornament played a more important role in Greek art than, for example, in Egyptian, Mesopotamian or Scythian, and Greek ornament will prove to be one of the more durable elements in our quest.

Much of what is considered in the following chapters belongs to the years after Alexander the Great's conquests in the east, and the rise of Rome. Alexander, and the various Hellenistic dynasties that succeeded him and that ruled Greece and the Greek east, mark a significant change in intention in the major arts. In some respects it is towards what had been influential elsewhere – palace patronage and ostentatious expression of dynastic power. The cultural frontiers of the Mediterranean world had been driven back: peoples, and artists, travelled more freely and widely than ever before. The figurative arts moved into a phase of more assertive realism, more highly charged emotionally, and therefore in effect less real, no longer a plausible counterfeit of nature but a deliberate attempt to improve on nature. Superficially, however, it is doubtful whether the non-Greek would have perceived much different except in the lavishness of production and in the new variations on old compositions and patterns which the artists of the new age wrought.

Greece became a Roman province in the second century BC and the Hellenistic kingdoms of Alexander's successors one by one fell to or abandoned themselves to Roman rule, except in the remoter east. The Greek world now embraced more than the lands bordering the Aegean, but the arts of the Greek homeland remained relatively unchanged under Rome. The only profound difference may have been architectural, with new materials (fired brick, concrete), techniques (the vault) and forms (the enclosed type of Roman theatre, triumphal arches, public baths, roads and aqueducts).

For the most part the arts of Greece and the eastern Mediterranean can be regarded as sub-Hellenistic, carrying abroad much the same messages as they had before. Roman art, as it developed in Rome itself, depended at first on Greek styles and even Greek artists, as we shall see in Chapter Seven. But in portraiture, where most Greek artists, it seems, had thought realism was not enough and had put character-portrayal before 'warts and all', the Romans made a virtue of realism and at the same time exploited the portrait as a vehicle of imperial propaganda. In commemorative sculpture the Romans favoured narrative techniques, typified in the great frieze that wound around Trajan's column in the Roman forum, which displayed his military campaigns in a manner not attempted by the Greeks for either their myth-history or historical events. Yet both the realism and the narrative have their roots in Greek art and may have been adjusted by Greek artists for Roman patrons. Even 'Roman' sarcophagi owe much to Greek models, and in the Greek world special forms of relief-decorated sarcophagi were evolved, in Asia Minor and Attica, that were to be more influential in the east generally than the urban types of Rome and Italy. The sheer realism of Classical art had passed and had been briefly, barely, and superficially recaptured for a while in early Imperial Rome. The figure arts of the later classical world lack that magic and, without such an almost impossible target to aim at, were able to diversify in quality and style; possibly, to give them the benefit of a doubt, the better and more easily to achieve what their artists and customers sought.

Roman styles in classical art had more effect on the imperial provinces to north, west and south, than in the east, and in periods and areas which this book does not consider in any detail. But there will be cause here and there to enquire to what extent anything essentially Roman was making its mark in places we might think penetrated only by Greek goods and craftsmen. I have tried to explain this quandary over Greek or Roman in my Introduction and apologize to those who may think I undervalue either Roman art or its legacy in the west. Rome's views of art and its uses become increasingly important in the east, and were dominant in the west, but for the purposes of this book what we are observing hails mainly from the eastern Mediterranean and from Greek sources, even when under Roman rule.

2 · The Near East and the Persian Empire

THIS CHAPTER DIVIDES NATURALLY into two parts, before and after the Persian invasion of the Greek world. The reader must be warned that, in terms of our quest for the diffusion of Greek art, the first part will prove to be fairly barren, but essential; the second sees the beginning of a process which will carry elements of classical art to its furthest limits.

A Before about 550 BC

Although there is evidence enough for enterprising Greeks in the east in this period, they found there more to learn than to teach, more influential matter to bring home than to sell. In the Bronze Age Greece had been the home of the distinctive cultures of Minoan Crete, which was not Greek-speaking, and of the Mycenaeans. These were not so unlike their immediate eastern neighbours and in some ways they were dependent on

MAP I ANATOLIA TO PERSIA

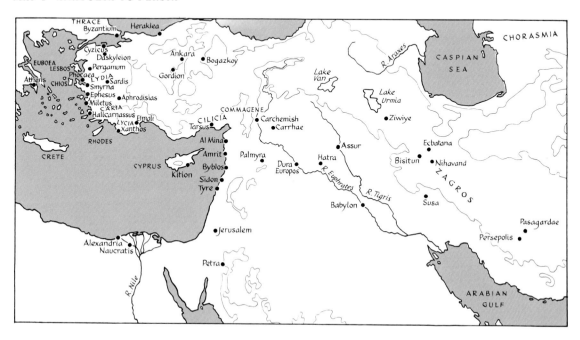

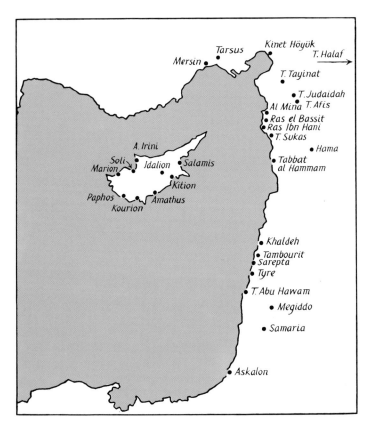

2.1 Map of Greek Geometric finds in the near east

them. The collapse of the Greek Bronze Age cultures left a period of recession, then of self-regeneration which was at first little dependent on foreign example, so far as can be judged. From the ninth century on serious traffic around the shores of the Mediterranean was resumed after a period (a so-called Dark Age) in which there was surely traffic of some sort, even if seldom long distance or of any influential character in subjects that concern us here. The Phoenicians, on whom much more will be found in the next chapter, were moving west, first to Cyprus, then much farther to areas which had been known to easterners in the later Bronze Age. The Greeks were beginning to prospect the eastern shores of the Mediterranean, mainly from the ports of Euboea (in central Greece) and the Aegean islands. They brought back trinkets and metalwork from Mesopotamia via North Syria, from Phoenicia and, probably via Phoenicia, from Egypt. To the east the Greeks had carried their Protogeometric pottery, though hardly as an item of trade, as early as the ninth century to the Phoenician city of Tyre, and it is fairly well distributed elsewhere along this coast [2.1].[1] The only place where it is found in significant volume is at Al Mina, in North Syria at the mouth of the River Orontes, and its hinterland, and in this area there could have been at least a seasonal Greek presence for the purposes of trade during the sailing months. There is certainly nothing to suggest that the easterners coveted Greek decorated pottery and they certainly did not copy it, nor was there anything else artistically influential that the Greeks could have carried. Greek priority in this traffic with Syria is demonstrable archaeologically but it is

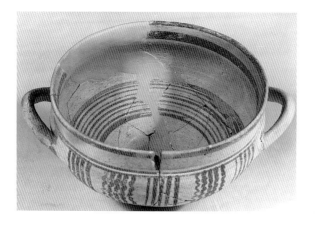

2.2 Greco-Cypriot cup from Al Mina (Oxford)

2.3 Bronze shield from Carchemish (London)

becoming fashionable to leave Phoenicians as the leaders in these matters. In the present context it is of little importance to determine the matter and traffic would never have been wholly one way, but the reader may observe that our subject is no less prone to academic fashion, even a degree of political correctness, than many other studies of antiquity or of the present day.[2]

The only exception to this pattern is Cyprus. The island had been part-colonized by Greeks at the end of the Bronze Age, and lived on in a sort of Greek twilight in which the Greek element, whether in culture or speech, can be easily overestimated. Some contact was certainly maintained, and this was a more receptive area than the coast to the east once Greeks began to travel again. As a result, from the ninth century on, we can detect the influence of Greek decorative styles in pottery. At the end of the eighth century, the heyday of Al Mina nearby, we can identify local versions of the fine-walled Greek drinking cups [2.2] which seem to have been the main class of pottery that Greeks could not find readily supplied locally and may therefore have made for themselves, or inspired others to make.[3] But it was in the ninth century too that the Phoenicians moved into the island and settled at Kition. In Cyprus they met Greeks and these years also seem to mark the beginning of Phoenician exploration farther west, in Greek waters and beyond.

Down to about 700 BC the eastern traffic of Greeks seems to have been mainly in the hands of the Euboeans and islanders of the Greek Sporades and Cyclades. Thereafter their place is taken by Ionians and other East Greeks, who seem to have been no more influential in matters that concern us than the Euboeans had been before them. Some more exotic Greek objects are to be found in the east, but they represent the activity of Greek mercenaries in the service of easterners or Egyptians rather than any cultural exchange. The best example of this is the Greek bronze shield found in the ruins of Carchemish on the Euphrates, destroyed by the Babylonians in 605 BC [2.3]; it is a heavily orientalizing work but its centrepiece is a Greek gorgon head (itself an adaptation of an eastern motif).[4] In the early sixth century at Babylon itself there is

record of Lydians and of Ionian craftsmen; disappointingly, however, their names prove not to be Greek rather than, perhaps, Lycian or from elsewhere in Anatolia (Ku-un-zu-um-pi-ja is an unpromising name for a Greek!).[5] And this raises a problem which will haunt later chapters, wherever we have to rely on local records for the identification of the presence of Greeks, a problem which is best addressed now.

The first Greeks met by easterners were Ionians (the Euboeans were Ionian by race too and seem to have reached the shores of the Levant before the Ionians from the Asia Minor coast): *Iones* or *Iawones* in Greek – to the easterners *Yavan* or, in Mesopotamia, *Yaman*.[6] But to the easterner one foreigner from the west was probably much like any other, and it is clear that the term was readily applied to people who were not strictly Ionian or even Greek-speakers. The desire to believe that all eastern records of Yaman or Yavan must refer to Greeks needs to be kept in check. It does not apply only to this early period, since the term persisted for centuries, together with the vagueness of its usage; indeed, it is likely that its derivation was soon completely forgotten. In Chapter Four we shall find the *Yonaka* of India presenting exactly the same dilemma. There is a telling modern analogy. The Franks were a Germanic coalition that occupied Gaul in the sixth century AD and gave France its name. Frankish princes of the Crusades established Frankish kingdoms in the eastern Mediterranean and in Palestine, and so to all easterners all westerners became Franks. The term *farangi, feringi, farang*, persists to the present day, as far away as Central Asia, regardless of the origin of the westerner, be it Berlin, Brighton or Baltimore.

An adjacent eastern area offers a quite different record. I refer to it as Anatolia – basically modern Turkey, or the Roman province of Asia Minor. Its western, Aegean, seaboard had been visited by Greek speakers in the Bronze Age (whether or not they attacked and destroyed Troy), and thereafter parts of the coast and offshore islands were settled by Greeks: from north to south, Aeolians, Ionians and Dorians (in Rhodes). The occupants of the hinterland had generally ignored the western sea. In the Bronze Age these were Hittites. Their successors were the Phrygians, known to us best from excavations at the old Hittite capital of Bogazköy and at their own capital Gordion.

2.4 Phrygian jug from Gordion (Ankara)

2.5 *(left)* Statue of Cybele from Bogazköy (Ankara)

2.6 *(above)* Marble naiskos from Sardis

Their culture owed something to their predecessors, but was oriented as much to the east, to Mesopotamia, and it was the Assyrians that trimmed their power in Anatolia in the late eighth century. It was this eastern aspect of their neighbours that made the Greek cities (as Smyrna) build massive defence works of a type not needed in the Greek homeland, where the threats were purely domestic and far more modest.[7] Phrygian art has an eastern aspect too, but also a Geometric one, superficially similar to the Greek [2.4] without it being possible for us to pretend that it owed anything to the Greek, although the occasional Ionian vase found on Phrygian sites shows that the peoples were aware of each other. There was more traffic from Phrygia to the Greek cities.[8]

From the mid-seventh century on the major power was Lydia, with its capital at Sardis, far closer to the richer Greek cities of Ionia. Most of these were gradually absorbed in the Lydian empire. By the sixth century the developing arts of Ionia did

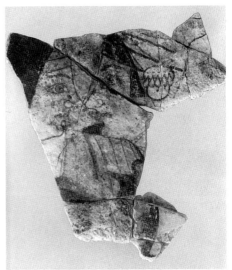

2.7 Clay revetment from Gordion (Istanbul)

2.8 Painting from Gordion

have something to offer other Anatolians in genres which had no local tradition. At Bogazköy we find a statue of the Anatolian goddess whom the Greeks came to know as Cybele [2.5], carved in a style which indicates the hand of a local craftsman aware of Ionian statuary but unable or unwilling to reproduce its essence of pattern and form.[9] When the same goddess is shown in a small marble shrine at Sardis a little later [2.6][10] we have to do with a Greek hand working for the Lydians and reproducing more faithfully Greek styles of dress, Greek architectural forms (the columns) and Greek subjects for the relief panels at the sides. Throughout Lydia and Phrygia buildings were decorated and protected by clay relief revetments sometimes decorated in a wholly Greek style and even with Greek mythological scenes, such as the Theseus and Minotaur from Gordion [2.7].[11]

The Lydian king Alyattes had walked over the massive defences of Smyrna in about 600 BC,[12] but his successor, Croesus, who subdued more of the Greeks' cities, proved something of a philhellene and a generous supporter of Greek temples of the homeland and in Ionia: golden bowls to Delphi, columns for the new Temple of Artemis at Ephesus. In his day there began a form of cultural symbiosis between Ionians and Lydians which produced a culture and art to which the Greeks seem to have provided much of the style, the Lydians the wealth. By homeland Greek standards it is rather old-fashioned, still orientalizing and betraying a certain oriental stiffness of execution, except in media which were wholly Greek in their development, notably sculpture. This seems the product of Greek orientalizing until there is direct Persian intervention. The Greek poetess Sappho, on offshore Lesbos, remarks the luxury and allure of Lydian court life, but its physical aspects were more obviously Greek than oriental. At Gordion, still an important centre, there are wall paintings [2.8][13] that closely resemble Greek styles more familiar on vases. But here we have to reckon also with the probable contribution of a longer Anatolian tradition in major painting that we shall revisit in the next Section. A marble base from Ankara carries clear traces of Greek Ionic

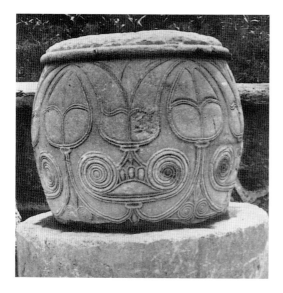

2.9 Marble base from Ankara (Ankara)

2.10 Greco-Lydian silver alabastron

2.11 Gold ornament from Aidin

architectural pattern [2.9].[14] Lydian silver vessels may copy Egyptian shapes but carry incised figures of Greek style and with Greek subjects [2.10].[15] The gold jewellery of Anatolia may even carry something of the older Greek 'Daedalic' style [2.11] which had been derived from a different part of the orient.[16] Croesus may have been the first to mint coinage, but the early coins seem to betray Greek influence in choice of subject and style. The little that the Greeks contributed to the arts of Anatolia seems then to be in media where there was no local precedent, or it was essentially superficial. The orientalising arts of the area were too like the results of Greece's own experience of influence from the east. The only hybrid art of any moment to develop was the Lydo-Ionian, which we shall trace into the Black Sea in Chapter Six.

In 546 BC Croesus was overthrown; the Persian King of Kings reached the Aegean and absorbed Croesus' empire including his Greek possessions. It was not so much that

those Greeks who remained independent had acquired new neighbours as that their old neighbours had acquired new masters. There was nothing inevitable, I think, about one of the near eastern, land-bound empires eventually reaching the shores of the Aegean and becoming directly involved with the Greeks. The stories of Greeks slighting Persians are not enough to suggest that the Greeks brought the Persian problem on themselves. The expansion of Persia was one of those turning points of history that would lead to both dire and stimulating effects on neighbouring peoples. It led indirectly to Athens' fifth-century role in the history of the west. And it opened the east to Greeks, Greek ideas and styles, in ways that were to be perceptible for centuries to come and in most distant areas.

B The Persian Empire

In a series of inscriptions in three different languages (Elamite, Akkadian and Old Persian) set up at Susa in the later sixth century, Darius, King of the Persians, records the programme of construction for his palace. 'The ornamentation with which the wall was adorned, that from Ionia was brought ... The captives who wrought the stone, those were Ionians and Sardians'. He also mentions the collaboration of Sardians and Egyptians for the woodwork, Babylonians for the brick, Medes and Egyptians for the decoration of the walls and goldsmithing, and he names the sources for materials: gold from Sardis and Bactria, lapis lazuli and cornelian from Sogdiana, turquoise from Chorasmia, silver, ebony and copper from Egypt, ivory from Ethiopia, India and Arachosia, while the cedars of Lebanon were carried to Babylon by Assyrians (Syrians to us), and from Babylon to Susa by Carians and Ionians.[17]

This account is a graphic commentary on the problems faced by the ruler of an originally nomadic people in attempting to create an urban and palatial setting of a dignity which answered the power of the greatest empire of the world. Nomads have no need for monumental masonry. Their way of life may be opulent but it is based on tented accommodation and portable furniture – so they recline to eat or receive guests rather than sit at table or enthroned. Nomads who settle down or take over an empire have problems. They must either adopt the behaviour of their predecessors in their chosen place of residence, and in the area which was to be the heart of the Persian empire there was no adequate precedent, or they must borrow. For the most part the nomad peoples who entered Persia had borrowed. They had arrived in Iran, with other, related peoples and possibly over a period of centuries, from the north east. The Medes, the immediate predecessors and neighbours of our imperial Persians (Achaemenid; descended from Achaemenes), hailed from the same general area and had, during the seventh century BC, created a major empire. They had encompassed the fall of the Assyrian empire and advanced into Anatolia, as far as Lydia, while in the east their rule extended to Bactria, south of the River Oxus.

Cyrus the Great, the first of the line of Achaemenid Persian kings, reigned from about 560 to 530 BC. He inherited the empire of the Medes, with its capital at Hamadan in central western Persia. Under Cyrus the Persians consolidated their control of this empire by subduing Babylonia, then Lydia, deposing the philhellene King Croesus,

which brought them face to face with Greeks; in the east they advanced to the Indus, and over the Oxus into Sogdiana, where Cyrus was killed, fighting on the River Jaxartes. His son Cambyses added Egypt to the empire. Darius, of collateral Achaemenid descent, came to the throne in 522 BC, dealt briskly with rebels in various parts of his realm, then proceeded to acquire closer knowledge of his western neighbours by taking most of the coastal cities of Greek Ionia and by crossing the Hellespont to mount an expedition along the west coast of the Black Sea into Thrace. An abortive revolt of the Ionian Greeks in 499 BC was supported by an expeditionary force from Athens and left Darius asking 'who are these Athenians?' – an anecdote whose truth is less important than the impression it conveys of the view from Persia of such remote border skirmishes. But he continued a policy of expansion and sent a force against north Greece in 492 BC, then to central Greece in 490. This appeared to the Greeks like a punitive expedition against Athens, as it partly was, given the way that Athens and Eretria were targeted. It came to grief on the battlefield of Marathon. Ten years later his son Xerxes marched against Greece in two successive years, and though he sacked Athens the Persian host was repelled from mainland Greece first in the waters off Salamis, then in the fields of Plataea. A minority of the Greek city states managed, briefly, to act in concert and exploit their superiority in tactics and troops against the numerical odds. Athens emerged as leader of Greece, leader of what amounted to an empire dedicated to the freeing of all Greece from Persian rule. By the mid-century the Greek cities of the eastern Aegean were free and for another hundred years Persia's involvement in Greek affairs was intermittent, not often hostile and almost always mercenary. From the Persian point of view the activities of Greeks were hardly more than an irritant in the distant west, stabilized by gold and diplomacy when arms proved ineffective. Many Greeks admired the Persians and the bearing of grudges was left mainly to the northerners, in Macedon.

The Achaemenid Persians were good rulers who have generally suffered a bad press by being viewed mainly through Greek eyes and sources.[18] Their empire was divided into provinces (satrapies), each with a capital city housing a Persian civil service and sometimes a garrison, but in some areas local ruling families were left in at least nominal control and the religious susceptibilities of the populace were not offended. Remoter areas were left virtually untouched except, it may be, for the occasional visit of a tribute-gatherer.[19] The culture of the Persians' adopted homeland in the early years of empire is not easily defined. Their traditional art must have been much as that of their neighbours and nomadic predecessors from Asia. It was expressed most clearly on portable objects, mainly weapons and horse harness of bronze (such as the famous 'Luristan' series), and expressed also in woodwork and textiles, but not without knowledge of the more sophisticated products of wealthier nomadic peoples, such as the Scythians, who had also irrupted into the near eastern world in the seventh century BC. The styles are, broadly, Animal Art (which we consider more closely in Chapter Six), as unlike Mesopotamian (and Greek) as they could be, and allowing nothing for monumental expression in sculpture or architecture. The most obvious models for the new empire were the palace cultures of Mesopotamia and the borrowings are readily apparent; yet they are demonstrated most clearly by imported techniques and technicians, as Darius' inscriptions indicate.

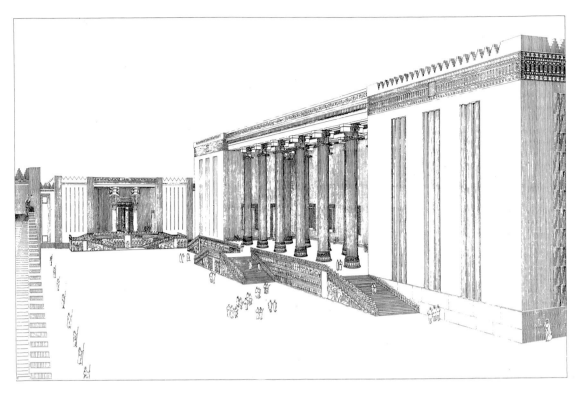

2.12 Persepolis, reconstruction of Apadana and Royal Court

The Persian buildings [2.12] – audience halls and structures designed more for effect and ceremonial than for living in – are not much like the Mesopotamian, and their ranges of columns more closely resemble the interiors of massive tents. Comparable ground-plans can be seen in earlier, ninth-century buildings created for other settled nomads, probably including the Medes, in north-west Iran.[20] On the walls of the Persian buildings the relief decoration may copy Mesopotamian and Greek patterns but the dominant theme of procession carved on relief dados gives a very different impression from that of the Assyrian palaces or Egyptian temples, with their overall scenes of battle, the king's court or the hunt.

Whatever the origins of the building plans, the real novelty was their execution in dressed masonry rather than undressed stone and brick. Both the Darius inscriptions and the surviving remains elsewhere show that in architecture it was indeed the stone-cutters of Ionia and Sardis (the capital of the Lydian satrapy) that were influential. The Lydians were not Greeks and the non-Greek, Lydian component in sixth-century Ionian art may easily be underestimated, as we have seen, but their architectural achievements and innovations seem to depend on Greek traditions rather than Anatolian ones. The peripteral temples of the Greeks inevitably encouraged the development of regular architectural orders, and the demands of working material as hard as marble led to the development of new cutting tools and techniques. Both the architectural orders and the techniques were introduced to Persia.

2.13 Pasargadae, columns

2.14 Persepolis, reconstruction column capital
and base

Something resembling a regular Achaemenid architectural order was created out of
motifs assembled from Ionian and, to a lesser degree, Egyptian prototypes adjusted to
local taste, which seems usually to have been disposed towards the even more ornate. It
was created and adjusted, we may suppose, by the forced labour of foreign master-
masons. In Cyrus' palace at Pasargadae stone column bases in the form of horizontally
fluted *tori* (like cushions) are quite Greek [*2.13*]. Designs for Persepolis and elsewhere,
later in the sixth century and in the fifth, are more complicated [*2.14*]. Below the plainer
tori are big bell-shaped bases decorated with floral relief motifs. The capitals have
hanging and upright rings of leaves which recall an earlier Ionian (and ultimately
Egyptian) style, and above them double pairs of volutes which resemble distorted Ionic
capitals, but really derive from furniture forms. Dividers are the Greek bead-and-reel
mouldings, an old pattern resembling carpentry on the lathe but exploited first by the
Greeks in a monumental, architectural form which was much copied.[21] Above there are
projecting foreparts of bulls, bull-men or various monsters – an old Mesopotamian
motif adopted eccentrically for architecture. Column shafts are fluted, but more closely
than the Greek. The whole effect is of gorgeous furniture, enlarged and petrified; but
this was true of the early experiments in the creation of stone architectural orders in
Ionia, taking minor orientalizing furniture or utensil forms and adapting them to a new
use and scale. The same process, or one like it and with similar orientalizing models,
seems to have been created with the help of Greek masons for new masters.

2.15 Pasargadae, rosette frieze

2.16 Tall-i Takht, ashlar foundations

Other patterns on the architecture are oriental, or Greek orientalizing: it is not easy to say which, nor, perhaps, important. I pick out particularly the fine rosette friezes with their concave leaves [2.15]. On the wall blocks the dressing of the stone at the joins (*anathyrosis* at the joining edges and drafted margins at fronts) and the forms of clamps are Greek. In the dressing of the stone the claw chisel is used, a Greek masonry tool of the earlier sixth century which makes for the rapid removal of stone close to its desired finish [2.16]. It is often in minor detail that the presence of the Ionian is betrayed, for example in the shape of cyma mouldings such as those at the wall tops of Cyrus' tomb at Pasargadae where there are also unfinished dentils of Greek Ionic type.[22] Colour contrast in the choice of stone for the masonry is also apparent in Persia and there were models for this in Ionia, but also, closer at hand, in Urartu.

The architectural details were introduced from Ionia, and are of the Ionic order. The Ionic capital itself lingers throughout the period of the empire as a minor feature. It is seen, for instance, topping pillars at either side of a relief ritual scene, with figures in Median (?) dress, at Qizqapan in Kurdistan [2.17].[23] Here it is decorating a rock-cut tomb façade of the fourth century and there are Ionic capitals on the apparently rather earlier tomb at Da-u-Dukhtar.[24]

The relief figure decoration on the monumental approaches to the Persian buildings generally takes the form of processional scenes of homage to the king, including long files of subject races bringing tribute. There are occasional separate groups of the king-hero subduing a lion, monsters, and the great lion-bull fight, all Mesopotamian subjects which had also been influential in Greek art. The files of tribute-bearers do not much resemble the tall-frieze decoration of Assyrian palace walls, nor anything Greek, and must be judged peculiar to Persian designers. In creating an iconography of Empire,

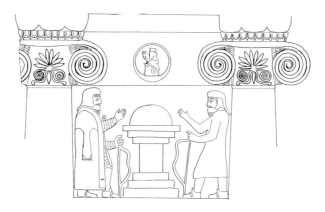

2.17 Qizqapan, rock-cut tomb façade

there was little the Greeks could offer. There are, however, some details of composition which seem at variance with the expected almost military precision and uniformity of an oriental frieze. They more readily recall Greek treatment of similar friezes which deliberately avoid a regimented effect by varying pose and gesture; thus, a line of Persians may be broken by allowing some figures to turn and converse with the next in line [2.18],[25] a matter of trivial observation of natural behaviour generally shunned in the formal eastern scenes of ritualized attendance on a god or king. These, indeed, derive much of their effect from the repetitive figures and poses.

Many of the details of execution in the friezes are also basically Mesopotamian, for all that some had also been adopted in Greek sculpture – the whorl treatment of hairlocks, for example. There are some, however, that suggest Ionian hands or inspiration. A minor detail is the common use of metal attachments to the stone relief figures and animals. The most obvious reflection of Greek practice is in the treatment of drapery. Early in the century Ionian sculptors had shown an interest in rendering the folds of dress as semi-realistic patterns, and this had developed around the mid century into a

2.18 Persepolis, frieze from Council Hall stairway

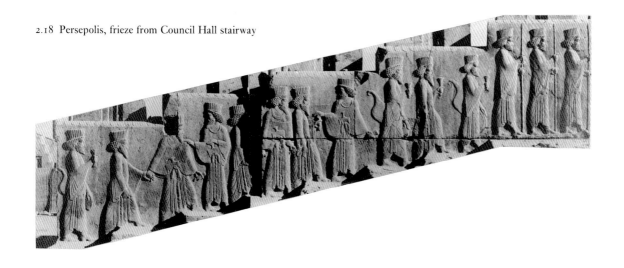

2.19a Pasargadae, relief fragments

2.19b Persepolis, relief on door jamb of Main Hall

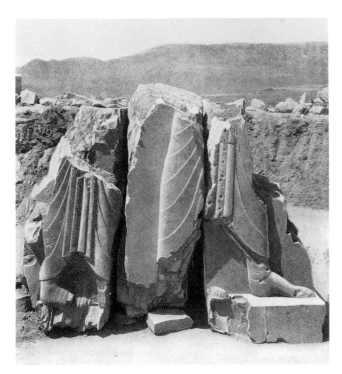

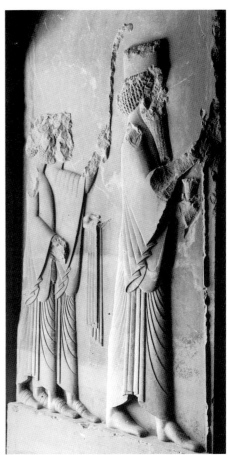

highly organized style of carving which 'stacked' folds on either side of a vertical strip, and which emphasized the three-dimensional overlapping by a pattern of zigzags at the hemline, sometimes terminating in flaring folds. There is no good reason to doubt that this disposition of dress, at least in this specific form, was a Greek invention, and it is the Greek form that appears at Pasargadae and thereafter for many long-skirted figures [2.19].[26] It could hardly have been invented or introduced by anyone else in Persia, and there are no real antecedents for it in the otherwise rich sculptural record of Babylon and Assyria. Given the documented presence of Greek masons the connection is certain, but the motif was not simply copied; it had after all to dress figures very differently conceived to the Greek. It was the superficial pattern that was copied, and the possibilities of realistic depth in dress that it offered were ignored.[27] In Persia, moreover, it never develops beyond this purely decorative pattern, while in Greece it shakes out in a realistic manner which enables it to express something about the forms of the body beneath. This element of anatomical interest was unknown in Mesopotamia and the Persian Empire, and so this was a development which the easterners ignored. New Greek sculptural forms became accessible even in Persia itself, for instance, the early Classical statue of Penelope brought to Persepolis; see [2.25]. These were not

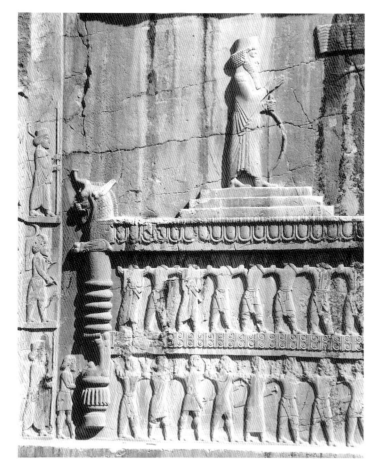

2.20 Naqsh-i Rustam,
tomb of Artaxerxes III

influential and Persian reliefs of the later empire barely show any development of forms. On the great relief façades of the royal tombs near Persepolis the figure and dress of the king change not at all from Darius to Artaxerxes III, who died in 338 BC [2.20].[28] There seemed no need to improve on the older Court Style which was dominantly displayed on the major buildings. This conservatism had long been a characteristic of eastern arts.

Major sculpture in the round was not an important feature of Persian art. A fine green greywacke (granite-like) statue of Darius was found at Susa in 1973 [2.21]. Its inscription and material show that it was one of a pair made in Egypt, but the style of the dress is so similar to that of the Ionicized reliefs in Persia that we must assume that sculptors of the same origin or training had executed it.[29] The new Greek forms in sculpture had been introduced and adopted but their potential was never realized. This is a good example of the translation of form without significance. We might ask, however, whether it was exploited in a manner peculiar to its new home. It is confined to figures of Persians – royalty, courtiers and royal guard. It is tempting to think that this foreign style seemed in its way most effectively applied to figures whose special status in society and art was secured by their positions of power. This might be true, but we have to remember that it was the loose Persian dress, rather than the more tailored Median or

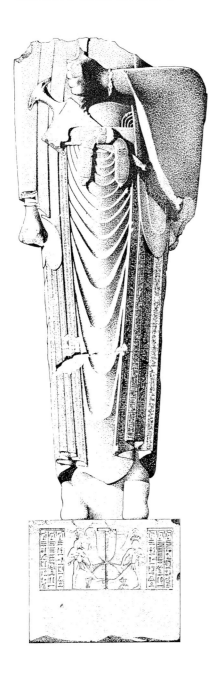

2.21 Statue of Darius from Susa (Tehran)

2.22 Glazed relief from Susa

that of subject peoples, which lent itself best to being rendered in the Greek manner.

The famous glazed reliefs at Susa, some of which may be of the later fifth century but most of which probably belong to Darius' reign and later, are similar to the stone reliefs but are accompanied by floral patterns which more closely resemble Greek orientalizing than the truly oriental from which, long before, the Greek derived [2.22].[30] This is not easy to explain. Darius' inscription attributes the work in brick to Babylonians, but the technique of the reliefs is different from that of Babylon (glazed faience rather than glazed clay), and the ornamentation of the walls was said to have been brought from Ionia. This is a phrase often quoted but never properly explained. 'Ornamentation' translates a word in Elamite that may also imply colour[31] and it is difficult not to think of

2.23 Incised fragment of sculpture from Persepolis (New York)

2.24 Incised stone plaque fragments, Persepolis

the glazed reliefs rather than any perishable decoration in wood or textile. Painted stone relief might be another explanation but this was not *brought* from Ionia even if some elements of the style of carving were western. If the colouring material for glazes is involved, this might have been imported, and possibly techniques of applying it, but coloured stone reliefs were no novelty. The East Greek world was familiar with glazing techniques on so-called faience, which is related to the practice at Susa, but never so far as we know executed at this scale or for this purpose. Egypt was a more obvious source for the technique.

And what can we know of the Greeks who worked in Persia? The ration accounts for workmen at Persepolis mention very few Ionians, but their names appear in Greek graffiti in a quarry near by ('I am [the mark?] of Phylarchos', and 'Nikon wrote [me]'),[32] and there are several groups of Carian masons named on the ration tablets. The Carians, southern neighbours of the Ionians, were a privileged people in the empire. Their queen Artemisia fought well for Xerxes at Salamis ('My men have behaved like women; my women like men') and they shared with Ionians the responsibility for bringing the

2.25 Marble statue of Penelope from
Persepolis (Tehran)

cedars to Susa. A Carian skipper, Skylax, was sent by Darius to explore the coast of
Arabia and the River Indus. A Carian mason would have worked like an Ionian mason
and we do not know what criteria the Persians used for distinguishing them other then
their languages which the Persians probably did not know. Pliny says that a Greek
sculptor Telephanes worked for Darius and Xerxes, so we have one name but no
certainty about his home (Phocaea or Phocis).[33] In the Elamite version of Darius'
inscription the stonecutters are described as captives with a word which was not applied
to other foreign workers,[34] although all must to some degree have been obliged to work
for the Persian king. Ionian women are mentioned in the ration tablets (including
allotments for those recently delivered of children), so the *Gastarbeiter* came with their
families, or may have married local women.

Other trivial but eloquent traces of Greeks in Persia take the form of scratched
figures, little more than elegant doodles, on some of the stone work and done in an
unmistakable late Archaic Greek style [2.23]. Most would have been finally covered by
paint but there are pieces of one stone plaque which carries an incised sketch of a Greek
mythological scene for painting [2.24]. This was a separate object of no significance to
the Persians or their stone-working, and must resemble the painted wooden plaques
which were surely very familiar to Greeks at home.[35] Other Greek objects in Persia
included loot from the Greek cities, of which there would have been plenty, and gifts,
but they seem to have made no perceptible impression on the minor crafts of Persia.[36]
The Early Classical marble statue of Penelope which was found at Persepolis in the
debris from Alexander's sack [2.25] is rather a puzzle, since the identical type must have
been visible, and survived, in Greece, to be copied centuries later for Roman patrons.

The circumstances in which such replicas were made are obscure, but this could have been a gift, or looted from one of the cities of Athens' empire where some scholars believe the Penelopes were placed.[37]

All in all, the ancient visitor to the Persian capitals would have found much to remind him of the palatial sites of Mesopotamia, a little of Egypt and virtually nothing of Greece unless he had an eye for architectural and sculptural details and techniques.[38] The forests of columns in the Persian buildings may indeed, in plan, recall the massed columns of the colossal Archaic Ionian temples, but the Greek columns are exterior to the temple, the Persian are interior with some shallow columnar façades which need not be of Greek inspiration. The double rows of columns seen on [2.12] are too unlike Greek temple periptera in their context to owe anything to them. Nevertheless, what little Greek there was in Persia was durable and long influential both there and farther afield. To regard Achaemenid art as, in some degree, provincial Greek, is absurd, and there can be no warrant for attaching Greek artists' names to Persian styles.

When we turn to the provinces, the satrapies of the Persian empire, the story is a different one. Many Persian officials and governors resided in the satrapy capitals and in places there would have been substantial garrisons, but the Persians were generally tolerant of local customs and religions. Anatolia is a sensitive area since the western seaboard was Greek and several of the native kingdoms were already heavily hellenized, while in the Lydo-Ionian culture it is hard to tell Greek Ionian from Lydian. There were satrapy capitals in the north at Daskyleion near the Sea of Marmara, at Sardis, the old Lydian capital of King Croesus who had been deposed in 546 BC, and at the Carian capital Halicarnassus.[39]

Sardis, a terminal of the Royal Road from Persia, was a crucial city and had been the target of the abortive Greek revolt of 499–98 BC. Here the Persians learned about coinage from the people who invented it, and adopted a version of Croesus' device of a lion and bull forepart for their first issues. Later coins exclusively display the Persian bowman, whom we identify as a king or hero, for the gold darics (named for Darius) and silver *sigloi* (Greek for shekels). But this Persian coinage seems mainly for circulation in the west where the Greeks too had developed a brisk production with individual die devices for different cities, many of notable quality beside the rather prosaic Persian bowmen.[40] Greek coins had first been struck, we believe, for civic purposes to pay public labour, or mercenaries, or fines and taxes, only later becoming more fully used for retail transactions. They rarely travelled far from their mints until, at the end of the Archaic period, coinage served as a convenient method of carrying bullion. Persian coins probably served much the same purposes, but probably not as bullion and types were minimally updated.[41] Greek style in coinage re-entered the Persian Empire in the hellenized satrapies of Anatolia and the Levant, and after Alexander spread farther east to lands already used to the commercial advantages of marked, weighed metal, but not in quite this form.

Eastern empires, including the Persian, were bureaucracies in which the validation of documents and goods played an important part, and this meant the common use and production of seals. (At this point the exceptional use of an Athenian coin as a seal on an early fifth-century tablet at Persepolis may be noticed,[42] and a fourth-century burial at Ur of a man, perhaps a seal-cutter, who collected Greek gem and coin impressions.[43])

The eastern seals were generally cylinders, but in the seventh century tall rounded conical stamp seals, commonly of blue chalcedony, became popular in Babylonia, or a variety with facetted sides giving an octagonal, slightly convex face for the intaglio device. This is a form (the pyramidal seal) which is adopted by the Persian court and local nobility at Sardis and numerous examples are known, nearly all of them carrying Persian motifs of the King-hero fighting a lion or a variety of monsters. Some have Lydian names on them, and many have individual linear devices to identify them, devices very similar in composition to those set on the masonry of Persia by the Lydo-Ionian masons. The bull on [2.26a] is more Greek than Persian, the inscription names a Lydian, Manes, and the device before the bull is more like a corrupt letter than the masons' marks. A very few of the seals have purely Greek devices cut in a Greek style. [2.26b] has Greek subjects and style, but both a little distorted: the Herakles with a mini-lion, and the Gorgon with two. Where a setting is preserved it is a silver loop and stirrup with duck-head terminals, such as appear on Lydo-Ionian silverware. Most appear to be of the later sixth and first half of the fifth century but we cannot be sure how long they went on being made, and the Greek influence on most of them is minimal.[44]

There had probably been a long tradition of painting in Anatolia, back to the Hittite Bronze Age. Later, in mid-sixth century Gordion, the Phrygian capital and perhaps already Persian, there is some wall painting which looks Lydo-Ionian [2.8].[45] At the end of the century and in the early fifth there is more from built tombs in Lycia. The style should probably be declared Anatolian, but it is indistinguishable from what we might judge to be Greek of the same period (which does not mean that there is more Greek in it than eastern), and some of the subject matter is purely Greek, mythological. The banquet scene [2.27] has many Persian trappings, however, and this tomb could well have been for a Persian official living in a society as strongly hellenized as any outside the Ionian cities themselves.[46] At nearby Xanthos the tomb monuments, of traditional local form, are decorated with stone reliefs done in a pure Ionian Greek style and admitting as many Greek motives and figures as do the paintings [2.28], yet here again we deal with a city which owed allegiance to Persia.[47]

Farther afield in Anatolia there are sculptured gravestones with reliefs showing Persians and funeral processions, but some of them with the familiar Greek anthemion finials; some may even be Greek stones reused [2.29]. The style of the carving owes little enough to Greek.[48] Gravestones at Sardis itself are just like the Ionian – plain shafts with anthemion tops. Much other sculpture in Anatolia belongs wholly to the history of Greek sculpture with the barest relevance to the Persian presence. An early example [2.30], recently made known, is a portrait-like head of the later sixth century from Herakleia Pontica (a Greek colony on the Black Sea north of Gordion). It is probably of a local governor; he is wearing a skin cap which resembles the Persian tiara but might be a local fashion.[49] Later, at the end of the fifth century, a long series of hellenizing decorated tombs in the Lycian capital, Xanthos, culminates in the so-called Nereid Monument. This, and several others of later date in Lycia, is purely Greek in its architectural forms and sculpture although its conception follows local tradition. And in the fourth century the same is true of the tomb of the Carian dynast Mausolus at Halicarnassus, a major monument of Greek art.

2.26a Seal with Lydian inscription (Geneva)

2.26b Seal with Herakles and Medusa (Boston)

2.27 Painting at Elmali

2.28 'Harpy Tomb' from Xanthos (London)

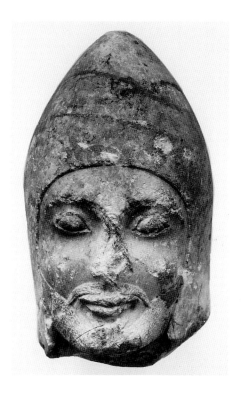

2.29 Tombstone from Daskyleion (Istanbul)

2.30 Marble head from Herakleia Pontica (Ankara)

In the minor luxury arts Persian studios excelled in the production of gold and silver vessels, many with handles or spouts in animal form. It is difficult to see anything Greek in their shapes or decoration, with the possible exception of some bead-and-reel mouldings, and the free poses of some of the animal elements might suggest that an Anatolian Greek had a hand in the design of some vessels. The fine goat handle of [2.31] does not display the anatomical realism of contemporary (probably fourth-century) Greek work, but the subtle poise of the head and flowing spread of the wings, as opposed to the usual more compact eastern treatment, as well as satyr features in the head at the handle base, show that it would not have taken the form it does without knowledge of Greek art.[50] In some respects the style is a successor to the Lydo-Ionian of the Archaic period. Craftsmen elsewhere (in Thrace) combined Persian and Greek in their own metalwork, as we shall see.

Much of what has been discussed so far has taken us beyond the period of the Persian invasions of the Greek mainland in 490 and 480–79 BC. In the terms of our subject this bitter struggle seems to have resulted more in the opening of the eastern world to Greek art than in its exclusion. In the Archaic period we have observed the service of Lydo-Ionian art to the Persian; in the Classical period a case can be made for the evolution of 'Greco-Persian' styles which were to be influential both east and west.

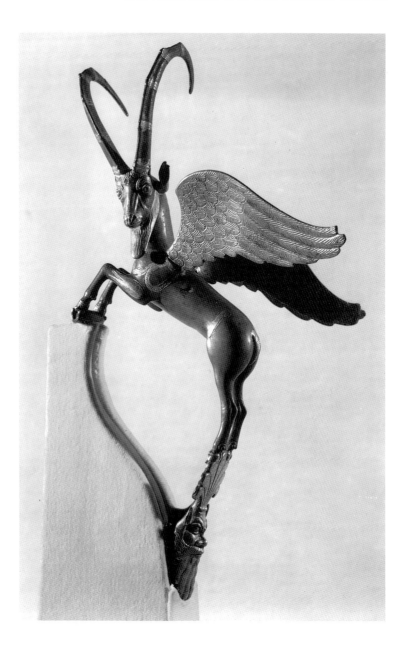

2.31 Gilt silver vase handle
(Paris, Louvre)

A series of gemstones which begins some time before the mid-fifth century, and which are quite distinct from the Lydo-Persian pyramidal seals, have acquired the title 'Greco-Persian' and are generally attributed to workshops in Anatolia. This had been suggested partly by their distribution (though they travelled far west, north, and east; to Italy, beyond the Black Sea and into Central Asia), partly by proximity to the Greek sources of assumed influence. They are almost all scaraboids, like plump rounded pebbles with flat oval faces for the intaglios. The shape was originally eastern but this form and size becomes the basic Greek type of the fifth and fourth centuries. The material is generally still blue chalcedony, which was almost as popular in the Greek

studios also. Less common alternative shapes are the tabloid, which can provide several flat faces for intaglios (the Greeks preferred these flat faces for cutting although it is more difficult to make good impressions from them), and the occasional cylinder, which may be sliced to give a flat face or cut on one side only to be used like a stamp seal and not rolled like a real cylinder seal. In recent years many more examples have become known with alleged proveniences in Persia itself (hitherto there had been virtually none) and even farther east, in Afghanistan. It may then be that there needs to be some revision of views about where they were made, or whether there were several centres of production, even non-Anatolian (but see below).[51]

The subject matter of the Greco-Persian gems is revealing. Few are in the Persian Court Style, usually with single studies of animals or monsters [2.32a], which is a Greek habit rather than an eastern one, and occasionally adding a winged sun-disc overhead. Later, and in a more Greek style, there are other and novel animal studies or animal fights, but these are not the hieratic lions and bulls of the eastern monuments, but more often a dog or eagle with deer [2.32b]. In the battle scenes between Persians and Greeks the latter are frequently discomfited [2.32c]. In the hunting scenes we see Persians in their distinctive dress, but hardly ever the formal King-hero grappling a lion; instead, there are realistic scenes of hunting fox, bear or lion, sometimes from horseback. Some are conventional action scenes, but some are après-hunt: such as the rider with his trident-spear (an unfamiliar mode of fox-hunting to our eyes) and dead quarry [2.32d], or the bowman bearing home a brace of birds [2.32e]. The horses are Persian too with their rounded noses, dressed tails and patterned saddle cloths. There are several domestic scenes on the gems, though, a wholly Greek genre and rendered in a very Greek manner, with a Persian and his lady, usually offering him an unguent bowl [2.32f]. She is more buxom than her Greek contemporaries in art, wearing the loose, deep-sleeved Persian dress and pigtails; there are even one or two far more intimate scenes of Persian and paramour. Xenophon remarks on the 'big and beautiful' Persian women and maidens, and fears his Greeks could be seduced by them into the life of lotus-eaters[52] One Persian on a seal performs a solitary dance [2.32g].[53] Some subjects are purely Greek [2.32h], bathing women, elders, a Greek rendering of a Persian, and many individual animal studies borrowed from the Greek repertoire.[54]

Stylistically, after the early Court Style studies of animals, there is much Greek in the work, with foreshortened figures, some three-quarter faces and realistic poses and dress. But equally, there is much that is not Greek. The way in which the animals are shown in the 'flying gallop' pose rather than the more naturalistic Greek is an indication that non-Greek taste is influential even in this series, since the motif is an old Mesopotamian one. It had been current in Greece only in the Bronze Age, but the rocking-horse pose will recur in the Hellenistic period as Greco-Persian arts become more fashionable. Technically, there is a preference for leaving undisguised the work of the cutting drill which gives the figures a corporeal pattern unlike the more realistically sinewy Greek figures on intaglios. The Court Style animals display a lot of very emphatic body patterning, and much of this is retained. Lion-paws rendered by a bunch of tiny close-set drill holes give a fine effect of power where the Greek engraver would have smoothed away the transitions to make a more correct anatomical rendering. This conscious renunciation of realism in the interest of pattern is not un-Greek, but it is not Greek of

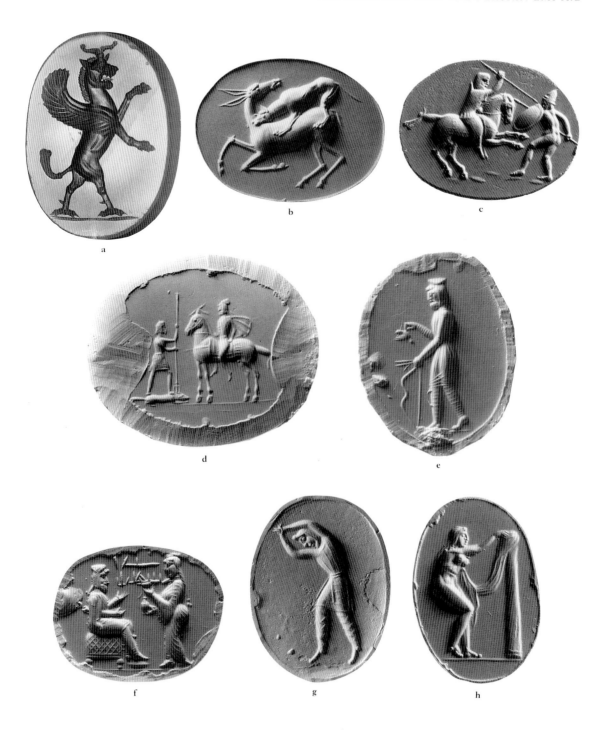

2.32a-h Seals and impressions

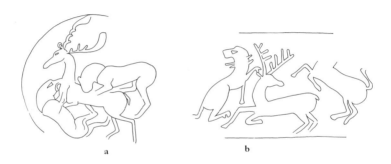

2.33 a, Sealing of Gobryas; b, cylinder sealing. From Persepolis (Chicago)

the full Classical period, so this is either lingering archaism (which is not altogether unexpected in the probable milieu in which the seals were cut) or a positive response to the taste of patrons and acknowledgement of the dominant Court Style.

The categorization of these seals, potentially from a wide area and with a long life, is not easy. Sealings from stones of this general type are found in Persepolis itself. [*2.33a*] shows the impression of the seal of Gobryas, dated 499 BC. The subject is oriental in origin, lions attacking a stag, but the forms and composition are Greek, easily matched in the Lydo-Ionian world and in very marked contrast to the purely eastern treatment of the same subject on a cylinder sealing from the same source [*2.33b*]. The animals have a non-oriental fluidity with none of the Greco-Persian anatomical patterning, but the stone that made the impression was conical, not a scaraboid or even pyramidal in form.[55] We cannot say whether any of the Greco-Persian gems were cut by Greek artists but the style and choice of subject matter were unthinkable without the example of both Greek craftsmen and of Greek subjects. It seems inevitable then that the series should have started in an already hellenized environment, such as obtained in Anatolia but not

2.34 Impression of seal from the Punjab (London)

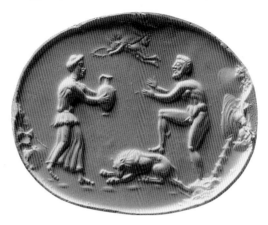

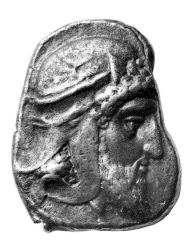

2.35 Coin of
Tissaphernes

farther east. Since some of the Greek subjects show a very sophisticated knowledge of
Greek myth we must suspect direct Greek intervention, at least for these stones. The
gem in [2.34] is in the familiar style and said to be from India. The Herakles with his foot
on the lion, safari-style, is matched only on a metope from the Temple of Zeus at
Olympia and on another sealing from the east (Ur), while the attendant nymph and Eros
are unique.[56] If the relaxed subject matter on many stones is also clearly Greek this
might also say something about the hellenized behaviour of the patrons. It is easy to
believe that they were made for the Persian and Persianizing courts and dignitaries of
the semi-independent kingdoms of Anatolia, and perhaps on the Syro-Phoenician
coast; difficult to see the more hellenizing made anywhere farther east, but the later,
rather repetitive animal and figure motives have an extended life in the east as we shall
see, and were probably created there.

It is in Persian Anatolia too that we find coinage of Greek style being minted in the
semi-independent kingdoms. The types are varied, like those of Greek mints and unlike
the Lydo-Persian darics and *sigloi*; the style resembles that of the pyramidal stamp seals
at first, but later recalls the Greco-Persian gems and includes studies of Persians. The
coins begin in early fifth-century Lycia and there are later important issues from
kingdoms to the east, Pamphylia and Cilicia, and to the north, Caria.[57] From the end of
the fifth century on some of the satrapal coinage carries heads of Persians which give the
appearance of portraits [2.35], but may not be more than shrewd Greek characteriza-
tions of the typical Persian governor; they are, nevertheless, often taken to be important
documents in the early history of true portraiture in Greek art, executed certainly by
Greeks for foreign patrons.[58]

It may be judged that the impact of Greek art on the Anatolian satrapies depended
more on the taste and already formed expectations and behaviour of the local peoples
than on the Persian presence. The Persians were, however, the occasion for certain
innovations, notably in coinage and gem-engraving. Very much the same is true of the
Syro-Phoenician area 'Beyond the River' (Euphrates), where the kings of the
Phoenician city states (Tyre, Sidon, Aradus, Byblos) also minted their own coins, with
many allusions to Persian dominance.[59] Persia depended very much on the Phoenician

2.36 Painting within shield on Alexander Sarcophagus

fleet for operations in the Mediterranean, but in the fourth century, after Egypt had thrown off Persian rule, the Persian hold on this coast faltered.

The effect of Greek art on the Phoenician and Egyptian world in the Persian period is considered elsewhere in this volume, since it has wider implications than anything inspired by Persian rule. We may, however, anticipate one monument that may serve as a fitting coda to the chapter. On the so-called Alexander Sarcophagus [3.10], the work of a Greek sculptor for a Phoenician royal burial at Sidon towards the end of the fourth century, there is a frieze showing Alexander and his Greeks fighting Persians. On the short side of the sarcophagus, where the fight continues, the Greek artist has carefully painted on the interior of a Persian's shield what must be a very close copy of a Persian scene showing an attendant before the Persian king, a group strongly recalling relief groups at Persepolis [2.36]. The artist displays close familiarity with his model, with its conservative style and its lingering Greek-inspired archaism in treatment of dress, so markedly unlike, by this date, that of the full Classical style that is executed so effectively in the marble relief.[60]

Alexander the Great put an end to the Achaemenid Persian Empire. He burned Persepolis and liberated Greeks deported by Persians, including men 'expert in their sciences and crafts', who had been mutilated by the Persians.[61] In a land which had become only superficially aware of Greek art he began a process of orientalizing which was to affect even the future of Greek arts in the homeland. But what there was already of Greek art in the east proved durable, and the way was open for more effective cultural infiltration, as we shall see.

3 · The Semitic World and Spain

THE PHOENICIAN CITIES of the Levantine coast – especially Byblos, Tyre and Sidon – emerge into the light of history and archaeology in the ninth century BC. Their early contacts with the Greek world, and especially with Cyprus, have been remarked already, in Chapter Two. Mutual influences were slight, but the fortunes of the two great maritime peoples of the Mediterranean world, of Greeks and Phoenicians, were to be intimately linked for many years. There must have been several communities where they lived side by side, both in Greek and non-Greek lands, possibly even in Phoenicia itself, though the time would come when the rivalry in the western Mediterranean would break into open war. To Matthew Arnold it was the busy Greek who drove the Phoenicians into western waters:

> As some grave Tyrian trader, from the sea,
> Descried at sunrise an emerging prow
> . . . Among the Aegean isles;
> And saw the merry Grecian coaster come,
> Freighted with amber grapes, and Chian wine,
> Green bursting figs, and tunnies steeped in brine;
> And knew the intruders on his ancient home.

Over the last hundred years scholarly argument over the relative roles of Phoenicians and Greeks in the early history of the Mediterranean, or indeed in the history of the western world, could easily leave the impression that the two peoples were born antagonists. The dispute can often be explained by anti- or pro-semitism (sometimes barely concealed), embarrassment at the assumed classical ethics that supported empire-building, and more recently by efforts to show that black Africa, via Egypt and Phoenicia, had lit and carried the torch of what is generally regarded as a western, white culture. The extreme views on this matter are nonsense, supported by a degree of selectivity and distortion in handling of evidence that would be more appropriate to a pre-election politician. More serious issues require assessment of the nature of what I have called the orientalizing revolution in Greece, which involves distinguishing both what was learned from the east, not necessarily or even often from the Phoenicians themselves rather than Mesopotamians and their vassals, and what the Greeks made of it. A better balance of views now obtains but the antagonism persists in some quarters and seems projected back into antiquity.[1] This too is nonsense. The Greeks and Phoenicians were less belligerent with each other than Greeks were with Greeks. It is even likely that they shared some early and pioneering settlements. In the east Greeks wandered freely, even before Alexander, and their artists were well received. In classical

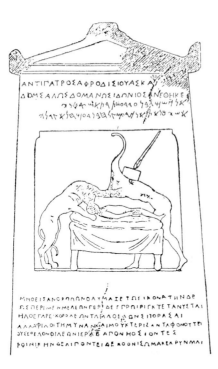

3.1 Gravestone from Piraeus (?)
(Athens)

Athens there was a Phoenician quarter in the port of Piraeus, and a Greek artist could make a Greek gravestone and inscribe Greek verses on it for a Phoenician who had died but whose soul seemed troubled until priests from his homeland came to his succour [*3.1*].[2] The Greek wanted to illustrate the event, as no Phoenician would or could, and the best he could do was to show a lion attacking the corpse and being fended off by a man with a ship-forepart for a head, representing help from the sea. The scheme is bizarre but effective, and suggests no lack of sympathy for the expatriate's problem. Later, in the second century, a western Phoenician, Hasdrubal, could become a leading teacher in the Athens Academy under the Greek name Kleitomachos.

The culture of the Phoenician homeland depended in part on the Bronze Age traditions of the area, related to but distinguishable from those of areas to the north, of Syria and Mesopotamia, and of their closer neighbours and rivals of the Kingdoms of Israel and Judah. But these were soon overlaid by a very strong egyptianizing influence.[3] There was a period in the early Iron Age when there was a power vacuum in this area, with both Assyria and Egypt keeping to their frontiers, but it was Assyria, not Egypt, that came to fill the gap politically if not culturally. The best prospects for expansion and wealth in the Phoenician cities lay in their maritime skills, enhanced by their wealth of timber. To these prime merchants of the Levantine coast the products of Egypt, which might be carried to the north and eventually by sea to the west, were certainly a better prospect as merchandise than the products of Mesopotamian overlords. They discovered too the virtues of a maritime power being also a producing power, and there is early evidence for Phoenician workshops making egyptianizing works in the appropriate forms (scarabs and amulets) and materials (glass, faience, ivory). Such people are always greedy for metal to be turned into consumer goods, and

their early voyages were in search of new sources. Egyptian subjects and decorative devices were freely borrowed by their craftsmen and there is an important subject, related to the theme of this book, in exploring the use, abuse and adaptation of Egyptian art to Phoenician purposes. History and geography made Phoenician culture thoroughly eclectic, and the Greek contribution to that particular melting pot generally manifested itself in fairly trivial ways except where the prestige of a monarch was at stake.

The story is complicated by the geographical division of the Phoenician world, east and west: the homeland, which fell under Persian rule for a while and was always more directly exposed to Greek interests; and the western, colonial, centred on the eighth-century foundation of Carthage (in Tunisia) and in other coastal areas, from Morocco, through south Spain, the Balearics, Sardinia and western Sicily. Carthage is the prime western centre but all that happened in the west was not inevitably dependent on Carthage. The Phoenicians, *Phoinikoi* to Greeks, become *Poenici*, *Punici*, in Latin; whence 'Punic', an adjective often used of the western Phoenicians. East or west there is an essential unity of culture, religion and art, but the separate history of the western cities led to some local development also in the arts, and for these the use of the term 'Punic' is justified. There was, however, more east-west unity than is sometimes allowed for by connoisseurs of the 'Punic world' and the east may be found to be giving the lead even in quite late periods.

Both Greeks and easterners had enjoyed some traffic with the west in the Late Bronze Age, the latter with Sardinia, the former with Italy. Both the homelands had suffered recession in the succeeding centuries and it remains a moot point whether the relationship of either or both with the west was to any serious degree maintained. Some measure of continuity might help explain how knowledge of the west could have encouraged both peoples to explore more freely when need arose, but the evidence is flimsy, the temporal gaps impressive, and so far there seems little to demand that either people remained in regular contact with western peoples or ports.[4] All this, as well as lesser problems over the use of the term 'Greco-Phoenician' such as we have met already with 'Greco-Persian', do not make an account of Greek art in the Phoenician world any the easier. We do well to remember that traffic, if not regular trade, might be quite busy, indeed incessant, even through 'dark ages', leaving very little archaeological trace and resulting in no perceptible influence on arts or crafts whatever.

We start in the east. Phoenicia and Cyprus, where there had been a strong Phoenician element since the ninth century,[5] were absorbed in the Persian Empire, and the prime mariners of the eastern Mediterranean gave the Persians what they would otherwise have lacked, a war-fleet which served them at the battle of Salamis. Hostilities with Greece did little to impede the flow of mainly trivial Greek goods to the east,[6] with no marked effect on local crafts. That there was, however, a deliberate trade in Athenian pottery north of Phoenicia proper is shown by the bulk storage of special shapes in warehouses at Al Mina.[7] In this respect at least the port seems to have maintained a role it had adopted in the eighth century, and with a better mercantile organization. It may even be that the easterners' continuing lack of interest in figure-decorated pottery helped foster Greek trade and production of plain black wares, at best imitating relief metalwork, since these remain an important import in the area for many years. In

3.2 Scarab (Nicosia, private)

3.3 Scaraboid (Paris, Bibl.Nat.)

Phoenicia of the Persian period there are two arts only in which we can detect positive influence which deserves discussion: seal-engraving and marble sculpture.

In the sixth century Greece was still susceptible to the influence of eastern crafts, and the engraving of hard-stone seals, generally of the scarab shape, was learned by east Greeks, almost certainly from Phoenicians, and very probably from Phoenicians in Cyprus.[8] It was a craft in which the Greeks soon proved their excellence and which they were to develop into a major art form. An early intimation of reciprocal influence may be detected in a number of scarabs made in Cyprus which combine Greek subjects, not always perfectly understood, with eastern trappings. An example is the carnelian scarab of about 500 BC [3.2] which has the Greek myth of Herakles rescuing Deianeira from the centaur Nessos, standing over the common eastern ground-pattern of cross-hatching, and with an Egyptian symbol (the *ankh*) and falcon overhead.[9] In the fifth century, and in Phoenicia itself, the process continues with Greek subjects, usually single figures of deities such as Hermes [3.3] who may be assimilated to a local god, in a rather emaciated hellenizing style. On the example shown the inscription, which was added later, names the god Baal.[10] However, the most distinctive seal series of the fifth and fourth centuries in the Phoenician world, east and west, is that of the so-called 'Greco-Phoenician' scarabs. The title is misleading and 'Classical Phoenician' might be better, although even this carries unjustifiable Greek connotations. The scarabs are virtually all of green stone, of varying degrees of hardness but commonly described as jasper, which is probably true only of a minority. Many carry subjects which derive from Greek Late Archaic art, but, oddly enough, not all of them obviously from gem-engraving. These are in a broadly Greek style, though not decisive enough for us to be able to affirm that any need be cut by Greeks. Indeed this is highly improbable since products of the same studios, which we may judge from the shared and distinctive treatment of the scarab

backs as well as their material and distribution, include devices of purely eastern or egyptianizing inspiration; indeed, these are the majority. The most we can claim, therefore, is a strong but minority influence of Greek subjects on the scarabs (e.g., [3.4]). Since the green scarab series is even more plentiful in the western Mediterranean, on Punic sites, than in the east, a problem is posed about the centre or centres of production, but there can be little doubt that some are eastern, directly affected by Late Archaic and Classical Greek art.[11] The gold and silver mounts for the scarabs are of different types, east and west, the former like Egyptian, the latter with distinctive loops which are twisted or with transverse rings for suspension. So they tell nothing about the origins of the scarabs themselves.

The jewellery traditions of the easterners had nothing to learn from Greece, indeed the Greeks had learned all their techniques from the east, but a Phoenician necklace from a fifth-century grave near Sidon [3.5] sports a superb Late Archaic Greek gorgoneion pendant, which suggests no little awareness and acceptance of Greek decoration.[12] The coinage offers much the same blend of styles and subjects as does that of Anatolia in the Persian period, the style in particular recalling that of the green-stone scarabs. This is clear enough in the fourth-century Judaean device of a god seated on a winged wheel (rather like a Greek Triptolemos), holding an eagle (like Zeus) and facing a Bes/satyr mask; the reverse has a Greek helmeted head, but on other coins misguided enthusiasm sees an Athenian owl in what is in all essentials an Egyptian falcon.[13]

The sculptural influence of Greece in Phoenicia reveals itself in two ways, one bizarre, the other yielding work of the greatest distinction. On a disputed occasion, but within a few years before or after 500 BC, it seems that the Phoenician city of Sidon received as booty from Egypt three stone anthropoid sarcophagi of the usual Egyptian type – shaped approximately to the body with a human head applied in relief. These were re-used for royal burials. More importantly, the type was thereafter copied, often in imported Greek white marble and regularly with heads of Greek type, some of which

3.4 Scarab (Paris, Bibl.Nat.)

3.5 Gold necklace from Sidon (Beirut)

are even equipped with an Egyptian box-beard [*3.6a,b*]. The earliest are the finest, in a pure Greek Early Classical style and surely from Greek hands. Many later examples may be the products of local workshops. The type of sarcophagus, with its Greek-style head, was soon adopted throughout the Phoenician world, from Cyprus to Spain.[14]

The history of the anthropoid sarcophagi is well demonstrated by the finds in the royal cemetery of Sidon and elsewhere in Phoenicia, but there were other sarcophagi at Sidon of greater distinction and of purely Greek workmanship. They are box-shaped sarcophagi of white marble, with gabled roofs. The type is most familiar to us from Roman sarcophagi, and there are early examples of relief-decorated sarcophagi in the Phoenician world (the sarcophagus of Ahiram),[15] but this form is a creation of the Greek world, although it is not easy to find there examples as early as those from Sidon and as lavishly carved in relief. The earliest, of around 420 BC, is the 'Satrap's Sarcophagus' which is close in style to the rather flat relief of the 'Greco-Persian' grave monuments from Anatolia, and carries scenes of the ruler in life – at rest, feasting or with his court and grooms, and in the hunt [*3.7*]. Another sarcophagus, in the form of the Lycian house-tombs with curved gable roof, is little later but although the shape is Anatolian, the style is more purely Greek, even Attic, and the subjects both reflect on the hunting skills of its occupant and offer Greek motifs – sphinxes and centaurs in a full Classical style of great finesse. One panel tells the story of the centaurs attacking Kaineus and so has a specific Greek mythological connotation [*3.8*]. The 'Mourning Women'

3.6 Anthropoid sarcophagi from Sidon (a, Istanbul; b, Beirut)

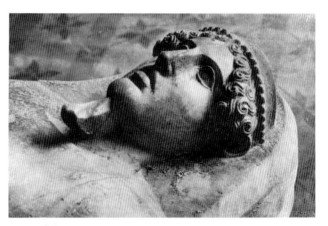

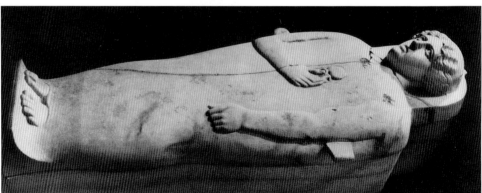

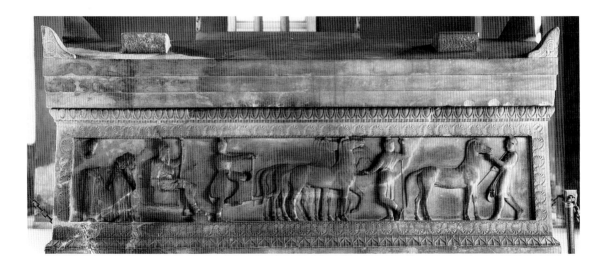

sarcophagus [3.9] must be of the mid-fourth century and takes the form of a colonnaded building with figures of standing women between the columns, a sarcophagus type which anticipates a common Anatolian form of the Roman period. But it also has an attic decorated with a funeral procession, and a base decorated with a hunt. And the last of the sarcophagi takes us out of the period of Persian rule into that of Greeks, the

3.7 'Satrap's Sarcophagus' from Sidon (Istanbul)

3.8 Lycian sarcophagus from Sidon (Istanbul)

3.9 Mourning Women sarcophagus from Sidon (Istanbul)

3.10 'Alexander Sarcophagus' from Sidon (Istanbul)

3.11 'Tribune' from Sidon (Beirut)

'Alexander Sarcophagus', whose Greek and Persian associations we have had occasion to remark already [*3.10*]; cf. [*2.36*]. All these works, except the first, are carved in a manner that matches the best of the homeland Greek world. Most of their subjects respect what we would judge to be the expectations of their owners, showing them at their most regal in life, or their most heroic in battle or hunting, and in these respects they differ from the general run of classical Greek funeral monuments. But the mourning women are wholly Greek: easterners did not take their grief so calmly. The Kaineus scene is Greek myth with little obvious funerary connotation, unless the image of a warrior being struck down by half-human demons carried a message for an eastern king. And the Alexander Sarcophagus celebrates the Greek ruler in a manner which the Phoenician might be bidding to share. So it seems that the Greek sculptors were able to add something of their own in their commission. The sarcophagi are now in the Istanbul Museum since they were discovered in years when the Ottoman Empire embraced this coast.[16]

If the types of the sarcophagi had been recognized in any numbers elsewhere, we might have been excused thinking that Sidonian kings made a habit of stealing the coffins of others. They were not, however, a unique phenomenon. The sanctuary of Eshmun in Sidon is a major monument of the city, its architecture including both Persian bull-protome capitals and Greek Ionic architectural features. In 1972 the excavators came upon a marble monument decorated with Greek relief friezes [*3.11*] in mid-fourth century style.[17] The monument itself is puzzling: commonly called a 'tribune' and apparently provided with a baldachin but too small to be a display place for a statue or a viewing stand. The upper frieze has an assembly of Greek gods centred

on Apollo and Athena; the lower frieze Dionysiac dance and music, with maenads and one satyr, who seems threatened by them. It could hardly be more Greek and it takes excessive ingenuity to make it relate to local cult or cult figures (Eshmun became equated with Asklepios), beyond the possibility that a Greek artist was expressing in his own terms a view of ritual involving song and dance. There is also from the same sanctuary as the tribune and of around the same date a rare example of a Greek-style statue in the round – a crouching child, of the 'temple-boy' type familiar in Cyprus.[18] There is other evidence too for the philhellene proclivities of Sidonian kings. Straton I (370–58) actively supported the Greeks at the Persian court and was honoured by Athens, and he or a successor might be associated with this monument (and has been thought the occupant of the Mourning Women sarcophagus). But it seems that a tradition of commissioning Greeks for such works persisted in Sidon for over a century.[19] It argues a remarkable acknowledgement by the easterners of Greek skills in a medium where there was no strong local expertise. There must also have been an effective means of recruiting the artists since the final work and painting, at the very least, must have been done on the spot. The works were carved at a time when Greco-Persian relations were generally good. This certainly applied to the Greek states of Anatolia, whence most of the sculptors were probably recruited, but by this time there was also a flourishing Phoenician quarter in the port of Athens, as well as diplomatic connections. This is about the date of the Phoenician's gravestone in Athens [*3.1*].

MAP 2 THE WEST MEDITERRANEAN

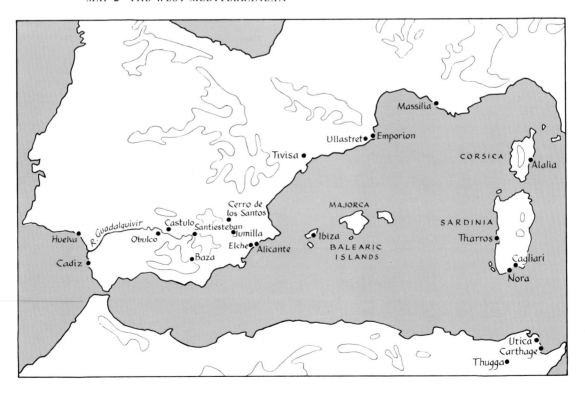

3.12 Gold ring from Utica (Tunis)

We turn now to the west, to what is to become the Punic world. In the eighth century Greeks and Phoenicians were exploring the western shores of the Mediterranean. From the mid century on their interests in the area began to be stabilized by the foundation of colonies, for commerce and subsistence.[20] Greeks soon dominated central and southern Italy and most of Sicily; Phoenicians were busy with Spain, the north African coast, and the islands including the western tip of Sicily. But there was much interplay. Phoenician and Syrian goods reach and are influential in Italy, as we shall see when we consider the Etruscans in Chapter Seven, but far less so once the nearby Greek colonies were well established. And the Greek objects found in most early Phoenician sites in the west may not all have been carried there by Phoenicians. These are most apparent in Spain (to be considered below) but not inconsiderable also in Carthage and Sardinia.[21] Demarcation of interests inevitably followed. A Classical source remarks on Phoenician ships supplying their settlements and neighbours on the Moroccan coast with luxury goods from Egypt *and* Athenian pottery, which is an interesting commentary both on the value of Athenian vases as a trading commodity and on who might carry them.[22] By this time the east had nothing of great importance or originality to offer the peoples of Italy and the trade was dominated by Greeks.

If we look for Greek artistic influence in the Punic world it is sensible to concentrate in the first place on Carthage and Punic Sicily, then on Spain. Before doing so there are some generalities, and one exceptional monument, to consider. The green-scarab phenomenon is generally taken to be a problem for the western sites but, as we have seen, it obtains throughout the Mediterranean, for all that most finds are from the west – mainly Ibiza, Sardinia and Carthage. In the writer's opinion the sources for whatever Greek there is in them should be sought in the east since the Greek subjects upon them are otherwise of no importance in the west, while the east was more directly exposed to Greek art in various media. The gold finger rings of the west are, however, readier to admit Greek subjects than the eastern [*3.12*], and more closely match the record of the

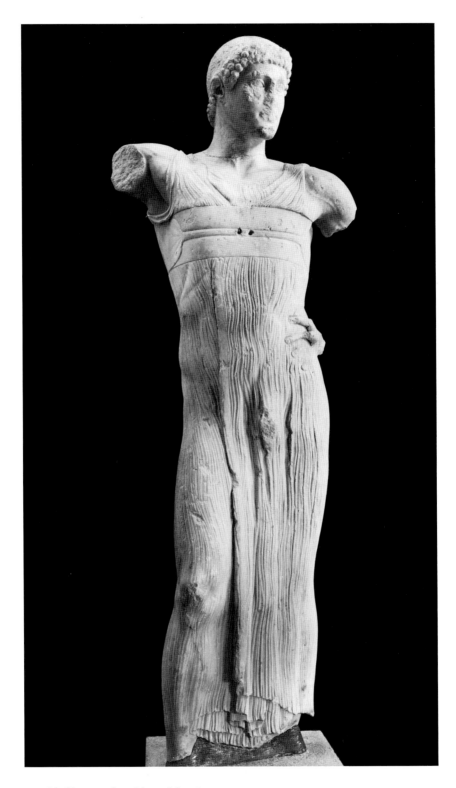

3.13 Marble statue from Motya (Motya)

3.14 Silver coin of Punic Sicily

scarabs in this respect.[23] Greek decorated pottery is not particularly plentiful on the Punic sites, although some is found everywhere, and there is more in some periods in Spain and Sicily when Greeks were allowed to be more active; nor is it any more influential than it had been in the east. Greek sculptural and architectural features are relatively unimportant until the fifth century and later. This is not the most fruitful area in which to explore our main theme, but there are some surprising individual monuments. The Punic world did not prove immune to a creeping popularity of classical styles that gradually overtook the oriental, with the result that the Punic cities faced by Rome had taken on a superficially familiar guise for all the differences in their way of life.

The most puzzling of the finds of recent years in the Punic world has been the marble statue of a youth [3.13], found at Motya, in Punic west Sicily. The style is purely Greek, of the mid-fifth century, and we might have judged it an import but for the fact that white marble statuary is a great rarity with the western Greeks, whether locally worked or imported, and the figure itself is difficult to interpret in purely Greek terms. The dress has been declared that of a Greek charioteer, or of a Punic priest or hero-king, even of a Greek hero (Daedalus) fitted with wings. I have no answers to offer, save to favour the charioteer hypothesis, to remark the excellence of its workmanship and sureness of its execution of both anatomy and dress, and to deduce that it is most likely either a work commissioned, for an unknown purpose, by a non-Greek from a Greek artist, or loot from a Greek city in Sicily where it had stood, probably as a monument to a chariot victory (like his famous bronze cousin in Delphi).[24] That Phoenicians would loot Greek art as readily as the Romans did later is indicated by the statues they took from Himera in Sicily in 409, later returned from Carthage by Scipio, only to be stolen again by the Roman Verres.[25] Could the Motya youth be one that stayed in Sicily?[26]

It is in Sicily too that we soon have other clear evidence for Greek artists serving the easterner, in the earliest Siculo-Punic coinage, starting in the late fifth century: gold on the Phoenician standard, silver on the Attic. The coins were minted to pay soldiery, it seems (some inscriptions on them refer to 'the Camp'), and for use in a Greek commercial milieu; whence the use of the palm-tree (*phoinix*) as an identifier for Greek rather than Punic customers. Other types copy Sicilian Greek [3.14] including the famous Syracusan Arethusa-head coins in an assured and purely Greek style. Carthage

3.15 Bronze razor from Carthage (Tunis)

3.16 Gravestone from Carthage

3.17 Gravestone from Carthage

soon followed suit, with gold and electrum coins, but the bulk of Punic coinage comes from imitative dies engraved and struck by non-Greek moneyers.[27]

Generally, however, Greek subjects and details in Punic art indicate knowledge of Greek work rather than the presence of Greek hands. This is not to say that no Greek artisans found employment with Carthaginians, but there seems not to have been the continuing patronage apparent from the marble reliefs found at Sidon and, perhaps, in the Motya marble statue, which at least shows appreciation of Greek art. Greek figures are to be found on Punic objects, rather as they are on the green scarabs. Bronze razors provided one such field, for eastern or Greek motifs, but the latter are rare, and are executed with notable plausibility if little relevance. At least, the eastern subjects are religious, the Greek often secular or at best heroic. A razor with a Greek and an eastern motif traced on either side is shown in [3.15]. The Herakles is normal enough, and it is commonly thought that such a very Greek image could have been equated with the Phoenician god Melqart.[28] The other side shows an easterner, presumably a Punic warrior but uncharacteristically shown naked, like a Greek, and his quarry is dressed as a Greek soldier, his helmet flying overhead, the whole group following an eastern formula for such a fight.[29] How close a Punic craftsman could get to Greek style on a somewhat larger scale is shown by the head on a stele [3.16].[30]

Architectural detail is more readily copied, and elements of the Ionic and Doric

orders were occasionally adopted.[31] A common type of votive monument takes the eastern form of a niche or of a stele with triangle top. The last soon adopts the outline, though not the proportions, of a Greek pediment with central and corner acroteria, such as appear also on Greek votive reliefs, but the architectural detail is commonly forgotten or misunderstood.[32] A clearer indication of Greek architectural influence appears when the gable is filled with a flame palmette, as in [3.17], where there is also a frontal sphinx on an Ionic column, which is a Greek motif.[33] But from the fourth century on the whole monument may adopt a Greek architectural form, including statuary motifs of Greek type and sometimes (especially in Sicily) paintings.[34] A Hellenistic example is the stele dedicated at Carthage by a Punic official, Milkyaton [3.18], but its recipient is the Greek goddess Persephone.[35] The cult of her partner and mother, Demeter, had been admitted to Carthage in the early fourth century, since she was readily assimilated to an eastern goddess, often to Isis. There is no profound religious 'conversion of the infidel' by Greeks to be read into such monuments.

We have already remarked the hellenized anthropoid coffins in the east. In one

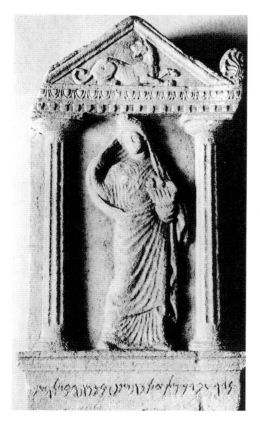

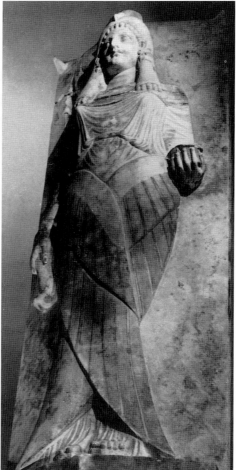

3.18 Votive relief from Carthage (Turin)

3.19 Marble sarcophagus from Carthage (Tunis)

cemetery at Carthage (Ste Monique; Rabs) of around 300 BC there is a special group of sarcophagi in the general form of a Greek building with acroteria, some with lids decorated with relief figures. The most remarkable [3.19] shows clear signs of Greek influence and competence in the execution of Greek forms of dress and features, although the whole figure of the woman, her headdress and wing-skirt, depends on its occupier's function as a Punic priestess. This group is as near as we get to the phenomenon of the hellenized sculptures of Sidon, and indicates a strong but strictly localized Greek influence (and possibly, in this case, presence) for a limited period.[36]

The craft of making clay figures from moulds had been learned by Greeks from the east around 700 BC. Early Punic and Phoenician figurines naturally resemble the Greek orientalizing. Archaic Greek motifs emerge on moulded clay discs, such as [3.20], where the cavalier and dog are a Greek group, the disc-and-crescent eastern.[37] From the sixth century on, however, forms of dress, features and posture for the hundreds of these cheap votives found at Carthage and on most other Punic sites, depend on Greek models, and often copy familiar Greek votive types (busts, half-figures, seated figures, etc.; [3.21]). Ibiza offers a particularly rich sequence of types that display local taste with Greek decoration beside more wholly Phoenician creations. [3.22] is a good demonstration of a local hybrid presenting the very odd proportions seen in several such figures, but close inspection reveals dress decorated with Greek late classical acanthus rinceaux and a gorgoneion.[38] The acceptance of Greek style at this level demonstrates more clearly than grander works how much the classical idiom had become part of the visual experience of the western Phoenician, for all that his behaviour and general way of life remained basically Levantine.

Monumental architecture with elaboration of stone orders was not a feature of the Phoenician world except in the hellenized use of detail on stelai, on a very reduced scale. There are a few more ambitious exceptions. At Thuburbo Maius in Tunisia a small Ionic shrine has been taken for a classicized version, of the second century BC, of the Phoenician Ma'abed shrine at Amrit, in the homeland.[39] Of the same date and later is a series of tomb monuments in Numidia which look like monumental versions of the triangular-topped stelai, with a superficial resemblance to the Mausoleum at Halicarnassus, and indeed are related to tomb monuments of the east, with pyramid roof, statuary and reliefs. I show an early example with a marvellous mixture of classical, egyptianizing and Punic, near Sabratha [3.23].[40] And there is the famous monument at Dougga, replete with Greek architectural detail, with a little Punic (Egyptian), but its dedication, in Punic and Libyan, shows it to be the work of a Punic architect (Abarish), well schooled in the classical orders. The structure had been virtually demolished to get at the inscription for the British Museum, and was restored by the French.[41]

The situation on the Spanish mainland (rather than the Balearic islands and Ibiza) deserves separate consideration. The apparent geographic unity of the great Iberian peninsula might lead one to expect a unified culture. This seems never to have been true in the historic period (even to the present day). The metal resources, especially silver, of the south west made this a wealthy area of particular interest to foreigners. The southern and eastern coasts invited exploration and settlement, by Greeks in the north, Phoenicians in the south, and the latter help to develop a strong, local but mainly phoenicianizing 'Iberian' culture, while the Greek colonies to the north generally held

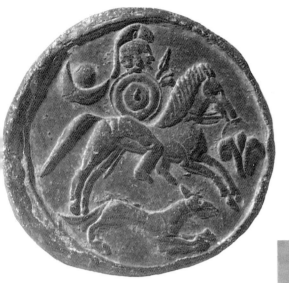

3.20 Clay disc from Carthage (Tunis)

3.21 Clay bust from Ibiza (Ibiza)

3.22 Clay figure from Ibiza (Madrid)

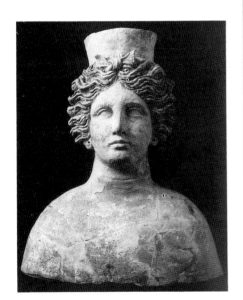

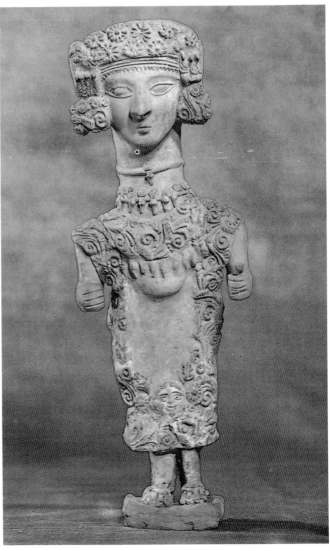

3.23 Reconstruction of
monument at Sabratha

off from their neighbours, as did their kin in Marseilles (Massilia). They were not, in this area, particularly influential. Their major foundation, Emporion (Ampurias), was a Greek colony like any other, but its effect on a major native town only twenty km away (Ullastret) was minimal except for some pottery sales.[42] We shall not consider this area further. The rest of Spain, central, north and west, has more in common with the cultures of France and Europe in general, and cannot be ignored here.

In some respects the peoples of Spain might be regarded as being no more sophisticated artistically than were the Etruscans at the time of their first exposure to Phoenicians and Greeks, which occurred in roughly the same years and were products of the same general expansionist or commercial behaviour. Here and there comparisons can be drawn. The responses were very different, however, and reflect on the different societies, their needs and expectations. So this investigation should provide grounds for speculation about the character of the two receiving societies as much as, or more than, about the results of the diffusion of Greek art. This is not our prime concern but it will not be ignored.

The Phoenicians reached the south of Spain by about the middle of the eighth century BC, to trade with the metal-rich areas behind Cadiz and Huelva, up the Guadalquivir valley, and to establish trading posts near native towns along the south-east coast.[43] Their sites, and native ones dealing with them, also yield Greek pottery, some as early as any in the west, including Euboean and Attic Geometric.[44] The assumption is that most of it was carried by Phoenicians, and this must usually have been the case, but in early years the seas were free, and there is record of a very successful trading venture by a Samian skipper, Kolaios, in the mid-seventh century, bringing home silver. This could not have been an isolated event, and in the sixth century we are told that the Tartessian silver king, Arganthonios, welcomed Phocaean traders and encouraged them to settle.[45] Of the Greeks, the Phocaeans were the prime colonizers and buccaneers of the sixth century in the north-west corner of the Mediterranean (at Marseilles/Massilia with great success, on Corsica very briefly, then in Italy at Velia). They must be the source of the East Greek and Ionian styles and objects introduced to the west, notably a fine series of Archaic bronze jugs. The phenomenon roughly parallels what we shall see happening in Etruria, but the Greek sources are mainly different.[46] The Phocaeans were soon checked by the Phoenicians in western waters, supported by their new city on the African coastal route, at Carthage. It is Phoenician arts that have the most serious effect, not Greek, and in ways commensurable with their effect in Etruria (where, however, the Greek became far more influential),[47] especially in media such as jewellery.[48] Still, the volume of Greek pottery arriving was notable, at least down to about 550 BC, some of it of very high quality, and this probably does argue at least sporadic live Greek (Phocaean) trade with the area.[49] At one of the earlier coastal sites there had been local imitations of Euboean Geometric pottery, Euboean exploration of the west having preceded the Phocaean though Euboeans need not have been carriers of the models and, if there were Greeks there, practising potters were not of their number.[50] There were Phoenician trading posts down the Moroccan coast too, and we have remarked a Classical author recording Phoenician ships sailing that way with luxury goods from Egypt and Athenian pottery.[51]

Phoenician activity in the south west helped promote a notable local culture, the

3.24 Head from Alicante

'Tartessian', producing a range of phoenicianizing goods and some fine, large cast bronzes of animals whose style and technique owe nothing to Greece.[52] Scholars' desire to detect Greek influence seems to have been as strong here as it has proved to be in some other areas of the ancient world, but with the Tartessians it should be largely discounted, or attributed to the same slight hellenizing traits that we have discerned in Phoenician art, east and west, with some admixture from visiting Phocaeans and what they brought with them.

The orientalizing Tartessian culture flourished into the first half of the sixth century; its distinctive qualities must be attributed to native taste for which the previous record in the area gives no ready clues. Association with folk from the other end of the Mediterranean brought new wealth in the form of imported manufactured goods, and a desire in the ruling class to express this enhanced status in new ways. In the sixth century there may indeed have been a substantial Greek presence to judge from the volume of imported pottery and effects on local art which we have yet to consider. In the fifth and fourth centuries the effects of this presence spread up into the hinterland of the south and eastern coastal strip, with its Phoenician settlements. This 'Iberian' culture is also phoenicianizing, quite plentifully supplied with Athenian pottery, generally of the poorest 'export' or 'end-of-the-line' quality, which cannot support the likelihood of any substantial continuing Greek presence, even on the coast, though at best it might reflect the proximity of the flourishing Greek colony at Emporion to the north.[53] Much is also carried across to the 'Tartessian' sites in the Classical period. A wreck excavated off Majorca, apparently a Phoenician or Punic ship en route to the southern coastline rather than the Greek northern coast (Emporion), carried much Athenian red figure and black pottery of moderate quality of near the mid-fourth century, and carriage amphorae (for

3.25 Group from Obulco

3.26 Figure from Obulco

oil, wine, etc.) from many parts of the Aegean world as well as from Sicily and Carthage.[54]

Some of the plainer Greek pottery is copied locally but we should look to more ambitious work for any evidence of Greek artistic influence. The earliest possible manifestations are not altogether the most rewarding for our present concern: stone sculpture in relief and in the round in a style barely matched at all in the Punic west and only tangentially attributable to Greek influence or hands, although both are regularly discerned. One or two major works seems to display more direct than usual knowledge of Greek Archaic sculptural forms: a head from Alicante whose headdress, forehead hair and face (especially the eyes) can only be explained in terms of Late Archaic Ionian Greek sculpture, though certainly not from a Greek hand [3.24], and the head of a sphinx in comparable style.[55] At a smaller scale, Iberian bronze figurines often display a sleekness that looks Ionian and recalls Etruscan figures of similar kinship.[56] Of the other and prolific finds what little trace of ultimate Greek origin may be detected might be attributable to Phoenician/Punic intermediaries rather than direct Greek intervention. That is to say, it recalls Carthage yet is totally distinctive in ways that we must judge 'Iberian'. 'Phocaean', some may still call it, but if the sculpture is of the date alleged, the middle and later decades of the fifth century, it is most unlikely that Greek hands or Greek models could be much involved, and if it is earlier we might expect much more demonstrably Greek in detail and composition.[57] What we find are a few decorative details including Archaic zigzag stacked folds, together with some flowing, figure-hugging dress which recalls Archaic Ionia (including Phocaea), and some attempts to

3.27 Capital moulding from El Prado

observe and render anatomy. But the overall effect could hardly be less Greek. There should be a vast difference between the effect of the presence of Greek craftsmen who might take a hand in work and design, and the more superficial influence derived from observation of Greek works, perhaps at second hand, or a lingering interest in Greek forms left over from days of closer contacts in the Archaic period. I show a man restraining a horse [3.25] and one draped figure [3.26], both from Obulco.[58] The most Greek-looking sculpture in mid-fifth-century Spain is from Cadiz – one of the anthropoid sarcophagi, of Sidonian type (as above, [3.6]), sporting an Early Classical Greek head.[59] It is, nevertheless, remarkable that from the sixth century on through the whole Classical period, on adjacent or the same sites in southern Spain, major works could be commissioned that seem wholly dependent either on Greek or on Phoenician inspiration. But the latter is dominant, to nearly as great a degree as was the artistic heritage of rule by other easterners, Moors, over a millennium later.

In the fourth century there is more Greek to identify, but again little that need go much beyond what the Punic world already admitted. A strange tomb monument at El Prado has a capstone with Greek architectural mouldings, but the egg-and-dart is improperly given a curved profile [3.27]; this, in Greek architecture, would turn the 'egg-' into a 'leaf-and dart'; and the members of the bead-and-reel have multiplied.[60] There is more hellenizing sculpture, however. In relief, there is a four-sided gravestone with horsemen and a seated woman and child from Jumilla, where the scheme and poses are Greek although details are not.[61] The figures in the round are more remarkable. The so-called Dama de Baza – Granada; early fourth-century; [3.28])[62] clearly copies models well familiar in Greek Sicily, mainly in clay figurines. But the type had already been introduced to Phoenician Ibiza, and the Spanish figure's archaizing dress is in keeping with the familiar trait of Greek loan-features being retained by non-Greek craftsmen long after their currency in Greek lands. Other figures in the round tell the same story: from the archaizing lady from Cerro de los Santos [3.29] to the classicizing Dama de Elche [3.30]. Neither are in any real sense Greek, but they could not have taken the form they did without Greek art. Both – and there are several comparable figures in Spain – demonstrate what can happen to sculptural style at one or two removes from the original source. The Dama de Baza in particular recalls the

3.28 *(top left)* La Dama de Baza (Madrid)

3.29 *(above)* La Dama de Cerros de los Santos (Madrid)

3.30 *(left)* La Dama de Elche (Madrid)

3.31 Gilt silver phiale from Tivisa (Barcelona)

3.32 Gilt silver phiale from Tivisa (Barcelona)

comparable phenomenon of the Latin-ex-Etruscan Athena from Lavinium, whom we have yet to meet [7.53]. A number of smaller stone figures also with zigzag-patterned dress are likely also to derive ultimately from Greek archaic fashions.[63]

From the fourth century on, to the second century when the Punic world falls to Rome, there is a steady increase of classical influence, and probably a stronger Greek presence though not strictly colonial. This means that Greek influence was more direct, though mainly at a fairly low level of interest, such as we have observed at Carthage itself. It is manifested most obviously in the arrival of Greek pottery and in mass-produced objects like terracotta figures, with types readily identified as local deities,[64] as well as in relief sculpture for funerary monuments and some architectural detail.[65] There is free copying of Greek pottery types and shapes, especially those of Campania in Italy.[66] The highly distinctive and colourful figure-decorated Iberian pottery is, for all its apparently archaic traits, Hellenistic in date. It owes hardly anything to Greek example and its superficially archaic appearance relates, albeit in a puzzling way, on the one hand to Phoenician styles derived long before from Cyprus, on the other to the Celtic north and north-west. A few motifs seem to show knowledge of Greek compositions and decoration of the period, but are totally translated.[67]

Metalwork of the fourth to first centuries is more interesting and revealing. A hoard at Tivisa, possibly abandoned during the Second Punic War in the late third century, includes silver phialai. The shape is of eastern origin but by now the appearance of such products in the Mediterranean world is determined mainly by Greek style and practice. One has a provincial version of a well-known Greek type, much copied also in Italy, showing a whirligig of chariots; another has a gilt pattern of Greek spiral tendril with acanthus joints and fish [3.31]; two others have animal-head central bosses in a style that seems almost to take one back to Tartessos, and the interior of one has a gilt figure frieze

3.33 Gilt silver phiale from Santiesteban (Madrid)

remotely Greek in inspiration and non-Greek in style [*3.32* – a centaur, animals, winged figures].[68] Another phiale, perhaps second-century, from Santiesteban del Puerto, has an animal-head boss, this time surrounded by snakes and with a human head in its jaws; but the friezes around have wholly Hellenistic putti, and music-making centaurs [*3.33*].[69] Other silver finds carry more purely Hellenistic patterns such as we meet in other chapters [*3.34*].[70]

The juxtaposition of Greek and Iberian on the Santiesteban phiale is dramatic, but it prompts brief consideration of other sources of influence which might seem out of place

3.34 Silver band from Tivisa (Madrid)

in a chapter on the Semitic World, but which cannot be ignored in Spain. Our story so far has concerned mainly coastal regions, or central southern. The centre north of the peninsula was, in the period that concerns us, the home of the Celtiberians whose culture and art has more to do with that of the Urnfield and Celtic peoples of France and Germany, whom we have yet to consider (Chapter Eight).[71] The account here has so far seemed mainly a matter of weighing the relative effects of easterners and Greeks on an artistically innocent population (I exaggerate slightly), which might leave us agreeably surprised at the distinctive local taste which could create from the mixture such a strong idiom as that of Iberian art. But Spain is the meeting ground of Greeks, easterners *and* Europeans, a situation paralleled in Thrace (Chapter Six). The Celts in Spain were well aware of their indigenous and immigrant neighbours, and generally as resistant to the influence of their arts as their northern kin. They were warlike and by no means unsophisticated in their technology, including luxury crafts such as goldsmithing. There are many features in classes of objects that we have mentioned that seem somehow to carry traces of Celtic style as well as Celtic content (armour, mainly). These range from the sculptures of Obulco, through the figure-decorated pottery to the animal and human heads on the silver just described. The human head in a lion's jaws on the phiale [3.33] is a motif also of Celtiberian art.[72] This further confuses identification of much serious influence of major Greek arts, direct or indirect. Scholarly discussion has mainly revolved around the rival claims of Greeks or easterners in the creation of Iberian art. The voice of the Europeans has been raised only in recent years.

This chapter has taken us from one end of the Mediterranean to the other. We can see that Phoenician resistance to, or indifference to, what Greek art might offer, only began to slacken as the Classical period wore on. Some fourth-century Phoenician kings could be enthusiastic patrons although the local craftsmen were little moved. But Alexander's conquests brought Phoenicia within the purview of Hellenistic princes, though never quite absorbed by Greek culture.[73] In the west, Rome destroyed Carthage in 146 BC, and the Punic-Classical culture that survived under Roman rule retained clear traces of both the eastern and the Greek craft influences that had, in varying degrees, stamped the prime period of Punic power. Greek art had made an impact, at certain periods and places, in the art of major sculpture, architectural ornament, and the production of craft trivia (like terracottas) at which the Phoenicians had always been adept. The possibilities of narrative art, in the service of religion or the record of life, were generally ignored, but where assimilation of deities was possible, their Greek images were also borrowed.[74] The monumental and realistic qualities of Greek art seem to have been almost deliberately shunned.

On the whole this has not been a notable success story for the diffusion of Greek art, rather than, at first, for the persistence of egyptianizing forms in a non-Egyptian world, and later, for loyalty to native eastern traditions. In Spain the interaction of diverse influences, local and immigrant, leaves Greek art as little more than a strong undercurrent, except in the poorest media of production, until the dominance of militant Punic kings and Roman generals imposed the common classical culture of the Mediterranean world.

4 · The East after Alexander the Great

ALEXANDER CAME TO THE THRONE of Macedon in 336 BC, aged twenty. Within two years he had won the first battle in his progress to the east, on the Granikos appropriately close to Troy, and his crusade of vengeance against the Persian Empire was under way. Only eight years later his soldiers crossed the River Indus and faced the armies and elephants of an Indian king. Three years later he was dead. In human terms the achievement was staggering; in terms of cultural history it worked a new orientalizing revolution in Greece, and it opened the east to the profoundly different arts, politics and behaviour of the Mediterranean world.[1] Little before Alexander's death he struck in Babylon large silver coins which showed him standing, being crowned by Victory, fully armed and holding Zeus' thunderbolt. He was as all-powerful on earth as Zeus on Olympus and the process of his own deification was in hand. The reverses showed a Greek rider, perhaps Alexander again, attacking an Indian battle-elephant [4.1]. Greek arms and art had found a new stage.[2]

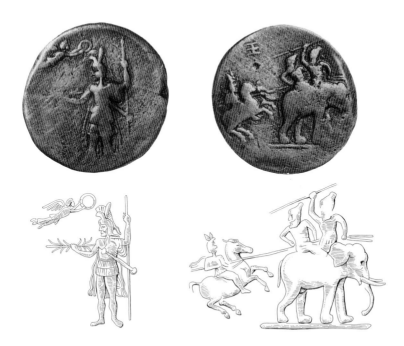

4.1 Silver coin of Alexander (London)

75

To Greeks of later years this might seem an act of civilizing benevolence. 'Alexander persuaded the Sogdians to support their parents, not to kill them, and the Persians to respect their mothers, not to marry them.... A most admirable philosophy, which induced the Indians to worship Greek gods, and the Scythians to bury their dead and not to eat them!... Those who were conquered by Alexander were happier than those who escaped his hand; for these had no one to put an end to the misery of their existence, while the victor compelled the others to lead a happy life.'[3] This is of course very much a Greek's view of the matter. They had intruded on civilizations of great antiquity and accomplishment, on a way of life quite foreign to them, and on at least one religion that more than matched their own for its dignity and humanity. Their most lasting legacy in the east lay in areas explored in this book – the grammar of art, and not in thought, politics or religion. The first profound cultural revolution in the east, after the indigenous growth of Buddhism, had to await Islam.

After Alexander's death his empire was divided and the eastern territories fell to one of his generals, Seleukos. They did not long survive as a unit but substantial areas remained Greek, and Greek influence and interests, once introduced, were tenacious. Greece was soon to become a Roman province, and in the first century BC it was already Roman arms that the lords of Persia had to confront. But cultural and economic links between east and west were mainly in Greek hands. It was the arts of the Greek world under the Roman Empire that were most influential in eastern lands, and it was Greek skippers and merchants who conducted the last stages of the trade in spices and silks from India and China for the emperors and the wealthy families of Rome. But embassies passed too and fro between the east and Rome, the coins of Roman as well as Greek mints affected the coinage of Indian kings, and some elements of Roman taste had been accepted by the Greek east and were passed on to neighbours. Roman Italy was out of sight but cannot be altogether out of mind even beyond the boundaries of the *pax Romana*. Usually 'Greek or Roman?' is not a real question here, but it will have sometimes to be asked, and we shall be approaching years in which the eastern Roman capital of Greek Byzantium became a more potent influence in eastern affairs than Rome.

The fortunes of the eastern countries that concern us in the years after Alexander's death, into the early centuries AD, are complex and indeed so confusing that even a summary would occupy several pages and still do little to illuminate our main theme. They involve the movement of peoples and dynasties from Central Asia to west and south, Parthians, Scythians (Sakas), Yueh-chi, Kushans, Sasanians and the native dynasties of north India. Close archaeological study of the area is a comparatively recent phenomenon and dramatic new finds regularly disturb attempts to provide acceptable patterns of its history. It may be some years before we can be as comfortable with the history and culture of the places and peoples discussed in this chapter as we believe we are with the Mediterranean world. While architectural monuments and their associated sculpture may be secure in their location they are seldom secure in date, and the many more mobile objects that we have to consider are perplexing in terms of both origin and date. One result is that books and articles dealing with Persia, Parthia, Bactria, Central Asia or north-west India are all found to be dealing with much the same body of material.[4] Objects which may seem to belong together stylistically may hail from as far

apart as Tibet and Siberia. Sometimes a well defined style can be determined, such as the Sasanian, but for the most part it proves easier to locate products in space than in time. Very often it seems that the repeated overlays of ruling classes only slightly affected local styles, through their new resources and patronage. Regional craft practice may outlive political change, and factors such as Hellenism, Zoroastrianism or Buddhism (as later Islam), even when carried by force of arms, prove at least as determinant as ethnicity. Dynastic change is best observed in the architecture of palace or temple, or the products of state interest such as coinage. Popular and even many luxury crafts retain a degree of independence. This chapter concentrates on the traces of classical art, but readers must not imagine that the arts of the regions discussed can be adequately described or assessed even partially in terms only of their apparently classical features.

It has proved simplest, therefore, to deal with this area in terms of geography rather than date or race, but whatever course had been adopted would have involved constant back- and cross-reference since the relevant ranges in time and space are so great. We start with the Persian homeland, roughly modern Iran, bound on the west by Mesopotamia, on the north by the Caspian Sea and the lowlands of Turkestan, on the east by the deserts of Afghanistan. (Modern political boundaries will often prove to ease descriptions but they seldom correspond closely to ancient cultural or political divisions.) Other areas segregated in this chapter are determined mainly by the configuration of mountain ranges. North of the range of the Hindu Kush, in northern Afghanistan, with parts of Uzbekistan and Tadjikistan beyond, the River Oxus runs up to the Aral Sea, an area bound to the east by the high Pamirs. This is ancient Bactria, with access west across or round the Caspian to Colchis (Georgia) and the Black Sea; south-west into Persia; east to the routes to China (the Silk Roads) and East-Central Asia; south-east past Kabul to India. The eastern end of the Hindu Kush (with the Pamirs) abuts the western end of the ranges of the Karakoram and Himalayas. At this point there is also access, through difficult passes, mastered in antiquity, and now by the military highway from Pakistan to China and tourist buses, to the Indus valley and North-West India (in Raj terms). The upper Indus valley (north Pakistan) and eastern Afghanistan, as far as Kabul, form an area which for a while was known as Gandhara and which, for our purposes, forms our third main geographical unit, with some other relevant parts of north India where Buddhist art was born. North-east of the Karakoram passes and north of Tibet lies Chinese Turkestan and Sinkiang province, with the routes to Mongolia and China. This, our fourth unit, is both the most remote and most diverse, since more than all others its fortunes were determined by the passage of peoples and goods, and its exploration has proved one of the most complex and dramatic of the past century.[5]

A Persia and Parthia

Succession to control of Alexander's eastern empire was not a simple process. In 312 BC Alexander's general Seleukos acquired the satrapy of Babylonia and inaugurated a 'Seleukid era', and his authority in the east could still be challenged by other

Macedonian princes, notably Antigonos who had bid to be Alexander's sole successor. Seleukos married a Bactrian wife (as had Alexander: the celebrated Roxane) but soon had to abandon the Indian provinces. By the time Antiochos III (the Great) came to the Seleukid throne in 223 BC Bactria was independent, while in Persia (Persis) local families had also attained no little measure of independence, issuing their own coinage. Antiochos may still have been regarded as the Great King, the old Persian title, but despite determined efforts to regain Bactria and to repel the new, Parthian threat, Seleukid control in the east was faltering by the end of his reign (187 BC). A vigorous policy of colonizing, the new Seleukeia cities which are so Greek in layout[6] and life, as well as many smaller settlements, do not disguise the very mixed culture of the Greek east, continuing orientalizing trends initiated by Alexander himself rather than attempting to impose Hellenic manners overall.[7]

Seleukid art is either Hellenistic Greek art, and so dependent still on Mediterranean fashions, or a continuation of the Greco-Persian. The last is readily traced in minor, traditional arts, which are often a good indicator of what is most broadly acceptable in any society. The Greco-Persian gems were valuable enough for their subjects not to be bound by mere convention though their currency may well have been mainly among the upper classes. They continue with the same shapes, materials and range of devices, though in a markedly different, looser style, and with significant changes in detail. The horses in the riding and hunting scenes become Greek in appearance (sharp-nosed, flying tails, high forelocks like horns) and their riders abandon the Persian skin caps that tie beneath the chin in favour of flat caps that resemble the Macedonian Greek *kausia* [*4.2*].[8] Animal subjects remain popular but the creatures come to be rendered with more and more emphasis on the forms imposed by undisguised drill-work: an *a globolo* technique, in Mediterranean terms, but this is a style with a long history in the east [*4.3*]. In the same style are studies of seated Persian women [*4.4*], which also occur on metal finger rings of Greek shape.[9] These are all very different from the hellenizing styles of ringstone current in most Seleukid cities, especially in Mesopotamia and farther west. They must have served a market that resisted the purely Hellenistic and was not itself

4.2–4 Seals

4.2

4.3

4.4

4.5 Turquoise cameo, Herakles
(Columbia)

wholly (or perhaps even partly) Greek, though the earlier pieces are simply Macedonian versions of the stones which had served the hellenized Persian provinces. The phenomenon deserves closer study but is bedevilled by lack of dates or clear indications of provenance. Some new materials (rose quartz, for example) suggest an eastern source.[10] An example of a more Greek product, but in a locally acquired material, turquoise, is the cameo head of Herakles [4.5] which seems to derive from a Seleukid coin type.[11]

Seleukid local arts in Persia are faintly barbarized. One of the latest, from a year (148 BC) when Greek control of the routes through the Persian highlands must have been at best flagging, is the robust Herakles carved in the rock face at Bisitun on the back of a conveniently placed earlier relief of a lion [4.6].[12] The hero has a long career in the east, as we shall see, but here he had perhaps already been assimilated to the Persian god Verethagna, who was to be a favourite of the Parthians.

4.6 Rock relief at Bisitun

In the mid-third century the Parni, occupying the Seleukid satrapy of Parthia (Achaemenid Parthava) to the north-east of Persia proper, had freed themselves from the Greeks of Bactria (on whom more below) and turned their attention to Persia itself. A new era, the Arsakid, was inaugurated by their king Arsakes I in 247 BC, and his successors so consolidated their control of Persia that by the early first century the river Euphrates could be agreed as their western frontier by the new power in the east, Rome. In 53 BC the Parthians annihilated an invading Roman army, numerically far superior, at Carrhae in north Mesopotamia. Soon afterwards their rule and influence was to spread far to the east, for a while into India (the 'Indo-Parthians').

The Parthians were essentially a north Persian cavalier aristocracy. Their culture is not readily definable since it revived or preserved much that was native Persian beside the pervasive Greek styles introduced since Alexander's day. They imposed no dominant religion, following Persian Zoroastrianism (Mazdaism), and the eclecticism of their arts leaves it difficult to define a Parthian style. We have to look for what lingered or was adopted of the Hellenistic, and it can be found mainly in a minor role in the decorative and luxury arts since the ruling class was for long philhellene in taste if not always behaviour. This Hellenistic heritage is clearest in architecture, but the basic planning for Parthian cities and fortresses is as un-Greek as the methods of construction, and the most characteristic building types, the vaulted *iwan* halls and fire temples, owe everything to eastern traditions.

The general impression we get is of a dominant military class cherishing a culture which was mainly Persian, of the Achaemenid mode, much as it had been left them by orientalized Seleukid Greeks. It was highly successful, controlling an empire somewhat smaller than the Achaemenid but over a longer period; and succeeding mainly for the reasons that kept its predecessors in power – a readiness to let local interests remain relatively undisturbed, plus considerable military efficiency and no great desire to impose a foreign culture. This ensured continuing diversity both in local, native styles and in the way that Greek elements survived in different parts of the empire.[13]

In the western areas we have the evidence of major sites on the borders of the Parthian Empire in Mesopotamia, such as Hatra or Dura Europos or Assur, and even beyond it – Palmyra, a Roman city of Syria but most clearly a staging point to and from the east and long dominated by Parthian interests; or the sites of north Syria, such as Nemrud Dagh, where the kings of Commagene played false with the Romans in sympathy with their Parthian neighbours. These are all areas which had been heavily hellenized and formed part of the core of the Seleukid kingdom. Nevertheless, their arts in the Parthian period are idiosyncratic, not to say provincial, to the point of seeming to have lost touch completely with Greek taste, except for what was imported for the comfort of the upper classes. While the influence or dominance of Parthia is acknowledged and even a Parthian artistic *koine* identified, it has been remarked that the art of Dura, for instance, is 'not basically a Greek art, even in a provincial form' but Asiatic, despite its physical proximity to Greek lands, and despite its celebration of assimilated classical deities with figures of classical form.[14]

Any continuing attraction to Hellenism is best observed in the adopted homeland of the empire. For much of the second and first centuries BC Parthian kings declared themselves (in Greek) philhellene on their coinage, but also Great King, or King of

4.7 Temple façade at Uruk

Kings in oriental fashion. It was said that when the head of the defeated Roman general Crassus was brought to the Parthian king, it interrupted a recital of Euripides (by a Greek) and was used as a stage prop in the *Bacchae*: a good story, suggestive, whether true or not. But the contrast between western provincialism and the strongly Hellenic styles that flourished in Parthian regions far to the east is dramatic and will require explanation.

We may move from west to east, but first consider the use of Greek architectural ornament throughout the empire, since here it is possible to generalize. Where the Greek orders served structural functions, albeit in a fairly simplistic manner, Parthian builders could divorce even the columns from their free-standing, weight-bearing role and use them as half-columns for decorative façades, considerably distorting the proportions of both shafts and capitals in the process [4.7].[15] The closest parallels in the Greek world are the decorative façades to stage buildings of the Roman period,[16] and knowledge of these was probably influential. Other Greek decorative features that persisted, though often used in unfamiliar roles, are the acanthus-leaf florals, sometimes displayed in friezes [4.8],[17] and, on mouldings, the Greek meander and varieties of the

4.8 Acanthus frieze at Hatra

4.9 Relief at Nemrud Dagh

4.10 Bronze Herakles from Seleukeia (Baghdad)

bead-and-reel or egg-and-dart that could appear also on minor objects. The usage does give a generalized classical form to many buildings, but combined with eastern decoration of battlement patterns and all-over relief designs in stucco, and strictly subordinated to local architectural design.

In the west, though close to the fully Hellenistic cities of the east, the Commagene kings celebrated their relationship to Persian deities, in Greek disguise, with statues and reliefs that combine effective oriental formality (for the kings) with a travesty of classical statuary (for the gods). The creator of the first-century BC Herakles (as Persian Verethagna) in [4.9] was unfamiliar with (and probably unsympathetic to) the classical treatment of nude sculpture, but copied the pose and sketched the anatomy patterns of a classical figure.[18] The artists serving the Arab capital of Hatra in upper Mesopotamia in the early centuries AD can make better bronze Herakles statuettes,[19] but the most remarkable of the figures of the hero is a comparatively recent discovery, inscribed in Parthian and Greek [4.10]. The inscription reveals the figure's identification with Verethagna, and that it was loot from the defeated Mithradates of Messene (at the confluence of the Tigris and Euphrates), dedicated to a local Apollo in the city of Seleukeia by King Vologeses in the mid-second century AD, though the figure itself is

4.11 Relief from Hatra (Baghdad)

late Hellenistic.[20] The western Parthian artists further demote classical draped forms in presenting local deities in Greek guise, startling in a stark frontality that is widely affected by sculptors and painters in the Parthian world [4.11].[21] A feature of this, and of the rather more accomplished statuary of Palmyra, which seems as much provincial Parthian as provincial Greek, is the linearity of dress detail. The expressive and deeply carved classical folds, originally designed to define the body forms beneath, are rendered in rope-like ridges, a translation of classical form that will prove characteristic of much eastern, classicizing art.[22] Yet even in Hatra there are local attempts at portraiture in the Roman manner.[23]

The linearity of treatment of dress in sculpture is an eastern version of Greek pattern; the frontality of much eastern sculpture is less obviously Greek and has been much discussed. It was determined by function rather than service to a radically different aesthetic. In any art of narrative where interaction of figures is essential, frontality plays a limited role except for centrepieces of symmetrical compositions. This is true in non-narrative Greek art and in much of the arts of Egypt and Mesopotamia, where also the importance of the procession as a relief motif imposes profile compositions. The arts in Parthia, when not closely following Greek models, are more demonstrative than narrative, engaging the viewer with statements of royalty, or godhead, or acts of cult which might be deemed shared with him. We find it rather startling and primitive; to some degree it was meant to startle and impose. It looks the odder for being so often presented in a sub-classical manner, and the closest parallels in Greek art are of the Archaic period.[24] Though not specifically Parthian, the style is readily associated with displays of Parthian rule.

4.12 Marble head from Susa (Tehran)

4.13a,b Bronze statue from Shami (Tehran)

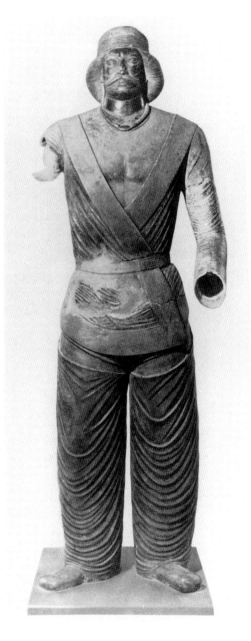

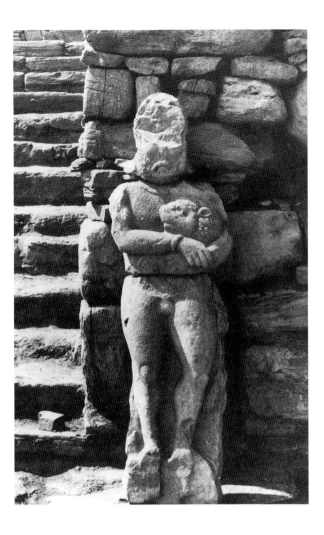

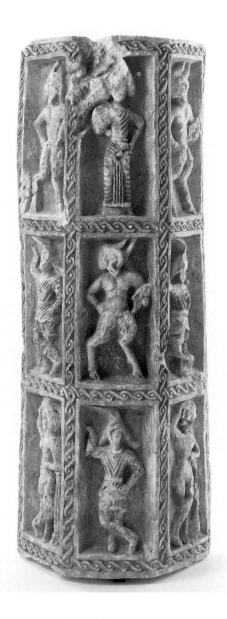

4.14 Herakles and lion from Parthia

4.15a,b Reconstructions of reliefs from Qaleh-i Yazdigird
(Toronto)

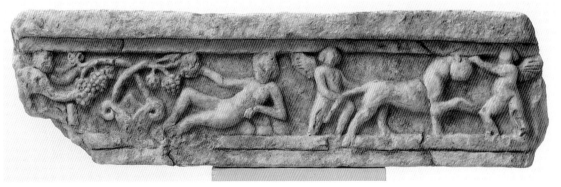

In Persia itself the sculpture ranges from the wholly Greek to the utterly oriental, with little of redeeming quality in any Achaemenid tradition.[25] At the old capital Susa, Greekness can reassert itself with work signed by a Greek, rendering a goddess or queen in white marble, but this is exceptional [4.12]: notice her Achaemenid stepped-battlement crown – an architectural pattern that recurs from Petra to India.[26] From nearby Shami the over-life-size bronze statue of a local ruler [4.13] is technically wholly dependent on the western tradition, but the head, pose and dress are heavily oriental, only covertly natural.[27] The same site has yielded earlier, purely Greek, late Hellenistic portrait statuary in bronze, perhaps of a Seleukid king; a measure of the changes in style and attitude though not technique.[28] Sanctuaries may still be dedicated to Greek gods, it seems, but although much of the portable material is of Greek make or style the sculpture is not of the same quality or aspirations. The Herakles and lion of [4.14] impresses for its size (2.4 m high) rather than its style,[29] but might be as late as the second century AD. At a late Parthian fortress site in north-west Persia (Qaleh-i Yazdigird) the stone reliefs still render recognizable individual Dionysiac figures and reliefs [4.15].[30]

The gradual orientalization of portraiture for the Parthian kings, which begins in a pure Hellenistic style, is most readily apparent in their coinage [4.16]. It suffers interesting regional debasement as time passes, through the first century AD [4.17].[31] The silver coin found far away in Bokhara shown in [4.18] carries a Parthian curly-head prince and a decomposed version of the seated Apollo motif that had graced earlier Seleukid issues and had served also for a seated Persian/Parthian with his bow.[32]

Classical influence on painting in the Parthian period is as difficult to determine as in other periods and places surveyed in this chapter. In the west, the rather wooden figures of the murals in the frontier town of Dura Europos betray nothing of real relevance. To the east there are to be found paintings of far greater sophistication, but it is uncertain whether any are to be attributed to the Parthian period rather than the Sasanian.[33]

The luxury goods of the Parthian court and nobles are strongly hellenizing, although in the golden earrings from Nippur (near Babylon) the figure (a naked goddess) has acquired odd proportions and an attractively stylized conversion of coiffure and wings [4.19].[34] Silverware best demonstrates the range of forms and decoration.[35] Shapes include hemispherical and shallower bowls and phialai which are of eastern and Persian origin but which in the Hellenistic period are decorated in styles dictated by Greek art. The style might be regarded as a continuation of the earlier Greco-Persian but it really owes little beyond some subject matter (usually animal) to the east, and it is the bearer of important new Greek floral fantasies. Much was certainly produced for Parthians. Several pieces bear Parthian inscriptions and their weights, also sometimes recorded on them, relate to local standards (though derived from earlier Persian or Greek). But here we have to anticipate the following section, and recall that there was an active and art-producing Hellenistic state in Bactria, on Parthia's north-eastern borders, down to the mid-second century BC. It too may have contributed to the stylistic development and subject matter of mainly later metalwork for Parthians, especially on the rhyton shape, which calls for a short digression.

The rhyton is an important shape in all discussions of Greco-oriental relations from the sixth century BC on. It will be mentioned often in this book. This context of its

4.16 Coin of Mithradates I 4.17 Coin of Gotarzes II

4.18 Coin from Bokhara

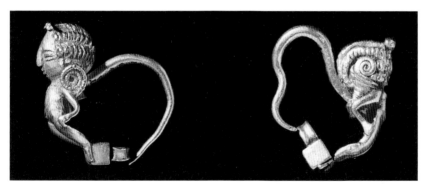

4.19 Earrings from Nippur (London)

Hellenistic form in Persia is the appropriate one for a summary discussion of its history and function. The cattle horn used as a drinking cup is a primitive and basic piece of equipment, especially for pastoralists. You drink from it like a cup (as the Scythians of [6.40e]) or pierce its tip to pour (rhyton means pourer) directly into the mouth. They are analogous to eastern animal-head cups, also copied in Greece (often with human heads). A nomad without static furniture and flat table tops prefers a vessel he can sling at his belt and does not linger over consumption of its contents. The form appears in clay in Greece in the sixth century but becomes more familiar in the fifth century, largely from

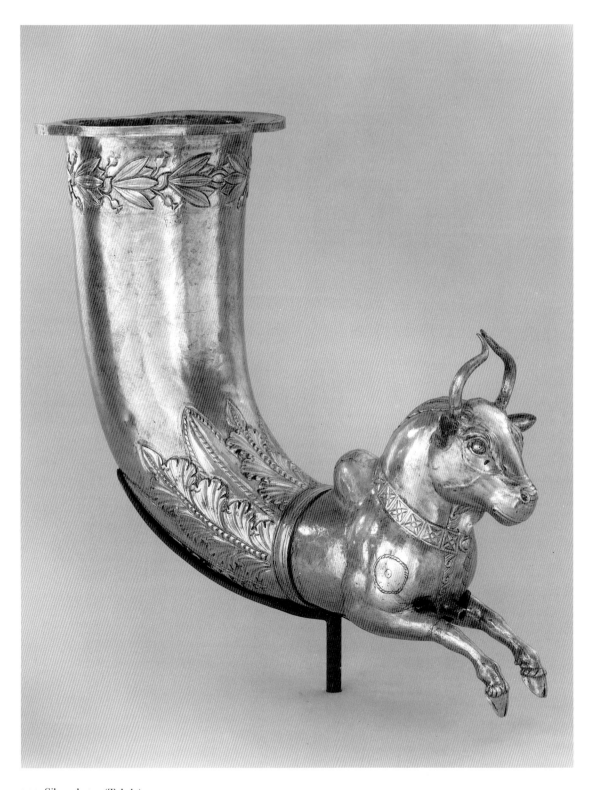

4.20 Silver rhyton (Toledo)

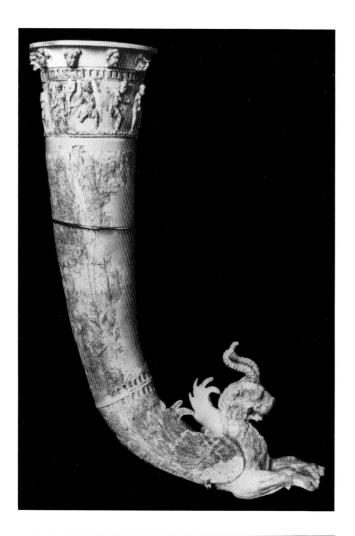

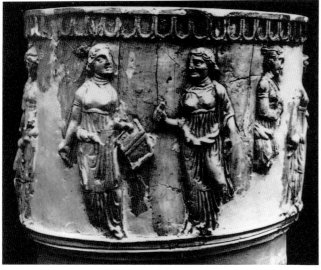

4.21a,b *(left)* Ivory rhyta from Nisa

4.22 *(above)* Marble statue from Nisa

Persian loot. The Persian vessels were usually silver (often gilt) in forms where the spout and sometimes much of the body is fashioned as an animal head or a forepart with a spout between the legs. The Greeks of the period translated it into clay and preferred to use it as a cup and to give it some sort of base, or even to attach the horn as mouth to a whole animal body or figure group, but closer acquaintance with the eastern world, on a less warlike basis, encouraged the production and presumably use of the metal rhyton-pourer. It is often seen in later representations of the reclining hero, itself an image of eastern inspiration given a special function in Greek votive and funerary art. Under Greek influence of the Classical period the stiff and patterned formality of the eastern animal foreparts gives place to more realistic forms of head, body and limbs, and some specifically Greek details, like the griffin's mane of [5.13].

Parthian silver rhyta favour feline foreparts, especially the lynx or lion, with a characteristic round head of the type that will have a long history in the area, and outside it, dependent more on the lynx than the lion. The shaft of the horn may be left plain but a variety peculiar to the area (the so-called Calyx Group) has the lower shaft, behind the animal forepart, decorated with a floral of acanthus leaves or the like [4.20].[36]

Closely related to these are the ivory rhyta from a hoard of about fifty discovered in the northern Parthian city of Nisa. They had been discarded or ignored by looters of more precious (or recyclable) material. A second-century BC date for them seems generally accepted on grounds of style. They are often taken as hellenizing Parthian but the style and subject matter is purely Greek, however abstruse some of the subject matter [4.21].[37] The proximity of Bactria suggests that the inspiration for them and for related vessels in other media might not be wholly Parthian; they might indeed be loot from Bactria, and the forepart of a similar ivory rhyton has been found in the Bactrian hoard of Takht-i Sangin on the Oxus.[38] We should remember, however, that Greek rule in Bactria ended in the mid-second century. That this also ended the practice of Greek arts in Bactria is another matter. Some of the ivory rhyta have florals on the horn like the silver Calyx Group. The animal foreparts take various forms from oriental to Greek, including a horned winged lion, winged elephant, female figures, and a male carrying a child. Unlike the silver they also carry relief figure friezes below the lip, which may additionally be decorated with a row of frontal heads – a mode of decoration familiar in architectural settings elsewhere in Parthia. The subjects of the friezes are Greek heroic and divine, religious, domestic and pastoral, but not mythological narrative, it seems. Details suggest manufacture in the east. Nisa also yielded more monumental evidence of Greek art which might be taken as more probably of Bactrian than of Parthian origin: silver statuettes and marble figures of late Hellenistic type, including a significant example in an archaizing style [4.22].[39]

One group of hellenizing silver vessels, later than the rhyta, provokes formidable problems of date, origin and subject matter. They are often referred to as Bactrian cups but it is likely that they were made long after Bactria lost its Greek kings and when the classicizing arts of the area (as at Tillya Tepe) were in a different style. Styles and subjects on the cups range from Greek to oriental (including nomad and Sasanian), sometimes on the same object, yet there is a unity for the main hellenizing group that suggests a period of production which should not be too extensive either in time or place. I discuss them here largely because they would sit less comfortably elsewhere!

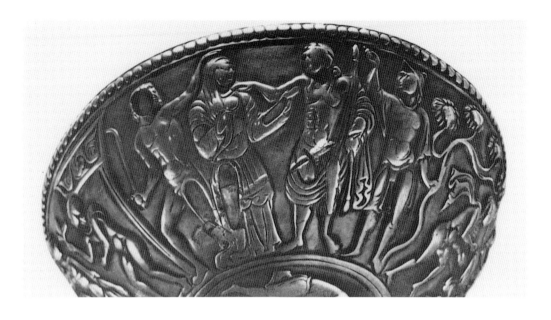

4.23a,b Silver cup from Kustanai (St Petersburg)

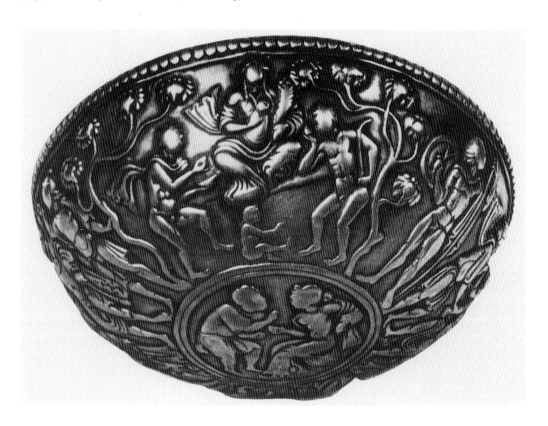

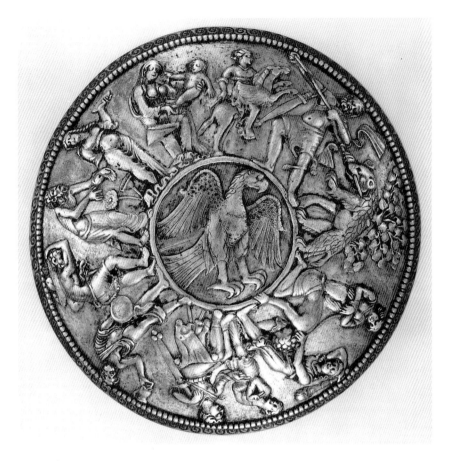

4.24 Silver cup (Washington, Freer)

The cups are decorated in relief on the outside only [4.23–5]. Shapes are relatively shallow, with rounded or straightish walls, and with a medallion device at the centre beneath. From representations we can see that the shape is handled in the way that earlier Achaemenid cups had been, on finger tips. They have no handles. A common feature is the Greek wave pattern on the rim of many examples, not in itself remarkable but this is not a common pattern in this position on homeland Greek plate although it does appear on Parthian.[40] They have generally been regarded as deriving from Hellenistic relief cups, better known to us in clay than metal.[41] These are usually hemispherical, which is not the common shape for our group though it appears for some more purely Greek examples of appropriate date and, apparently, findspot; for instance, a gold cup in Leningrad from western Siberia;[42] and there is an example from Bokhara decorated with a floral scroll and Dionysiac figures.[43]

On three of the cups with very Greek-looking relief scenes Professor Weitzmann thought to see subjects inspired by Greek models depicting episodes from the plays of Euripides.[44] The models are, however, wholly lacking in the otherwise rich repertoire from Greek lands and there are too many deviations from Greek norms. In this respect

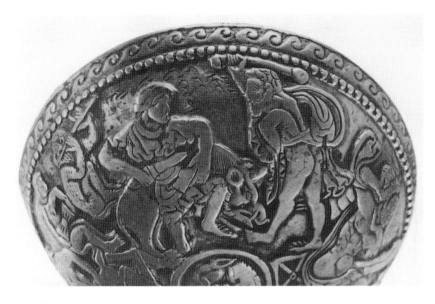

4.25 Silver cup (St Petersburg)

4.26 Silver cup

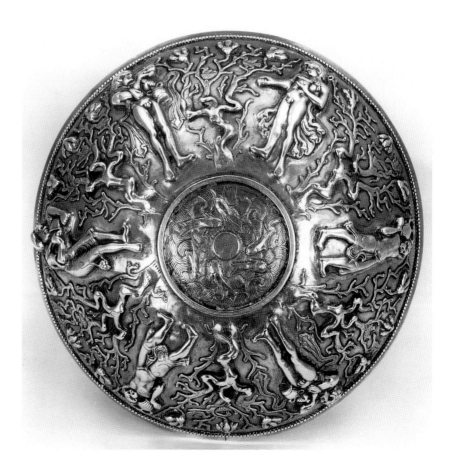

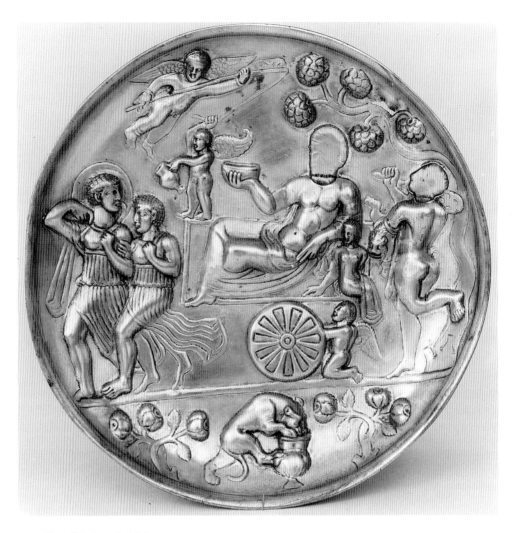

4.27 Silver dish from Badakshan (London)

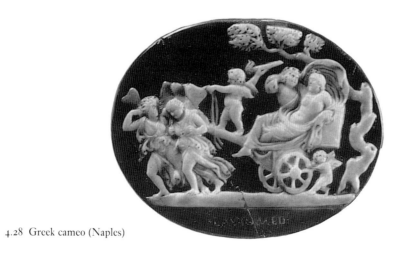

4.28 Greek cameo (Naples)

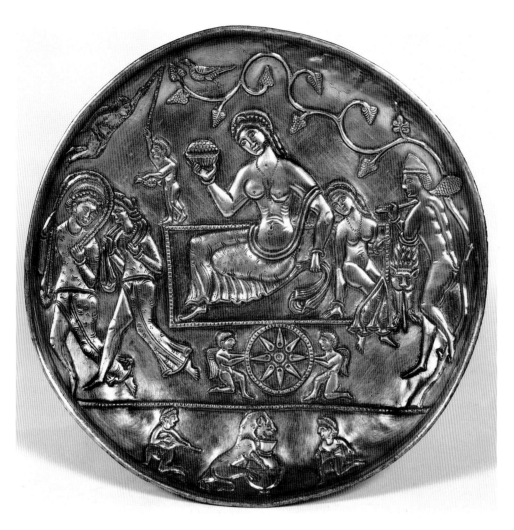

4.29 Sasanian silver dish (Washington, Freer)

they are quite unlike the relief scenes on the earlier Nisa ivory rhyta, and one stage further removed from original Greek work than these are in both subject and style. Though some groups do seem to derive from Greek narrative scenes they are non-specific or have been adjusted to serve a narrative which does not seem basically Greek at all. Thus, on the cup from Kustanai (some one thousand km north of the Oxus), a group does recall, in all but details of attribute, the Greek way of depicting Admetos bidding farewell to Alkestis [4.23a]. The translation of identities is, however, complete, and on the same cup it is difficult to impose any Greek narrative on other figures [4.23b].[45] And while the general style and compositions are mainly Greek, there are many features that are clearly eastern, not least the female physique and the dress and posture of some males. The two other cups (the Kevorkian/Freer and Stroganoff) are clearly related, including some Greek, some eastern groups, but with no clear message

about style and origin [4.24].[46] Beneath the Stroganoff cup the facing head is mainly that of a Greek satyr but with a lion's jaws [4.25];[47] this is a motif with an interesting later history.[48] A fourth cup, not known to Weitzmann and once in Tibet, has a clear Herakles but several far more exotic characters [4.26] and the style is much looser, surely later.[49] Moreover, on this cup parts of the figures are soldered on – a technique met very seldom in Roman silver and more often in Sasanian, where some cups with hunting scenes strongly recall those just discussed, although they have abandoned narrative in favour of symmetrical compositions of hunting.

Dates as late as the fourth/fifth century AD have been suggested for these cups, but the most classicizing of the figures are very different from those of Sasanian art or of contemporary Byzantine silverware to the west. There is no other metalwork in the east so late which retains so much of the purely Hellenistic in style and subject; and there is nothing here notably Indian, and little enough essentially Persian. They are decidedly not the pure Hellenistic of the true Bactrian but seem to represent a style exercised for a courtly market after Greek rule had ended, in the first centuries AD. Contrast the pure style of the few surviving pieces of Mediterranean decorated silver that passed east even in the first century BC.[50] The later, related specimens of our cups do evince clearer knowledge of Sasanian subjects and styles and are as late as the period of the Hephthalite Huns in the fourth century AD and later.[51]

Three more vessels, silver dishes, deserve attention. The first is made in the same technique as the Tibet cup, with appliqué figures. Its style is far removed from that of the cups yet there are features that are even more classical [4.27].[52] Here the subject matter is a deconstructed version of a classical scene, as known, for instance, on a cameo in Naples, where there is Dionysos in his chariot, drawn by two Psychai (winged girls) and an Eros helping push the wheel, while another assists above with a torch [4.28].[53] On our dish the artist has translated the chariot into a couch-throne of eastern type and its occupant into a reclining symposiast (like the Herakles of [4.6]); a woman sits on its corner beside her consort; the women drawing the former chariot have naturally lost contact with it and one has flying dress over her head, like a halo; Eros stands on the chariot/couch edge with a jug and shares with a flying Eros a decorated ribbon which could have been inspired by a whip; the wheel is detached while an Eros still kneels at it; a lively satyr dances behind, and has been given a heavy club translating him to Herakles, who is also a proper attendant for such a scene but not in this pose. In the exergue Dionysos' panther investigates a pot. The tree in the main scene is nondescript like many on Roman silver and cameos, but in the exergue it seems that peonies bloom! This is essentially a classical scene but not understood in detail nor, it seems, reinterpreted in any detail.

I have dwelt on this vessel because it is a good demonstration of what can happen to a classical motif far from home, and because the phenomenon has a sequel – two wholly Sasanian versions, perhaps of the fifth century AD (one in [4.29]), which are in many respects copies of the Badakshan dish, yet have moved on a stage and appear to have reinterpreted the scene, so far as was possible, given an apparent compulsion to copy the scheme and figures closely.[54] Dionysos has changed sex and holds his/her bowl full of fruit; the tree has become a vine and the flowers below are exchanged for musicians; a slimmed Herakles has a hat and appears to grow from the vine, while two Erotes kneel at

the wheel – attention to wheels or discs is another eastern religious motif. The Badakshan dish seems possibly to have survived antiquity above ground – it was an heirloom of the Mirs (rulers) of Badakshan[55] – and may have been important enough in early days to have itself been the inspiration of the Sasanian version. There is a misguided tendency to think that objects which happen to have survived enjoyed as much prominence in antiquity as they do today, but this might be an exception. The phenomenon might also shed light on the means of transmission of such subjects. The misapprehension of the chariot and other features on the Badakshan plate could be explained by the miniature scale of its model. Late Hellenistic cameos bring us closest to the scene, and on cameos we see the bunch-leaved trees such as the one on the dish – a product of the exigences of scale and technique rather than of botanical knowledge. The skipping satyr/Herakles is a Hellenistic motif (best known on the marble Borghese crater in Paris) which travelled east on a clay relief vase found at Termez (our [4.94]) and no doubt in other media. The artist's own contribution, the flowers in the exergue, are far more plausible. The sex change is, however, a clear indication of reinterpretation, since the woman with the fruit dish is very familiar in Sasanian art, and the two before the one-time chariot might be taken for dancers. The fidelity over five centuries to a late Hellenistic model, even in misunderstood or reinterpreted detail, is extraordinary.

Except in terms of imports, some local luxury production and some architectural ornament, there is still not a great deal to claim for the significant or influential survival of Greek art in Parthia. To discern how Greek art served the Parthian empire is none too easy. It provided a form of court art, mainly through the momentum given by Seleukid predecessors and not for any ideological display, except perhaps in coinage where styles and subjects were no little determined by the expectations of those using them. The works that seem to express best the Parthian attitudes to war and empire are on the whole the least Greek in aspect. Greek forms were admired and there are some notable products by Greek or strongly hellenized craftsmen, as we have seen, but there is no distinctive progress in the hellenized arts of Parthia; classicism is stagnant and has no significant role to play. The other arts seem to mark time, over what is after all a very long period. From west (Dura Europos) to east, Greek art helped the Parthians but little to set their mark on the arts of their subjects in the way that Achaemenids before them and Sasanians after them did. It inspired no serious narrative, and divine imagery was heavily translated. The artists who served the Parthians seem gradually to have distanced themselves from the classical arts of a world they had outwitted. They seem deliberately to have kept in currency forms (the flying gallop for animals) and subjects (the hunt, the feast) that had been hallmarks of Achaemenid Persian art, and these were expressed with minimal borrowings from the west. As a result there is in Persia a certain continuity in art from the Achaemenid to the Sasanian, and in this continuum the constant presence of Greek arts, even under Greek rule (the Seleukids), did little to disturb the overall pattern. This is the more remarkable because, farther east still, essential and developing Greek arts were being practised, and the 'Bactrian cups' we have just discussed, if made within the confines of the Parthian empire, were neither inspired by nor intended for Parthian owners.

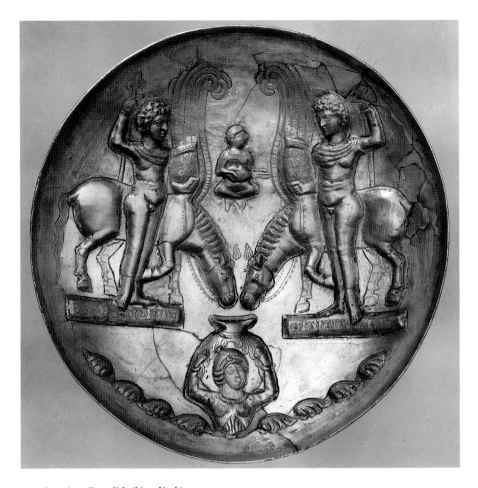

4.30 Sasanian silver dish (New York)

The end of the Parthian Empire came in the early third century AD after the revolt of Ardashir, a subject king in the Persian homeland. The resultant Sasanian dynasty ruled an empire as extensive as the Parthian and for as long. For many years it successfully held at bay Romans in the west and pressed Kushans (whom we have yet to meet) in the east, and grew fat on the continuing trade with India and China, which we have also yet to consider in any detail. Sasanian arts are far more individually distinctive than the Parthian. They appear to express far more deliberately the heritage of Achaemenid Persia, with slight acknowledgement still of those Greco-Persian arts which helped form the Achaemenid style. This is perhaps most apparent in the seal stones, which we have found to be a telling medium in this area. In many respects they seem to continue the traditions of the studios that supplied the Persian courts in the centuries after Alexander, and they replace the amorphous derivative styles of the intervening years of Parthian rule. The artists adopt too the Greco-Roman medium of cameo-carving in layered stones (onyx) but in a distinctively non-classical style, for all their superficial resemblance to products of the Mediterranean world.[56] Any close inspection of

Sasanian art for classical themes is rewarding, but not for this book. Many classical subjects recur, generally adjusted to Persian religion and mythology. The metalwork is still the most revealing, both of the strong Persian Sasanian style and of occasional classical motifs. We have discussed a notable example already [4.29] and I show just one more [4.30], with figures that appear to conflate the classical group of the two Dioskouroi (Dioscuri) and their horses with the single group of Bellerophon with Pegasus drinking from a personified spring on Acrocorinth; its Sasanian reinterpretation is hard to fathom but there probably was one.[57] Where there is a stylistic relationship between Sasanian art and the classical it relates more to the Late Antique, early Byzantine arts of the eastern Mediterranean, especially after the foundation of a New Rome in Constantinople in AD 324. But there is much more of earlier Greek art to be sought even farther east, and to this we must now turn.

B Bactria

Far to the north east of Persia, beyond even the Parthian homeland, the broad irrigated valleys of Bactria offered a rigorous climate and fruitful soil, that may have been tilled by Greeks even before Alexander. They are surrounded to north and west by apparently limitless, thin pasturage and desert. Here stretched the deserts and caravan-oasis sites of Sogdiana and Chorasmia, as far as the Aral and Caspian seas; to the east and south the land is mountainous but the valleys are fertile and the sites rich. All this had been embraced by the Persian Empire. The area had a rich and distinguished early history, revealed by excavations of this century. Its native peoples were close kin to the Scythians (Sakas) of the eastern steppes and probably to the peoples south of the Hindu Kush.[58] Bactria had been used by the Achaemenid Persians to settle deported peoples (as it has been in more recent years) and the fact that some Greeks had been sent there[59] might help explain the strength of the Greek presence and response after the death of Alexander. Several Greek-style coins are thought to have been minted before Alexander reached Bactria, and it has proved easy for some to assume a sort of pre-colonization by Greeks, completed by Alexander, which was to lead to a flourishing Greek kingdom. But it is clear from the archaeological evidence that Bactria had long been prosperous, with substantial cities and high living standards. Indeed, the Greek coins found there probably reflect far more upon the importance of Bactria in the Persian Empire than on the pervasive influence of Greeks.[60] Greek coins of the Alexander period and perhaps even earlier include versions of Athenian 'owls'.[61]

The Bactrian Greeks soon revolted against Macedonian rule from Babylon and were dealt with ruthlessly. But Seleukid control remained shaky, and a local satrap, Sophytes, was able to mint his own coins.[62] Soon after the mid-third century the Greek satrap of Bactria, Diodotos, could reject Seleukid rule completely and inaugurate a Greek state that flourished in Bactria for over a century, and spread its influence south into Seistan, south-east into India. The capital city (Zariaspa/Bactra/modern Balkh) was strong enough even to bear a two-year siege by Antiochos the Great, who then recognized the Bactrian king Euthydemos. Before the mid-second century Greek rule had been extended into the upper Indus valley. A city laid out in the Greek manner (the

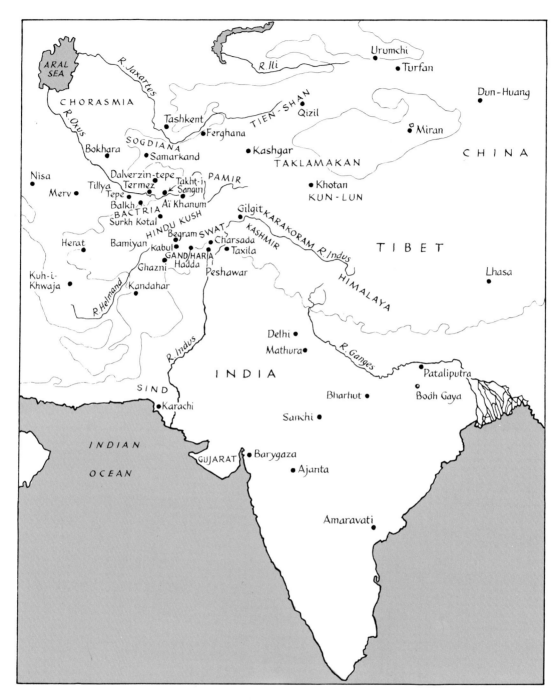

MAP 3 CENTRAL ASIA AND NORTH INDIA

4.31 Coin of Amyntas (Kabul)

Hippodamian grid plan) can be recognized at Taxila, at the site Sirkap, although in its excavated form it appears as it was rebuilt in the century following Greek rule. There will be more to say of this Indo-Greek episode in the next section though some of its more purely Greek manifestations will be alluded to here.[63]

Hellenization in Bactria is a far more easily perceptible process than it has proved to be in Persia. There must have been a considerable, and growing, Greek population here beside the native, though perhaps mainly confined to the new Greek foundations. The Bactrian and Indo-Greek kings seem to have employed their coinage for propaganda and display to at least as great an extent as is observed in other parts of the Hellenistic world. The best coins are superb and clearly the design of Greek artists.[64] Their ostentation is shown by the size of some: the largest Greek gold coin, minted by Eukratides, and the largest Greek silver, by Amyntas [4.31]. Reverse devices are generally figures of Greek deities. Some coins record the kings' titles, as Great King, but later ones minted by kings ruling in India carry inscriptions on the reverse in local scripts (Kharoshti derived from Aramaic, or Brahmi).[65]

Alexander had founded cities in Bactria, and the site best known to us, from French excavations of 1965–78 at Aï Khanoum, may have been one of these new towns – Alexandria on the Oxus. It has all the hallmarks of a Hellenistic city, with a Greek theatre, gymnasium and some Greek houses with colonnaded courtyards.[66] The religious architecture here and at other Bactrian sites is, however, decidedly oriental.[67] This is one of our most fruitful sources for the work of Greek artists in Bactria and also the most reliable since, for some of the more spectacular products attributed to Greco-Bactrian art, we have no secure evidence for findplace or date, and they were at any rate more readily portable. The settlement was probably not, however, one of the major cities, more an important frontier town, which makes the richness and variety of its finds the more remarkable, and the lack of evidence from the city of Bactra itself the more frustrating. Architectural decoration at Aï Khanoum is purely Greek [4.32],[68] not a vague reminiscence of earlier Greek forms, and there are pebble mosaics of the type

4.32 Corinthian capital from
Aï Khanoum

4.33 Statue from Aï Khanoum

4.34 Painting from Dilberzin

found on Macedonian and Greek sites. Some sculptural styles appear to have suffered a slight sea change [4.33] but a herm, a relief stele and pieces of acrolithic statuary (flesh-parts stone, the rest in cheaper material) make for a thoroughly Greek setting on this distant bank of the Oxus. Here at least the visual experience of a resident Greek would not have been so unlike that at home for all the difference in the landscape. There are new or unusual sculptural techniques too which have a long record from Syria to India in our period – the use of plaster (stucco), sometimes gilt, or a mixture of stucco and clay, usually for reliefs. In other cities yet to be fully investigated, the assimilation of Greek to local taste must have appeared near-complete; and to a far greater degree than in late-or post-Seleukid Persia.

Forty kilometres north west of the Bactrian capital at Bactra another site, Dilberzin, is far less Greek in general mood, but it has in its eastern-style temple two niches decorated with paintings of the Greek gods, the Dioskouroi [4.34],[69] of pure Greek form and in a broadly Greek style. The dating of such work is always hazardous in an area where styles change slowly, but the suggested second-century date for the complex could be correct, and if so this is a nice demonstration of Greek divinity in an eastern setting. And far beyond the Oxus, at Samarkand, new excavations promise to extend our knowledge of Achaemenid settlement and of early Greek penetration of Central Asia on the heels of the Persians.[70]

Less satisfactory excavated evidence comes from hoards found along the Oxus which include material of both earlier and later date. The Oxus Treasure, now in the British Museum, has a more strongly Achaemenid Persian flavour.[71] What, for instance, can we make of the silver figure [4.35]?[72] He is Persian, to judge by his gilt headdress, but as naked as a Greek *kouros*, for all that his anatomy lacks Greek clarity and accuracy of observation. He was probably made before Alexander reached the east but it is difficult

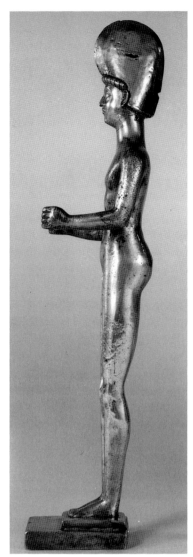

4.35 Silver statuette from Oxus Treasure (London)

to decide whether he could have been made in Persia or in Bactria, by an artist on whom classical Greek forms had made little impression.

The finds made by Soviet archaeologists at Takht-i Sangin on the Oxus (a hoard, of which some believe the London Oxus Treasure once formed part)[73] take us into the Bactrian period proper, and later. The small bronze piping satyr standing on a stone altar dedicated, in Greek, to the river Oxus [4.36], is an apt demonstration of Greeks in their eastern home, but the dedicator has a Persian name, Atrosokes, and the temple is again of eastern form.[74] Ivory relief decoration for weapons of Greek type [4.37],[75] such as also appear on the rhyta found at Nisa, are in a pure Hellenistic style. The piece shown is the chape of a scabbard with a creature whose mixture of human, equine, wings and fishy tail is extreme for Greek taste. We have remarked the fragment of an ivory rhyton in the form of a lion forepart already *à propos* of the Nisa ivories. But beside these

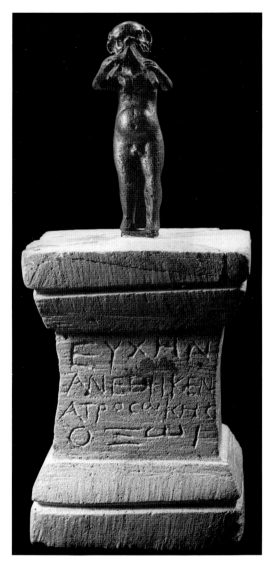

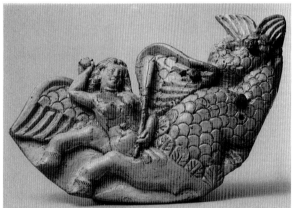

4.36 Bronze satyr on stone base from Takht-i Sangin

4.37 Ivory chape from Takht-i Sangin

finds at Takht-i Sangin are many whose ultimate source or inspiration far to the south and east are equally apparent: an Achaemenid ivory sheath, examples of the Siberian Animal Style, and a carved jade pommel.[76]

Many of the finds I have mentioned are as fully Greek as any might wish; others are at best barely touched by Greek styles and serve to remind us that the Hellenic crust of Bactrian culture might have been relatively thin, very much the creation of the royal courts and palace workshops, and so familiar principally in the new Greek cities. But here also, to look away from Fine Art for a moment, the common forms of plain Hellenistic pottery were in general use. More importantly, it can be seen that this relatively humble craft was able to keep up with developments in the Aegean potteries despite the great distance and the generally hostile area between.[77] This is a matter of some importance since it means that in other arts too we can legitimately expect local

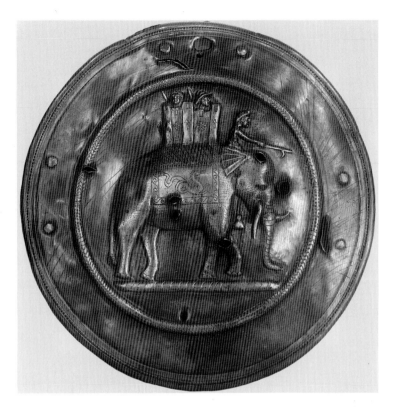

4.38 Gilt silver phalera
(St Petersburg)

4.39 Gilt silver phalera
(St Petersburg)

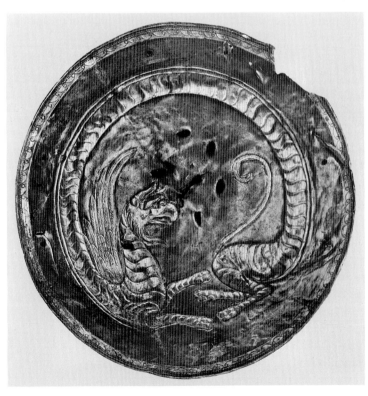

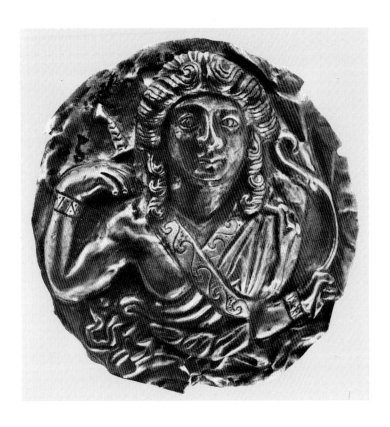

4.40 Silver medallion from Siberia
(St Petersburg)

craftsmen to be producing work reflecting the developments of the homeland, such as
the ivory rhyta and the archaizing figure from Nisa [4.22], without having always either
to assume the intervention (or circumvention) of Parthians, or to look for imports.

In the last section we discussed metalwork in a Parthian or Sasanian context. Other
silverware, from different and generally earlier workshops which are more readily
associated with Bactria, is also more wholly classical in aspect. There are discs (*phalerae*
– horse harness) with Greek-style subjects: one pair with a war elephant manned by
Greeks, the beast having a Greek sea-monster (*ketos*) patterned on his saddlecloth; the
other pair with a stretched classical griffin [4.38–39].[78] The latter are from
Novouzensk, 250 km north of the Caspian, but they go with the elephant discs for their
shape, while the elephants are eastern for their subjects. The distortion of the griffin is in
keeping with the taste of the nomad rather than Persian or Indian.

Medallion bowls, decorated inside with heads or busts in high relief, are another
probable Bactrian product or legacy. This is a well-known Hellenistic type, met in
examples from Persia,[79] west Siberia (the Artemis [4.40]),[80] Bactria,[81] and India; several
are in a very pure Hellenistic style, including one from Taxila with Dionysos.[82] All these
works were produced under various degrees of influence from Greek craftsmen or
imported works. We are fortunately able to judge one of the possible sources for them
from the plaster casts of late Hellenistic metalwork found at Begram; on which more
below [4.58]. These appear to have been prized for their own sake, to judge from their
findplace, but could also have served local craftsmen as models for the type of

metalwork we have been discussing (which most scholars seem to believe to have been their prime purpose).

Since Bactria was a wholly Greek state it might seem unnecessary to reflect on the role of Greek art there, but its remoteness and precarious existence give it an exceptional place among all the Hellenistic kingdoms. When its king Euthydemos was trying to appease Antiochos the Great he observed that 'large hordes of nomads were at hand who presented a threat to both of them, and the country would certainly be barbarized if they allowed them in.'[83] The Bactrian and Indo-Greek kings may have been powerful and generally succcssful, and they enjoyed a culture which must have compared quite well with that of many of their kin far to the west; but they were living at what was, to the Greeks, the end of the world, if not virtually beyond it. They were neighbours and rivals of peoples whose numbers and vast tracts of land must have been beyond the imagination and certainly beyond the experience of Greek statesmen at home. Alexander had indeed dragged the Greeks to the ends of the world and made them face modes of life for which even their experience of Persia had barely prepared them. Their survival and success, even without Alexander, is a fair tribute to their courage and skills.

Greek arts in Bactria flourished beside strong local traditions, the pervasive and very foreign arts of the nomads, and the remarkably durable arts of Persia, which had left their mark even on the frozen steppes of the Altai, more than a thousand miles from the Oxus and on the borders of Mongolia. Bactrian Greek art worked for the ruling minority, yet it seems to have penetrated deep enough for certain elements to outlive Greek presence. Many Greek forms seem not to survive, and others are, as it were, fed back from a partially hellenized India, with Buddhism, in centuries AD. It is Greek decorative elements that seem most persistent: figure subjects that still look Greek but have lost their Greek identity and narrative content, florals and architectural patterns divorced from their original contexts and applied to work dictated by either the more formal taste of the Parthians or the less formal one of the nomads. To determine how much of this survival, or feed-back, is indeed due to the survival of Bactrian Greek art in its homeland is but one of the unanswerable questions for the following two sections.

Before the end of the second century BC the movement of nomad tribes from Central Asia sent through Bactria first the Sakas (Scythians), who were to go on to place one of their kings on the throne of Taxila in India around 80 BC; then the Yueh-chi who were to go on to found the Kushan dynasty in India.[84] The Kushans, flourishing in the early centuries AD, soon controlled Bactria and most of northern India. Their story belongs to the next section, but in the years of their rule in Bactria there are major sites and finds which reflect their court styles, tinged with Greek elements of a type we shall meet more prolifically, though often more disguised, in India (Gandhara). There is indeed almost an artistic *koine*, from the Oxus to the Ganges, thoroughly hybrid in its derivation, and betraying western influences to different degrees in different places. In early days the Persian will sometimes seem to have been a more important determinant than the Greek. The next section deals primarily with India and Kushan rule there, but we shall return to Bactria when we consider the evidence for the classical elements disseminated with Buddhism by the Kushans into Central Asia (Section D).

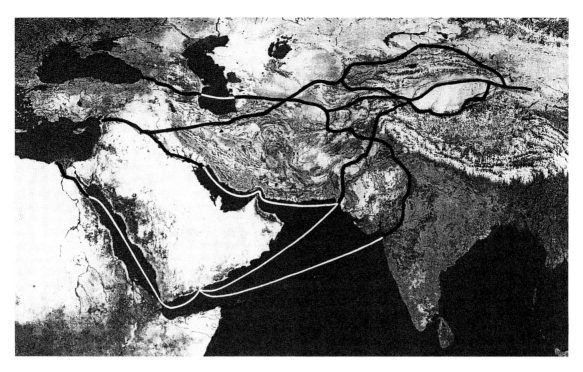

MAP 4 ROUTES EAST AND WEST

C Gandhara and North India

After Alexander's invasion of Bactria and his incursions beyond the Oxus he turned back, and east, into the upper Indus valley, and confronted the war-elephants of an Indian king [*4.1*]. To his long-suffering Greek soldiers, who had walked from Macedonia to India, the journey must have seemed no less miraculous than arrival on the moon in our own century, and the culture-shock, even after what they had seen in Persia and Central Asia, must have been extreme. But India of the later fourth century BC was not that land of relief-smothered temples, a riot of exotic and sensuous sculptural forms, that characterizes the Ancient India of the modern tourist and art connoisseur. Alexander had passed through two of the cradles of early civilization, in the valleys of the Nile and Mesopotamia, and now he was approaching a third, no less brilliant in its day.

The long history of civilization in the Indus valley had left traces of cities and empires, but when Alexander arrived in north-west India, this area (called Gandhara), west to Kabul and as far north as the southern valleys of the Hindu Kush, seems to have been a domain of minor kingdoms. After Alexander, the Indian Mauryan dynasty established itself with extensive territories, and King Chandragupta (Sandrakottos to the Greeks) was given the southern part of present Afghanistan by Seleukos I in return for war-elephants. The Indian king's grandson, Asoka, was a convert to Buddhism. His edicts appear carved on rocks and on a number of the free-standing pillars which are

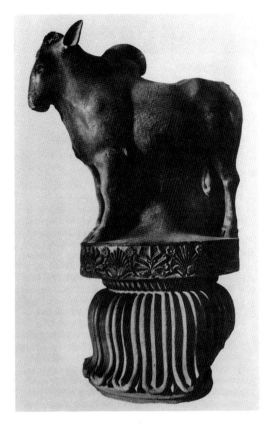

4.41 Capital from Rampurva (Calcutta)

4.42 Capital from Sarnath (Sarnath)

found right across north India. These owe something to the pervasive influence of Achaemenid architecture and sculpture, with not a little Greek architectural ornament and sculptural style as well. Notice the florals on the bull capital from Rampurva [4.41], and the style of the horse on the Sarnath capital, now the emblem of the Republic of India. Some of these pillars have been thought earlier than Asoka. [4.42][85] The edicts are sometimes carved also in Greek, and bilingual inscriptions of the king are found as far west as Kandahar. The Persian/Greek architectural elements in Mauryan India are accompanied by animal sculpture of notable originality and finish (a high polish is sometimes thought a hallmark of Mauryan sculpture, but this seems not to be an altogether sure criterion of date or source). Of about this date too must be some pilaster capitals [4.43] with Greek florals and of a form which is of Greek origin (though generally described as Persian) going back to Late Archaic (sofa capitals).[86]

The Sunga dynasty, based far to the east, is the Indian successor to the Mauryan, and for the arts of India of the second and first centuries we have to turn away from the north-west towards the south. For the first time we are offered major complexes of architectural sculpture, typified by the great stupas of Bharhut and Sanchi.[87] They are Buddhist monuments, but all north India was by no means Buddhist and even the

4.43 Capital from Pataliputra
(Patna)

iconography of these stupas is firmly based on figures and patterns which must have
long served to decorate the monuments of the older Hindu gods. In political terms this
is a period of fragmentation. The Indo-Greek kings penetrated far into India, even if
only momentarily and superficially (their stronger influence in the north-west we shall
consider later); in the first centuries BC/AD there were intrusions by the Sakas from
Central Asia, by Parthians, and ultimately by the Yueh-chi who had first displaced the
Greeks from Bactria and who by the first century AD founded a major dynasty in India,
the Kushan. All these peoples, their religions, and, to a degree yet to be determined,
their arts, contributed to the development of Indian art. We need to characterize the art
of the great early stupas, analyse it for any traces of influence from the classical west, and
judge what it might still have had to borrow or learn from that same source in later years.

The principal sculptural decoration of the stupas lay in the great doorways (*torana*)
and the balustrade (*vedika*) around the domed stupa, which covered Buddhist relics.
The act of worship was perambulation of the stupa within the balustrade, which offered
visual commentary on Buddhist story and thought. The stone architecture obviously
copies wood, and since the sculptural style of Bharhut can hardly have been born fully-
fledged we must assume a preceding period of elaborate wood carving which was the
model.[88] Within this period various motifs and subjects could have been absorbed from
non-Indian sources, but these we first observe later, in stone. Bharhut seems the work of
one of the last Sunga kings, so is probably mainly around 100 BC, and the earliest
features are not likely to be much earlier though some have put them into the third
century.

One thing we notice is a relic of the Achaemenid empire – the friezes of sharp-leaved
Mesopotamian (ultimately Egyptian) lotuses, to be distinguished from the broad-
leaved Indian to which they are naturally assimilated, and of the familiar stepped
battlement pattern.[89] The Persian associations of the Sunga kings might be reflected in
some of their names with the -mitra suffix, and they were by no means all enthusiastic
Buddhists. The few major stone structures devoted to Buddhism may distort our
judgement of styles and subjects of this period.

The figure work is strong though not as supple as we see it later at Sanchi. There are lively though chaotically composed narrative scenes, but some individual figures catch the eye – a near-classical *déhanchement*, a fondness for back views, which is not an expected motif but one that Hellenistic Greece had favoured and had, as we shall see, introduced to India in a different context. One striking figure of a warrior decorating one of the balustrade posts has often been discussed, and sometimes even described as a Greek [4.44]. He is certainly meant to be a foreigner, perhaps more generically foreign than specific in nationality, and most of his dress probably belongs somewhere in Parthia, but there are about him two features which take us west.[90] His head, with the curly short hair and headband with flying ends, is Greek. But this does not make him a Greek warrior, since the head could easily have been inspired by a Hellenistic royal coin portrait, of a type minted also by the Indo-Greek kings.[91]

More problematic is the way the warrior's dress is gathered in vertical folds between his legs, patterned with ascending zigzag hems and ending in a point. The same is seen on numerous other Bharhut figures, but also on some of the early *yaksas* (local heroes or demons; the female are *yaksi*) in the round which can be taken with the sculptures of these early stupas, and are the earliest monumental free-standing statues in India [4.45].[92] It has no local antecedents and looks most like a Greek Late Archaic mannerism. This could only be explained if it derived from Achaemenid Persian relief sculpture, which (as we have seen in Chapter Two) derived this styling of dress from Greece. This would also be in keeping with other persistent Achaemenid features, notably in architectural decoration, but the problem is that this exact type of dress is not the dominant feature of the hellenizing Achaemenid, and even less is this true of the rise and fall of zigzag hems on some *yaksa* [4.45] and later figures.[93] These are even more Greek than the Achaemenid, and we would have to assume a medium of transmission, via Persian or Parthian art, that so far eludes us. In some respects the pattern recalls even more closely archaizing sculpture of the Hellenistic period.[94] We have seen reason to suspect that this was known in or near Bactria [4.22], so it is perhaps not necessary to assume fresh inspiration from the west. The pattern for dress in Buddhist art has a long life, and can be traced through China even to Japan, introducing a geometric element beside otherwise flowing patterns of dress.[95] It does, however, seem to be reserved for major figures, often free-standing, and is less conspicuous on Gandharan reliefs though by no means ignored. There seems no local antecedent in India, and although its geometric quality becomes softer and more graceful, it remains a basically unrealistic, decorative formula. I have suggested that the Greek elaboration of dress had been similarly restricted in the Persian Empire to significant court and military figures; it may be that its later eastern counterpart had similar but more holy connotations.

Other nuances of detail at Bharhut might reinforce the feeling that this essentially Indian art has in its antecedents some things that are not Indian. The sofa capitals, of Greek rather than Persian inspiration (see above, and [4.43]), are represented on columns whose Persian origins may be disputed. They do not carry the flame-palmette decoration which is, however, evident in rather different forms elsewhere at Bharhut, and used for fern-like plants.[96] Other features are probably Indian but are of a type that will naturally, as we shall see, attract new treatment in a classical manner in centuries AD. These are the wavy tendrils – lotus rhizomes – peopled with little figure scenes and

4.44 Relief from Bharhut (Calcutta)

4.45 Yaksa from Vidisa (Vidisa)

growing exotic jewel-bearing blossoms;[97] the pairs of hovering winged humanoid demons and sirens [4.46]);[98] the looped ropes of garlands.[99] Each of these will later find a classical counterpart which is enthusiastically adopted, but it would be difficult to hold that their forms at Bharhut necessarily owe anything to the west.

Other Sunga stupas share the general style of Bharhut without its elegance, but can add a very classically composed frontal four-horse chariot and splaying team [4.47] (from Bodh Gaya),[100] with which goes a group on stupa 2 at Sanchi, which might be earlier.[101] The decoration of the great stupa at Sanchi (stupa 1) belongs already to the first century AD but is in the same relatively slow-changing tradition. The style for major figures, though not for the reliefs which have changed little, has become more sensual, especially in the splendid *yaksis* at the gates [4.48]. Here it seems more a modelled than a carved style, and the only antecedents for it have to be sought in, for example, the clay figures and reliefs from north and east Indian sites which may be pre- or early Mauryan.[102] Perhaps it is simply that the Indian sculptor has wilfully abandoned or ignored the sort of proportional-realistic approach that informed Greek studies of the relaxed figure, preferring a style that for centuries will succeed in expressing a degree of sheer delight in fleshy forms undreamt of by Greek art. One of the pillars of the stupa was carved and dedicated by ivory-workers, which offers a hint at the origins of the style and techniques.[103] And the style is very close to that of the Indian ivory figure found at Pompeii (destroyed in AD 79).[104] The glorious nudity might lead us to think again of Greece, but it is clear that the nude figure, a novelty if not a disgrace in the lands between Greece and India, was certainly no novelty in Indian art.

We shall return later to the general area of these early stupas of the first centuries AD, without always being sure of the distinction in date or style. They have shown elements

4.46 Relief from Bharhut (Calcutta)

4.47 Relief from Bodh Gaya

4.48 Gate figure at Sanchi

which are certainly foreign, some possibly classical. Masons' marks at Bharhut include some in Kharoshti, which indicate their writers' origin in the north, in Gandhara.[105] If we expect to find precisely the same classical traces in the north, however, we shall be disappointed, although the classical record there is far richer. They were wood-workers, perhaps, but if so their style differed markedly from that of their neighbours. But we have now to return north, nearer to Bactria and into the lands of Gandhara ruled by the Indo-Greek kings for about a century. They built themselves a new capital on the Greek plan at Taxila (the site at Sirkap)[106] and continued to mint Greek-style coins in India, though soon carrying inscriptions in both Greek and the local script, and some of them adopting the unfamiliar (to Greeks) square form derived from local use of stamped metal bars.[107] Under King Menander (mid-second century BC) Greek rule had reached its greatest extent. He may have become a Buddhist and the Discourses of Menander (Milindapanha) are an important document of Buddhist doctrine. It was surely this century of rule in India that ensured continuing familiarity with Greek arts, and may account for features we have had cause to discuss already in areas barely reached, if at all, by Greek rule, though the Greeks made armed incursions far and wide, even to the old Mauryan capital at Pataliputra (Patna), where the sofa capital [4.43] was found.[108]

After the last of the Greek kings, the displaced Sakas (the eastern Scythians) followed by Indo-Parthians ruled parts at least of Gandhara and north India. A third-century tradition has Saint ('Doubting') Thomas go east to build a palace for an Indo-Parthian king at Taxila.[109] The Greek wizard Apollonios of Tyana visited Taxila also about that time and found his place in Sanskrit tradition.[110] On the River Beas he saw the altars to the twelve Olympian gods set up by Alexander before he turned for home. These may be mere anecdotes but they serve to demonstrate the comparative intensity of contact possible at many different levels between the Mediterranean world and India in these years, some details of which we shall need to consider.

Before the turn of the era (dates are sorely disputed)[111] the descendants of the Yueh-chi established the Kushan dynasty in north-west India. Under the Kushans the native arts flourished and developed their characteristic styles, serving Buddha or the Hindu pantheon, and only the court arts of the Kushans, notably their striking royal statues, retain a hieratic form which is ultimately Central Asian.[112] All else is Indian, of varying styles, permeated in differing degrees by various western or northern traditions. Some of these were highly influential in pottery, for example,[113] others merely superficial. It is not possible to give a wholly coherent record of the arts in these centuries (first to third AD, and the approach of the Sasanian Persians), or, in these few pages, to attempt to explain all the sources and effects of foreign models and traditions. The following account therefore proceeds by major types and major sites, concentrating on what is plausibly of Greek invention or dependent on Greek influence, and vagueness about dates is well in keeping with the quality of the evidence available for them.

We naturally look first for any possible relic of Bactrian and Indo-Greek rule. One fairly numerous class of small objects seems to demonstrate very well the transition from work decorated in a mainly Hellenistic style and of Hellenistic form (as at Aï Khanoum) to the purely Indian. These are small round stone palettes, decorated with relief figures usually allowing for one or more sinkings in which oil or perfume could be mixed and dispensed. They were invented in early Hellenistic Anatolia or Alexandria, where the figure decoration is generally busts of gods. A few examples have been found to the east, in clay and stone, in the Seleukid or Parthian world, but the main concentration of finds is in India, and the richest source the excavations at Taxila (Sirkap). The main period for them in the east seems to run from the late second century BC into the first AD (when they are decidedly on the decline).[114] The earliest have purely Greek myth subjects only slightly indianized in the physique of the women and their jewellery (heavy anklets etc.). On [4.49] Artemis crouches naked at her bath, watched by the hunter Aktaion above; at the right she is dressed, supervising his dismemberment by his own dogs, the punishment for his impertinence.[115] Such work need not be from Greek hands but the artists were well familiar with purely Greek work, perhaps objects yet to be uncovered in the Bactrian cities. On other palettes the subject of the Greek scene has been somehow mislaid. Some show a Greek sea goddess (Nereid) riding a sea-monster (ketos); she is usually naked, showing her back. But on [4.50] she is replaced by a dressed figure holding a cup (not armour, as Nereids do, for Achilles) and only the monster has retained his identity.[116] The latest of the series have regaling couples and these approach the style of other first-century AD minor arts in Gandhara, with subjects of less or no classical content. There was, however, good classical precedent for such

4.49 Stone palette (London)

4.50 Stone palette (London, V&A)

4.51 Stone palette (Oxford)

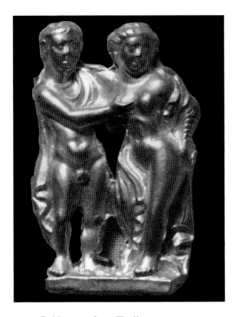

4.52 Gold group from Taxila

4.53 Gold sphinx ornament (Private)

carousing, and the figure of a drunken Herakles supported by two women, familiar from classical sarcophagi, appears on one palette, while on another relief of the same style but different shape, we see their busts only [4.51].[117]

Another feature of the hellenized finds at Taxila is the jewellery, especially small figures of a naked or near-naked goddess, to be found also elsewhere and later in the Kushan empire. These are clearly based on Aphrodite figures, and are often shown leaning on columns or accompanied by an Eros/Cupid. Some are given butterfly wings, which are an attribute rather of Psyche, and there is a fine little gold group at Taxila of Cupid and Psyche [4.52].[118] All seem eastern products though there are few Indian features; most are hollow or simply plaques but one stands on a lotus base in the eastern manner.[119] More remarkable is the gold ornament [4.53] which is not Greek in shape, so possibly for Indian dress, perhaps a turban pin. It is purely Greek in workmanship, derived from earring types with the forepart of a sphinx, an indianized version of one of which has been found in Bactria. This example, however, said to be from Kashmir, has been given human arms also, and holds a scroll (a Greek reading device, not Indian) on which is written, in Greek, *thea* 'goddess' or 'divine', an epithet appropriate for an Indian winged guardian (a *devi*, for which *thea* is a perfect translation) but hardly for a Greek sphinx.[120]

Gem engraving is another western craft that proved informative in Chapter Two but which I have so far avoided in this chapter since it is best treated independently of territorial divisions. The head on a gem in Oxford [4.54: impression] is one of the finest of all original portraits of Alexander the Great.[121] Discreetly cut below the neckline is an indecipherable inscription in an Indian script – so discreet as to have escaped detection in the museum for seventy-five years. It makes it probable that it was cut in the eastern

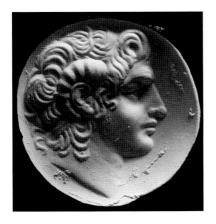

4.54 Tourmaline gem impression, Alexander (Oxford)

4.55 Turquoise in gold ring from Tillya Tepe

4.56 Gold ring from Tillya Tepe

regions of Alexander's empire, perhaps a gift to a local prince, and not long after Alexander's death if not, possibly, before it. The stone is tourmaline, very seldom used for engraved gems. It comes in many varieties but the type used here, a crackled greyish stone, is exactly that which can be bought in the bazaar at Kabul; another suggestion of eastern origin. Gems in this purely Hellenistic style, followed by the smaller types of 'Greco-Roman' ringstones, are not uncommon through the period and areas considered in this chapter, but most are probably imported. Some betray by their style and subjects a local origin, often having Persian or local divinities as devices.[122] Some from Kushan Bactria employ turquoise [4.55],[123] a material peculiar to the area (recall the Persian Darius' source for the material in Chorasmia, west of Bactria, and our [4.3]), as is lapis lazuli (from Badakshan in eastern Bactria, and perhaps the Quetta area). They often deviate from classical forms in much the same way as the stone palettes; thus the seated woman with the shield on the turquoise ringstone illustrated has long parted company from her classical prototype – perhaps an Athena.

'Greco-Persian' gems, made before Alexander's day, are also found on Bactrian sites and farther south.[124] Their successors, notably the drilled *a globolo* styles, are well represented also, as far south as Ceylon.[125] At Taxila was found a travelling salesman's (or artist's) stock of finished and unfinished gems of later Greco-Persian type (but not later than fourth-century BC, it seems).[126] The western tradition inspired various derivative styles, for instance on gold and silver finger rings with intaglio devices [4.56: with a gold bezel],[127] such as are found in quantity at Taxila.[128] This is not, however, a craft that seems to have inspired the best work locally, and at Aï Khanoum the seals all owe more to non-classical forms of stamp seals than to anything classical.[129] There had been a very long and distinguished tradition in stamp seal manufacture in the Indus valley and in prehistoric Bactria, but these forms of rings and ringstones are new, and classical. In return, Alexander's conquests had revealed to the west new sources for precious stones in India, soon exploited by engravers in the Mediterranean world.

4.57 Glass goblet from Begram (Kabul)

4.58 *(below)* Plaster reliefs from Begram (Kabul)

Hoards proved informative for Bactrian art, as those on the Oxus. Another, in Gandhara, serves us here. It reveals an early aspect of new Indian styles and of new western imports and influences, most of which do not depend directly, or probably even indirectly, on Bactria. We have, in other words, moved on in time. Just north of Kabul lies ancient Kapisa (Begram), on the major route from the north out of Bactria into India. In the rich Kushan site excavated there two rooms were found filled with objects

4.59 Bronze balsamarium from Begram
(Paris, Guimet)

of such varied source, style, and apparent date, that some have thought it a customs-house. A treasure house, by the standards of the day, it must have been, though in what we would call works of art rather than precious metals and materials. The date of deposit is generally taken to be the early third century AD, but a case can be made for the early second or even first.[130] The objects are certainly of various dates, back to late Hellenistic.[131] The stone palettes are not represented; they were perhaps already out-of-date or not exotic enough. Works in Greek style are all Hellenistic or from the Greek world of the early Roman period. They include painted and relief glass [4.57] (with a representation of the famous Lighthouse of Alexandria), a rich selection of plaster casts of late Hellenistic metalwork [4.58] of the type already remarked for their value as craftsmens' models (but not here found in anything like a workshop),[132] and a variety of western metalwork: several bronze incense phials (*balsamaria*), for example, of a type widely distributed in the early Roman Empire and mostly deriving from Alexandria. I show one of the finest, an Athena [4.59].[133] With these western objects were found pieces from China (lacquer) and Indian ivory statuettes which recall without quite matching the one from Pompeii (AD 79), already mentioned, as well as various items of decorated furniture and boxes. The Indian origins of these are obvious and the style is that of the great stupa at Sanchi (first century AD). Although ivories in just this style have yet to be found in the south we saw that ivory-workers carved stone for the stupa. The Begram ivories carry evident traces of western pattern, which are not, however, to be found at Sanchi. The most notable example is the border pattern of meander,

rinceaux and bead-and-reel enclosing a figure subject of purely Indian style [*4.60*]. In the frieze corners are hybrids of animals and human heads recalling the so-called *gryllos* devices on classical gems. We find even the Hellenistic wave pattern, noted on the silver bowls.[134] In the decoration of a great ivory couch there are clear echoes of the classical group of an Aphrodite wringing her hair, her swan at her side [*4.61*].[135]

Rome has been mentioned, and our use of the all-purpose 'classical' tag needs closer scrutiny. The case for direct Roman, rather than Greek, artistic influence in the east has been pressed by some scholars for various reasons.[136] The debate was initiated a hundred years ago when classical traits in Gandharan art were properly identified and then attributed to Bactrian influence. A reaction set in after the last war, as Roman finds in central and south India multiplied, and it seemed that this second source, in its way quite Roman, was responsible for the classical elements in Gandharan art. There was a lack of evidence for any continuing hellenizing arts in Bactria and Gandhara after the fourth century BC, but this has been effectively answered by excavations in the last forty years, especially Aï Khanoum. At the same time, excavation in central and southern India and in Ceylon[137] has yielded many Roman coins and some Roman pottery of the early empire. The source of these was the new route from the Mediterranean, through the Red Sea and then directly across to the Indian coast. The traders and ships' captains were Greeks, principally from Alexandria: the Indians called them Yavanas (or Yona, Yonaka) using the term long familiar for westerners in Mesopotamia and Persia (see above, p.24). The new direct route to India, not having to skirt the whole coast of Arabia, Afghanistan and north India, was possibly in use already in the first century BC. It ran from Alexandria down the Red Sea, coasting the southern shore of Arabia, then using the monsoons for the outward and return runs across to the Indian coast. A first-century AD Greek described the route in some detail (the *Periplus*), naming the cargoes carried and picked up.[138] Another remarks how Alexandria had become the focus for the trade of the world: '. . . the outer waters that lie beyond [the Mediterranean] are in your grasp, both the Red Sea and the Indian Ocean. . . . I behold among you not merely Greeks and Italians and people from neighbouring Syria, Libya, Cilicia, not merely Ethiopians and Arabs from more distant regions, but even Bactrians and Scythians and Persians and a few Indians.'[139] The object of trade in India was principally spices and precious stones, and Pliny[140] alleges that India received no less than five million silver sesterces from Rome annually, selling back goods at a hundredfold profit. He also records, from a first-century BC author, the overland route from India via Bactria, across the Caspian, to Colchis and the Black Sea.[141]

The seaward approach would also have opened an alternative route north, into the heart of the Kushan empire. Adding to this the various apparent echoes of Roman motifs in the arts of Gandhara, we may readily see how a case for 'Indo-Roman' rather than 'Indo-Greek' art could be developed, and it is likely that the route could have had some effect beyond that of material trade. Against attributing too much to it, however, is the absence of much Roman (i.e., Italian) material on northern sites and the way in which many of the 'Roman' motifs can more readily be explained by the continuing Greek tradition.[142] There is, after all, little of classical ornament and design in Roman Italy that did not derive from late Hellenistic Greece, especially from the eastern areas of the Greek world (Asia Minor), and the characteristically Roman contributions in the

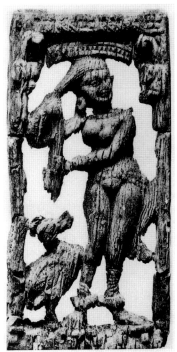

4.60 Ivory lid from Begram (Kabul)

4.61 Ivory relief from Begram (Kabul)

fields of realistic portraiture and historical narrative find no real echoes in the east. The old problem of Greek or Roman in India is rather unreal, given that Greeks are the intermediaries, but it would be wrong to attribute much that appears in Gandhara only in the second century AD to any sort of survival of Bactrian Greek art. There had been diplomatic exchanges between Rome and India from the early years of the empire, and in the second century AD there are copious records of active links with Rome, and envoys to Hadrian and Antoninus Pius from 'Bactrians and Indians'.[143] Rome naturally kept a heavy hand on commerce from and through Alexandria for as long as possible. We shall observe the probable effects of this more clearly when we turn to sculpture, but it could well be that further finds in Bactria will surprise us no less than those of the last forty years. Meanwhile we can only fairly attribute to Bactrian or Indo-Greek influence what seems to have been current still in first-century BC Taxila, and look for other sources for any new classical motifs in the east.

In their coinage the Kushan kings did take note of Roman coin types although their coinage derives more immediately from the Indo-Greek tradition and any inscriptions not in an Indian script are in Greek. Thus, a coin of Kanishka [*4.62*] shows the king in his oriental stance, familiar from statues, with a legend in script deriving from Greek; and on the reverse a standing Buddha inscribed in Greek (BODDO).[144] Other coins display reverse devices with a pantheon of deities.[145] A minority of these are Greek, with Greek names, but very few of them are presented as they were on Roman coins or on

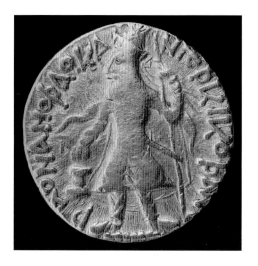

4.62 Coin of Kanishka (London)

Greek coins of the Roman period (two Herakles and an Athena), and most are stock
figures with appropriate attributes, representing Persian Zoroastrian deities adopted by
the court and to some degree assimilated to the Indian repertory. One earlier Kushan
type copies a Roman Augustus,[146] but the Romanization of Kushan coinage is at best
superficial, mainly devised for commercial purposes. Most of the finds of Roman coins
have been made in the south and east,[147] but a disputed reading in the *Periplus* seems to
suggest that Roman coinage was also imported as bullion, perhaps to supply local
mints.[148] Perhaps the gold coins that reached the Kushan realm were treated as bullion
and normally melted down; those in south India used for exchange. Most of the coins
from Rome are first-century AD in date and seem to represent specific payments for
goods (spices etc.) to be delivered to the wealthy of Rome. The trade was initiated under
Augustus, witnessed by repeated testimonia to missions sent from India and Bactria
(i.e., the Kushans) to Rome,[149] while in AD 97 the Parthians allowed a Chinese, Kan
Ying, as far west as Antioch in Syria where he reported on busy trade with the east.[150]

We turn now to Gandharan art of the Kushan empire. There had been a strong
Buddhist following in the area since the days of Asoka. The Kushan King Kanishka I,
who ruled from about AD 100,[151] may have been converted to Buddhism, though the
Buddhist subjects on his coinage [4.62] are a tiny minority and it may be wrong to
believe that he promoted much new building which signalled any new phase in
Gandharan stone sculpture. We have to look for the beginnings of Gandharan Buddhist
art both in the residual Indo-Greek tradition, and in the early Buddhist stone sculpture
to the south (Bharhut, etc.). The most characteristic product of Gandharan art is
sculpture in stone, but we must not forget the possibility of a precedent tradition in
wood, perhaps Mauryan. Not all of the hypotheses I have mentioned to explain the
inception of the style – Indo-Greek, southern, wooden – may prove viable in any or to
the same degree. Marble like that preferred for much Greek sculpture is not used, but
the earlier works are in a comparatively soft stone, like serpentine (the earlier

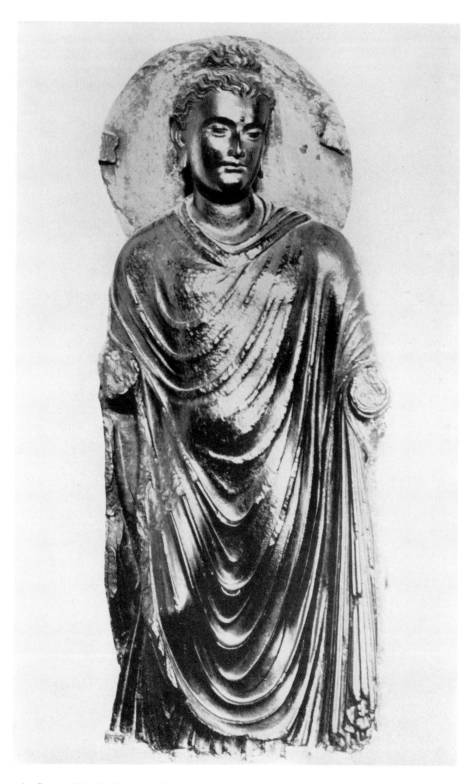

4.63 Statue of the Buddha (once Mardan)

palettes),[152] and the main series of reliefs are in dark schist (phyllite) which is also relatively easily carved with techniques more akin to the woodworker's than the mason's. The dark stones are frankly unpleasant and we must assume the addition of paint and gilding, which is rarely preserved;[153] in more recent times, and not only in officers' messes of the Raj, boot polish has been found effective to supply a surface sheen.

Much of the discussion over the last century about Greek influence on Indian art has centred on the creation of the sculptural type for the Buddha. He had at first been represented only by symbols – a footprint, tree or throne – thus at Bharhut, and elsewhere in north India. The creation of a figure type (expressly forbidden under early Buddhism) seems to have happened in the first century AD, either in Gandhara or in the Mathura region to the south, which we have found not altogether immune to western influence.[154] We are concerned with the standing Buddha rather than the seated figure, long established in the east for princes and sages.[155] One might regard the classical influence as including the general idea of representing a man-god in this purely human form, which was of course well familiar in the west, and it is very likely that the example of westerners' treatment of their gods was indeed an important factor in the innovation. Seated figures adopt an eastern pose, but the monumental standing ones soon take a lightly relaxed stance, of which we see an early example on the gold casket from Bimaran.[156] This is closer to classical contrapposto than to the almost boneless treatment especially of female figures in Indian art, as at Sanchi, or the rather wooden, four-square studies of *yaksas* from the same general area, that appear to be the earliest examples of monumental stone free-standing statuary in India (as [4.45]), and are the only precursors to standing figures of the Buddha. More significant probably is the rendering of dress. We have already observed in the Parthian world the linear adaptation of naturalistic Greek dress. This is apparent also on the Buddhas, but combined with a far more realistic treatment of the fall of folds and on some even a hint of modelled volume that characterizes the best Greek work [4.63].[157] This is Classical or Hellenistic Greek, not archaizing Greek transmitted by Persia or Bactria, nor distinctively Roman.[158] The *usnisa*, a topknot which characterizes the Buddha, is translated into a Hellenistic coiffure of wavy hair. To define the classical sources for the figure more closely is difficult. In a way they are implicit in most Greek divine and even athlete images created since the fifth century BC and were familiar in miniature on coins. There was nothing in earlier Indian statuary to suggest such a treatment of form or dress, and the Hindu pantheon provided no adequate model for an aristocratic and wholly human deity.

Gandharan relief sculpture is more varied and brings us back closer to Hellenistic forms than do the Buddhas, and certainly to earlier years, pre-Kanishka. It is useful now to bear in mind the Greek poses and dress of the figures on the early stone palettes, and the standing figures carved in high relief on the ivory rhyta from Nisa, as [4.21], isolated yet engaged with each other by gesture or pose. In Gandhara there are several series of small frieze reliefs, often identified as stair-risers, but which perhaps served as thresholds to niches on Buddhist monuments. The earliest stylistically carry figures of men and women in Greek dress and poses, often couples regaling each other with cups, and sometimes pouring from wineskins into cups or mixing bowls in the Greek manner.

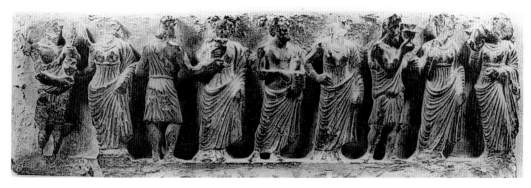

4.64 Stone relief (Peshawar)

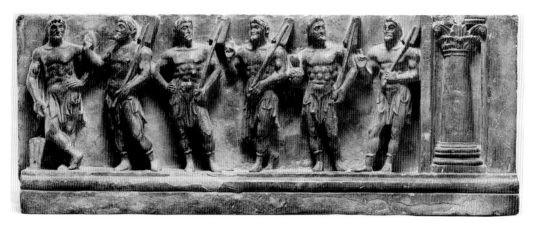

4.65 Stone relief (London)

4.66 Stone relief from Hadda (Paris, Guimet)

The very earliest, as [4.64], have the pairs grouped around the figure of an older man dressed in a Greek himation, with or without a chiton beneath.[159] Another series from an unlocated monument comes very close in style,[160] but the friezes are framed by boxed Corinthian columns, which are to become a very common feature on these reliefs. There is now a greater variety of paired figures, including musicians and foreigners, several with figures in Indian dress, but many with Greek features of pose and Greek and Parthian dress.[161] Two half reliefs (the column at one side only) have each three pairs of mariners shouldering oars and one holding a dolphin [4.65].[162] Their lumpy torsos look like a misconception of the hyper-musculature of Hellenistic statues, while their acanthus-leaf skirts are borrowed from other Greek figures where the device is used to mask the transition between human and animal on mixed creatures such as centaurs and mermen. Some triangular reliefs of the same dimensions and style seem to go with these reliefs, whatever their purpose or place on any monument, several of them decorated with classical mermen or sea monsters.[163] Reliefs in a closely comparable style from Hadda (a site in Afghanistan to which we shall return in the next section) carry very similar Greek figures but the boxed columns are the so-called Indo-Persian we have met already,[164] and on one slab a woman carries a classical, pointed-foot wine jar [4.66].[165]

All these reliefs owe a great deal to Greek art and much of this could most easily be taken to derive from an existing Greek tradition rather than from new inspiration, which might have been better digested and understood. In other words, if Greek hands were involved, which is at least possible for the earliest examples, they were of families or guilds that had long worked in the east. But this is about the last generation of their activity since there are already clear signs that the significance of many figures and motifs (e.g., the anatomical and some of the dress) had been forgotten. If the inception of the style, and possibly with it the standing dressed Buddha type, does derive from the Bactrian/Indo-Greek tradition, the presence in western Gandhara of early reliefs such as [4.66], and of the Bimaran casket (above), would be explained by proximity to the sources of the style, which then spread east to Peshawar, Swat and central Gandhara.[166]

None of these reliefs show the Buddha and all could well be still first-century AD and as early or earlier than the creation of any figure type for him, yet they surely belong to Buddhist monuments. Their relationship to woodwork is shown by the use of tenons and flanges to fasten them to adjoining blocks rather than the metal clamps used for later reliefs. They are followed by reliefs which do show the Buddha, in a related classicizing style,[167] and these herald a rich series of relief plaques in dark schist carrying multi-figure scenes, commonly of the life of Buddha, though there are a few other subjects as well as decorative friezes with figures and florals. At first sight they recall Greek or Roman votive reliefs, and there are some that seem to copy the grotto form, but accommodating the Buddha, not nymphs and Pan.[168] They are virtual icons, executed in a not over-expensive form, such as could be rendered in more precious materials (at smaller size) or as murals; yet they clearly soon acquired a style and repertory of their own. They are often compared with Roman narrative reliefs or relief sarcophagi.[169] It is not easy to judge just how much in them has to be of specifically Roman derivation, though some echoes of imperial scenes have been caught by some scholars and we shall return to this problem. It has been held, for instance, that they closely mirror changes of style in the relief carving of Roman monuments, implying a regular and updated

4.67 Stone relief with Vajrapani
(London)

knowledge of work in the Mediterranean.[170] The comparisons seem the more plausible
because the Roman works are datable, the Gandharan are not, and so can be placed in
any convenient sequence.[171] Neither the medium nor specific models for direct
inspiration from the west for these reliefs can be readily identified, though the example
set by some immigrant artist might be imagined. As with the sculptural expression of
the Buddha, it may be no more than a matter of various expressions of classical narrative
art suggesting comparable treatment for the cycle of stories about the Buddha. The
range of styles of narrative adopted by Indian artists also goes some way beyond the
fairly restricted manners of the classical world in this matter. Roman art exploited
serious use of continuous narrative, with the same protagonist(s) shown in one or
successive frames, but this was a mode for the truly monumental (such as Trajan's
column) and it is more likely that the Indian artist devised his narrative styles to meet his
needs; they are not, after all, all that subtle or difficult to read, and some are implicit in
the earliest sculpture.[172] But the general idiom of narrative in Gandharan art is quite
unlike that of the Sunga sculpture and Mathura, and the explanation for the difference
must lie in the non-Indian source of inspiration.

Isolated but recurrent features seem to point as much to fresh inspiration as to native
adjustment of a familiar repertory. The massing and overlapping of figures, set at

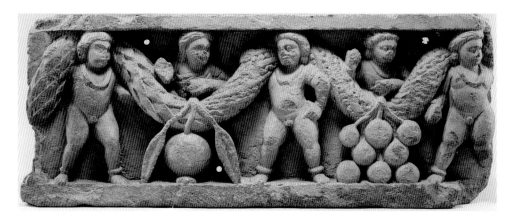

4.68 Stone relief (London)

different levels in the field, have a western look to them, but these features are not novel in Indian art; they are common enough at Bharhut and Sanchi. More importantly, on some reliefs the direct influence of classical figures and poses can be detected. The Herakles type was adopted for Vajrapani, guardian and attendant to the Buddha, keeping his lionskin and classical pose but exchanging his club for a thunderbolt [4.67].[173] He thus combines various attributes of classical saviour deities. Naked figures (also for Vajrapani) may be lightly draped with a slim cloak that is slung low across their legs exposing the torso – an old Greek motif, see below, on [4.73], but not unlike the way an Indian scarf may be worn, over a *dhoti*. On the other hand, the most characteristic true Roman figure, wearing the toga with the two distinctive curving sweeps of the hems across the body from shoulder to right leg and ankle (the Greek cloak, *himation*, was rectangular and worn tighter), and the end tucked in across the chest, is not seen.[174] The similarities to some western mythological groups and stock scenes are impressive but the sources and means of transmission obscure.[175] We may recall here the possible source of the scene on the Badakshan plate [4.27] in gems or cameos, but these are not a possible source for the stone relief scenes. Most derive from the eastern Mediterranean but there are some that appear to have been more at home in Italy and the possibility of emigrant artists must be admitted.[176] However, the exchange of trade goods was mainly with south India, where local sources write of immigrant Yavana (no doubt Greek) carpenters. As early as the second century BC a Greek (Eudoxos) was carrying craftsmen (*technitas*) to India, along with dancing girls and doctors.[177]

Some other friezes and figures are more directly informative about origins. Figures of Erotes/Cupids, usually wingless, as they may be also at home in such a context, carry long serpentine garlands [4.68].[178] The Greek putti with garlands or swags of flowers start as a Hellenistic motif, later taken up enthusiastically in Italy for sarcophagi, but by no means forgotten in the east Mediterranean. Moreover, it is here, initially in Anatolia (Asia Minor) and spreading south and into Egypt, that the type copied by Gandhara is to be found. It is distinguished by its fondness for having bunches of fruit hanging from the garlands, the composition of the garlands more as a continuous rope of leaves than as separate swags of flowers, and the common use of busts to fill the valleys. These features

4.69 Corinthian capital from Jamalgarhi (London)

are far less common in Italy, but in Asia Minor they begin to appear together only about
AD 150, and spread rapidly over the rest of the east.[179] This gives a probable *terminus post
quem* for their appearance in India. We can be reasonably sure that this motif is a new
arrival and has nothing to do with any Bactrian heritage. The source must have been via
non-monumental media, and by no means impossibly from travelling artists since some
seem remarkably classical in style and execution. The scheme recommended itself to a
society in which the long garlands played an important religious and decorative role; we
saw them at Bharhut, but hung on hooks, not supported by figures.[180] A version of the
motif but with a Kushan prince sharing the load and seated Buddhas in the valleys,
appears on the famous gilt bronze reliquary casket from Peshawar inscribed with the
date 'year 1 of Kanishka'.[181] If the motif with the swags is unlikely to be earlier than the
mid-second century, the casket must belong to a later Kanishka, some hundred years
later, but the scheme is different from that of the stone reliefs in many respects.[182]

Various classical architectural motifs supply the subsidiary ornament for Gandharan
reliefs. Whole Corinthian capitals are oddly constructed by being divided horizontally
with the upper half sometimes sheltering a figure of the Buddha seated beneath the
acanthus foliage [4.69].[183] These decorated the outer walls of monumental stupas, as
half columns, but can also be free-standing. The small boxed Corinthian columns
which frame reliefs have been remarked. This usage is not in fact very common in the
west though some sarcophagus reliefs are treated in this way, especially in the eastern
Mediterranean, and it is to be found at Palmyra.[184] Far more common in the west is the
colonnade or arcade arrangement of columns or pilasters. This is also seen in the east,
sometimes with the Indian pointed arches, as on the gold reliquary casket from
Bimaran;[185] but these simply reflect local architectural practice. There is an early model
stupa in clay at Taxila (Sirkap) which is basically designed as a massive Corinthian
capital [4.70].[186] The Corinthian column was, of course, current in Bactria and there are
indications that the Gandharan derive as much from the Indo-Greek as from any new
inspiration from the west.[187] The acanthus derived from the Corinthian column can also
be arranged as a frieze pattern, as it was in Parthia [4.8].[188]

Another common moulding on the Gandhara reliefs is the rigid garland of

4.70 Clay stupa at Taxila

4.71 Stone relief (London)

overlapping, pointed leaves, which serves as a horizontal but also sometimes as a vertical, as on [*4.72,97*], or curving frame. Its floral origins seem forgotten but it was invented for architectural use in Hellenistic Greece (not, I think, applied in Greek Bactria). A more important decorative element is the floral scroll (rinceaux). We have met them on the Begram ivory [*4.60*]. They are quite different from the Sunga tendrils of Bharhut, since the loops fold back on each other with curling leaves, making the whole look more like a cable, which is how some are composed [*4.71*],[189] than a wave. The scheme is Greek, but made acceptable in India through familiarity with the tendril patterns seen at Bharhut and Sanchi, where they are peopled and grow jewels, but also soon found in Gandhara.[190] In India many of the attachments which accompany these florals, invented in Greece in the fourth century BC and long popular especially in metalwork, are adopted too: trumpet-shaped flowers, small spiralling tendrils.[191] There is a good example in openwork in a gold ring from Taxila,[192] but they appear on stone reliefs also, often with vine leaves.[193] As decoration to vertical pilasters [*4.72a*][194] they bear an uncanny resemblance to western pilasters, as those on Severan buildings at Leptis Magna in North Africa [*4.72b*] (about AD 200), made by craftsmen from Asia Minor, where the earlier examples are to be found.[195] They will have a long and

4.72a Stone pilaster from Gandhara (Boston)

4.72b Marble pilaster at Leptis Magna

4.73 Group of Pancika and Hariti (London)

4.74 Group of Pancika and Hariti from Takht-i Bahi (London)

distinguished history in the east.[196] With them go simpler classical architectural patterns like the bead-and-reel and leaf- or egg-and-dart (resembling the broad-leaved Indian lotus), familiar also in Achaemenid Persia.[197]

Palmette-like patterns are more of a problem. The flame-leaf palmette was a Greek invention, based ultimately on the old Mesopotamian motif of the straight-leaved or fan palmette. As such we have seen it in India already, but here there is also, at Bharhut and in Gandhara, a palmette-like device with fern leaves, the side leaves often shown folded,[198] which is less obviously a Greek motif. And the flame leaves of these patterns are sometimes given swollen tips making them look like honeysuckle, which is how some incautious scholars have described all palmettes in the east. We are again left uncertain how much to attribute to western example, and whether it should be sought first in Gandhara (even if not on the stone reliefs but in jewellery or wood), or earlier in the south.

The reliefs offer the best chance of observing a continuum in Gandharan art, through to at least the third or fourth century AD, and of identifying classical loans. But there are other subjects, and media, no less revealing though more difficult to place in terms of date and sometimes origin, many of them not exclusively Gandharan. There are figures

4.75 Stone statuette of Tyche from Taxila

4.76 Stone Herakles and lion from Charsada

in both Gandhara and the Mathura region that display both the Greek style of dress and subjects that are closely modelled on Greek figures. Of the pair of guardian gods beneath a tree [4.73] she is dressed as a Greek, he has the Apolline stance and body-revealing dress already remarked.[199] The Indian Hariti (goddess of children and smallpox *inter alia*) carries much of the physique and apparel of a Greek matron [4.74], and is shown as an eastern Tyche/Fortuna sometimes even with the vestige of Tyche's turreted crown.[200] She carries a classical cornucopia, but the horn was an unclean object for an Indian so it is given a leafy shaft (recalling the silver rhyta [4.20]) and has its tip turned into an animal head, like the simpler type of rhyton. In the east it is eventually stylized into a single elaborate bloom.[201] Her companion and consort in the group shown is Pancika, god of wealth.[202] The pair were assimilated to Persian deities, Pharro

4.77 Stone river god (Karachi)

4.78 Stone relief, Trojan horse (London)

and Ardoxsho, who were not consorts.[203] In the reliefs Hariti at least is presented in Greek form, prefigured at Taxila by a seated Tyche, with headdress and plain cornucopia [4.75].[204] A few other individual figures are closer copies of the Greek, though less finely executed – the gauche stone statuette of Herakles from Charsada [4.76][205] or a reclining river god [4.77].[206] A relief carries details which are puzzlingly close to the Greek story of the Trojan horse [4.78] (an angled view to show the depth of relief).[207] The figure plunging his spear into the horse's body is from western literature (Virgil) and not, so far, art, while the distraught Cassandra at the city gate never looked like this in the arts of the Mediterranean! There are centaurs and centauresses,[208] Tritons,[209] a goddess wearing a version of Athena's helmet,[210] and amorous couples recalling the golden group at Taxila [4.52].[211]

Of the recurrent motifs, less common but no less revealing than the putti with garlands, are pairs of winged figures in free fall, like Christian guardian angels (which must be near them in function as well as appearance, and derive from the same source). We have remarked them, as humanoid and sirens, at Bharhut and Sanchi, and they recur in Gandhara, normally only humanoid, but now they sometimes share a burden, a wreath or umbrella. In this respect they recall the common classical motif, notably on sarcophagi, of Victories or Cupids holding between them a shield or wreath. Apart from the pose and composition the most distinctive feature of some of the Greek figures is the treatment of the dress which flies high over them in an arc, worn perhaps more commonly by Nereids than Victories in the west at this date.[212] In Gandhara the fliers are generally male, and the dress does not behave in this way although the scarf slung around shoulders, as also worn by standing figures, does rather resemble it. Later, certainly, the classical flying dress is adopted and the debt becomes obvious; this is apparent in Buddhist Central Asia, as we shall see, but in India only with Gupta

sculpture (AD 320 on).[213] So we cannot be certain that it is a classical loan in Gandhara. Another relief and free-standing motif is of kneeling males, sometimes winged, supporting an entablature [4.79]:[214] these can only derive from classical Atlantes similarly occupied. Rows of them support Buddhist monuments, notably model stupas.

We return south now, to the general area of the early stupas, and especially to Mathura, both for its role as a Kushan capital and for its distinctive school of sculpture. Its style derived from that of the early stupas and it was nourished by ready local supplies of satisfactory red sandstone, a welcome relief to us from the blacks of Gandhara. It is the source of some outstanding statues of Kushan rulers, in their stiff foreign garb and posture, not without touches of the west in details of dress.[215] But the Buddhist (and Jain) art of Mathura presents a style which, very broadly speaking, is to become the *koine* of India, Gandhara being a local deviation, for all its special interest for us. It is expressed in stupa reliefs but also in free-standing figures and groups. There are many points of contact with Gandhara, but in some respects there is an even stronger classical element to be detected in what is otherwise a far more robustly Indian style than that of Gandhara, which smacks somehow of repetition and mass-production. We pursue it through individual monuments and motifs.

The Greek sea-monster (*ketos*) has a particularly interesting career in the east. We have seen it decorating an elephant's saddlecloth on a Bactrian silver disc [4.38] and with a version of its classical goddess-rider on a palette [4.50]. It recurs often at Bharhut, Sanchi and on later southern friezes, sometimes ridden by putto-like figures, though generally not in Gandhara after the period of the palettes. It can be argued that the Greek *ketos*, an artistic invention perfected in the fifth century BC and thereafter much used (eventually for Jonah's whale in early Christian art), affected the appearance of the Indian monster *makara*, which was more like a crocodile, inducing it to shed two legs, and to grow ears and a fishy tail. In this form it threatens to swallow heroes and pilgrims in scenes that greatly resemble classical groups of Herakles confronting the *ketos* at Troy [4.80] (beside a 'normal' *ketos* with rider).[216]

Among the groups in high relief, the hero fighting a lion, from Mathura [4.81], derives from the group devised by Lysippus in Greece for Herakles in the fourth century BC, but has the hero already wearing the lionskin that he has to win from the beast.[217] Various reliefs showing drinking and dancing with music include figures, dress, and musical or drinking equipment that suggest inspiration from classical Dionysiac scenes though seldom close copying of groups [4.82].[218] The women are more remarkable than the men, and there are several reliefs with women alone. It is easy to call them bacchants in such contexts but their imbibing and drunken dancing probably reflect something with more relevance to Indian popular religion than to anything Dionysiac, for all the familiarity of their classical dancing postures. The association is encouraged by the universal association of the Greeks with vine-growing and wine-drinking, together with the story that their god of wine, Dionysos, invaded India. Nysa, in the Swat valley, was said to have been founded by the god and its Greek inhabitants visited by Alexander. It is likely that wine-drinking and vine-growing were encouraged by Greek presence, at least from the time of the arrival of Indo-Greek rulers, but the stories of Dionysos in the east are Greek stories and seem to have made no serious impression on Indian literature or religion.

4.79 *(above)* Stone atlas from Jamalgarhi (London)

4.80 *(below)* Stone relief from gate (Delhi)

4.81 *(left)* Stone Herakles and lion (Calcutta)

The dress, or undress, of several of these bacchant figures, as well as others (*yaksis*) is generally Indian. In Gandharan sculpture, where the women appear rather as consorts of men, it is more Greek. Several Indian nudes wear cross-straps with jewellery discs at the junction, shoulders and hips – a Begram ivory, Bharhut relief, our golden sphinx [*4.53*] and often later.[219] They are seen also on Hellenistic nudes, and in the east on the Nisa ivory rhyta and what may be Indo-Parthian figures at Taxila.[220] The style of provocative adornment of undress may be of Mesopotamian origin and of religious significance.[221] The Indian usage may be of some antiquity locally but its application from the period of the palettes on looks very close to the Greek, especially given the classical and often vinous contexts in which the dress is worn.

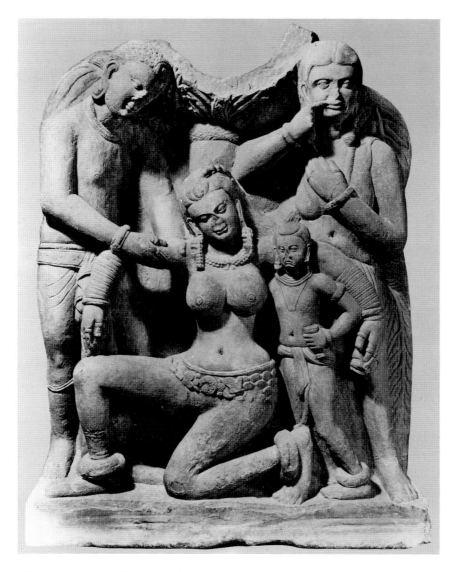

4.82 Stone relief from Mathura (Delhi)

Consideration of these bibulous scenes raises a wider question, however, and brings home the almost impossibly great range in time and space that such a brief discussion is obliged to span. The more energetic scenes are executed in styles and materials associated with workshops at Mathura, more than a thousand miles away from the Gandharan sites and in an area where the vine was certainly not grown. Yet it is on the Mathura sculptures that we see the most explicit rendering of Greek vine scrolls and vinous scenes, and it is from Mathura that several of the individual studies of translated Greek divine subjects appear – the Herakles and lion [4.81], for example. Does this indicate a deliberately different choice of classical motifs in the two areas? The sculpture of Mathura is more varied, in its way more monumental than the Gandharan, perhaps

serving aspects of Buddhism which assimilated the non-Buddhist Indian tradition in a different way, and which therefore found it desirable to accept different classical traits. It serves to highlight the exceptional character of Gandharan art, and it must have been more than geography that allowed the latter such rich access to classical narrative groups and figures. This was surely due, initially, to the immediate legacy of the Indo-Greeks, and then, from the second century AD, reinforced by new western contacts, the effects of which pervade the rest of India, from Mathura to the east coast (as at Amaravati – see below).

The only other genre that deserves mention here is that of bronze figurines. These were made as attachments to furniture but also as free-standing statuettes, probably votives, and those that have no provenance and betray no Indian traits are probably indistinguishable from Parthian. The Herakles figures copy at some removes familiar classical types [4.83].[222] The goddess [4.84] is dressed as a Greek Demeter or Tyche, with a slim cornucopia but a generous oriental physique and round head.[223] And there are many mystery pieces, not readily placed, such as the bronze monster in the British

4.83 *(left)* Bronze Herakles (Private)

4.84 *(above)* Bronze goddess with cornucopia (Private)

4.85 Bronze monster (London)

Museum from south Afghanistan [*4.85*], which is essentially a Mesopotamian horned lion-griffin with something of the Greek *ketos* in its muzzle, Greek winglets and an acanthus pattern on its neck.[224] This could easily be a much earlier work, of a period when Indo-Greek styles were as important as Persian/Parthian in the area but it has also been called Sasanian.

Our attention in this chapter has been held mainly by the finds in old North-West India, new North Pakistan. But there is one site west of the Khyber Pass, still in Gandhara proper, that it is easier to consider now that the main sequence of Kushan sculpture has been reviewed. It is the Buddhist site at Hadda (near Jelalabad, in eastern Afghanistan, and totally destroyed, it is said, in the recent fighting). This has long been known as the source of clay and plaster statuary of a strikingly classical cast of which there are many examples from all over Gandhara – I show just one example, from Taxila [*4.86*][225] – and of the early reliefs already mentioned [*4.66*]. Bimaran, source of the famous early casket, is not far away. The area might indeed be the cradle of incipient Buddhist sculpture in Indo-Greek style (see above, p.128). In the 1970s a sanctuary (*vihara*), confidently (but not unquestionably) dated to the third century AD, was excavated, with niches decorated with major figures in the near round, executed in unfired clay.[226] The centrepiece is generally a formal seated Buddha, but beside him can be recognized, even to the physiognomy, a seated Lysippan Herakles personating Vajrapani and holding a thunderbolt, not a club, though with his lionskin draped over his left shoulder [*4.87*], and a female figure already familiar to us as a Tyche/Hariti

4.86 Plaster head from Taxila

4.87 Clay Vajrapani at Hadda

4.88 Clay Hariti at Hadda

4.89 Clay head at Hadda

4.90 *(below)* Relief from Amaravati (London)

holding a cornucopia [*4.88*]. Both figures look virtually late Hellenistic and, divorced from their context, might at first (and even second) glance, pass as, say, from Asia Minor or Syria of the first or second century BC. Tyche has, perhaps, a touch of eastern plumpness and Herakles looks a shade ascetic, but these are essentially Greek figures, executed by artists fully conversant with far more than the externals of the classical style. A second, youthful Vajrapani, bears features that recall to some that other alter-ego to Herakles, Alexander himself [*4.89*].[227]

The statuary and relief types mentioned in the last paragraphs are, except for the standing Buddha figures, decidedly untypical of much of the sculpture of north India, for which we turn to the magnificent reliefs and *à-jour* figures decorating the gates and

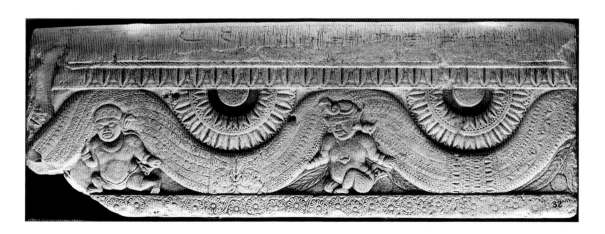

4.91 Head of Boddhisattva
(Vandoeuvres, Ortiz)

walls of stupas. But even far to the south east, near the east coast on the stupa at Amaravati, the patterns and style of the north west can be easily recognized, while the putti and garlands have rapidly become totally indianized [4.90],[228] or rather, the Indian motifs (the dwarf figures in tendrils) which encouraged borrowing the Greek are still strongly apparent.

It would be impossible to hold that the sculptural style of north India owed a great deal to anything other than native inspiration and tradition. But what classical there was proved influential and may even have determined the direction in which the arts of Gandhara were to move. It produced some striking individual studies and persistent motifs, a stock-in-trade for artists whose own traditions could not readily answer the needs of Buddhism, but who found in classical art a responsive and easily assimilated idiom. It was, moreover, continuously accessible, from the Indo-Greek and Bactrian heritage and through new intercourse with the west. The Buddha, the man-god, is in many ways far more like a Greek god than any other eastern deity, no less for the narrative cycle of his story and appearance of his standing figure than for his humanity. As a result Buddhist art carried the subtle stamp of the classical for centuries and over thousands of miles. But the monumental arts of the Kushan courts and of later Buddhist and Hindu temples absorbed and obliterated (for all but the most keen-sighted) the occident far more effectively than Greece had done the arts of the east, until its own Classical period. It would be perverse to think that Greek art was the undoing of native Indian art; it contributed to its richness and development in the way that many foreign arts had worked long before on Greek art. Its message lingered in forms long abandoned

in the west. We observed this with the Hadda figures [*4.87–89*] and it is no less apparent in many late statues of Boddhisattva, such as the head [*4.91*], whose classicizing style and excellence of carving would be hard to match in the contemporary Mediterranean world.[229]

The tenets and practice of Buddhism are so unlike those of the classical world that it is surprising that classical art could play any role at all in visual interpretation of the eastern religion. The cosmological and mythological content of Buddhism, largely derived from the Hindu, was if anything more grotesque than the Olympian Greek. Classical art may have helped devise expression of the essentially human and peaceable aspects of the Buddha's life and teaching, but not through any shared view of man's place in the world. Buddhist practice transcended the almost mindless cruelty of the classical world: the difference, it may be, between encouraging man to aspire to immortal *nirvana*, and making immortals behave like mere men. The success of classical art in Gandhara was probably largely the result of the earlier infiltration of Greek art into India, and of the skilful choice by Indian artists of what could serve them. Beyond and after Gandhara it was only the trappings of classical art that survived – but survive they did, and tenaciously.

D Central Asia and the Far East

In the first part of this section we retrace our steps north of the Hindu Kush, to the Oxus, Bactria and beyond, areas that were controlled or influenced by the Kushan kings and to varying degrees converted to Buddhism.[230] In effect the Kushans were sending back their new religion over the routes they had traversed from their Central Asian homes: but it made no headway west, in Persia.[231] The classicizing features of Kushan art travelled too, back to areas where many would seek their origins, and this does not make the task of unravelling dates and influences any the easier. A good example can be found at one site just north of the Hindu Kush, Surkh Kotal, where the arts are persianized Kushan and Bactrian Greek, with no serious admixture of the Indian.[232] Worship of the Buddha is attested at Surkh Kotal too, but it seems that in areas that had long remained untouched by Indian art and barely touched by empires based on India it proved easier for the longer familiar classical or Persian styles to flourish and even recover. We have anticipated this phenomenon at the end of the last section, discussing Hadda.

Farther north there are finds that recall first-century BC Taxila and raise the question of whether the classical inspiration is local or from the south east. Tombs at Tillya-Tepe (some one hundred km west of Balkh/Bactra) have fine gold work set with turquoise (from neighbouring Chorasmia) and subjects which include Aphrodite/Psyches, their figures of slightly more Indian aspect, as well as a Roman first-century AD cameo and gem, an early Kushan coin, a Parthian, and a gold coin of the Roman emperor Tiberius.[233] We can observe the shift away from Greek forms via the very classical winged Aphrodite, and a plump lady with butterfly wings, a tame Cupid and two pillars to support her [*4.92*]. Other gold and turquoise ornaments carry a version of Dionysos and Ariadne riding a griffin, with a drunken satyr in attendance.[234] The hairpin finials

4.92 Gold figurine from Tillya Tepe

4.93 Gold pin head from Tillya Tepe

offer a fine hybrid of acanthus, lotus and palmette [4.93].²³⁵ There are in this general area other traces of imports of the Roman period that probably passed via Indian ports rather than Parthia. A coin of Nero,²³⁶ a fine clay relief vase with Dionysiac scenes of Hellenistic type and a frieze of Roman sacrificial paraphernalia [4.94].²³⁷ The presence of some Egyptian works of the Roman period recalls the principal source of trade in Alexandria. There are several statuettes of Harpocrates from Gandhara, but similar objects travelled yet farther afield: Harpocrates in the Ferghana valley and Bes in the Altai.²³⁸ The classical subjects are eventually rendered virtually unrecognizable through copying and reinterpretation.²³⁹

Several sites with Buddhist foundations also yield wall paintings, a medium as yet poorly represented in Gandhara, as well as reliefs. At Khalchayan, north of the Oxus, the putti with swags appear. The Russian excavators dated them to the first century BC, suggesting a Bactrian source for what we have seen was more probably a far later phenomenon inspired by a different route. They appear also at Surkh Kotal,²⁴⁰ and can hardly be earlier than the second century AD.²⁴¹ It can be seen how slim the margins are upon which decisions about Bactrian or Roman influences depend. Later still even the Roman wolf and twins will be found, but possibly serving an eastern story.²⁴²

In and beyond Bactria the Kushans were treading familiar ground, in areas that had strongly influenced their own culture through the foreign presence of a Greek kingdom. To the east of the Pamirs, closer to the old nomad homes, Buddhists carried their religion into areas barely if at all touched by anything classical, and we have to adopt a

different viewpoint from which to observe the reception of arts already deeply affected by the classical. Needless to say, any direct intervention by western artists must be judged highly improbable.

So far we have had to deal with cultures, indeed civilizations, which had been in touch with each other for centuries, sometimes millennia: the civilizations of the Nile, Mesopotamia and the Indus. China, beyond the ramparts of the Himalayas and Tibet, might as well have been on the moon for all that Mesopotamians or Indians might have known. Yet Chinese culture, technology, architecture and art could, by any standards, bear comparison with those of any other area of the Old World. The only intermediaries were the nomad inhabitants of the steppes, generally inimical, uncommunicative and little interested in organized trade. Seepage of goods and information from the real Far East must have been intermittent and barely intelligible. But in the second century BC the emperors of the Han dynasty in China evinced growing concern about their western borders and the activities of the Hsiung-nu (Huns). In 138 BC an envoy, Chang Ch'ien, was sent to consult the Yueh-chi on joint action, and visited the walled cities of Bactria, which the Yueh-chi were beginning to threaten before their move south into India.[243] In 101 BC there was an expedition to Ferghana (north-east Bactria), ostensibly to acquire a divine horse for the emperor from an area that was long to have a reputation for the quality of its livestock. The horses are the divine flying steeds of Han art, thought to sweat blood, and were sought to transform the Chinese army into a force that could deal with nomad cavalry. One of the immediate non-military results was a strong stimulus to east-west trade along routes and through lands that had long flourished on their native resources in land or metals, but had also suffered from nomad incursions from Central Asia, such as those of the Sakas and Yueh-chi that we have met already: routes and

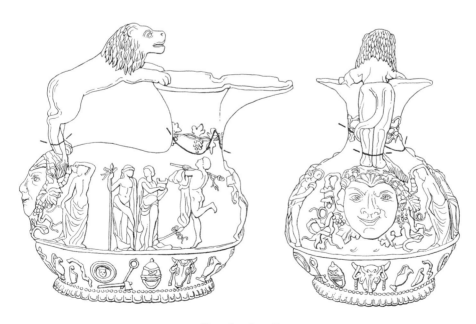

4.94 Clay askos from Termez

incursions that were to continue busily into our era, with Turks, Genghis Khan and more recent Chinese involvement that has created a nominally Chinese province (Sinkiang) to as far west as the Pamirs.[244]

The prime commodity from the east, soon to be highly prized in Mediterranean lands and ultimately manufactured there once the secrets were acquired, was silk. So the routes have become known as the Silk Roads, and our concern in this section is to see what of classical art they may have carried east. From China the routes led west, either north of the Mountains of Heaven (Tien-shan) towards the Caspian; or south, to either side of the shifting dunes of the Taklamakan desert, past veritable oasis sites watered from the ranges of the Tien-shan on the north, or the Kun-lun (Mountains of the Moon, Tibet's northern border), on the south. To pass farther west the main route was through the northern Pamirs into Bactria; then either west to the Caspian (and across it, ultimately to the Black Sea); or south-west into Persia; or south-east, past Kapisa (Begram) into the upper Indus valley and Gandhara. An alternative route south into Gandhara lay over the Karakoram, a difficult road but not ignored even in antiquity.[245] The most important export from Gandhara to China was intangible – Buddhism.

The shores of the Mediterranean are a long way from China. Although a second-century AD Roman mission to China bore gifts, there is no clear evidence for a substantial flow of classical goods on the eastern routes.[246] But the occasional curio could go far along the coast: a Roman period *gryllos* gem in south Indo-China, a lamp in Thailand, glass in Korea.[247] These must be distinguished from that flow of ultimately classical motifs that was carried east with Buddhism, overland through Central Asia.

Trade was not direct but conducted by stages, to the profit of middlemen. This accounts for much of the wealth of cities we have already considered, in the caravan cities of Syria, in Persia, but especially in Gandhara (Chinese lacquer at Begram) and Bactria (bronzes and jade), with neighbouring lands to north and west. Chinese Han mirrors even reach eastern Europe.[248] A first-century Roman geographer had been told how the Chinese conducted trade by leaving goods in lonely places to be picked up – no doubt on mountain routes.[249] Pliny remarks that the Chinese were a mild people who preferred to wait for the trade to come to them.[250]

That there is in fact much classical from the sites along the routes of Central Asia is due therefore to the classical presence in Bactria and Gandhara, rather than any more direct influence from the ultimate destination of many of the western products. It must be regarded as an extension of arts we have already considered in this chapter, sometimes mingling in a yet more confusing manner the characteristics of classical, Persian and Indian arts, sometimes presenting real novelty. The latter is mainly the result of the nature of the sites explored, from many of which early remains of fabric and wood have been recovered. The sites themselves also remained relatively undisturbed for centuries until the brisk exploration and plunder of the 1890s to 1920s. Problems of date are, however, if anything even more dire than for other areas we have considered.

The nomad arts of the steppes of Central Asia are more strongly affected by Achaemenid Persia than anything classical and they demonstrate how much more effectively penetrative Persian influence could be, even as early as the fifth and fourth centuries BC, and how persistent were the patterns it introduced beside the Animal Style arts (to be considered more fully in Chapter Six). Much of it was, after all, of

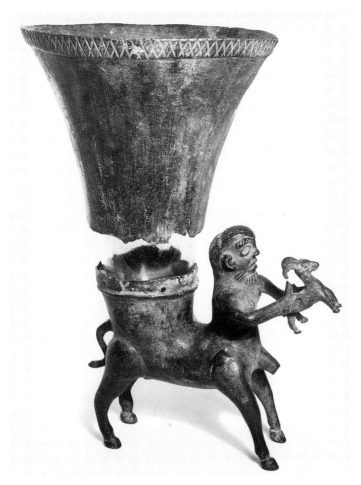

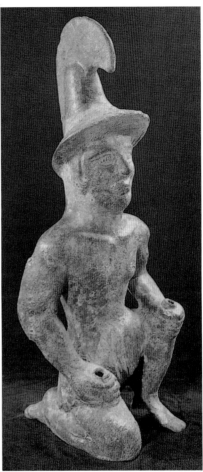

4.95 Bronze centaur rhyton from near Gilgit (Oxford)

4.96 Bronze warrior (Urumchi)

nomad origin like the Persians themselves. The Persian element is demonstrated most dramatically in the finds from the frozen tombs of the Altai,[251] while in eastern China there are silver vessels from second-century BC tombs that must derive their decoration from Persian phialai.[252] Nothing Greek can compete with this so early. Farther south, on or near the later Silk Roads, nomad peoples became sedentary. In the eastern Pamirs bronze vessels attributed to the Sakas are related to a strange bronze centaur rhyton (found with one of them) in Oxford [4.95] which is classical in form and subject though not in style, but it was found on the route south of the Karakoram.[253]

Most of the classical traits on the Silk Roads relate more to Gandhara than Bactria (except of Kushan period), which is unsurprising given the dates (post-first century BC) and the strong Buddhist element. But even this statement may need qualification. A puzzling recent find carries hints of Bactria and of the world of Alexander and the Seleukids. It is a bronze figure of a kneeling warrior [4.96];[254] not Greek work but

4.97 Carved wooden members from Central Asia (London)

wearing a version of the Greek Phrygian helmet and in a style rather recalling the silver figure from the Oxus Treasure [4.35]. It is from a burial, said to be of the fourth century BC, just north of the Tien-shan range.

On the Central Asian routes it is pattern, mainly the floral scrolls familiar from Indian as well as Bactrian monuments, that recall the classical world. They appear on minor objects, wooden furniture and the like, rather than on major architecture (of which there is a lack in country without building stone). I illustrate a substantial piece of a simplified Corinthian capital, a scrolled beam, and the familiar leaf-garland moulding with an angular version of lotus leaves looking much more like a classical leaf-and-dart [4.97].[255] Various sites also yielded gems, or sealings on tablets, with classical motifs, similar to those current in Bactria and Gandhara rather than imports from farther west.[256] Paintings from various Buddhist shrines betray western traits in rather unexpected ways. The shading and three-quarter faces on paintings from Miran (east of the Taklamakan) vividly recall Gandhara and in a way seem even more Mediterranean in flavour.[257] One has a painted version of the Gandharan/classical putti with garlands [4.98].[258] The goddess with the cornucopia reappears on a textile from Niya on the southern borders of the Taklamakan,[259] and the atlantes can be followed into China and Japan.[260] Possibly more remarkable than stylistic features, which might have been learnt from the west at many removes, are various architectural elements which appear in the paintings or frame them. These include perspective renderings. At Qizil, at the north of the Taklamakan and at a date far later than Miran, a scene with the Buddha is

4.98 Painting from Miran (Delhi)

crowned with a frieze of perspective dentils, scrolls and a classical leaf-fascia which might easily have graced a Roman wall [*4.99*]. Another classical motif we found in India is the pair of hovering winged figures, generally called apsaras. At Qizil they appear in Indian style, but with the wholly classical treatment of the dress flying in an arc over their bodies, and bearing a wreath between them [*4.100*]. This is a more direct copying of the classical than appears in India before Gupta sculpture, and it may be that in Central Asia the associations with the west are more direct. The figures seem sexless and their wings are barely recognizable, but the flying dress, an integral part of the image, is clear.[261]

4.99 Painting from Qizil

4.100 Painting from Qizil

These classical elements in the arts of Central Asia and particularly on the Silk Roads are very slight beside the more imposing influence of India, Persia, and of course China. Some of them, however, reached China itself, although it would be difficult to imagine an art whose idiom was more essentially foreign to the arts of the Mediterranean world. Several architectural elements are soon adopted from the west to serve the Buddhist shrines in China.[262] The floral scrolls in particular seem to have been enthusiastically received [4.101],[263] and this appears to be a case in which the discipline of classical pattern seems to have proved the main attraction to artists already highly sophisticated in their rendering of the floral. One reason for it may have been the demands made by Buddhist shrines for religious displays and icons hitherto not required in the east. The scrolls survive for centuries as a basic pattern in Chinese ceramics, with peonies replacing the vine or lotus.

Buddhism reached China in the first century AD.[264] One of the earliest major Buddhist complexes was the series of cave shrines at Dun-Huang, far east of the Taklamakan desert, south of the Gobi, at the western edge of China proper and on its Silk Roads. The paintings, none earlier than fourth-century AD, are initially Indian in style, not unlike Qizil, but they soon adopt an idiom that is purely Chinese both in style and in depiction of dress and features. All the traditional figures of Buddhist art are accommodated, including their classical fellow travellers. The flying Victories/apsaras have abandoned their wreaths, however, and fly free in the field over the Buddhas, wingless now and Chinese-dressed, but still with the flying arc of dress above them (an elegant pair in [4.102]).[265]

4.101 Rubbing of ornament on stone base from Datong

4.102 Painting at Dun Huang

Such examples of the minor arts as may have reached China from the west seem not to have been influential. A rare exception is the Chinese version of the classical silver dish decorated with wavy fluting which appears in the sixth century AD, as it had also in Kushan Gandhara and Sasanian art.[266] More exotic is the silver gilt rhyton from Tibet, decorated with the familiar rinceaux and birds in a classical/Sasanian style, but inscribed as a gift for a seventh-century Chinese princess.[267] Sasanian too must be the main inspiration for the silver jug with very classical figures, including a heroic nude, found in a sixth-century tomb.[268] In other words, Persia is again proving a more influential source of inspiration in the east than the classical world, though often the carrier of classical subjects.

It is unlikely that any Greek, let alone Roman artist ever reached China in the centuries we have surveyed, though it is possible that there was some Indo-Greek Marco Polo. Through this chapter the direct influence of Greek art, notably in the Hellenistic cities of Bactria, can be seen to have promoted second- or third-generation classical work in the east, perhaps spasmodically reinforced by import or even visiting artists, but for the most part frozen in the styles of the late Hellenistic/early Roman world of the eastern Mediterranean. Their significance long forgotten, these classical features served new purposes for religions and cultures, even major civilizations, which probably knew little of and cared little for their ultimate origin. It is not a Greek sun that reflects from the fragments of classical art that crossed eastern deserts, but there was something that in antiquity answered a need, was cherished, and to our eyes at least can recall its western homeland.

5 · Egypt and North Africa

T HE VALLEY AND DELTA irrigated by the River Nile fostered the second major cultural source for Greek and western civilization – second in importance rather than date, which is hardly relevant for us. It was essentially introspective, conservative and effectively resistant to foreign influence even when under foreign domination. The Nile was its life and provided all its needs. This contributed to the isolationism and to a reluctance to bother much with distant journeys and sea-faring. But a culture that changes little over some four thousand years can hardly be regarded as a backwater; it had a secret. We may not much admire or approve it since its political and religious systems were as illiberal as they could be. But they survived; they survived the impact of the Mesopotamian, Persian, Greek and Roman worlds. They offered these other cultures little beyond some useful trade and they took virtually nothing. Indeed, the only periods of influence from Egypt in subjects that concern us are confined to the Minoan non-Greek world of the Bronze Age (when there was a degree of give-and-take), to parts of the near east, especially Phoenicia in the early Iron Age, and for a short while to monumental arts in Greece in the seventh century; and in each case it was a matter of styles or techniques being selectively borrowed or copied, not being consciously imposed.

The Delta (Lower Egypt) enjoyed and enjoys a temperate/warm Mediterranean climate, but upstream, Upper Egypt, centering on, in tourist terms, Luxor, Karnak and the Valley of the Kings, must be regarded as a second, more nearly tropical and desert-conscious focus, and farther still, in Nubia (Sudan), the climate, with the life it imposed, was yet closer to that of tropical central Africa. In early days Upper and Lower Egypt were for a while politically though hardly culturally separate, while Nubia came to be regarded as border territory to be exploited for resources of men and material, and for access to the wealth of the south, especially ivory and gold.

Egyptian art takes an exceptional place in the history of world art. The physical achievements are breathtaking, to our eyes sometimes almost sinister and infinitely remote to the point of being almost detached and alien, yet capable of moving us with their warmth and colour. It is also reassuringly recognizable, which is in itself a reflection on its unlikeness to the arts of others. The essential elements of style and expression in the major arts of architecture, sculpture and painting were in place early in the third millennium BC and readily apparent still in the second century AD. The record is not a matter of mindless conservatism, nor is stagnation a proper term for it, although there were doldrums, sometimes centuries long. And in the last seven hundred years the dominion and arts of foreigners (Persians then Greeks then Romans) provided

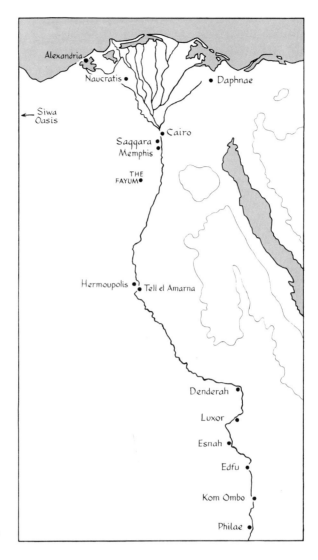

MAP 5 EGYPT

alternatives and compromises. These could only be ignored in the arts through rigid adherence to the traditional rules enforced by a still dominant religion rather than by political power. But one cannot fail to be impressed by the way a Greek king or a Roman emperor could be portrayed in an idiom mainly unchanged from that which had served his Pharaoh predecessor over two thousand years before: on [5.1] the Greek Ptolemy II faces his wife Arsinoe II in complete Egyptian guise.[1] The Greek queen shown in [5.2], again Arsinoe II, is Egyptian in conception, material and technique of execution; the head is not a portrait in the Greek sense and only the double cornucopia that she holds, a symbol of extra-abundance and joint rule in the family of the Ptolemies, betrays her status and identity. In her other hand is the Egyptian *ankh*, symbol of life.[2] But on a later royal figure from Karnak [5.3] we do find a classical portrait head, possibly the Roman Emperor Augustus as Pharaoh,[3] and there are others.

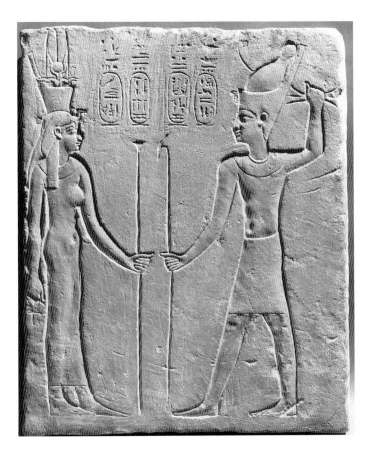

5.1 The Tanis stele; Greek royalty (London)

There was of course change in Egyptian art over these many years, periods of innovation and adjustments in convention, but the changes did little to affect overall appearances and the innovations were shortlived. The explanation surely lies in the strong continuity of behaviour (even if not always of race) in the ruling families, dictated by religious practices which tended to strict observance of ritual intended to secure life (the annual inundations of the Nile) and preparation for a death which would be effectively an eternal afterlife. The major arts were devoted to these ends and a certain conservatism of approach was also a natural guarantee of success. Only towards the end of our period did Egypt accommodate a substantial middle class corresponding to the majority of Greek society, and while the contribution of Egyptian art to the visual experience of the worker and farmer was not insubstantial, they made no demands on it which might have led it into different paths. Art was for the royal court and state religion, as it was in Mesopotamia. Artists were generally anonymous employees, though they could achieve status and display pride in their work; but this we have to learn from the record of their graves rather than signatures or much acknowledgement of their role in official archives.

Architecture expressed permanence through mass: pyramids, lofty obelisks, and temples with pylon façades like mighty bastions; also through articulation in mouldings and columns, a mode that the Greeks were to observe and learn from. The Greeks were

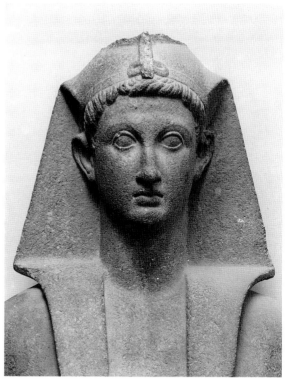

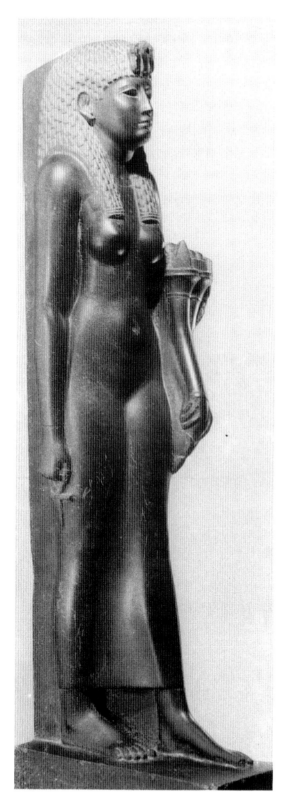

5.2 *(left)* Arsinoe II (St Petersburg)

5.3 *(above)* Augustus as Pharaoh (Cairo)

characteristically irreverent – pyramids were *pyramides*, little cakes, obelisks were *obeliskoi*, little spits (compare 'Cleopatra's Needles' now in London and New York). The art of painting we have to take with stone relief, since this too was painted and is basically linear with little depth of modelling, although this could be subtle; but it was quite unlike the Greek manner, in which figures could be rendered virtually in the round. It was disposed on everything from massive plain wall surfaces to tomb walls, in friezes or in overall, often multi-tier compositions. The conventions were simple and highly effective. Human figures are rendered in a combination of profile and frontal views with no more attempt at indicating depth or three-quarter aspects than we observe in the superficially very similar conventions of Greek Late Archaic art. Even so, most 'natural' Greek poses had been anticipated in Egyptian art, even if only sporadically and without that understanding and observation of the structure of the human body that is a requirement of the Classical revolution in the arts.[4] Juxtaposition of different viewpoints was normal where there were architectural settings (plan with elevation), in the interest of offering a complete statement. The shape and construction of objects depicted were closely observed and reproduced, so the unreality of human forms was a matter of choice, not naive conceptualism. As an effective language through which to express the physical world, and even to give form to the imagined world of divinity and the afterlife, it could hardly be bettered. It could certainly not be bettered by realism. (This is why Greek Archaic art, which resembles Egyptian but with a lesser range, is a more responsive medium for narrative than the realistic tableaux of the later classical and of the classicizing arts of Rome.)

Egyptian sculptors were as ready for the colossal as the architects; ready too to execute large statues in harder stones than the Greeks ever employed, and without the hardened iron tools already available to the Greeks when they started to imitate some aspects of Egyptian sculpture in the second half of the seventh century. An Egyptian sculptor's studio could of course deploy plentiful cheap labour, but the use of recalcitrant materials must be seen as part of the intention of the product, to symbolize permanence, and the old techniques were not abandoned even in late periods when different tools were readily available. Appearances depended on conventional measurements laid out on grids, drawn on the sides of the stone blocks, which were then cut back systematically, from all sides, with the guidelines repeated at each stage. The process was exactly that adopted by the Greeks too for their hardstone (white marble) sculpture of the Archaic period. But Egypt's sculpture is in a different class from its painting and relief. Much was certainly executed following comparable rather mechanical conventions, but the glib contrast between Greek realism and Egyptian convention comes adrift in the face of many statues, and from early periods on, in which elements of true portraiture seem to be intended although body forms remain little more than plausible approximations to life. This is much more than a matter of idle experiment by a few gifted artists, and the point is worth further consideration since it bears upon the effect, or non-effect, of Greek realistic arts in Egypt, and indeed it reflects on our view of classical art itself. The key may lie in finds of the Amarna period in Egypt.

In the early fourteenth century BC the Pharaoh Akhenaten, who founded the city of Akhetaten, modern Tell el-Amarna, in Middle Egypt, promoted a new focus for

5.4 Plaster head from Tell el-Amarna (Berlin)

religious belief and practice in a form of the Sun God, the Aten. It was accompanied in art by a turn to more realistic renderings of form and posture. To call the religion heretical and the art revolutionary ignores the fact that both were well embedded in Egyptian tradition; the cult of Aten had been established by Akhenaten's predecessors and elements of realism in the arts were not unknown. What happened was a temporary and distinctive shift of emphasis.[5] The art is widely admired for its relative realism and perception, but this was not quite an anticipation of Greece's Classical revolution of the fifth century BC since sheer realism in the major arts was carefully avoided. Some finds at Amarna in a sculptor's workshop, generally associated with the name of Thutmose, are revealing.[6] They included many plaster renderings of heads, faces, hands and feet. The heads seem reference casts of works executed in stone or wood. But some faces [5.4] are highly realistic and have been thought casts from modelled clay heads. Modelling seems not to have been a technique of as much relevance in Egyptian sculpture as it was to be in classical Greek, and the Amarna heads were not themselves built up in plaster as a modelling material. But casting from live (or dead) models is also suspected.[7] It does not matter much which is the case; it is enough to observe that the sculptors sought to create and preserve wholly realistic features of a type never admitted to official art or rendered in stone – even in the pieces found in the same workshop. The striking difference between the plaster faces and the features of all other Egyptian sculpture, of this or other periods, makes it seem very likely that the sculptors were most concerned in the close study of live forms. In Greek sculpture these are practices born in the fifth

century and first attested in the fourth, but for very different ends since the major sculpture of the day had positive aspirations to realism.

At Amarna the official art, in stone or wood, was executed by sculptors aware of live forms (from the cast models and observation) but deliberately setting it aside, or even going beyond it to express something more in keeping with Egyptian expectations and not at all, one must judge, like Greek idealizing. If this is true, Egyptian adherence to traditional and conventional forms for most of their art was not *faute de mieux*, but the conscious choice of their greatest artists, who formed the tradition and created an idiom that their kings and priests found an effective expression of the otherworldly. This may be why many of us may, with confessed but not necessarily misguided subjectivity, find in the best Egyptian sculpture qualities which go beyond the blend of real and ideal achieved by the Greeks, perhaps through their ability to add an element of the immortal. They demonstrate that the 'ideal forms' posited by Greek philosophers were better expressed in art through an idiom that was *not* determinedly realistic. The Greek sculptor Pygmalion was delighted that his statue of an ideal woman could be brought to life – but thereby she was also brought to death. Egyptian sculptors were not to be taken in so easily.

This lengthy preamble is a necessary introduction to the following account of how classical art continued to fail in Egypt for as long as the traditions of Egyptian religion were alive and influential.

The relatively easy sea passage between Crete and the north African coast, as well as the longer coastwise route via the Levant and the Greek islands, explain the rich evidence for mutual contacts between Egypt and the Aegean world in the Bronze Age, notably with Minoan Crete. Cultural exchange did not go deep but there was more than casual mutual awareness. The end of the Bronze Age broke the link. In the tenth century Egyptian and egyptianizing objects begin to appear again in Greece, but almost certainly via contacts with the Phoenician coast and the egyptianizing arts of Phoenicia (see Chapters Two and Three). From the beginning of the seventh century there are more Egyptian objects arriving in Ionia, especially Samos, and after the mid-century we have record of a Samian merchant (Kolaios) on the Egypt route, and of an Egyptian king (Psammetichos I) employing Anatolians (Ionians and Carians) as mercenaries. This led to a measure of Greek settlement in Egypt both of veterans and of merchants from Ionia and Aegina. Later, in the second quarter of the sixth century, the Greeks were allowed by King Amasis to regularize their use of the town of Naucratis in the Delta, but were restricted to it as the only official port of entry for Greek goods. Egyptian suspicion of the foreigner was ever present, but Greeks and Carians, it seems, were not positively discouraged, though they may have had little to offer at first beyond their military skills. In Greece itself the contact with Egypt led to developments in monumental architecture and hardstone sculpture in the later seventh century. There was little enough in return.

Naucratis was not a colony but a city of Greeks from various parts of East Greece and the homeland. They were allowed to build their own temples, as well as a joint sanctuary, the Hellenion, for worship of the Olympians in a land used to a plurality of gods. A half-hearted equation of Egyptian and Greek deities began. Local workshops

5.5 Greek vase from Egypt (Basel, Cahn)

produced Greek-style pottery for local consumption (votives) and trivia in the popular Egyptian medium of 'faience' which was already well known through the Greek world and beyond. These are mainly scarabs and figure-vases; they are evidence for Egyptian influence on Greek work, albeit overseas, not vice versa.[8] In the sixth and fifth centuries there are isolated instances of Greek manufactured objects (hardly an art trade) directed to specific sites or occasions in Egypt. An Ionian black figure vase showing a Dionysos ceremony which involved carrying a ship was taken to Karnak in Upper Egypt where a similar ceremony was performed for the god Amun. This may have been bespoke for the occasion, while other pottery, including a piece with painted cartouches, might have been made in one of the Greek studios in Egypt itself [5.5].[9] Athenian pottery of high quality reached Egypt, including a great volute crater from the same stable as the François Vase but of which only two fragments survive.[10] Other finds reveal a range of different blends of Greek and Egyptian: kouroi and korai which are simply provincial Greek, gravestones for Carians decorated with Greek scenes (including the laying-out *prothesis*) acted by semi-Greek-style figures but in the Egyptian sunken relief technique and topped by the Egyptian winged sun-disc [5.6], a faience *ushabti* (Egyptian tomb figure, a deputy for certain menial afterworld tasks) with a Greek head [5.7].[11] More revealing for Greek art than Egyptian is the wooden plaque from Saqqara [5.8] with an Ionian painting of a sacrificial procession, made by an immigrant related closely to those artists who travelled west from Ionia in the later sixth century to make the Caeretan Hydriae in Etruria [7.11].[12] None of this amounts to influence on Egyptian art: simply the presence of Greeks and awareness of Greek styles but none necessarily practised by Egyptians or for Egyptians.

Late Archaic (in Greek terms) Egypt was already under Persian rule and there was a successful but expensive Athenian raid on Egypt in support of a local insurrection by

5.6 Prothesis relief from Abusir (Berlin)

5.7 Faience ushabti from Saqqara (Cairo)

5.8 Wooden plaque from Saqqara (Cairo)

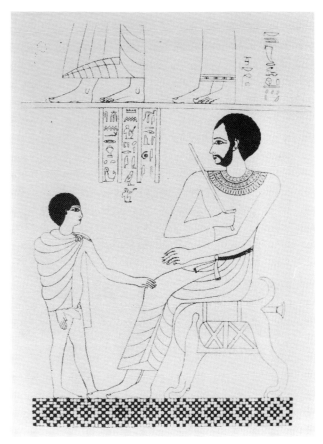

5.9 Figure vase from Egypt (Paris)

5.10 Painting at Siwa Oasis

5.11 Bronze figurine from South Arabia
(Vandoeuvres, Ortiz)

the mid-fifth-century. A trickle of Greek objects continued to arrive, some perhaps revealing deliberate choice or manufacture. A mid-fifth-century Athenian potter, Sotades, specialized in figure-vases with an oriental flavour, notably horn-cups on a modelled figure base in the Greek manner. One with a Persian, a negro and a camel was found in Memphis [5.9]; another with an Amazon rider in Nubia.[13] From Memphis there is another Greek-style relief showing the laying-out of the dead, recalling the one for a Carian [5.6], but this is for a Persian.[14]

If we look west to the Libyan desert, there is the shrine of Amun at Siwa oasis, which was regarded by the Greeks as the seat of an oracle of Zeus (Ammon). So Zeus appears with rams' horns on coins of Cyrene. And a Greek beard and dress appear in an otherwise wholly Egyptian tomb painting for a Greek who may have become a priest there [5.10].[15] The painting is clearly by an Egyptian, and the degree of hellenizing is as superficial as all else of Greek character in Egyptian art of the day. Cyrenaica itself (modern Libya) was a colonizing area for Greeks where the local inhabitants are obscure archaeologically (mainly nomad) and Greek influence was overwhelming;[16] it penetrated even far south.[17] Beyond lived Phoenicians (Chapter Three).

To the east, over the Red Sea, the find of a Late Archaic Greek bronze figurine in South Arabia might indicate no more than the passage, hand to hand, of a curio [5.11].[18] The way that the South Arabian scripts on stone seem relatable to Greek styles in lapidary inscriptions of the Classical period (rather than anything Egyptian) might be more revealing; but of what?[19] This was a coastline which was traversed by the new sea routes from Egypt and the Roman world to India, as we saw in Chapter Four, and from these later centuries there are traces of the trade at sites along the way, as well as more substantial evidence for the local creation of highly classicizing works.[20]

Alexander invaded Egypt in 332 BC, putting an end to nearly two centuries of Persian rule. In this time the Persians had made as little impression on traditional Egyptian culture and art as had Greek merchants and mercenaries.[21] The new lord of Greece and the east traced the outlines of a new capital for Egypt, Alexandria, on the coast downstream from Naucratis. He visited the oracle of Zeus Ammon at Siwa oasis and was hailed as a god himself, whence the rams' horns that later portraits of him could bear as [4.54]. After his death Egypt was ruled by one of his generals who, as Ptolemy I Soter (the Saviour), founded the dynasty that would rule Egypt for nearly three hundred years, until the country became a Roman province and the last of the Macedonian rulers, Cleopatra, followed her Roman lover to a suicide's grave.

Alexandria was a Greek city, and the new rulers of Egypt, the Ptolemies, were Macedonian Greeks. The arts of Alexandria are part of the history of Greek art and not our concern in this volume, though their quality and influence in the rest of the Greek world, and later in Rome, were remarkable, and they were a major source for the Hellenistic and later influences on the arts of Buddhist India. There was no serious accommodation to Egyptian styles although some Egyptian techniques – for instance in the production of faience relief vases – were borrowed for works in a purely Greek style. The example I show has Queen Arsinoe II, holding the double cornucopia and pouring a libation [5.12].[22] The style is stiff and linear, impure Hellenistic, but dramatically

5.12 Faience oinochoe (London)

different from the Egyptian treatment of the same Greek queen in [5.1,2]. There was otherwise a strong Persian, or Greco-Persian, flavour still to some of the Greek products in Ptolemaic Egypt. Other faience vessels with shallow figure and floral patterns betray this.[23] Glass and glazed vessels are naturally prominent in a land where the techniques of production had been long familiar.[24] The Persian interest in carved vases of stone, including precious stone, resulted in some impressive works often combining Greek and Egyptian motifs, from Greek hands in Egypt.[25] The same source of inspiration accounts for the finds and local production of silver rhyta with animal foreparts [5.13], of the widespread Hellenistic type encountered in earlier chapters, and discussed there.[26]

Since the ruling family adopted Pharaonic behaviour, even to the marrying of their sisters (though this had been rare enough in Egypt), there is some adoption too of Egyptian styles of dress and court or ritual paraphernalia. There was a deliberate attempt to reconcile religious practices, possibly with the help of an Egyptian priest, Manetho. A new god had been identified – Serapis, a version of the Egyptian Osiris-Apis – but his iconography is purely Greek, probably invented by a Greek sculptor, Bryaxis,[27] and his worship was never important to Egyptians or in Egyptian towns. Isis was adopted as an Egyptian Demeter, and Horus (Hor-pa-khered, naturalized as Harpocrates) borrowing the physique of Eros. Other Greek gods were, with varying degrees of plausibility, assimilated to Egyptian gods without their images acquiring

5.13 Gilt silver rhyton from Tuch el-Karamus (Cairo)

anything more than the superficial Egyptian features of dress or attribute. Religion was not a field in which Egyptian artists had anything serious to contribute to Greek taste. Throughout the Greek and the Roman period, temple building was either Greek or Egyptian in style with little significant interaction.

The Greek cemeteries of Alexandria take distinctive forms, related to others of the Hellenistic world, but their debt to Egypt is mainly confined to occasional architectural elements – a frieze of *uraei* (cobras) in the Egyptian manner combined with Greek Ionic dentils, or sphinxes as tomb guardians in local rather than Greek poses. It would have been impossible for such monuments not to be affected by such strong local traditions in funerary art, but even in these respects the lead seems to have been given by general Levantine egyptianizing as much as by Egyptian practice.[28] The Greeks generally held themselves aloof from the life of the older civilization into which they had intruded, yet they had much to contribute to it in certain areas of behaviour and administration. For instance, in Egypt coinage (always Greek) had been treated more as bullion than as true currency, but the later Pharaohs, under Persian rule, had started copying Athenian coins, and there was a short-lived issue of Egyptian coinage in the Greek style, before

a b

5.14 Egyptian silver (a) and gold (b) coins

the establishment of the busy new Ptolemaic mints. The head and horse on the obverses of the coins shown in [5.14a,b] are Greek-inspired, but the reverses have hieroglyphic devices, though the leaves on [14a] copy the olive leaves on Athenian 'owl' coins.[29] Colonial analogies for ancient colonial activity are unpopular with historians today, but comparisons with the British Raj in India come inevitably to mind. Culturally, Rome rather than Greece was ready to be won over by Egypt, just as France and then Europe were won over aesthetically after Napoleon's shortlived conquest, but it was an Egypt seen through Greek eyes.[30] Neither Greece nor Rome succumbed to the romance of Egypt as readily as did England to that of the orient, and the disregard was for long mutual.

What we have to observe are the continuing traditional arts of Egypt, normally in the service of Egyptians, and the degree to which they were affected by the presence of Greek art and artists of high quality, and high productivity.

There is one early and exceptional example of a monument in which there seems to have been a deliberate attempt by Egyptian craftsmen to accommodate some elements of Greek art. The contrast with the record of the rest of Egypt is striking. Egyptian priests and officials had continued in office under the Greeks, probably with no perceptible loss of independence and status. Petosiris belonged to a rich priestly family at Hermoupolis in Middle Egypt. He apparently died in the early years of Greek rule, and inscriptions in his tomb revile foreign occupiers, the Persians, under whom he must also have lived. He was a local dignitary and priest of Thoth, whose temple had been refurbished by the Greeks, probably during Petosiris' stewardship. The superstructure of his tomb is unusually in the form of a small temple, and essentially Egyptian. It has before it a horned altar of the sort found often later in Egypt, combining the Egyptian block with what is probably a simplification of Greek corner acroteria.[31] It is one of the last of the private tombs in Egypt with lavish painted relief decoration. It has often been cited as an isolated example of Greek influence on Egyptian art, but its message is more complicated and revealing.[32]

The reliefs that deal with the ritual of death are executed in a totally traditional style. Others which show the activities of Petosiris' estate, guaranteeing thereby their further service to him after death, include several features which must derive from knowledge of Greek art. This appears in some naturalistic relaxed poses, for standing figures or for children carried by their mothers in procession; some frontal and three-quarter views of figures which ignore the Egyptian frontal/profile canon; naked figures and their poses in

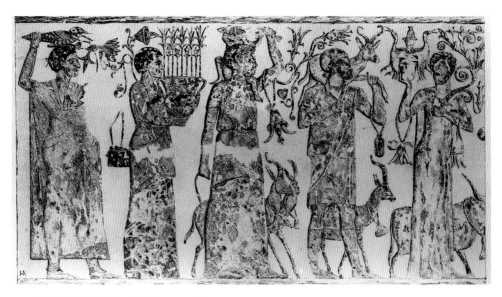

5.15 Relief, Tomb of Petosiris, Hermoupolis

agricultural scenes, especially the vintage; and other elements in some of the processional groups where the florals, for example, include the rich and fanciful Hellenistic confections [5.15] rather than the Egyptian which appear in another procession.[33] This hellenized procession appears in the lowest frieze of the tomb forechamber where we find the most remarkable of the scenes, which is also unencumbered by the usual accompanying hieroglyphic commentary in the field

5.16a,b Relief, Tomb of Petosiris, Hermoupolis

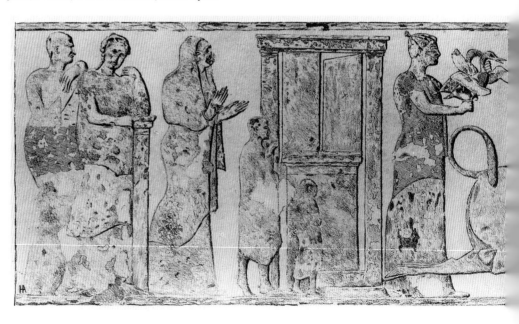

[*5.16*].[34] It shows figures of the family attending a shrine which must represent the tomb of the dead. Their dress is Greek and so are their poses, notably the woman leaning on a colonnette and the man at her shoulder. And beside them a bull is being wreathed and another sacrificed – a wholly Greek cult act performed in a manner unknown to Egyptian ritual. The execution is not Greek but carried out with full knowledge of Greek art, and, perhaps more importantly, Greek behaviour: and this some four hundred km from Alexandria. It is difficult to escape the conclusion that Petosiris' family dressed as Greeks, at least for ceremonial occasions, and were prepared either to enact or at least to claim for their dead kinsman through this scene a degree of deification in the Greek manner, such as had been provided for in the other reliefs and rites, in the Egyptian manner.[35]

If the sacrifice scene remains puzzling in its significance, there are other reliefs in the tomb that reveal more clearly some sort of Greek presence in Petosiris' household. There are scenes of workshops, where smiths are making gold and silver vessels [*5.17*]; the materials are specified in the hieroglyph captions. These include several rhyta of Greco-Persian type, with animal foreparts, such as have been remarked already in Hellenistic Egypt [*5.13*]. There are examples with the foreparts of horses or deer and one with a horned lion [*5.18a*].[36] The last is a favourite creature for this role. The term Greco-Persian is justified since by this date Greek elements in these vessels are becoming dominant: the griffin of [*5.13*] is Greek, and the animal foreparts on rhyta have become less formal, more realistic. Some of the other vessels seem of Persian shape, and a phiale is being worked. An odder object is a terminal in the shape of addorsed foreparts of harnessed horses. Assembled [*5.19*] it sits on a pillar of Egyptian form, but, more remarkably, it supports a domed object, perhaps an incense bowl lid, topped by a crouching Eros with raised wings – a wholly Greek motif [*5.18b*].[37] We

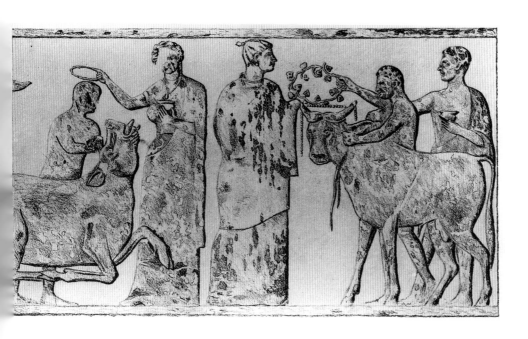

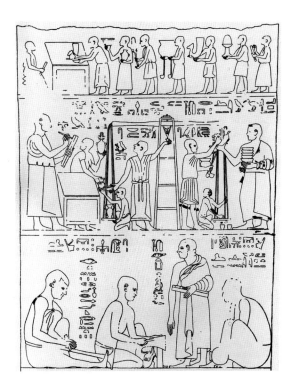

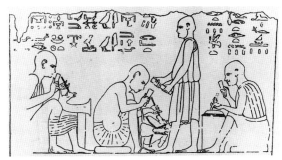

5.17a,b Relief, Tomb of Petosiris, Hermoupolis

knew that these Greco-Persian forms were current in Egypt; now we know that they could be made in an Egyptian workshop beside Hellenistic Greek figures, though we know nothing of the nationality (they are depicted as Egyptians, or at least not as Greeks)[38] and can only guess at the training of the craftsmen. There seem to be no Greek names in this context in the tomb; the craftsmen are described as 'unique in his craft', 'chosen in all the world'. In the same set of reliefs carpenters are at work on a bed decorated with figures of recumbent horned lions and panels showing Greek or Greco-Persian, not Egyptian, sphinxes with raised forepaws [5.20].[39] The whole complex gives a remarkable insight to a strongly hellenized Egyptian family of the upper class, and its commercial and social, even religious relationship to the new lords of the land. It is wholly isolated, so far,[40] and this degree of assimilation has no following that we can detect, indeed such a close association of the two races may well have been discouraged by both parties.

The tomb of Petosiris demonstrates a positive willingness to compromise and assimilate elements of Greek art. In many other, more trivial cases, the influence is no more than a matter of copying forms and patterns which had become familiar through the presence of Greeks and Greek artefacts. These are mainly apparent in the Delta towns. A stone stele takes the form of a Greek one, but this is because it is to be dedicated

5.18 Vessel types, Tomb of Petosiris, Hermoupolis

5.19 Relief, Tomb of Petosiris, Hermoupolis

5.20 Relief, Tomb of Petosiris, Hermoupolis

by a Greek to Anubis and the relief on it is purely Egyptian.[41] A wooden sarcophagus takes Greek form but crudely shaped, and painted with awkward Greek ornament and bucrania as well as effective if hasty Egyptian figures and inscription.[42]

The record in major sculpture is more important. Alexandrian Greek sculpture is unaffected by Egyptian style, as has been remarked.[43] To Egyptians the Ptolemies and Romans were the new Pharaohs and to be depicted as such, as we have seen [5.1–3].[44] They are presented in hardstone statues of traditional posture with features which range from the totally stylized Egyptian to works that admit elements of Greek realism, but always strictly subordinated to the traditional treatment of royalty. There is a far subtler blend in the portrait of Ptolemy VIII Physkon [5.21],[45] but the figures neither stand nor dress as Greeks.[46] They remain rigidly supported by the back pillar, left leg advanced, a less realistic pose even than that of an Archaic Greek kouros, but itself contributing to a sense of stolid permanence, which was surely the intention. The features deviate from Greek portraiture not through incompetence but from a deeper concern to express that element of idealized immortality that had long been an innate feature of Egyptian statuary. They are based on the semi-realistic portraiture of the Alexandrian studios, much in the way that the Amarna sculptors were guided by but never copied their own essays in realistic modelling or casting more than a thousand years earlier.[47] Only a few

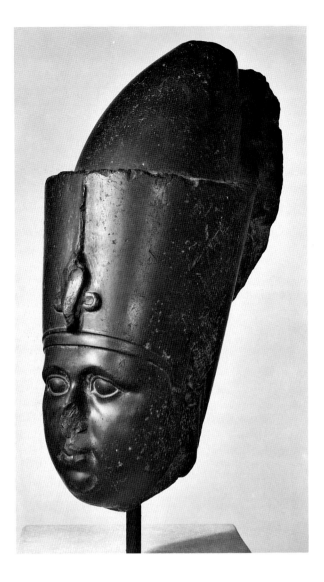

5.21 Head of Physkon (Brussels)

5.22 Statue of woman (Leiden)

5.23 Head of man (Berlin)

statues of private persons of this period accommodate formal elements of Greek dress to native form; [5.22] shows one whose pillar back bears an inscription in Greek, a dedication by a Greek to Isis.[48]

In portraits of Egyptians some subtleties of expression which may have been inspired by Greek work are less important than the native strength [5.23].[49] This is apparent even in those figures whose heads are Greek in coiffure and expression though their dress and stance are traditional. The head in [5.24] is one of the finest examples, the hair Greek, the features barely classicized and unquestionably *not* carved by Greek hands.[50] Major statuary of women had long been absent from the Egyptian sculptor's repertory. The appearance in Egypt of innumerable Hellenistic Aphrodites may well have prompted the Egyptian nude [5.25].[51]

5.24 Head of man (Brooklyn)

5.25 Statue of woman (Alexandria)

It has not proved possible to find anything of importance that traditional Egyptian craftsmen found worth borrowing or copying in Greek art although they were more directly exposed to it than most non-Greeks, especially after Alexander's conquest. Greek art had nothing to offer that might improve their effective service to their religion for as long as that religion was alive, and neither Persians, nor Greeks, nor Romans did anything to disturb it. But eventually it was disturbed, and since the aftermath does reflect more actively on what classical art might offer it is worth a few words here, for all that the arts of Roman Egypt have to be dealt with summarily.

Egypt under Roman rule presents much the same record of traditional portraiture adjusted to new subjects, though with diminishing flair. In funerary art the masks of mummy cases had usually been highly stylized but in the early Roman period the plaster busts assume classical and recognizably Roman coiffures and semi-classical features [5.26].[52] Painted heads and busts for mummy cases, which culminate in the fine second-to-fourth-century portraits from the Fayum, follow the same pattern but with far more distinguished results. These are familiar appendixes to most accounts of classical

5.26 Plaster bust (Cairo)

5.27 Gravestone of schoolgirl (Cairo)

painting but I show a forerunner, an Egyptian painter's portrait of a schoolgirl for her grave monument, of the first century AD [5.27].[53] Only the technique is classical, not the conception and execution. The head of the man painted on a shroud [5.28] with Osiris and Anubis attending his passage to immortality through the observance of proper ritual is more like those of the Fayum mummy portraits.[54] In the minor arts a rich series of Greco-Roman clay figures provided popular images of classical and classicized Egyptian gods. I illustrate an Athena assimilated to the Egyptian goddess Neith, with her massive torch [5.29].[55] The same heritage provided the subjects and techniques of the rich series of Gnostic engraved gems, mainly of the second to fourth centuries, serving the special needs of a closed group dedicated to what might be regarded as deviant paganism, classical and Egyptian, in an aura of magic and ritual.[56]

Under Rome the construction of temples to Egyptian gods and Roman god-emperors continued, more often now admitting some classical architectural elements although they were never permitted to dominate design. The principal monuments are mainly in Upper Egypt at sites which had received the attention of the Ptolemies also – at

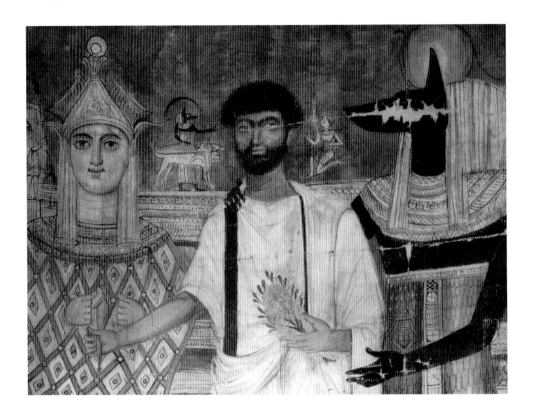

Denderah, Philae, Kom Ombo, Edfu, Esnah.[57] The Emperor Hadrian visited Egypt in
AD 130–31, to hunt lions in Libya, and lost his lover Antinoos by drowning; whence a
new foundation, Antinoopolis opposite Hermoupolis, and statues of Antinoos as an
Egyptian god. But it is interesting to observe that these egyptianized statues of Antinoos
seem to have been produced for the imperial court in Italy, not in Egypt.[58] It was at
about this date that house tombs at Hermoupolis, where Petosiris had been buried,
receive classical wall paintings which include complicated mythological scenes, labelled
in Greek, and accompanied by Greek epigrams for their Greek occupants [5.30].[59] The
subject is Oedipus solving the riddle of the sphinx, and killing his father Laios, with
unusual personifications of Puzzle (*Zetema*) for the former, Ignorance (*Agnoia*) for the
latter. One thinks of the mosaics of countries of the Mediterranean coast, but these
paintings in Egypt are as remote to the south as, say, Dura Europos was to the east, yet
far more purely classical in content.

Roman control of Egypt faltered in the following century and the growing Christian
population was alternately persecuted and tolerated. But this was the new religion that
was to destroy the old. The temples were one by one converted to churches although it
was not until AD 527 that the last of the Egyptian temples, at Philae, was closed.

We know Christian Egyptians as Copts, using a version of the Greek word for
Egyptians, but not all Copts were Christians. The Christian element in their arts only
becomes important after the mid-fifth century when the Council of Chalcedon (AD 451)
set them on the course of Monophysite Christianity, and it becomes dominant after the

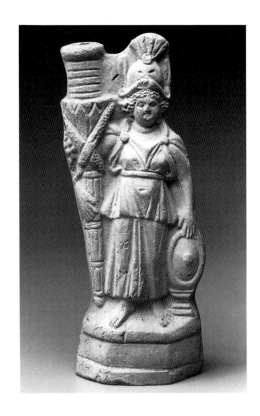

5.28 *(left)* Painted shroud (Berlin)

5.29 *(right)* Clay figure of Athena/Neith (Hamburg)

5.30 *(below)* Painting at Hermoupolis

arrival of Islam in the seventh century. Coptic art paid little attention to the traditional arts of Egypt and at last, in the service of a popular rather than a court and temple religion, a version of classical art emerged as the main idiom for the arts of Lower Egypt. The media were essentially non-monumental, although the Roman basilica form was to serve as the basis for church architecture, while the new monasteries, of which there were many, generally observed local styles of construction and plan with no excess of architectural ornament. Now too we have the evidence of a medium that must have been

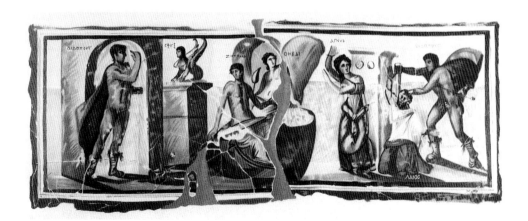

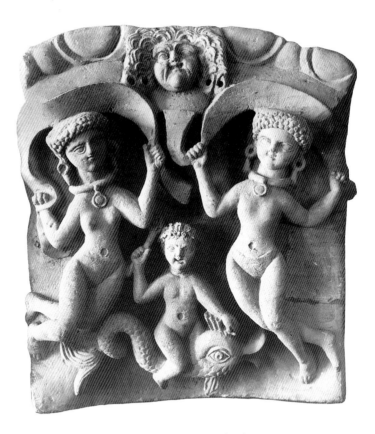

5.31 Coptic relief (Trieste)

of major importance in antiquity but one which we have had largely to ignore through its inability to survive anything but the most dry or wet or cold of burials – textiles.

Coptic art is homogeneous, mainly dependent on Egypt's Hellenistic traditions; not oblivious to the arts of the Greek world now dominated by Byzantium but in no respect provincial Byzantine. While figure and floral decoration remain the principal themes they have lost all claim to monumentality. The overall appearance is very much that of a 'folk art', except that the quaintness does not seem arbitrary, and it is expressed as deliberately in stone relief as in textile or painting. There is something inescapably comic about it to modern eyes, but it is not a comicality achieved through incompetence. Wherever in antiquity classical art had lost its roots in carefully planned and proportioned monumentality, it readily turns into something marionettish, seemingly superficial and decorative, although this must often do less than justice to the intentions of its makers. But there is a remarkable sameness in the peripheral classical arts of late antiquity, be they in Gaul, Egypt, Persia or beyond.

I offer very few but typical examples of Coptic art, not needing to select especially the Greek subjects, since they are everywhere. Relief sculpture for architectural settings is not one of the earliest media. [5.31] has a version of a subject that has become well familiar to us through this book – the flying ladies with the arc of drapery over their heads, but here they are quite naked and the dress reduced to a broad ribbon.[60] The

head above derives from gorgon heads in this position but has lost its identity, and the putto on a fish makes Nereids of the ladies. The strong symmetrical pattern created by the figures is more important than the subject, and subjects had always been at least as important in classical art as pattern; the large heads and attenuated boneless bodies characterize the Coptic style in most media. This relief is from Ahnas, just south of the Fayum, a rich source for such work. The relief in Oxford [5.32][61] is a more honest version of a classical myth scene, probably with Leda and the swan, although this could be Aphrodite: compare an earlier Indian treatment of the group [4.61]. The poses are closer to their Hellenistic models, but the big heads and frontal poses put one strongly in mind of comparable, peripheral versions of the classical in the Parthian world. These two reliefs must belong to the last years of the mainly pagan period of Coptic art, at the turn of the fourth and fifth centuries AD.

The textiles, which have been plentifully recovered from tombs, derive from the dress of everyday life, sometimes shrouds, only later from liturgical costume. The classical figures used in the decoration are even more thoroughly translated. The themes are closely observed but for an occasional misunderstanding of identity. The study of the god of the Nile on [5.33] is an early example of the genre, not yet Coptic, but inscribed in Greek and retaining in woven cloth much of the painterly elements of late classical art, including shading and highlights.[62] It might be as early as the second century. Barely two centuries later (dating is vague in the extreme in this area) is [5.34], in the most typical Coptic style, mainly monochrome, and with a Herakles and the Lion performing incongruously in a Dionysiac setting of vine and hare.[63] [5.35] is close enough to its classical model, with Apollo casually threatening Daphne, already turning into a tree;[64] but she proffers to him a cross: the christianizing of the pagan subjects is beginning and will gather pace through the remaining record of Coptic art, which more and more approximates to provincial Byzantine in its appearance, especially in its architecture and painting. Although the motif of the Virgin suckling the child might

5.32 Coptic relief (Oxford)

5.33 Textile, the Nile (Moscow, Pushkin)

derive ultimately from Egyptian Isis with the infant Horus, the intermediary is the hellenized group familiar from Greco-Roman terracottas in Egypt, not Pharaonic art.[65]

Within three centuries the traditional arts of Egypt which had served the land for over three millennia, had been totally supplanted although their record remained, as it does still, a vital but no longer vitalizing presence. In their place classical art, which had long served foreign rulers in Egypt, Greek and Roman, now served the needs of a native population, still dominated by imperial regimes, but also increasingly guided by a new religion, Christianity, which could be no less despotic, but to which the greater part of the people could respond. The wondrous arts of dynastic Egypt had needed nothing of Greece and Rome. Their messages of eternity, even their expression of the more trivial subjects, had found an idiom that totally suited them. Realistic Greek art presented life, really lifelike forms, and life implies death. Egyptian art, by avoiding realistic forms, could carry promise of eternity. It was only when a new religion promised eternity to more than royalty, priests and nobles, an eternity to be achieved through spiritual rather than material effort, that the old style was abandoned and, inevitably, classical art rushed in to fill the vacuum. But in terms of the history of ancient art it is difficult to see it as other than something of an anticlimax.

5.34 Textile, Herakles and lion
(Düsseldorf)

5.35 Textile, Apollo and Daphne
(Paris, Louvre)

6 · The countries of the Black Sea

MANY OF THE PEOPLES bordering the Mediterranean were vigorous seafarers, though mainly shore-huggers; a fact which helped determine their own and their neighbours' fortunes. The Black Sea, however, presents a very different picture. The Greeks at first called it Inhospitable (*Axeinos*) and only placated it with the title Hospitable (*Euxeinos*, the Euxine) once they became accustomed to its waters. The inhabitants of its shores in our period seem seldom to have ventured far upon it and were mainly aware of each other by overland contact. On the west the Thracians are recognized first as a Balkan people, with more to link them with northern Greeks than with other peoples of the Black Sea. Around the north coast the Scythians, nomads from the east, either roamed still or had settled in the cornlands of Ukraine. To the east, south of the Caucasus, the Colchians had evolved a strong local culture which looked mainly to the south and east. Thus, Thracians and Colchians probably knew very little of each

MAP 6 THE BLACK SEA

other. And the rugged north coast of Anatolia sheltered outliers of the great empires of the Hittites, then of the Phrygians.

To the Greeks the Black Sea was a route for access to the wealth and resources of its people, along its coasts and up its rivers – the Danube, Dniestr, Bug and Dniepr, Don and Phasis. They were certainly aware of it by 700 BC and already planting colonies on the approaches, in the Propontis. They had devised stories of the voyage of the Argo, which took Jason to Colchis and brought him back to the Greek world, in some versions, via the Danube. (Greek views of geography in the early period bear little relationship to what we find in The Times Atlas.) The way into the Black Sea was difficult, against wind and currents through the Hellespont (Dardanelles) and Bosporos, but not impossible and it proved worth the effort once the rewards were recognized. In the last quarter of the seventh century the Greeks began to found colonies, generally near the mouths of the great rivers, and stray Greek goods passed far up them, hundreds of miles from the coast, but hardly in Greek hands. West, north and east the Greeks found customers, each of very different temper, for their manufactured goods, and the fortunes of Greek art and artists in the Black Sea are as varied and evocative as in any part of the ancient world.[1]

A Thrace

Thracian tribes occupied, roughly, the area between the Danube and the north coast of the Aegean, with the Black Sea on the east and vaguer frontiers with Illyrians and Macedonians to the west. They were a warlike, essentially non-urbanized people before the period of confrontation with Rome, ruled by various localized dynasties. In the Classical period the kings of the Odrysae were dominant. The early culture of Thrace was broadly linked to that of other areas of the upper Balkans and lacking in any notable luxury crafts although there is evidence for quite advanced metalworking, especially some very fine goldwork at the end of the Bronze Age. In south Thrace there was gold to be mined and the coastal and central plains were fertile. This relatively unsophisticated and rather greedy people was stubbornly independent. They found the Greeks colonizing the north coast of the Aegean, their southern border, from the late eighth century on, and observed their advance to one or two points on the Thracian Black Sea coast. The result was that in the Archaic period the Thracians became customers for some fine Greek imports, probably as gifts–cum–tribute, to keep their minds off Greek expansionist and gold-mining activities on their borders, but the finest goods seem to have been destined for their western neighbours before the fifth century, and the Greek objects in Thrace made no impression on native crafts. Such figurative art as can be recognized from the sixth century BC is executed in a manner broadly related to that of the Scythian Animal Style of which there will be more to say later, but it had already introduced a rather stiff, patterned treatment of animal and other motifs, and it is this which was to be affected by foreign forms.

The Persian king Darius bridged the Bosporos in 513 BC and invaded Thrace, apparently mainly intent on reaching the Scythians to the north, an aim which essentially failed. But Thrace was held by the Persians until they were dismissed from

the Greek mainland in 479 BC.[2] So the area was exposed to both Greek and Persian influence, each apparent to differing degrees in different areas. Thus, at Sindos, a site not far from Thessaloniki, we find the cemetery of a settlement which must have been more native, Thracian, than Greek. The burial customs are native, including the use of gold masks, but most of the grave goods are imported Greek pottery, with a little Persian metalwork, and a good quantity of gold jewellery which is distinctive, and perhaps unthinkable without some influence from the Greek side even if this is not easily defined. The earliest of the tombs thus furnished are Late Archaic.[3] This is the period of the most influential Persian import and influence in Thrace itself.

In the fifth and fourth centuries the picture becomes clearer, the finds richer. This is almost certainly due to the demands of the Thracians themselves, and the need felt by their Greek neighbours to satisfy them. The Persian influence introduced at the turn of the sixth and fifth centuries is less immediate but still detectable and revives towards the end of the period in terms of styles and, perhaps, practices. This is one of the few areas where there was an element of competition (though not conscious competition, I imagine) between Persian and Greek arts in the creation of new local styles.[4]

The Greek historian Thucydides, writing at the end of the fifth century, makes the point well: 'The tribute that was collected from the Greek cities and from all the barbarous nations in the reign of Seuthes [King of the Odrysae] . . . was valued at about four hundred talents of coined money, reckoning only gold and silver. Presents of gold and silver equal in value to the tribute, besides stuffs embroidered or plain and other articles, were also brought, not only to the king himself, but to the inferior chiefs and nobles of the Odrysae. For their custom was the opposite of that which prevailed in the Persian kingdom; they were more ready to receive than to give; and he who asked and was refused was not so much discredited as he who refused when he was asked. The same custom prevailed among the other Thracians in a less degree, but among the Odrysae, who were richer, more extensively; nothing could be done without presents.' (2, 97; trans. Jowett). The result archaeologically has been a series of most remarkable finds, dating mainly to the second half of the fourth century or little later but including many earlier objects. These are largely in north Thrace, just south of the Danube. The gold and silver which came as bullion was converted in some areas into coinage of Greek type or into plate, influenced by Greek and Persian imports and carrying a developed figure style which we shall have to analyze. The Persian metalwork, mainly Late Archaic in Greek terms, is probably of Anatolian origin; the Greek from various sources, some of it, even that decorated with gilt figures on the silver, manufactured on a Persian, some on an Attic weight standard.[5]

There have been several notable finds of hoards of plate, as well as individual discoveries, sometimes markedly different in terms of their display of dominant Greek or Greek/Persian derived styles in what we can recognize now as a distinctive local idiom. The most remarkable find of recent years has been at Rogozen in 1986: 165 silver vessels (31 of them gilt), weighing in all some twenty kilos.[6] It had been deposited some time in the later fourth century BC. There is fine Persian metalwork, and a number of Greek silver vessels of varying quality. I show the most striking, a gilt silver bowl with the scene of Herakles' drunken assault on the priestess Auge, rather mysteriously inscribed [6.1].[7]

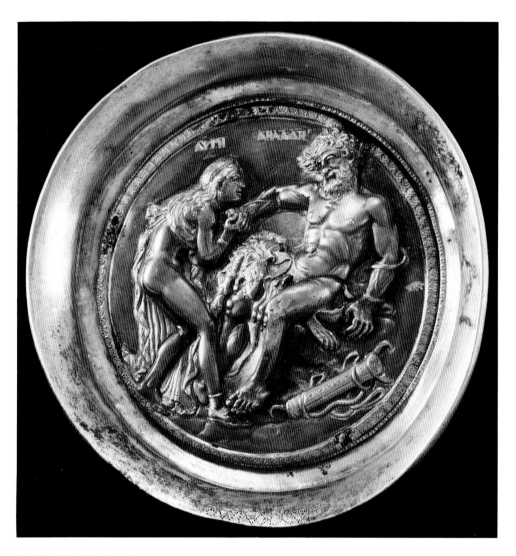

6.1 Gilt silver dish from Rogozen

Other vessels from Rogozen and several other sites are clearly of local manufacture and display a figure style which can be recognized also on other objects, notably pieces of armour. It owes something to the figurative animal styles of the sixth century, remarked already, but these had never been pressed into the service of narrative or of explicit religious iconography as was the new style, and it was for this purpose that Greek figures and groups were borrowed. They are often, however, disposed in repetitive compositions for which some Persian influence may be invoked. Thus, on the silver jug from Rogozen [6.2][8] there are repeated groups of a youth with a club, who looks a little like a Herakles, even to the dress hanging below his thigh which seems a remnant of the lionskin he would be wearing in Greek art. His opponent seems to be an Amazon, and the fighting group is essentially Greek. In fourth-century Greek art

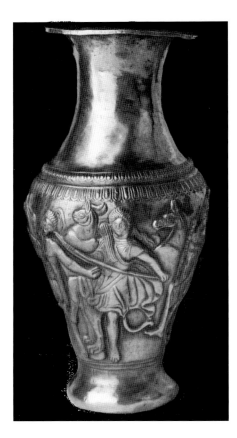

6.2a, b Gilt silver jug from Rogozen

6.3 Gilt silver plaque from Letnitsa (Lovech)

Amazons are commonly shown beside horse heads (they were skilful riders), and so we see a horse head here between the groups; but immediately beside the Amazons appears the forepart of a horned creature who seems also to be attacking the hero. The encounter may mean something in terms of local story, but elements of Greek art have been borrowed to attempt to express it. On another jug a goddess with a bow, riding a lion, is a local deity shown according to the Greek scheme for an Artemis.[9] From Letnitsa a group of gilt silver plaques of various shapes offers subjects of both eastern and Greek origin, as well as many local, heroic cavaliers in Thracian armour. I show [6.3] one with

a rather stiff goddess not quite riding a Greek sea monster (*ketos*), a very awkward version of a common Greek-theme: compare the Indian [*4.50*].[10] In all this we are dealing with Greek forms borrowed for new religious or narrative iconography by craftsmen to whom this whole genre was novel, and who made no attempt to copy or borrow any more taxing stylistic renderings. The overall style has been called North Thracian, or Low Danubian, and deserves respect for its individuality and integrity, whatever it may owe to Greeks or northerners.[11] Its expression on armour, especially helmets, owes little enough to Greece, though the greaves with human faces at the knee caps must owe the conceit at least to the Greek gorgon heads found in the same position.[12]

In the years around 300 BC, however, there are several objects and groups that are distinctly more Greek in style.[13] There may indeed have been deliberate manufacture of plate for Thracians by Greeks working in the Greek colonies on the Thracian Black Sea or Aegean coast, and these were by no means poor establishments, but it is not easy to recognize. The pieces in question look far more like the products of Thracian studios that had absorbed and to some degree comprehended contemporary Greek styles. Some

6.4a,b Gilt silver flask from Borovo (Rousse)

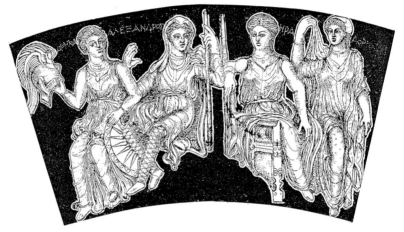

6.5a,b Gold rhyta from Panagurishte (Plovdiv)

shapes are shared with homeland Greek work, but they are often of Persian origin, and where there are sets of vessels which could have served rituals of drinking or libation which seem of eastern derivation, we may suspect a lingering or revived influence from Anatolia, whether Persians were still dominant there or not. Stylistically they must be ranged with the Low Danubian products just discussed, but the subject matter now seems totally Greek, including some rather obscure iconography and many Greek inscriptions.[14] The Rogozen bowl with Herakles and Auge [6.1] is a good example. Some of the finest examples are the sets of rhyta and head-vases, and the rhyton, phiale and amphora from Panagurishte,[15] but I show a flask of local form and function from Borovo [6.4]. A Dionysos-like figure with consort is attended by wholly Hellenistic satyrs, but also by two figures of what, to a Greek, might be taken for Erotes, but who might have acquired some other identity in this new northern environment. They are given, for instance, radiate heads. And in the frieze of dancing maenads above some

seem very overdressed while there is a quiet couple, man and woman, of unknown identity.[16] A closer look also (as at Panagurishte) reveals stylistic treatment which is removed from the mainstream of Greek art: the rendering of heads and especially eyes which gives figures a rather theatrical air, some odd figure proportions, the patterning of dress. I show a whole rhyton and a drawing of the decoration of another, with a Judgement of Paris inscribed in Greek [6.5a,b].[17] The vessels look Greek enough at first sight, and have been claimed by some as made in central Greece,[18] but their origins outside that mainstream are undeniable, and we must return to the questions just posed. Could a Thracian craftsman have learned and understood so much of Greek style to produce such plausible work, employed perhaps in studios once manned by Greeks but, with time, slipping into habits suggested by traditional crafts? If so, where could such studios have been? If they were in the colonies on the Thracian coast they abandoned Greek form and style more thoroughly than did their kin working for Scythians (as we shall see). This seems unlikely at any rate given the similarities to certain local products, locally inspired. Or is this all the work of immigrant provincial Greeks? Such questions probably do no more than demonstrate the futility of attempting to determine nationality of art and artists, but we have been asking them often in these chapters.

We may hope for more information about early Greek penetration of Thrace from new sites now being explored in the central area (Vetren), and these may be able to remove the discussion from preoccupation with luxury goods. Otherwise there are few

6.6 Gold ring from Golemata Mogila (Plovdiv)

6.7 Gilt silver plaque from Letnitsa (Lovech)

6.8 Gilt silver on iron pectoral from Vurbitsa

6.9 Silver plaque from Panagurishte (Sofia)

other relevant objects beside the vessel forms of Greek or Persian inspiration. Classical Greek gold finger rings are admitted and copied. A particularly fine import [6.6] was inscribed, in Greek, *Skythodokos*, 'host of the Scythian'. Later examples are locally made, and some are inscribed, in Thracian with Greek letters.[19] Anatolian or Greco-Persian animal styles made little impact, but there are examples from Letnitsa, notably the plaque with a lion, a griffin and two snakes fighting: the griffin has a Persian head, Greek mane [6.7].[20] The decorated Thracian armour has been mentioned; mainly helmets and greaves. But there are also deep crescent-shaped pectorals for use over corselets which avoid figure decoration of the style just described but come to admit purely Greek rinceaux [6.8] of a type we shall find popular also in Scythia at this date.[21]

The figure style persists, and the content perhaps begins to lose whatever purpose it might at first have claimed, so that whatever Greek may lie behind some of the images has survived at second hand or worse. The silver plaque on [6.9] is from a shield.[22] The figure at the top is only Heraklean for his club and action, dragging along a boar; the siren at the bottom, playing her lyre, has surely lost whatever narrative or funerary significance she may have had farther south; and the griffins between them partially

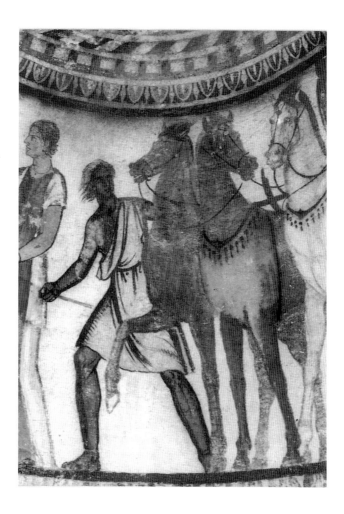

6.10 Painted tomb at Kazanlak

revert to the northern Animal Style. Yet this is from a tomb at Panagurishte where the hoard of gold vessels of about the same date (around 300 BC) was also found.

From the start of the third century the rich life of neighbouring Macedonia had its effect on the behaviour and artistic expectations of Thracian royalty and nobles. At Kazanlak there is a tomb whose main chamber has a corbelled roof painted in a colourful if rather crude manner with figures which seem to make very little concession to any peculiarities of local funeral practices or beliefs. There are chariot races, a Greek decorative frieze of bowls and bucrania, and the main scene offers figures approaching the dead prince and his consort seated at a table. The painter was probably a Greek, not too close to the height of his profession. All the trappings and furniture are purely Greek [6.10].[23]

The barrel-vaulted tombs of Macedonian type also appear, with a degree of Greek architectural ornament, though generally not disposed in the Macedonian manner with elaborate architectural façades. Greek or Macedonian masons might have been employed but the design was imposed by the patrons. A bizarre form of interior decoration appears within a tomb chamber at Sveshtari, where ten women (1.2 m tall, in

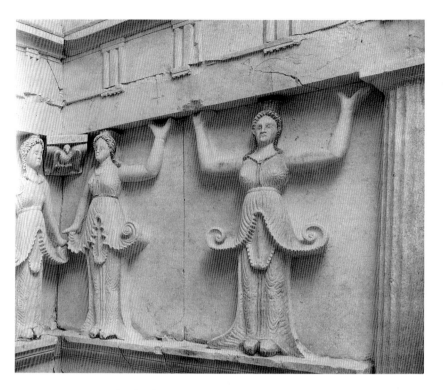

6.11 Tomb interior at Sveshtari

high relief) support a Doric entablature on their raised hands with the help of five Corinthian half-columns [6.11]. They may recall Greek caryatids, but probably owe as much to half-figures we shall meet later in this chapter [6.32,43] and are even echoed in second-century Etruscan tomb painting.[24] They are dressed as Greeks, in an archaizing style.[25] The Thracians no doubt identified them as goddesses of fertility or death-related functions, familiar also to Greeks – but to us they are nameless.

The Hellenistic period marks the beginning of Celtic movement from the west into the upper Balkans and ultimately into Anatolia. Thracian art remains tinged deeply by the Greek,[26] not least in the ubiquitous reliefs of the Thracian rider hero who appears as a Classical Greek cavalier. It would be wrong, however, to claim that Thracian art of this period is simply provincial Greek since there is so much of native and oriental inspiration still to be recognized in it. And it is soon to be Roman arms and taste that affect the life and arts of this important but troubled border province of the new empire.

B Scythia

When the Persian king Darius drove through Thrace in 513 BC he bridged the Danube so that his armies could get to grips with the Scythians whose main territories lay beyond. They were a people who, in their earlier history, had known the Persian homeland, and who, in their more recent history and new homes, had come to know the

Greeks. They were a nomad people, skilled horsemen; Darius got nowhere with them, and turned back.[27]

Scythian tribes at that time occupied the coastal regions and hinterland from north of the Danube, across the northern shores of the Black Sea, including the Crimea, round to the Caucasus in the east. The term Scythian embraces different and often opposed groups, ethnically related, but also the residue of the settled population, especially the agriculturalists of the Dniepr area. And there were other neighbouring tribes, notably the Tauri in the Crimea, described in a rather colourful way by Herodotus and not easily distinguishable archaeologically. They do not upset the broad picture of a unified native culture in the area just defined. (The area south of the Caucasus – Colchis – will receive separate treatment here.) The Scythians roamed the rich valleys and plains between the great rivers – Danube, Dniestr, Bug, Dniepr, Don – and most of southern Ukraine at least as far north as Kiev. This was natural terrain for them though their original home lay farther east. They are, for us, the first manifestation of that pulsing movement of nomad pastoralists from east to west across Asia that lies on the periphery of the history of Europe and the Mediterranean world, but that sometimes intruded devastatingly into it. The story ends only with Genghis Khan and Tamerlane.

Part of the earlier history of the Scythians is relevant to our subject. They struck south into north-west Persia, in the seventh century, before being thrust back, north and west through the Caucasus into the Kuban peninsula, to reoccupy areas abandoned by the related Cimmerians, who had been raiding Anatolia and ravaging Phrygia. Thereafter the Scythians spread across the north of the Black Sea to be in possession of the lands described above by the mid-sixth century.

In 'Scythia' not all the tribes continued to cling to a purely nomadic lifestyle. The Ukraine is good wheatland and once its potential as a source of grain was perceived by the Greeks, its inhabitants and their lords devoted themselves even more to an agrarian style and to enjoyment of at least the trappings of Mediterranean high life. But this was still not a land of high urbanization for centuries to come, and the characteristic archaeological sites are the clusters of tumulus burials at traditional centres rather than towns and temples, although there are a few fortified settlements. To the east lay the lands of the thoroughgoing nomads and the 'Royal Scythians', more warlike and generally richer, at least in their funeral furnishing, than their more settled kin. We shall find two main concentrations of sites: along the Dniepr, with the Greek city of Olbia at its mouth; and in east Crimea and the Kuban peninsula opposite where, on the coast, there were several Greek colonies, notably at Panticapaeum (Kerch). (This is on the so-called Cimmerian Bosporos, the approach to the Sea of Azov, to be distinguished from the Thracian Bosporos approach to the Black Sea at Byzantium/Istanbul).

Scythian art belongs to a nomadic *koine* that can be traced from China to the North Sea. Despite its inevitable diversity – inevitable given the area involved and the long span of time – its essential quality is little altered by time or place. It is known as the Animal Style (of which we have met elements already in Thrace). It is expressed mainly on small objects, such as nomads would favour, and especially on dress, weapons and horse harness. Materials are bronze, bone, wood and various textiles such as have been preserved for us only in the exceptional, frozen sites of Central Asia.[28] Its function tends then to be broadly decorative, yet the motifs chosen have an obvious relevance to nomad

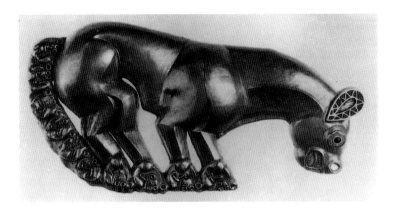

6.12 Gold blazon from Kelermes (St Petersburg)

life and probably to nomad religion, being derived almost wholly from the animal kingdom. Accurate depiction of anatomical forms was of lesser importance (indeed, generally of no importance) beside a desire to express movement and to create compositions which suited the objects to be decorated. There can be little doubt that these animal figures carried some potency for the hunters and warriors who wore them. They seem to have had their power enhanced by being multiplied in a manner which also admirably served their secondary function of filling a defined decorative field. This was achieved by the combination of figures, and typically by the rendering of animal parts (e.g., manes, hooves, antlers) by miniature figures of animals or animal heads. To this is added a natural fluidity of composition, twisting and stretched bodies and especially fighting groups of animals, giving an overall impression of a very close-knit pattern. Repetition of parts and bodies was not shunned but used to enhance the overall unity of design. The examples I show are a gold shield blazon [6.12] – notice the paws and tail rendered as tiny animal figures; and a bronze plaque with a curled feline [6.13], stretched, its shoulder stylized into the figure of a goat whose own horn ends in a bird's head and beak, which recur on the feline's rump.[29] It is difficult to imagine any figurative art less like the arts of Mesopotamia and Greece, with their clearly delineated forms rendered in a broadly realistic manner, and with their apparent intention to convey messages of majesty, divinity and humanoid narrative.

The Greek cities of the Black Sea were one of the meeting places of these two opposed art forms: the northern Animal Style that characterized most of northern Europe and Asia with its dominantly pastoral or nomad societies; and the urban cultures of the temperate zone, from the Mediterranean to India. South of them lay the totally conceptual arts of the Tropics, from central Africa to Polynesia. Each zone, each style, seems to have been virtually impermeable by its neighbour, but this is no place for speculation on the history of world art. Our enquiry into the penetration of Greek arts into nomad society, of the confrontation of Greek logic with the superb yet controlled licence of the Animal Style, takes its main interest from the attempts by artists and craftsmen to reconcile opposites. The results were rarely successful in achieving what can be recognized as a valid, hybrid style, and were often grotesque.

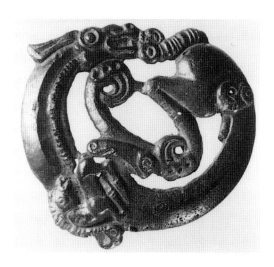

6.13 Bronze attachment from Crimea
(St Petersburg)

This simplistic picture needs modification, however, in two respects. First, it would
be unjust to suggest that Greek art was incapable of suiting subject to space, since this
was one of its strengths, whether the space was on a jewel or on a building. So there is
more to this phenomenon than principles of composition. Secondly, a measure of
confrontation between the zones had already taken place, during the Scythians'
seventh-century adventure in the near east. It was, indeed, in Persia that the Animal
Style of the eastern plains confronted the utterly different idiom of the arts of
Mesopotamia. The finds on sites which seem related to this period of occupation and
warfare in Persia (as at Ziwiye)[30] can juxtapose the arts of the near east (mainly Assyrian)
and the Animal Style. As a result elements of the more formal near eastern styles were
carried north. An example on a gold sheath which had been taken to lie eventually in a
Scythian grave far north of the Black Sea coast, offers purely Assyrian-type monsters
whose wings have been translated, in the Animal Style manner, into fish.[31] There are
other objects, especially swords, a battle axe and furniture fittings, which seem to be of
Mesopotamian or other eastern manufacture or inspiration.[32] But we shall find one of
these swords provided with a scabbard made by a Greek. We shall also find comparable
stylistic surgery executed by Greek artists for their new customers.

Before considering in detail the service of Greek art and artists to these northern
nomads we have to review and repeat some remarks about the first contacts between the
two peoples. The Black Sea had been known to Greeks in the days of Homer but not
explored. In the seventh century the approaches through the Bosporos and Propontis
were visited and some colonies placed. At the same time occasional Greek goods
travelled far into the lands of the Scythians, almost certainly not in Greek hands but
through gift or exchange, far up the Don and the Dniepr, almost to Kiev. These are
decorated vases from Ionia. Yet again, this penchant of the Greeks for figure-decorated
pottery seems to have provided them with a cheap but effective medium for engaging
the attention of foreigners, since the vases were not accompanied by other
manufactured goods that have survived. They were soon followed by colonists, mainly
from Ionia and especially from Miletus. These aimed first for the mouths of the great
rivers, at Istros and Tomis near the Danube, Tyras on the Dniestr, Berezan and Olbia

on the Dniepr/Bug, and in the east Crimea on the approaches to the Sea of Azov and the Don. Most were in place by soon after 600 BC.

It was with the mainly East Greek colonists that the Scythians had to deal but the developing corn trade was rather with the Greek mainland and when, in 480 BC, the Persian king bridged the Hellespont for his invasion of Greece, he watched the corn ships go by on their way to Aegina. As the Scythian nobles grew wealthier on such trade – and they were probably never by ancient standards at all an impoverished people – they came to know more of Greek city life. Herodotus (4, 78–80) has the story of a Scythian prince's house in Olbia 'set about with marble sphinxes and griffins'. But this philhellene, Skylas, was exiled and murdered by his compatriots for his excessive zeal in following the foreigner's ways.[33] There is, nevertheless, a considerable degree of archaeological evidence for a mixed culture that flourished in and around the Greek cities, at a somewhat lower level, and 'Mixellene' was a term that came to be applied to such a society.

During the fifth century the Greek cities of the Cimmerian Bosporos formed a league for commercial and defensive purposes. By the end of the century this fell under the control of what became the Spartocid dynasty, of hellenized Thracian kings, which lasted some two centuries. It was in this Bosporan Kingdom that most of the works to be discussed now were created, though it must be recalled that the Greek and Scythian sites on the Dniepr were outside this region, yet will be seen to share many of its products and styles. The degree of non-Greek control must account for the strong confrontation of styles, both in life and art, and there are many instances in which we cannot be sure whether we are dealing with Greeks copying the grander native manners of burial, or Scythians who had adopted a totally Greek way of life: a problem that scholars are understandably quicker to observe than to answer.

The objects that concern us most in this section are of precious metals, most being of silver with gilt detail or figures, but many also of gold. These show the greatest sophistication which can, in turn, reveal more about the origins and influence of style. There are other important media, but they are on the whole less informative, and will be mentioned briefly later. From the early sixth century on there is a rich series of finds from the Scythian tombs: fine works that demonstrate in detail what Greek artists could do to satisfy their new customers. They are the pride of the Hermitage Museum in St Petersburg and have been the subject of more than one travelling exhibition, but there have been many spectacular recent finds to enrich other museums (notably Kiev). The earlier finds were the product of Tsarist interest in the archaeology of the area at about the time that comparable western European interests were being engaged by the riches of Etruria. But in Italy the exploration was largely in the hands of individual collectors, in Russia it was at least loosely controlled by an Academy of Sciences, founded in 1725.

It may seem crude to attempt to categorize the main classes of these fine works, but it will help us to focus on some of our main concerns: the marriage (or misalliances) of styles, the reasons governing choice of form or subject, and the response, if any, of the customer to the new products with whatever effect he may have had on their production. We have then, very broadly, Greek goods of purely Greek type which might have appeared anywhere in the Greek world, but were purveyed to the Scythian (1). Then objects of Scythian form but decorated by Greeks (2). This is the major class,

and, contrary to what is often written, I think it can be shown that it is almost only on these Scythian forms that Greek artists practised their skills especially for the new market, and that they did not make objects of Greek forms (though some are shared) with decoration adjusted or designed for the market. Within this class there are a few objects on which the Greek and the Animal Style are combined or juxtaposed, many on which the subjects are purely Greek, several on which the subjects are of Scythian content though not style. Finally, there are objects of native type (generally decorative plaques for clothing) among which we find examples which seem Greek in both subject and execution, or Greek in subject but *not* execution, as well as the purely Scythian (3).

1 Imports which are purely Greek in type and style need not detain us. They range from Late Archaic bronze vessels and mirrors to the finest later Classical jewellery. There is no particular reason to believe that many of them were made in the Greek cities of the Black Sea rather than imported from the homeland. The range of types is no different from that used in the Greek colonies, and their distribution to native sites is mainly confined to those of the Bosporan Kingdom for the later period. Decorated Greek pottery was not especially popular though some is to be found in most sites, seldom of as high quality as that in the Greek cities, which are a major source for the best of Athenian fourth-century production. But an Athenian late-fifth-century Panathenaic prize vase was found in a tomb deep in the Kuban (Elizavetinskaya) where the finds in other tombs are largely native, but for a decorated Greek corselet.[34] And yet farther from the sea, from the burials at Uljap that yielded the fine Greek rhyton [*6.30*] come two more Panathenaic vases of the same date as well as Athenian black figure (earlier), red figure and black vases.[35]

2 The main category of products can be roughly subdivided by date and form, each recording slightly different responses by makers and customers to what Greek art could offer the Scythian nomad princes and farmers and their families.

 (*a*) At Kelermes, one of the easternmost sites in the Kuban, come gilt silver objects decorated by incision (strictly, tracing, since the metal surface is not cut) in a Late Archaic Greek style, more Ionian than anything, and mainly with Greek subjects. The mirror [*6.14*] has a gold sheet on its decorated back. The subjects include an orientalizing Mistress of Animals, with lions, various other monsters and animals, but with concession to local interest in two subjects in Greek style – a bear, and the scene of hairy men (Arimasps) who were thought to fight griffins for their gold in the frozen north; and one most significantly in Animal Style, the tiny crouching quadruped beneath the two rampant Greek sphinxes. Here the native style is merely juxtaposed to the Greek. The rhyton, the eastern shape barely yet adopted by Greeks at home, has a similar range of figures perhaps from the same hand, and more Greek subject matter in the centaur and a hero fighting a lion [*6.15*]. And from the same site is a gold diadem with a griffin protome, of Greek type. These are all sixth-century still, the earliest sophisticated products of a Greek studio for Scythian customers. The general style can be matched in Anatolia: see above [*2.10*], and Colchis [*6.45*]. We must assume that the Kelermes finds were manufactured in one of the Bosporan cities, since it is not easy (though not impossible) to imagine a Greek metalworker travelling to a Scythian site for

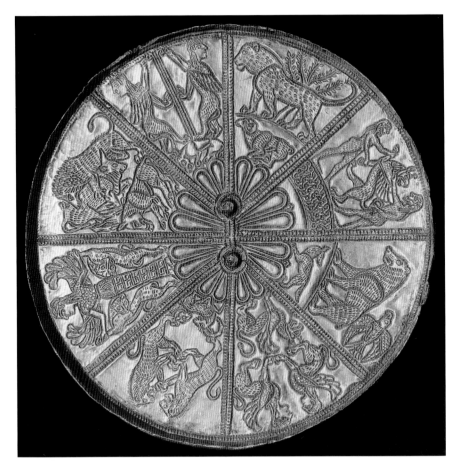

6.14 Electrum-plated silver mirror from Kelermes (St Petersburg)

6.15 Silver rhyton fragments from Kelermes (St Petersburg)

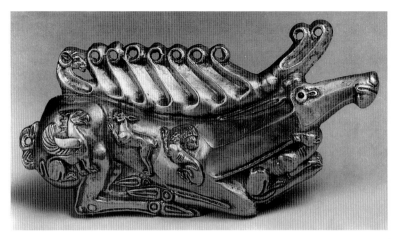

6.16 Gold blazon from Kul Oba (St Petersburg)

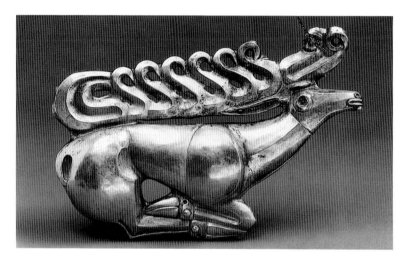

6.17 Gold blazon from Kostromskaya (St Petersburg)

6.18 Gold horse frontlet from Vettersfelde (Berlin)

6.19 Gold rhyton plaque from Seven Brothers (St Petersburg)

6.20 Gold quiver cover from Crimea (Kiev)

such a commission; nevertheless, we await more of this style from any site nearer to the Greek colonies.[36]

(*b*) The objects of the last group were domestic; the next are mainly related to armour and are more broadly distributed although not far inland, with one notable exception [*6.18*]. The style is expressed mainly in hammered relief, silver gilt, with boldly patterned forms of Greek Late (or Sub-) Archaic type. The subjects are all animal, and the date mainly late sixth-century to mid-fifth.

From Kul Oba, a Scythian cemetery near Panticapaeum on the Crimea, comes the stag [*6.16*]. It renders rather stiffly a favourite Scythian subject, as in the specimen from Kostromskaya (near Kelermes) in [*6.17*]. But contrast the stiff antlers of the Kul Oba creature, barely identifiable, the angularity of limbs and body. While the rear antler is stylized into a ram's head (not an uncommon Greek treatment of such a terminal) there is no further attempt to weld animal forms, and the body of the beast is simply patterned with a griffin, a hare and a lion, and with a dog beneath the neck, its head turned (to attack?). The workmanship is fine, inspiring in Greek terms, but a world away from the fluidity of the Scythian. It bears a Greek inscription – PAI. Both objects shown are over a foot long, attachments to shields (the Scythian one was found still in place).[37]

The same treatment was accorded the fish, probably a horse frontlet [*6.18*], with rams' heads at the tail but otherwise simply applied animal groups, an eagle and a merman with a shoal of fish. With this were found a breastplate of four roundels, and a scabbard, similarly decorated. These must own the same or a related source as the Kul Oba stag, but they form part of a hoard found far away, at Vettersfelde (Witaszkowo), some fifty miles south east of Berlin, from either a tomb or a collection of loot.[38]

In a somewhat more developed style is a series of plaques which may have decorated

6.21a,b Electrum cup from Kul Oba (St Petersburg)

wooden quivers or rhyta, from Kul Oba, and a quiver top from Ilyich'ovo (Crimea). These carry animal fights of varying complexity but one from Kul Oba has a beast compounded of the forepart of a Greek sea monster (*ketos*) a swan's head, and the stylized head of a bird of purely Scythian type [*6.19*].[39] Here a local motif has been grafted on to a Greek concoction. The other plaques – with a winged panther attacking a goat (there were two of these) and an eagle attacking a hare, are decorated too with Greek egg-and-dart; a fifth plaque is purely Scythian, but also with an animal fight.[40] The quiver top is more involved, with eagle and lion attacking a stag, a snake before them [*6.20*]. The stag's antler is stylized in the Scythian manner as a series of bird heads and its pose, tail and feet are similarly of local inspiration, but the rest is rendered as the Kul Oba plaques, and the stag's throat-hair is a Greek bead-and-reel.[41]

(*c*) A series of globular cups with flaring mouths have subjects rendered in styles that range from the late fifth into the fourth century, fully Classical. The shape is Scythian. Subsidiary decoration is of compass-drawn cable patterns of Greek style, egg-and-dart, and fluting such as was by then common on Greek and Persian metal vessels. The animal subjects have moved into the new style which we shall observe in groups (*e*) and (*f*) below, but what looks an early cup, from Solokha, has heraldic sphinxes over an old-fashioned pattern of overlapping rays. But there are also now scenes of the life of Scythian warriors. They are in no way concerned with ritual nor, it seems (but see below), myth, and can be readily explained only in terms of the Greek interest in these genre subjects, such as we have seen already affecting the choice of subjects within the Persian Empire, notably on gems. These are sympathetic ethnic studies by Greeks of the Scythian warriors in camp, in discussion (an example from Chastiye, far to the E-N-E of Kiev!) or preparing for battle and tending the sick – a wounded leg and a sore tooth,

6.22 Gilt silver flask from Kul Oba (St Petersburg)

6.23a,b Gilt silver cup from Gaimanova Mogila (Kiev)

from Kul Oba [6.21].[42] Others from Kul Oba have the familiar animal fights, and one has a row of geese, which seems a popular subject for this area; and there is one with simple fluting and a wavy floral, from the Gaimanova grave, as well as some perfectly plain. One with animal fights from Kul Oba [6.22] has elaborate rinceaux over the base, a pattern which will be considered later.[43]

Here then, for the first time, we have subject matter of Scythian content, invented by Greek artists for the delight of Scythian customers. What their reaction could have been to such an unexpected interest is hard to imagine; it must have been almost entirely dependent on their degree of acclimatization to Greek artistic practices in the genre, if indeed they were taken by it at all. The animal fights, albeit in a manner which had developed considerably beyond the orientalizing styles with which their ancestors had been familiar, would have been easier to accept, given the apparent significance accorded such subjects in their own art. But the stereotyping of the Greek lion and griffin fights belong to a quite different order of communication from that of the Animal

6.24 Gilt silver cup from Solokha (St Petersburg)

Style groups. They had also moved on far from the Archaic Greek groups, themselves of eastern origin. This is apparent not least in the more realistic rendering of the animals, and in the new Greek griffin, with its serpentine neck, spiny mane and greyhound body, a type created in Greece in the Late Archaic period. We have seen more of these in later years and far afield, as [*4.48, 5.13*].

(*d*) Two cups from tombs in the Dniepr area go together for their shape and style. They are roughly hemispherical, with pierced lug handles, and look like copies of a local wooden shape.[44] The style is finer by far than that of the best of the last group, more purely Greek in expression, command of pose and composition [*6.23*].[45] Pairs of Scythian warriors relax on either side; beneath the handles a young attendant toils over a skin full of wine (?), and an older one seems to mourn a spilt bucket. These subsidiary subjects are precisely what we might expect of a Classical Greek artist, a realistic, sympathetic and even humorous commentary on the councils of the seniors with their near-Olympian features. At the rim is a leaf-and-dart moulding, a feature borrowed from furniture and far less common than the egg-and-dart (which appears below the scene here) on metalwork.

The second cup, from Solokha [*6.24*],[46] has the cable and fluting of the cups of our last group, but there is an ivy tendril at the rim, another novelty for Greek work in this region. The main scene is of a Scythian hunt on horseback, the quarries being a lion on one side and a horned female feline on the other. There are hunting dogs, and a pair of lions below one handle. Both cups have rams' heads decorating the lug handles. There is

6.25 Gold bow case from Vergina (Thessaloniki)

6.26 Gold scabbard from Chertomlyk (St Petersburg)

6.27 Gold scabbard from Kul Oba (St Petersburg)

much here to call to mind the great painting of a hunt on the façade of Philip II's tomb at Vergina in Macedonia: the turned heads of the horses, the broken spear in the lion's mouth.[47] There is nothing finer or more Greek in spirit among the finds of Greek manufacture in Scythia than these two vessels.

(e) There are two distinctive items of Scythian weaponry: short-sword scabbards with a heart-shaped guard at the top (akinakes), and combined quiver-bowcases (gorytoi), both often depicted in scenes with Scythians, as [6.21, 23]. The scabbards are familar from an early date, and we have remarked one made by a Greek at Vettersfelde. Many are purely Scythian in decoration, one is Mesopotamian in style but admitting Scythian touches (the monsters' wings turned to fish, already mentioned), and one Persian.[48] Around the first half of the fourth century several scabbards and gorytoi were made by Greeks. The impressed decoration on the gold plaques that cover them was from matrices that could be used more than once, so duplicates of the Greek gorytoi are found. The subjects are animal, monsters and animal fights of the familiar type; fights between barbarians, or Greeks, or between Greeks and Persians; and a Greek mythological scene which is straightforward in all but its identity.[49] Four replicas of the gorytos with the last scene are known; and there was a replica of the one with a fight of Greeks found in Philip II's tomb at Vergina in Macedonia, presumably either a gift to the king or acquired as booty since he had campaigned against Scythia shortly before his death [6.25].[50]

The scabbard from Chertomlyk has the Greeks fighting Persians [6.26] and, ironically, was used for a sword of Persian design.[51] The fight recalls the frieze on the Athena Nike temple at Athens (late fifth century) in style and detail. The best of the animal fights is seen on one from the Tolstaya grave,[52] but the creatures on [6.27] from Kul Oba betray elements of the Animal Style in limbs and other details, though it bears an inscription in Greek (PORNACHO) and is bordered with bead-and-reel.[53]

The gorytoi are more complex and admit leaf-and-dart friezes, as on the Gaimanova cup [6.23], multiple guilloches and rinceaux with flowers. Other gorytoi are fragmentary but of comparable quality to the one I show [6.25].[54]

(f) In this and the following group I present vessels, then ornaments, in styles which do not go beyond what has already been shown except that some may be of slightly later date, into the third century BC. This is especially true of those with the more advanced rinceaux and some with inlaid stones (a Hellenistic fashion) or enamelled decoration. There are two dominant features: on the best work a finesse of detail and composition that matches the best jewellery from anywhere in the Greek world; and on the poorer work, the importance of the technique of impressing from matrices, which makes for repetitive forms and easy copying, a factor of even greater importance when we come to the dress plaques (3).

The prime example among the vessels is the great amphora from Chertomlyk [6.28].[55] The basic shape is Greek in this case – perhaps there was no suitable local model, or no model easily adaptable by a Greek metalsmith to serve the purpose. It has been provided with strainers and three spouts with plugs in the lower wall to serve the characteristic Scythian drink, kumys, fermented mare's milk. The shoulder is decorated with animal and monster fights of the familiar type, and below is a frieze showing Scythians with their horses, like the genre scenes on the metal cups.

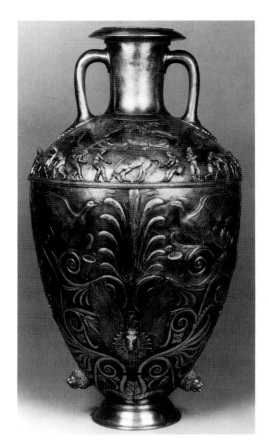
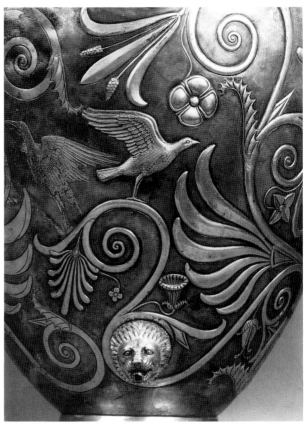

6.28a,b Gilt silver vase from Chertomlyk (St Petersburg)

The body of the vase is covered with a great arabesque of spirals and palmettes, with flowers and spiky acanthus-type leaves, and birds. It is a superb example of a decorative scheme familiar on many Greek metal vases and in other media, and one we have met in earlier chapters. The principal feature is a combination of various floral details with the spirals and palmettes, which go back to old oriental patterns, totally translated by Greek artists over more than two centuries. Closely related are the rinceaux friezes, some already remarked on other objects, which have similar and sometimes more elaborate floral additives, including spiral tendrils. On the Chertomlyk vase the older palmettes are still the dominant factor. This is a decorative style worth dwelling on for a moment. The flame-leaves to the palmettes were invented by Greek artists to enliven the rather stiff orientalizing florals in the later fifth century. At the same time the Corinthian capital, which introduced the acanthus leaf to the repertory of Greek floral patterns, was invented. Parts of the floral fantasies (other than the totally stylized palmettes) are real, but not in the combinations created. 'This is shamelessly unnatural history, but none the worse for that' (Robertson). The style is most familiar to us in various media in South Italy, and in northern Greece, from around the mid-fourth century on. It is a style most suited to luxury articles, which is why it appears on the extravagant red figure

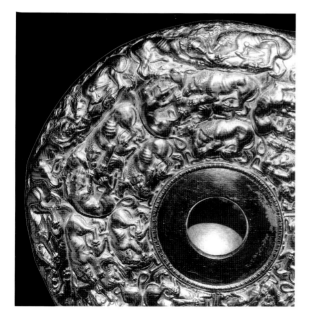

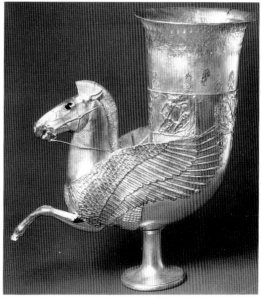

6.29 Gold phiale from Solokha
(St Petersburg)

6.30a,b Gilt silver rhyton from
Uljap

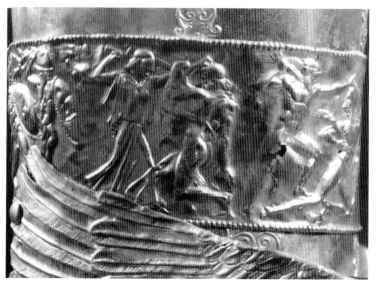

vases of the west but not on the simpler wares of Athens. That it has seemed
comparatively ignored in central Greece has occasioned speculation about direct South
Italian influence in north Greece and the Black Sea, but we are probably at the mercy of
survival of media. The north, including Scythia, is full of luxury goods, as was South
Italy. In Greece the record is poorer, yet there is enough to suggest that the style was not
only known there, but may have been invented there.[56]

Phialai are an eastern shape, adopted by Greek artists in the Archaic period,
especially for metalwork but remaining equally familiar, of course, to easterners,
especially throughout the Persian Empire. A gold phiale from Solokha [6.29] carries

animal fights of Classical type, but disposed in an interlocking manner over the whole surface, which is surely a concession to Scythian taste.[57] Another, from Kul Oba, has the usual lobed composition but incorporating whiskered heads that might be thought ethnically appropriate, of friend or foe.[58]

Horn-shaped cups which pour from a spout, rhyta, are in like case with the phialai, an eastern metal type much copied by Greeks. We have considered their role and record briefly already (pp.86–90). Of examples in Scythia which seem to have been made by Greeks most carry animal subjects (once, horsemen) and rinceaux, and are from the Kuban.[59] The finest example, however, is from Uljap, near Kelermes north of the Caucasus [6.30]. This is not designed as a rhyton-pourer, having no spout, but is perched rather precariously on a foot like that of a Greek cup. A fine Pegasus forepart supports a horn decorated with Greek palmette scrolls and a relief band showing a gigantomachy. It seems mid-fifth-century in style. The same burial mound contained Athenian Panathenaic amphorae.[60]

A less common shape which attracts Greek decoration is the shallow round-bottomed bowl, of which there is a bronze example decorated with a gilt plaque with the usual griffin fight;[61] and a silver example with a semicircular gold lug handle decorated with acanthoid rinceaux in the style just discussed.[62] A magnificent shallow bowl, silver gilt, from Chertomlyk [6.31], has a goddess' bust below its swing handles, set in an acanthus scroll, the finest fluting on the bowl, with a myrtle wreath at the rim and the centrepiece a splendid spiral and palmette interlace, recalling in miniature the Chertomlyk amphora.[63]

(g) Examples of ornament are mainly but not exclusively, for women's wear, but I start with a frontlet, probably for a horse, since its subject is interesting.[64] It is from Tsimbalka (Dniepr area) and shows a frontal woman, with snaky and floral lower extremities, ending in horned-lions', griffins' and snakes' heads [6.32]. The ornament is still Classical, the dress archaizing in a manner appropriate for an apparently divine figure and at any rate a style that persisted long in the east; I shall return to consider the subject below.

The gold cut-out cap (for a felt lining) from Ak-Burun (near Kerch) is unique, but the strangeness of its form is countered for us by the totally familiar spiral, acanthus and spiky flower composition that comprises its decoration [6.33].[65]

The jewellery includes some of both the best and the most banal of the metalwork considered in this chapter. Flat bracelets (Kul Oba) are decorated with fine animal fights in relief, and their simple cylindrical shapes are not especially diagnostic.[66] But a bracelet from the same site relies on repeated impressed groups of Greek mythological subjects – Peleus fighting Thetis, Eos carrying a paramour – with little wire rosettes.[67] And beside all these there are, it must be remembered, many examples of purely Greek jewellery types such as might have been found in any well-appointed Greek burial where such rich offerings were customary. Many of these were in forms which were as well familiar in the east: bracelets with animal-head or monster terminals, for example. We need to remember that most of this period is that of the Persian Empire when broadly Greco-Persian styles which were discussed in Chapter Two were current in the areas adjacent to the Black Sea. The Scythian sites have been rich sources for examples of these styles, metal vessels, jewellery and gems.

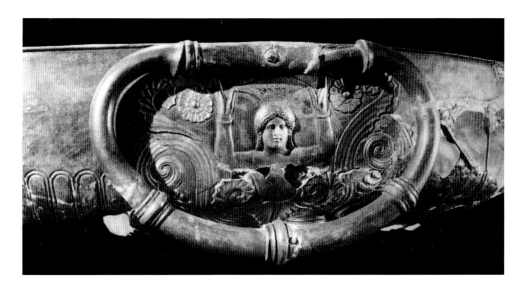

6.31a,b Gilt silver bowl from Chertomlyk (St Petersburg)

6.32 Gold horse frontlet from Bolshaya Tsimbalka (St Petersburg)

6.33 Gold helmet from Ak Burun (St Petersburg)

6.34 Gold headdress from Chertomlyk (St Petersburg)

Female head-dresses are composed of plaques and impressed strips of gold attached to cylindrical, tapering or splaying caps. The elements often include subjects of animal fights and rinceaux. I illustrate a possible reconstruction of one from a Dniepr site [6.34].[68] An example from Chertomlyk incorporates also one gold strip with Animal Style subjects beside others with the animal fights and rinceaux.[69]

The finest of the ornament presents the familiar subjects but rendered now in the round and with decorative detail made in filigree appliqué, not impressed. They are two pectorals and a comb. The pectorals are only remotely related to the military equipment of the Thracians [6.8].[70] The most elaborate example from Scythia is from the Tolstaya tomb (a man's grave, it seems) near the Dniepr, a find of 1971. The cut-out scheme is familiar, but here the Scythians with their sheep, goats and horses, and the great animal fights (the corners of the frieze are filled by dogs chasing hares and locusts!), are rendered in the round, while the rinceaux in the frieze between are worked in wire and carry individually made flowers with enamelled detail [6.35].[71] A similar though slightly less complex example, with one frieze of domestic animals only, was found in the Great Bliznitza tomb (Kuban).[72]

The comb [6.36] is from Solokha,[73] buried with a warrior, beside his Scythian-sheathed sword and Greek helmet. The handle is in effect a miniature statuary group, showing a local fight (the armour and equipment is mixed, native and Greek). The style is clearly that of the Scythians shown on the finer metal cups and in the pectorals. We are dealing, it seems, with a Greek studio that specialized in such subjects over a period of perhaps one generation or two in the fourth century, but we cannot easily locate it since the products are so widely dispersed – not surprisingly, given their quality.

3 Our final, rather mixed category, is of Scythian objects influenced by Greek art, and the clothing plaques, generally of rather indeterminate production but heavily

6.35a, b Gold pectoral from Tolstaya Mogila (Kiev)

6.36 Gold comb from Solokha (St Petersburg)

6.37 Bronze cauldron (St Petersburg)

6.38 Gold plaque from Alexandropol

hellenized. Of the first class there is very little indeed. A typically Scythian bronze cauldron [6.37] has relief decoration which, in the top frieze, copies the Greek motif of alternating phialai and bucrania, with an ordinary Greek palmette frieze below.[74] Then there are some cut out plaques with Greek animal and monster subjects done in such a garbled manner that the purist might wish to believe them not Greek by manufacture. The one I show is odd, but not unparalleled in Greece, in having a Greek sea-monster (*ketos*) with wings [6.38].[75] Finally, there are impressed plaques with figure scenes of possible local cult significance but acted by figures rendered in a broadly Greek style, which might also be local work in the Greek manner.[76]

The clothing plaques, fastened to dress and headgear, are the most prolific of the Scythian jewellery finds, to be counted in their thousands. Some are rectangular or circular, some follow the outline of their subjects like cut-outs. Subjects are usually single figures or heads. The mode of decoration no doubt began as felt or cloth cut-outs sewn onto cloth which became replaced by similar decoration in metal; these are attested from the fifth-century frozen tombs of the Altai.[77] The crop of gold plaques which we know from the Scythian tombs represents a new series. It is not easy to judge to what extent it may be related to the new artistic styles which Scythians were coming to accept from the Greeks. But the earliest of the assemblages of such plaques from our region include, beside the expected Animal Style subjects, many of purely Greek type and very probably Greek workmanship.[78] We may relate the phenomenon to nomad practices in decoration and dress, but it had a long history too in Mesopotamia. The Greeks of Anatolia had adopted the practice, perhaps from the east, by the seventh century, and at Ephesus there are gold plaques from the first half of the sixth century and later that recall some of the Greek motifs made in the north for the Scythians.

The record of the Greek types for these plaques (which seem a majority) is worth attention. I assemble some of the earlier examples in [6.39]. The very earliest are from tombs near the Greek colony on the Bosporos at Nymphaeum, and, barely later, from

6.39 Gold plaques from Seven Brothers and Nymphaeum (St Petersburg)

6.40 Gold plaques from Chertomlyk, Chmyrev, Solokha, Kul Oba (St Petersburg)

the Seven Brothers Tomb 2.[79] Most are purely Greek Late Archaic types [a,b] some of which admit Scythian elements – the tail of the lion [c], the whorls on the conjoined heads, human with leonine [d]. The last is an eastern conceit, little copied in Greek work, and that generally of an eastern flavour.[80] Finds in Seven Brothers Tombs 3 and 6 present several of these early subjects in a fuller, early Classical style [e,f].[81]

Most of the early plaques are cut-outs, following the shape of the subject. The type persists with the later Classical, but many of these are set in rectangles or circles, some with a Greek border of bead-and-reel or ovolo. More of the finds are now from the Dniepr area, rather than the Bosporos, notably from Chertomlyk and Solokha [6.40a,b],[82] but there are comparable and identical examples from Kul Oba.[83] Many are in a looser style, possibly not from Greek studios,[84] and the Greek griffin can now be persuaded to sit with folded legs, like any Animal Style creature.[85] Several are the finest Greek work, such as a superb frontal head of Herakles from Chmyrev (Dniepr) [c].[86] There is a greater range now also of generic scenes and figures, such as the Scythian-dressed Greek mistress-and-attendant group [d] (Chertomlyk and Kul Oba),[87] and Scythians drinking from a single horn [e] (Solokha),[88] or wrestling (Chmyrev)[89]. These are in rectangles but there are cut-outs such as the two archers [f] from Kul Oba,[90] a stocky elder,[91] and versions of a winged or snaky legged goddess such as we saw on the frontlet [6.32], including one holding a human head, further discussed below [6.43].[92]

Wholly Greek are the two fine dancers on a plaque from Kul Oba [6.41a][93] and these lead us to the latest of the Classical series which are also purely Greek in style and subject. They include single figures and groups of maenads [6.41b] and kalathiskos dancers (with basket head-dresses), goddesses riding animals, and a group from the Great Bliznitza with busts of Greek gods [6.42].[94]

The whole plaque series serves a Scythian dress style but can be seen to have been largely (certainly not exclusively) dominated in our area by Greek subjects and often served by matrices made by Greeks. That examples of work from the same matrix are found on different sites does not help us to localize production, but this is a subject that requires more study from autopsy of the finds. It is perhaps important that most of the early examples are from the eastern group of sites (Bosporos and Kuban).

This mighty crop of hellenizing art from Scythia comes to an end in the third century, when new nomads move into the area. The Greek cities of the Black Sea flourish still, but pursuit of our theme into later centuries must be summary. First, we should consider what this Greco-Scythian art tells us about the processes and motivation for the introduction of Greek styles to these mainly nomad people. Stylistically, we have seen, there was never any real marriage of idioms. It is rather as though the need to provide rich gifts or tribute to a people not interested in accumulating coined wealth or urban possessions, resulted in the imposition of Greek styles of workmanship on objects of great intrinsic value, which were then accepted by the Scythians, settled or nomad, as indicators of status or power. To a very limited degree this may have been accompanied by some adoption of a Greek way of life, but probably only in settlements near the Greek cities, and especially in the Bosporos area and near the end of our period. For earlier days, we must not overestimate the evidence of one story of a philhellene Scythian in

6.41 Gold plaques from Kul Oba and Deyev (St Petersburg)

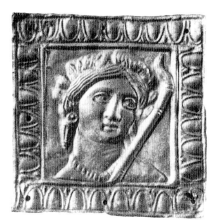
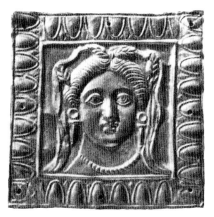

6.42 Gold plaques from Great Bliznitza (St Petersburg)

Herodotus; there was a lot of ill-feeling as well, and the majority of the Scythians could be as unfriendly to Greeks as any secure society approached by merchant-colonizing foreigners, at any period or place. Meanwhile, the question remains about the true character of the so-called Greco-Scythian burials, where the rites seem mixed and the grave furniture largely but not wholly Greek. This is a problem for the Bosporos area principally, but it ranges in date from the early tombs near Nymphaeum to the late, like the Great Bliznitza on the Kuban. The overwhelmingly hellenized appearance of the grave furniture in tombs which were surely for no Greek-born, is a remarkable testimonial to the grip that Greek style had on their owners.

There is nothing to suggest that Greek art gave the opportunity to local craftsmen to indulge in new forms and new methods of communicating symbols of power or cult. It seems not even to have provided an idiom for story-telling – surely a vital element in the culture of an illiterate people. It has been suggested[95] that the Scythian story recounted by Herodotus (4, 5–10), of their first king Targitaos, was conflated with the Greek story

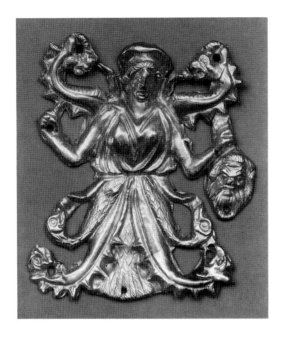

6.43 Gold plaque from Kul Oba (St Petersburg)

6.44 Gold headdress from NW Caucasus
(St Petersburg)

(also told by Herodotus) of Herakles in Scythia, consorting with a snake-legged woman (a story inspired by earlier apparition of the figure as on our [6.32] – see also below), and testing his sons by a contest of bow-stringing. The handing over of the bow on a cup and the bow-stringing on the Kul Oba cup [6.21] are then seen as illustrations of this. But these are Greek works and there is no hint of narrative, let alone of a scythized Herakles here, while the bow-stringing is a favourite Greek military genre subject, and on the Kul Oba cup is practised by no princeling but a grizzled warrior. Herakles is not especially popular as a subject in this area, or at least not as popular as we have found him elsewhere in the east.

I return briefly to the snake-legged goddess who haunts Greco-Scythian art.[96] She is frontal, wearing a crown, and we might imagine her to be an Archaic Greek Artemis type modelled on, for instance, the snake-legged gorgons that serve as handles to many a bronze volute crater, as [8.4], below.[97] A fine example is on the plaque [6.43], with her monster limbs and holding the severed head of a victim most closely resembling a Greek satyr![98] But her close ancestry in Greece depends largely on the goddess that springs from a floral (the *Rankenfrau*). Her fortunes in Scythia may indeed be affected by some local story or demon, in turn affecting Greek myth, but if so the circumstance seems unique.

We think we know a lot about Scythian life, but most comes through Greek eyes and texts. The Greek-style finds and Herodotus are given prominence, but the majority of

sites and tombs tell a different story, of a people immune to most Mediterranean ways of life and probably more likely to exploit than be exploited by the newcomers from the south. Their presence and custom, however, were the reason for the existence on the Black Sea shores of some of the very finest studios for metalwork and jewellery known in the Classical Greek world.

The story of this area cannot be left in the fourth century BC, and I have necessarily been cavalier in my treatment of the local history, especially that of the nomads.[99] Herodotus knew of other nomads, related but distinguishable, who lived to the east of the Don, around the Volga.[100] These were the Sauromatians (Sarmatians). From the late fifth century on the Scythians of the Pontic area were being infiltrated and pressed from the east. Eastern elements intrude and the Bosporan Kingdom was probably dealing with Sarmatians as much as Scythians. Theirs were the rich, great tombs of the fourth century, from Chertomlyk (where the king was Siberian by race to judge from his skull) even to Kul Oba. Their armoured cavalry may have helped Olbia ward off Alexander's general Zopyrion in 325 BC. In the second century the Sarmatian-Scythians built themselves a new, Greek-style capital city in the Crimea (Neapolis) and maintained the closest connections with the Greek world. The head-dress from Besleneevskaya Stanitsa (N-W Caucasus) may be of this date and shows Greeks still imposing Greek styles on local forms [6.44].[101] By the end of the second century the Bosporan Kingdom was absorbed by the kingdom of Pontus, across the Black Sea, and that, in turn, by Rome. The hellenized areas of the Asian steppes became a buffer state against the nomads. And they, for centuries to come, as Huns, Goths and Vandals, were to sweep past to threaten and to burn, even Rome itself.

C Colchis

The land the Greeks knew as Colchis lies to the east of the Black Sea, south of the Caucasus range. It deserves separate treatment here because its history and archaeology, and its experience of the Greeks, were markedly different from those of Scythians. There was something in common with the Thracians in this respect, although in no other. Throughout antiquity, and indeed to the present day, the land of Colchis, modern Georgia, has enjoyed a rugged independence of spirit though not often autonomy. This is largely due to its natural resources not only in farm land but also in the metal-rich foothills of the Caucasus. Lying across the bridge between Mesopotamia and the Russian steppes it was very much at a crossroads and must have felt the passing of Cimmerians and Scythians in our period. It also lay on an east-west route, from Central Asia via the southern Caspian to the Black Sea and beyond. We should probably consider its territory as extending outside modern Georgia, to the south west, along the present-day Turkish coast towards the area of the ancient Chalybes who were famous for their iron-working.

Homer knew of the riches of Colchis and the voyage of the Argo for the golden fleece, so from an early date the land had taken a place in Greek myth-history. Getting gold from streams by pegging out fleeces to catch the granules was an attested practice in the area (and no doubt elsewhere) and it would be perverse not to associate the story with

6.45 Silver aryballos from Vani (Tbilisi)

knowledge of the process, or at least of its effects. At this early date there may have been some passage of goods from the Caucasus area into Greece, but nothing surely in return.[102]

The main river was the Phasis, and at its mouth, according to late sources, the Milesians placed a colony. This has proved remarkably elusive, and the first indication of the arrival of Greek goods is some pottery of the second half of the sixth century on coastal sites and, over sixty miles from the sea, at the important site of Vani. With the fifth century there are cemeteries to be found near the sea (Pichvnari/Kobuleti) where Greek interest and practices are evident and from this time on there does seem to have a been a growing Greek population in the country, though not necessarily disposed in wholly Greek settlements and colonies (not, at least, until the fourth century) except probably at the town of Phasis on the coast. It seems rather a matter of fairly thorough infiltration of people and goods, and, with them, Greek styles and crafts; and, not least, use of the Greek alphabet.

The strong indigenous culture, dependent on the rich local resources, was more durable and well defined than that of the Scythians and of most other peoples met by Greeks on the Black Sea. It is expressed in fine metalwork, often elaborately decorated with animal and other motifs. These bear some comparison with Animal Style arts, but more with those of Persia (Luristan) and Mesopotamia, and at any rate are distinctive enough not to be regarded as to any serious extent derivative. The arrival of some Greek goods at the end of the Archaic period made no serious impact although the needs of trade soon encouraged the production of coinage based on Milesian mints. The imported objects are Athenian vases and metal vases from various places, probably mainly Ionia, including a little silver aryballos with incised figures [6.45] which reminds one of the silver products of Lydo-Ionian Anatolia [2.10].[103] This is from Vani, an inland site much excavated in recent years, rich in finds and architecture from Archaic to Hellenistic.[104]

6.46 Gold torque plaque from Vani (Tbilisi)

In the fifth century the Persian Empire had a more direct effect on Colchis than on other parts of the Black Sea littoral. It is not altogether clear whether Colchis was part of a formal satrapy, though the area to the east and south (Iberia) probably was,[105] and elements of Persian Court art are unmistakable at various sites, including even architectural features (bull-protome capitals)[106] which suggest a more substantial presence. Gold was readily available and had long been worked. Fifth-century gold, worked into local forms, is found to be decorated with versions of that sub-Archaic Greco-Persian style, mainly with animal subjects, that we observed both in Anatolia and, in early days, in Scythia. Greeks had certainly settled in numbers in various parts of Colchis, possibly by now in properly established colonies. A Greek relief gravestone was found in the sea off Dioskourias,[107] and the Greek habit of placing a coin in the mouth of a body (Charon's fee) caught on in several cemeteries. Although relations with the Greek cities of Ionia was clearly strong it is likely that much Greek influence and immigration came from the south coast of the Black Sea, notably the Greek colony at Sinope whose coins and wine jars are well represented in excavations. Sinope gave access to the heart of Anatolia, no less Persianized than the western coast and Ionia.

Prime examples of the style are animal groups worked on the diamond-shaped plaques attached to diadems or torques [6.46]. It is hard to say whether these should be taken as evidence for Greek production for Colchians, in the same spirit as the Greek production for Scythians, but there are other finds which make this seem very likely. The torque plaque illustrated looks as though it must have been composed and executed by an Anatolian Greek, but others are imitative or simply patterned in a non-Greek manner.[108] The torques are from rich tombs at Vani of the fifth century. Beside them are the silver aryballos [6.45] and other Greek imports, but also jewellery of local or orientalizing types – radiate pendants, Persian-type bracelets. Little bowls with lids and swing handles seem a local type and one in bronze has native animal decoration on its lid,[109] while two others of silver have delicate handle-attachments of animals of

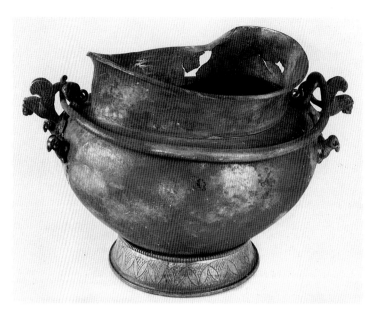

6.47 Silver bowl from Vani (Tbilisi)

Anatolian Greek style [6.47].[110] More remarkable are gold earring or head-dress pendants with pairs of gold horsemen on wheeled platforms with acorn pendants.[111] These seem to anticipate some of the more extravagant figure-group pendants in Greek jewellery of the fourth century, but must be of eastern inspiration.

Several all-metal finger rings found in Colchis are purely Greek in type and decoration, though fairly simple in form and all sub-Archaic.[112] These seem imports from Ionia, but a fine silver example in which the intaglio is outlined in gold wire is so unusual in this respect that we might suspect local production, but by a Greek [6.48].[113] As time passes the Greek ring types still appear but obviously from local studios in poorer styles. One has a seated lady with a bowl [6.49] recalling the common Greco-Persian type and with the name DEDATOS in Greek letters.[114] It looks as though the local metalworkers took what they wished from observation of Greek types without wholly surrendering their traditions. Some fine metal vases with cast attachments may be locally made since the basic forms do not seem Greek, but there are purely Greek imports too, accompanied more and more by other Greek goods, best attested by the many finds of Greek wine amphorae. Down to the Hellenistic period at least it would seem fair to say that Colchis was receptive of Greek goods and to a minor degree of the Greek way of life, but to nowhere near the same extent as the urbanized natives of the more northerly shores of the Black Sea and the hinterland.

With the Hellenistic period Greek influence and probably presence grow apace. Vani has stone buildings of some architectural pretension from the fourth century on, and later graces itself with fortifications of broadly Hellenistic type. The buildings are not Greek in plan or, probably, function (most are thought to have been temples). But there are Greek architectural forms – not as pure as those we might expect in a Greek town but of some sophistication: Corinthian colonnades [6.50] with busts in the capitals,[115] animal-head water-spouts,[116] some quite elaborate mouldings. At a lower level there is a

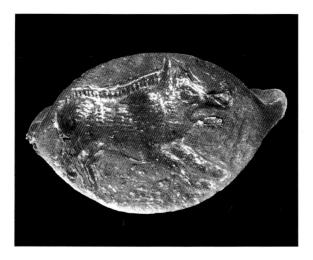

6.48 Silver ring from Vani (Vani)

6.49 Gold ring impression from Vani (Tbilisi)

lively production of clay figurines derived from the Greek and plain pottery of Greek shape; and at a higher, some impressive bronze statuary which seems to have been made on the spot to judge from casting debris. A recent find is the torso of a classicizing bronze youth, latest Hellenistic in date and style [6.51].[117] Imports are of high quality too including pieces of a bronze relief vase with scrolls, putti, some fine high-relief heads of satyrs and maenads and figures in the round (if they indeed belong to the vessel).[118] In precious metal there is a silver bust medallion from a bowl, a common feature of Hellenistic jewellery which was very popular in the east, and silver figurines of youths.[119]

East of Colchis, in Iberia, Persian influence was stronger throughout the Classical and Hellenistic periods, but there is one bizarre architectural feature which derives

6.50 Corinthian capital at Vani

6.51 Bronze statue from Vani (Tbilisi)

from the Greek world – a version of Doric capitals decorated in relief with the broad waterlily (Lotus) leaves we find on fourth-century and later Greek metalwork [6.52].[120]

In the second century Colchis had become a pawn in the power struggles of Hellenistic kingdoms based in Anatolia, soon to be clients of Rome, and there is no call to look for particularities of hellenizing in the arts of a region which had become culturally almost indistinguishable from many others on the periphery of the Mediterranean world.

The different responses to Greek art and artists in the three main areas around the Black Sea that we have surveyed are worth summarizing. In Thrace and Colchis there were relatively settled populations with strong local traditions. But in Thrace a need was perceived for a figure style that could express story and, more importantly, religion and

6.52 Stone capital from Sairkhe

status, and the result was a distinctive local style which owed far more to Greek art than to the Persian, which was also well received but which did not offer in its figurative art the opportunities for narrative and characterization of deities. The style is accompanied by acceptance of Greek myth scenes and immigrant Greek masons and painters. In Colchis the hellenizing of the arts is more superficial and no new figure style developed. The difference in response may be largely due to the relative proximity in Thrace of Greek colonies and homeland, while the situation in Colchis seemed to depend less initially on a strong Greek presence. Purely Greek work directed to the Thracians, by way of gift, tribute or commerce, seemed to make no particular concessions to local taste, no doubt because this was satisfied by the hellenized local schools; in Colchis such Greek work as there is in the Archaic and Classical periods is expressed wholly on forms already familiar in Colchis, or at least non-Greek.

In the lands of the Scythians the diffusion of Greek art depended mainly on production in the colonies of objects of Scythian form and function, executed in a purely Greek style that made no notable, or successful, concessions to the native Animal Style. Only as local society became more urbanized in the fourth century did the Greek way of life begin to dominate the behaviour and tastes of the population, and by then the familiar mixing of Greek and native that characterizes many of the areas studied in this book makes the definition of what is Greek a difficult if not redundant exercise.

With the Hellenistic period all areas succumb to the pervasive styles of the Mediterranean world and Greek traditions are established in local studios, generally to the exclusion of the native, until they are revived by immigrant peoples from the old eastern homelands. Greek art and life had, as it were, won over the arts and life of totally alien populations. It was a situation that a Greek geographer, Strabo, born near the south coast of the Black Sea in the first century BC, could reflect upon with some melancholy: 'for we regard the Scythians as the most straightforward of men and the least prone to mischief, as also far more frugal and independent of others than we are. And yet our mode of life has spread its change for the worse to almost all peoples, introducing amongst them luxury and sensual pleasures and, to satisfy these vices, base artifices that lead to innumerable acts of greed. So then, much wickedness of this sort has fallen on the barbarian peoples also, on the nomads as well as the rest.' (Strabo 301; trans. N.L. Jones).

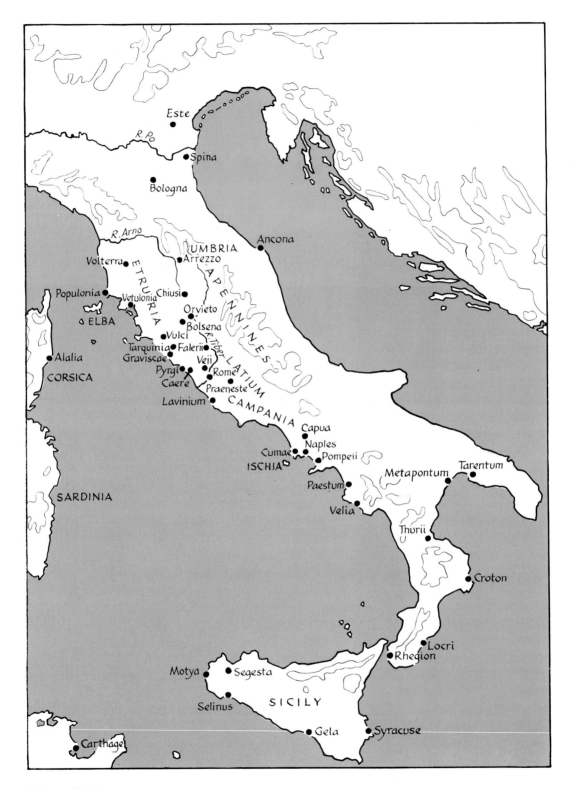

MAP 7 ITALY

7 · Italy

GREECE'S EARLIEST AND MOST successful colonizing area was South Italy and Sicily. There, in the eighth century BC, her newly formed Geometric culture confronted native populations whose own cultures were, in terms of their crafts, hardly less sophisticated than the Greek. The Greeks – individual cities, of course: this was no national effort – sought land and materials, especially metal, and they did not have the numbers at first to pursue these aims belligerently.[1] We should not over-estimate the scale of the operation in its early years, nor should we forget that Phoenicians too were pursuing similar aims in the same waters; I have touched on these matters in Chapter Three. However, the Greek colonies grew rapidly in numbers and wealth, their arts developed briskly and in pace with developments in the homeland, and relationships with their neighbours changed accordingly. In most areas the impact of Greek art became more a matter of the exchange or gift of admired but unfamiliar artefacts. These had some effect on local crafts, and there was also minimal reciprocal influence. This chapter will not dwell on Greek art and its effects on the native peoples of Sicily and South Italy, the Apulians, Daunians, Sikels and the rest; not because there is no subject here but because it is relatively uninformative about our main concern. This is far more effectively pursued through consideration of the record of Greek influence on their northern neighbours in Italy: first, the Etruscans, whose reaction to Greek art is perhaps the most striking of all recounted in this book; then the Romans, into whose hands the Greek classical tradition in art was to be entrusted. In early years the record in Etruria and in Rome is virtually the same and they can be considered together, and in some areas matter proper to the Roman section (B) is treated with the Etruscan. For later years the records are profoundly different.

A Etruria

Etruscan art holds a great appeal for the twentieth century. It affords a degree of relief from the apparent austerity of classical Greece. Its colour, life and assumed passion, together with the mystery which generally accompanies discussion of the origins and language of the Etruscans, make it more glamorous, more artistic, even Artistic. To say that Etruscan art is 'a showy blend of Greek, oriental and barbarian taste which can still inspire or impress those who cannot come to terms with the more controlled achievements of Greek art' invites condemnation, as of a Michelangelo who despised the Gothic.[2] Its eventual dependence on Greek art is clear and it becomes the one

foreign art most completely formed by Greek example. But it did not begin as a response to Greek art, and its later distinctive development perhaps owes more to other influences as well as native wit than has been generally acknowledged. To the art historian and archaeologist it provides a fascinating test case of the effects of immigration, proximity of diverse cultures, needs and responses. We do well to withhold instinctive and highly subjective judgements, at least until the manner in which it was created and developed has been explored.[3]

The heartland of Etruria lies between the Rivers Arno and Tiber, from west of the Apennines to the sea, north of Rome. In its most flourishing period, the sixth century BC, its influence spread east and north, to the Adriatic, and, until the rise of Rome, over the Latins to the south and into Campania, where there were Greeks. Etruria was never truly a nation; more a league of states which could on occasion act together. The hills and valleys of Tuscany were divided into well defined territories centred on strong, fortified towns, somewhat like the city states of Greece, and not necessarily more cooperative. But destruction of neighbours seemed not as regular an occurrence. The land was fertile enough; in the north (and on offshore Elba) there were important sources of iron, and there were mines for copper, silver and lead. Several of the major cities were on the coast and as seafarers the Etruscans acquired a reputation in antiquity as pirates, and even enjoyed, in the view of ancient historians, a period of command of the seas – thalassocracy.

Origins are obscure – the Greeks thought the Etruscans came from Anatolia, a view shared by a few modern scholars.[4] In Italy they form an archaeologically distinct unit from the early Iron Age on. We have evidence for their language after the early seventh century, when they learned how to write from the Greeks. Most of the surviving inscriptions (some ten thousand) are merely names with very few lengthy texts, but they are both decipherable and for the most part intelligible and not at all mysterious.[5]

At the end of the Bronze Age, when the Mediterranean was busy east and west, North Italy played its part in the exchanges of goods if not also of ideas. With the collapse of the Mediterranean Bronze Age societies North Italy turned more to Europe for cultural nourishment. The artefacts of Etruria in these years (the culture has for long been called Villanovan but might as well be 'proto-Etruscan') include a good range of metal goods and fairly plain, unpainted pottery. The range of decoration is undistinguished, broadly geometric with minimal animal elements, mainly bird heads and the like. Decoration was important but unsophisticated and unambitious. In the eighth century BC the city states had begun to take shape and assume some individuality, apparent in their products, but there was still little to show for any awareness of the outside world, except to the north. In the following century easterners began to appear on and off the shores of Etruria: the arts of Etruria and the visual experience of the Etruscans were utterly transformed.[6]

At this point we must recall events discussed in earlier chapters. In the eighth century BC both Greeks and Phoenicians were beginning to explore the west. To what extent the effects of much earlier contacts were still no more than dormant, awaiting renewal, is hard to judge. It is likely that some sort of traffic continued but without perceptible effect. Folk memory without written records is not much use to a navigator, and there is reason enough to believe that both Greeks and Phoenicians had grounds for

undertaking fresh exploration in these years. The motive was generally the search for materials or for land. The Etruscans had materials to offer, not land, and may already have acquired some reputation as xenophobes. There was no question of planting colonies on *their* coastline. But the routes to Etruria passed by rich and available land in Sicily and South Italy which was in the following hundred years to be occupied by Greek colonies. That the first settlements were on the Etruscans' doorstep suggests that their presence was a considerable if not decisive attraction.

There is little to show for either Greeks or Phoenicians in the west until the first half of the eighth century. By around 770 BC stray finds of Greek pottery are frequent and well enough distributed to suggest that exploration had begun. An ideal point for trade with a foreign power is just off the borders of its territory, an otherwise uninhabited piece of coast (which is what the Phoenicians chose in the west), or a nearby island. The crucial approach to Etruria was made by the Greeks on the island of Ischia, off the Bay of Naples, in easy reach of the Etruscan ports but well to the south of them. It had been visited by Mycenaean Greeks; its current residents were not Etruscans but must have had close relations with the Etruscan cities either directly or via sites in the Naples area (Campania). The Phoenicians possibly had opened relations even earlier, via Sardinia, but there are Euboean Geometric finds there too, carried by Greeks or Phoenicians, and one of the Late Geometric vases is duplicated by a recent find at Caere in Etruria.[7]

So by the mid-eighth century the Etruscans found that they had Greek neighbours – from Euboea, which had been the prime state exploring in the east also. The newcomers became customers for metals;[8] iron ore from Elba has been identified in Greek contexts at the main town of Ischia, which the Greeks called Pithekoussai. At the same time, along the coasts of Italy, on Sardinia and in Ischia itself, there are indications of eastern, non-Greek (conventionally 'Phoenician') presence; not dominant occupation, but goods and influence at sites either not yet visited by Greeks, or too little visited (to judge from finds) for it to be right to think that Greeks were the carriers of all things eastern. The Euboeans would have been in a good position to do this, and must in fact have been responsible for some of the orientalia that went west, just as the Phoenicians may have been for some of the Greek objects, though hardly in Italy. The role of Phoenicians in Sardinia is still difficult to judge and the date and significance of early Phoenician inscriptions there are still disputed. The metal sources of North Etruria were perhaps slightly more accessible to them, but not to the degree that we would take Ischia to be a second choice for any visitor from the east. At any rate, it was always South Etruria that had the wealth and power, at least well into the Classical period.

Not the least of the problems of Etruscan art in the following century and a half is to determine whether its orientalizing aspects, which are dominant, are Phoenician- or Greek-inspired. The problem can be demonstrated by anticipating a later part of the chapter. There is a class of eastern seal, the 'Lyre-Player Group', that is not Phoenician but of North Syrian origin, well distributed in the Greek world and plentiful on Ischia. It dates mainly to the years 740–720 BC. The examples on Ischia might have been brought by Greeks, but there is enough else of eastern origin in Ischia too for this not to be a necessary assumption. On the other hand, North Syrians were not sea-goers, and if Phoenicians were carrying the seals it is odd that not one example has yet been found in any other of the western areas known to have been visited by Phoenicians (Sardinia,

west Sicily, Spain and North Africa), while they are well distributed in all areas known to have been visited by Greeks as well as in Greece itself.[9]

In the next pages we review the orientalizing period in Etruria down to about 600 BC in terms of sources and effects of change. It will be seen that the Greek influence is strong in the archaeological record, but that since it affects mainly the poorer though prolific artefacts – such as pottery, it might easily be exaggerated; that oriental influence of whatever source is dominant in the production of more valuable goods; and that neither Greek nor oriental were simply copied but that the local contribution amounted to a profound translation of the sources into an idiom or range of styles that suited Etruscan needs or taste, but were not determined by any notable native tradition in the arts.

In the second half of the eighth century there are finds of Greek Euboean pottery in many Etruscan towns. Most must have come via Ischia and much seems to have been made on the island in styles like those of the homeland, though by the end of the century a Euboean colony had also been planted at Cumae, on the mainland opposite. The style is normal Greek Late Geometric, including modest figure work, mainly of animals, and clearly distinguishable from Attic, but there are also some strongly Corinthianizing products with Corinthian shapes and with the distinctive fine decoration of close-set parallel lines over the body. The Euboean settlement on Ischia fades at the end of the eighth century and imports from Greece cease. But from the mid-eighth century on through the sixth century there was also a strong flow of real Corinthian pottery into Etruria. This is largely because the Corinthians must have been actively trading in the west even though their colonizing activity was confined to more southerly areas, notably Syracuse in Sicily, founded by about 730 BC. And although the Euboean presence faded it was the Euboean and not any other Greek (or Phoenician) version of the alphabet that was borrowed and adapted for the first Etruscan writing, in the first half of the seventh century.[10]

This personal knowledge of Etruria explains how it was that a Corinthian, Demaratos, left home for political reasons in the mid-seventh century and came to the Etruscan city of Tarquinia, with wealth and an entourage. There he became ruler and married a noblewoman. The story that one of his sons by her went to Rome, became known as Lucius Tarquinius Priscus, and king of Rome, need not be true, but Demaratos' arrival and acceptance indicates how readily a Greek family could be admitted, though there was also a tradition that his son was despised by the Etruscans for being the son of an alien refugee. For our present concern it is of at least as great importance that Demaratos was said to have brought with him a painter Kleophantos, and clay sculptors, Eucheir, Diopos and Eugrammos, who introduced their craft to Etruria.[11] The combination of Euboean neighbours and Corinthian immigrants indicates that the effects we observe on Etruscan products was more than a matter of imitation of imports or gifts, but allowed of personal participation, by Greeks. In Demaratos' time we also find Etrusco-Greek names (Larth Telikles, Rutile Hipukrates [= Hippokrates]) inscribed on vases at Tarquinia, probably as owners.[12] These are likely to be 'naturalized' Greeks.

The effect of this access to Greek pottery and Greek craftsmen is mainly observed on pottery. Most of the earlier pottery is dubbed Italo-Geometric (since its like is found in

7.1a,b Vase from Caere (Cerveteri)

7.2 Vase from Vulci (Vulci)

7.3 Vase from Narce (Philadelphia)

native areas farther south too), and the later Etrusco-Corinthian, but in early years the influence is mainly Euboean (the Euboeans being also carriers and imitators of Corinthian styles, as we have already observed). The result is a range of Geometric pottery in Etruria, running into the seventh century, carrying Greek Geometric patterns. The simplest are found incised on native shapes in the plain *impasto* ware. The painted pottery is more informative and some pieces are so close to native Euboean that the the presence of painters not merely from Ischia but from Greece has been suspected.[13] On one example shown here [7.1] the style is purely Euboean, notably the angular-winged birds, upside down in the lower frieze.[14] The Euboeans had been making pottery in Ischia, at Cumae, and maybe even in Etruria, probably from the mid-eighth century on.[15] The shapes decorated in Etruria are either Greek or native, such as the biconical urn from Vulci [7.2].[16] On this we see Euboean Geometric patterns, with the close-set lines of Corinthian vases covering the lower body of the vessel. The Geometric patterns are accurately rendered and disposed in roughly the same way as on Greek vases. Of the figure subjects, the long-tailed Euboean Geometric birds acquire a sweep and flourish which must owe something to the native styles in metalwork. In [7.3][17] they are seen painted on a stand whose shape is probably of eastern inspiration, but here the vessel is made in the plain dark *impasto* of local type and the figures perforce painted in white, rather than in the Greek manner on a pale clay ground.

There are other wares wholly influenced by Corinthian from this time on, and Etrusco-Corinthian is the common term for this production down into the sixth century. On these it is Greek orientalizing patterns that first appear, copying the home Protocorinthian products, though often with bigger, bolder compositions than the Greek miniaturist styles, which is probably another western trait taken up by Etruria [7.4].[18]

Although Corinthian pottery is dominant, other Greek vase-painting styles are copied and their sources require some explanation. The biconical urn from Caere/ Cerveteri [7.5][19] has outline-drawn, large, stippled figures of a type not found in Corinth. The style resembles that of other areas of Greece, Athens, Argos and the islands. A source of inspiration may be indicated by another vase from the same site which is of probable Western Greek manufacture, perhaps at Cumae. It is signed by a Greek, Aristonothos ('noble bastard'), and carries the first substantial Greek mythological subject introduced to Etruscan eyes, the blinding of Polyphemos by Odysseus and his companions, a story best known to us from the *Odyssey*. But the other side of the vase has what is perhaps deliberately a more topical subject, an encounter between a Greek warship and an armed merchantman (eastern?) – early 'trade' [7.6].[20]

These figure scenes are, however, not the dominant feature of the hellenizing pottery of seventh-century Etruria, although they are strongly indicative of a form of intellectual contact with the Greeks. For the most part it is the animal frieze decoration of Corinth that is the source of inspiration, an orientalizing scheme but in its Greek not oriental form, with rows of mixed animals and monsters. In Etruria, though, they are often rendered in techniques uncommon in Corinth: for example, the incising of figures on a black ground is a version of the Greek black figure technique not much practised at home, but in Etruria it more closely resembles figure work on the dark-ground *impasto* vases. The *impasto* also attract orientalizing figure scenes rendered in white paint, the

7.4 Vase from Cumae (Rome)

7.5 Vase from Caere (Cerveteri)

reverse of Greek orientalizing.[21] There is also developing in Etruria a new native, black pottery to succeed the *impasto – bucchero –* with impressed, incised or relief decoration.[22] This too may admit Greek animal friezes and figures. The animals themselves are often treated in a novel manner. Proportions are distorted and patterning admitted that does not even roughly follow the natural anatomy forms and patterns that are observed on the Greek vases and their eastern models. A degree of abstraction of the animal forms renders them more decorative than the Greek, and a fondness for the wilder monster subjects, often giving a predator a human limb hanging from its chops, lends the Etruscan animal friezes a life and colour lacking even on the most highly coloured but essentially sober and predictable Greek products. Here we are experiencing the native contribution that makes the vases Etruscan and not simply imitative or provincial Greek, and traits which will be met again.

This role of Greek models for pottery decoration in seventh-century Etruria is impressive. It seems even that painter signatures are to be recognized on some of the Etruscan pots, painted or plain *bucchero*, following a Greek practice.[23] It represents acceptance of Greek forms, lightly translated in the Etruscan manner, by those classes of the population that used decorated pottery and consigned it in quantity to their tombs. These must have been the majority, so the hellenizing manner cannot be dismissed as merely working–class because of the relative cheapness of the medium. In

terms of the development of Etruscan art, however, it is barely half the story. Works in bronze, ivory and gold betray quite clearly a far more direct oriental influence and it has been thought probable that Syrian ivory-carvers were working in Etruria like the Greek potter-painters. I am not sure whether this is true, but there was a notable influx of eastern objects which found their way also into tombs, some of them, we might judge, long after their first arrival, and these too bred imitations.[24]

Earliest are hammered bronzes, like those found in Greece, and almost certainly of North Syrian origin; which must raise the question of whether it was Greeks or easterners who brought them west. This is no place for a detailed discussion of the orientalia in Etruria, but it is clear that North Syria was a major source and will explain much of the local production of elaborate bronzes, jewellery and carved ivories.[25] The question of Greek intervention depends on whether purely Phoenician products and influence can be detected, such as we might expect given the Phoenician presence in the west, and as close as Sardinia.[26] It can be detected in some pottery shapes (generally carrying Greek-style decoration), especially the conical-topped jugs which copy a common Phoenician metal form, and some of the subsidiary decoration, especially the rows of deep 'cup-palmettes' which are a Phoenician form very different from the Greek treatment of the same eastern motif. But, by the same token, the orientalizing ivories and bronzes of Etruria admit animal friezes of Greek rather than eastern type, and even some Greek monster and mythological figures (Minotaurs, for example). So even in the orientalizing period, when the luxury materials are worked in eastern forms, elements of Greek design intrude, while on the lesser, more popular works (the pottery), they are dominant.[27] And even some of the goldwork in southern Etruria seems, for all its orientalizing style, to be the product of neighbour Greeks.[28]

I suspect that the major period of introduction of eastern luxury goods was comparatively early, mainly the first half of the seventh century, however long they lasted above ground before deposition in tombs. Purely Phoenician import and influence may be no later, and these often carry a Cypro-Phoenician air. The Bernardini Tomb at Praeneste (in Latium, not in Etruria proper) contained four silver vessels of Phoenician manufacture, one of them inscribed in Phoenician and another fitted out locally with snake handles that cover part of the incised decoration (which perhaps makes it an adjusted import). Yet the style of decoration on most such works, though of the usual egyptianizing Phoenician type, seems not quite pure, and craftsmen of eastern origin working in the west, perhaps even in Etruria, are reasonably suspected. This would explain other vases, silver *kotylai* (a Corinthian vase shape much copied in Etruria in clay) carrying similar Phoenician decoration, surely locally made.[29]

The picture emerges of Greek *and* eastern imports, Greek *and* eastern resident craftsmen, competing for the attention and custom of the Etruscans, the Greeks providing the most influential figure and subject idiom, the easterners the luxury forms and techniques, especially in fine jewellery in which the Etruscans were to excel.[30] Once the Etruscans begin to employ these techniques their jewellery remains very eastern in concept and even outdoes its models,[31] while their ivory work soon adopts some of the same range of animal frieze and figure decoration that we have remarked on the painted vases, which were mainly Greek in inspiration. The Greek presence and influence seems to be operating at a different level from the eastern, helping to create a figurative,

7.6 Aristonothos vase from Chiusi (Rome, Conservatori)

decorative idiom for Etruscan art rather than expressing status and wealth. And it is rendered in the cheapest medium, pottery, rather than that of precious metals and materials (especially ivory) which were the common stock of the eastern world.[32] By the later part of the seventh century there was still perceptible interplay between the two classes of work: isolated Greek mythological figures and friezes on the bronzes and ivories, a residue of eastern subsidiary patterns on the vases. But by this time too it is not necessary to believe that Greek artists in Etruria were still making much contribution, but that it was rather the continuing import of Greek goods that had their effect. To demonstrate such an effect it would be necessary to show that the development of the crafts of pottery manufacture and decoration in Etruria was running more or less *pari passu* with developments in Greece. This does seem true to a minor degree, in that the new incising styles of 'Early Corinthian' black figure pottery, with its crowded incised background ornament, is copied. But it is more a matter of translation than copy, a question of choice rather than any deliberate attempt to keep up with Greek fashions, and it is not easy to judge what time lag there might have been between the arrival of new styles (and they were not all that novel) and their effect. Generally speaking, new styles are most influential when they are current, without any time lag, but in this case the new styles were current for a long time (the Corinthian animal-frieze black figure running to the mid-sixth century).[33] What is happening is a phenomenon already observed in this volume in other parts of the ancient world – Greek idioms are adopted and adhered to long after their currency in Greece itself, and artists are seen to be deliberately ignoring novelty. It is one of the measures of the difference between the artistic temperament of the Greeks, or of the social climate in which they operated, compared with that of other cultures. It will prove to be a strong theme in the continuing story of the hellenizing of Etruscan art, but the Etruscans will show themselves capable of developing distinctive idioms of their own from this base. That more than one hellenizing style can be in production in Etruria at the same time is a function of the character of the Etruscan 'state' and the independence of the cities within it. Local production in various media is often strongly differentiated, reflecting differing exposure to different influences as well as variations in local practices (burial furnishing, for example) and local, perhaps personal and royal, taste.

The end of the seventh century heralds a change in interests and influences. The eastern fall away. The reason for this is not easy to find. Phoenicians were by then well established in the west. Carthaginian, Greek and Etruscan spheres of influence were beginning to develop, but the political situation need have had no effect on craft products and influences, and if anything the easterners and Etruscans came to regard the Greeks as rivals and even leagued against them, however freely the passage of goods between them continued. The Greek hold on the coastal areas of South Italy and East Sicily was by now strong and the process of hellenizing the hinterland well advanced, as we can judge by the diffusion of Greek goods and their effect on local crafts.[34]

The late seventh century to the early fifth marks the period of greatest Etruscan political and territorial authority, extending north to the River Po, south into Campania. Relations with Carthage seem to have been close, and the two peoples could combine to check a group of immigrants from East Greece (the Phocaeans) in a sea battle off Corsica (Alalia) in 540 BC. But in 524 BC Etruscan influence to the south was

weakened by defeat at the hands of Greeks at Cumae, and in 474 BC, off Cumae, a combined Etruscan and Carthaginian fleet was defeated by Greeks from Syracuse. Meanwhile Rome had emerged as a powerful state, beginning to cast off its Etruscan cultural and political veneer. The Greeks also defeated the Carthaginians in Sicily in 480 BC, the year of their defeat of the Persians at Salamis.

This is also the most lively and innovative period in Etruscan art, dominated now by Greek example. It has often been held that for the first part of this period Corinth remained the main source of influence (the Euboean had long before disappeared), being replaced by the East Greek, as the Greek inhabitants of western Anatolia began to look for new homes in the mid-sixth century, under pressure from the growing Persian Empire – whence the Phocaeans' decision to go west, and their rebuff at Alalia (see above). The explanation may be over-simple. East Greeks had been under threat before, at the end of the seventh century, from their nearer neighbours, the Lydians, who proved philhellenic only in the next generation, under King Croesus. One of the greatest of the East Greek Ionian cities, Smyrna, was sacked by the Lydians in about 600 BC and others suffered the same fate. People were more ready to move home in antiquity than some recently fashionable views against diffusion of culture might credit. The mid-sixth century might not have been the only occasion for a desire to find a safer home than the east Aegean shores. Much of the novelty in Etruscan art of the sixth century can be explained by East Greek (I shall call it Ionian, with some justice) presence and influence. Craftsmen were surely not at this date differentiated as a significantly separate class in any community, with significantly different careers and expectations; where their neighbours went, they went, and they continued to serve their community, or their community's new neighbours, as before. This is very clear for the Ionians of the mid-sixth century, both in Etruria and in other parts of the Greek world, west and east (in Athens especially); it may have been true earlier.

The first intimation of new sources of Greek influence appears in a small group of vases from Vulci decorated by a single artist – the Swallow Painter. Most shapes and all decoration are clearly East Greek, Ionian, in the familiar Wild Goat style and quite unlike Corinthian products [7.7].[35] Since there is some comparably Ionicizing pottery in South Italy also in these years, we cannot be certain that the painter is a newcomer from the east rather than a local migrant from a Greek colony (some of which in the south were founded from Ionia), but it may amount to much the same thing. It is interesting to see that the Swallow Painter's Ionian manners could affect even the work of his Corinthianizing townfellow, the Painter of the Bearded Griffin, who introduced a Wild Goat style frieze on one vase; but the Swallow Painter himself could use a Corinthian shape, the olpe.[36]

Through the first half of the sixth century the Corinthianizing vases continue in brisk production in Etruria with yet more extreme variants on the animal-frieze style in terms of coloration, proportion and composition [7.8].[37] These do not so much follow Corinthian fashion as perpetuate that of the end of the seventh century. Corinthian vases continue to arrive in quantity, a speciality being the colourful column craters. These are copied in Etruria, but on no great scale and in styles different from those of the continuing Etrusco-Corinthian series of animal-frieze vases.[38] The latter persist beyond the mid-century which is when the production of figure-decorated vases in

7.7 Swallow Painter vase from Vulci (Rome)

Corinth also dries up (for whatever reason), and import is confined to plainer patterned wares.

Of greater importance than the continuation of interest in Corinthian styles is the beginning and then dramatic increase in import of Athenian black figure vases from about the 470s on. Given the burial conditions in many Etruscan cities for the wealthy – built tombs with contents commonly recovered intact – and the brisk exploration of Etruscan tombs in the last two centuries, Etruria has proved a major source for our knowledge of this ware and has stocked the major collections of the world. The picture is somewhat deceptive and it is easy to attribute too much to the influence of these imports, and even to deduce that they were imported only to serve as tomb furniture. It is not plentiful in settlements, which have been seldom explored, but certainly not absent.[39]

Athenian pottery reached all corners of the Mediterranean, and in considerable quantity, so the completeness and visibility of the vases from Etruria (which were at first taken for Etruscan, they were so plentiful) distorts the picture. That Etruria was a major market is clear, and there is evidence for some classes of pottery made in Athens being targeted on Etruria. In the years before and around the mid-century there are the Tyrrhenian Amphorae, colourful small vases, stylistically akin to current Corinthian.

7.8 Vase from Pescia Romana
(Florence)

Since vases from Etruria are so much more visible, it is easy to be misled by the statistics
of find-place into believing that some Athenian groups were deliberately made for
export west. For the Athenian Tyrrhenian (also once thought to be Etruscan in make)[40]
the case is simpler, though it is still debated. No examples of amphorae of this style (as
opposed to other shapes by the same artists) have been found outside Etruria, even in
Athens where the sources are prolific.

A further example of specialist production in Athens for the Etruscan market is
provided in the second half of the century by the potter Nikosthenes who made special
vase shapes (amphorae and *kyathoi*, dippers) which copy Etruscan *bucchero* shapes.
Virtually all the amphorae were sent to Caere, all bearing the potter's signature.[41]

It is not easy to assess the volume of Athenian pottery reaching Etruria in the sixth
century and calculations from ready sources, such as lists of vases attributed to artists,
woefully undervalue the numbers from excavations old and new. In the tombs it is rare
to have the record of the whole inventory, but a double burial at Caere of the third
quarter of the century had gold jewellery, two Athenian Tyrrhenian vases and one

7.9 Pontic vase. Judgement of Paris
(Munich)

other, one Caeretan hydria, one *bucchero* vase (local), one silver and nine Etruscan bronze vases.[42] It must be remembered too that Athenian merchants were not always, and perhaps were seldom, the marketers of Athenian vases, rather than Ionians, Aeginetans, and others; even Etruscans possibly took a hand.[43]

Given the abundant presence of Athenian vases in sixth-century Etruria one might expect them to be a major source of influence on pottery styles, and that Athenian art was to be as influential as Corinthian had been in earlier years. This is not the case and the explanation is presumably that the presence of Ionian artists counted for more than the popularity of Athenian vases. At any rate, clay vases cannot have been responsible for all the most important effects on arts and crafts, although their ubiquity and functional value make them a most valuable mirror of current fashion. If we look away from the Corinthianizing vases to other ceramic novelties in sixth-century Etruria, we find first the so-called Pontic vases [7.9].[44] The shapes, where not Etruscan, are principally amphorae which copy the Tyrrhenian and attest the popularity of this Athenian shape in Etruria. But the style is not Athenian. While Corinthian pottery had its effect through the import of vases and observation of their style, we now deal with a style introduced in vase-painting but not from vases. In Ionia the few vases given figure decoration did not travel in quantity. The Ionian style travelled with people (sometimes

7.10 Northampton Group vase (Private)

potters, as we shall see) or in other media. If the first Pontic potters were immigrants, they significantly abandoned shapes familiar to them for shapes acceptable to their customers, and since they appear to have been operating in Etruria itself, this is readily understood.

This Ionian style needs definition since it appears in both the better decorated pottery and other, more valuable media. In its homeland it is apparent more in sculpture and relief than painting, though we may be sure that it was current there too even if less well attested. The main pottery style had been of animal friezes (the Wild Goat style, as of the Swallow Painter) until just before the mid-sixth century, with figure scenes developing, in outline or black figure, only in the second quarter of the century, mainly in Chios, Samos and Clazomenae. In Etruria it appears as a manner of figure drawing that is far more fluent, less anatomically articulated that that of mainland Greece (Corinth and Athens). The rounded heads and flowing outlines to limbs and dress distinguish them immediately. In many respects it is a more painterly style. In compositions the repetition of figures in friezes was more readily acceptable in Ionia than it had been in the Greek mainland, where the vase-painters became more interested in narrative or symmetrical composition. There are other iconographic details that derive from the East Greek world – head-dresses, some animal types, and the fondness for satyrs with human legs but horses' hoofs. Imaginative use of colour was, it seems, another trait, naturally acceptable to the Etruscans who had already adjusted Corinthian styles in this direction. So, the animal frieze on Pontic vases is of unquestionable Ionian origin; there will be more to say of the subject matter later.

If the nationality of the first Pontic artists is in doubt, this is not the case with the creators of other local pottery workshops of the middle and second half of the century in Etruria, by which time the dominance of animal-frieze decoration had been broken. North Ionian black figure potter/painters, whose work can be detected in the east Mediterranean, are responsible for the Northampton Group, mainly of fine colourful amphorae in a delicate miniaturist style [7.10]. They have a local following in the Campana Group *dinoi* (cauldrons), less likely to be by Greek artists, or at least not first-generation Greek.[45] They are followed by a different group making the Caeretan hydriae, exclusively for (and surely at) Caere, through the last third of the century [7.11].[46] There is a difference here, though, in that the style is not attested on pottery in Ionia, though there is strong circumstantial evidence for the presence there of the painting style in other media (see above [5.8]). Only in Etruria did the artists (a very small, probably family group) apply their skills to pottery decoration. These Ionian vase painters in Etruria attest the continuing presence of the practice of Ionian style there to the end of the Archaic period.

The successors to the Pontic vases, representing workshops not dependent on the presence of Greeks but continuing a tradition that had become Etruscan, however hellenizing, is found in a series of black figure vases. These, as the Pontic, are generally Athenian shapes (or local) but the figure work is Ionian in style and the subject matter still basically Greek-derived. Vulci seems the principal centre, and production continues into the first half of the fifth century, with the occasional identifiable painter of interest if little merit. I show one of the more lively vases with a scene deriving from Greek versions of pirates turned to dolphins by Dionysos [7.12].[47]

7.11 Caeretan hydria (Malibu)

The overall effect of the Ionian painters and their companions in other crafts, beginning at the end of the seventh century with the Swallow Painter, was decisive for the formation of Archaic Etruscan art. The effect in other media is more impressive, and to this we now turn, but the record in pottery decoration gives the clearest indication of the processes involved.[48]

As in earlier years, bronze work is conspicuous among the Etruscan finds of the sixth century, of high quality and varied form.[49] Much is in hammered or cast relief, applied to furniture [7.13], chariots or the like;[50] much is cast, generally in the form of small statuettes also serving as decorative additions to furniture and vessels but as independent statuette offerings too.[51] Style and iconography owe more to East Greece

7.12 Etruscan hydria (Toledo)

than to mainland Greek products, and by now virtually nothing to the east. The more Etruscan of these figures combines Ionian grace with an attractive flamboyance of posture, such as the dancer on the incense-burner stand [7.14].[52] One major class of decorative bronzes begins in the sixth century: mirrors, their backs decorated by careful incision or, less often, relief. We shall return to these when we consider subject matter.

The record is much the same when we seek the inspiration for major production in terracotta, especially for architectural decoration. Evidence for the introduction of Greek practitioners of the craft was apparent in the Demaratos story, though of course the medium had been as well exploited in Italy as in most other parts of the ancient world. The special application of figure decoration to architecture, however, seems to depend very much on Greek example. Fine marble was not readily accessible in Etruria (the Carrara quarries were exploited only in the Roman period) and local traditions in stone carving were at any rate feeble, so pedimental groups are modelled in clay, even to life size and more. Whole figures are also admitted to roof ridges, as on the famous

7.13 Bronze tripod from Vulci (Munich)

7.14 Bronze candelabrum (London)

Temple of Apollo at Veii at the end of this period (and see below [8.50] at Rome).[53] There are soon some spectacular clay pedimental groups, as that at Pyrgi with the Seven against Thebes. Closely comparable major work in clay is represented by the famous sarcophagi in Rome and Paris which take the form of figures of the dead couple at life size reclining on a couch [7.15].[54] Frieze decoration of moulded clay slabs becomes a common adornment for temples and probably other buildings, the type being a purely East Greek, Anatolian one, not found in mainland Greece, except in the north [7.16].[55] Again, it takes the presence of architectural craftsmen from the Greek world to introduce such practices, which cannot be learned from observation of imports.

The very mention of architecture calls to attention the fact that the traditional monumental arts of Greece, sculpture and architecture, have played a very small part in the Etruscan story so far. We have found Greek architectural orders travelling a long way in the ancient world, but when Etruria begins to build monumental temples, in the sixth century, they owe nothing to Greece by way of plan and construction, and nothing

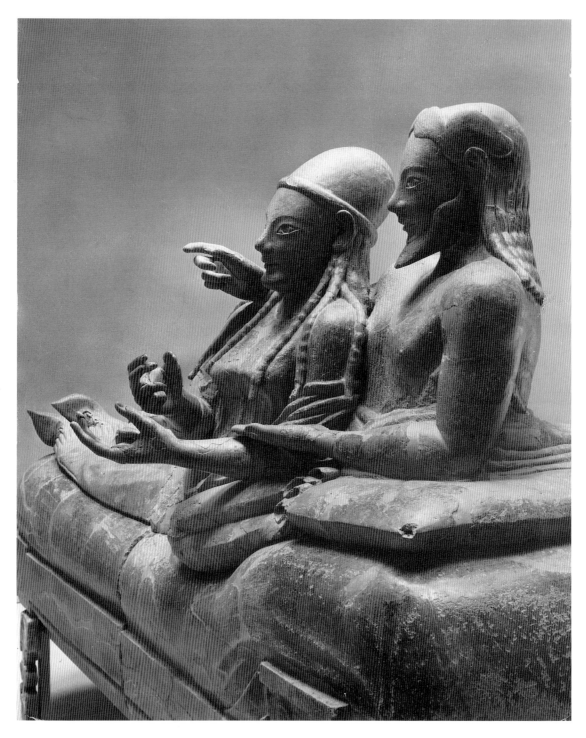

7.15 Clay group on funeral couch (Rome, Villa Giulia)

7.16 Clay architectural relief from Acquarossa

to the main architectural orders (indeed, Etruria developed its own, Tuscan); only in the clay revetments and other decoration did Greek style dominate. Major stone and much clay sculpture presents little that can be explained in Greek terms rather than through local traditions in, for instance, the modelling of large clay heads for funeral urns.[56] This, if you will, is true Etruscan art, impressive often but indefinable. There is also some major sculpture of human figures, animals and monsters, notably from Vulci. The earlier ones have a crude vigour, related to Greek work of the earlier sixth century; later ones are monumental versions of the Ionian Animal Style [7.17].[57] We do not even know whether an Etruscan temple served primarily the same purpose as a Greek one – to

7.17 Stone lion from Vulci (Vatican)

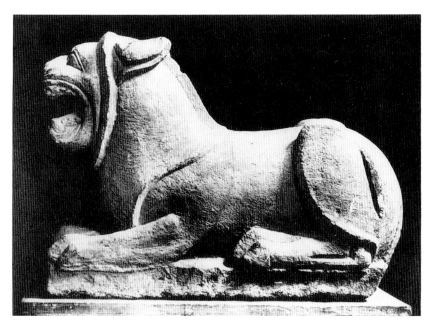

7.18 Marble statue from Canicella (Orvieto)

7.19 Stele from Populonia (Florence)

house a cult image representing the presence of the god. This seems to become true eventually but early cult images are hard to identify. There is a near-half-lifesize nude woman, carved in Greek marble, rather kouros-like, from Orvieto (Cannicella) which might qualify [7.18]. Her head is very Ionian, of the second half of the sixth century, but her origins, even in Italy, are obscure. She can hardly be an import since there is a revealing frankness about her nudity which we do not look for in Greek statuary but which might seem appropriate for some orientalized Etruscan cult; but she may not be a cult statue at all.[58] Sculptured relief stelae from various Etruscan cities have still much of the oriental about them, or at least un-Greek, except for some close copies of Ionian tombstones with floral capitals at Populonia in the second half of the century [7.19].[59]

7.20 Painting in Tomba Campana

Perhaps the most familiar product of Etruscan art, and the one in which they might seem most fully to express their national character, is tomb painting.[60] Many Etruscan tombs take the form of underground houses, sometimes with plausible architectural detail, and with painted walls. There are no such tombs in Greece, but we know that Greeks of the Archaic period were well able to 'paint big' and there are comparable tombs of the latest Archaic period on the eastern periphery of the Greek world, in Lycia, where we can see work in Greek or mainly Greek style [2.27]. It is significant, perhaps, that it is again to the East Greek world that we have to turn for parallels for such an important phenomenon in Etruscan art. Among the earliest is the Tomba delle Anatre (ducks) at Veii where the style is still virtually sub-Geometric.[61] The genre might not then depend altogether on Greek example. It is followed by tombs at Veii and Caere decorated with animals of the Corinthianizing type seen on vases, distortions, fantasy and all; such is the Tomba Campana [7.20].[62] An alternative wall decoration is of painted clay slabs, and examples of the second quarter of the sixth century (the Boccanera plaques, from Caere) exhibit the familiar Ionian style of drawing below a massive cable pattern – a favourite of the East Greeks [7.21].[63] From now on the Ionian style dominates. By the mid-century Greek mythological scenes are admitted in the tombs of Tarquinia and an increasing number of generic scenes of high life rendered through the conventions of Greek art. It is in these larger scenes, which appear in a broadly homogeneous style over more than a century, that the quality of some of the strongly Ionicizing painting can be best appreciated and the flair of the style as it had been translated for its new patrons. [7.22a,b] has figures from a tomb at Tarquinia of

7.21 Painted clay plaque (London)

about 470; the comparison, [7.22c] is an earlier Athenian vase, more sober than anything Ionian, but demonstrating well enough the gulf between the Etruscan and Greek conceptions.[64] Some have suspected Greek hands in the painting of some tomb interiors, even the hands of recognized vase painters.[65]

The story of Etruscan sixth-century art has so far been dominated by Greeks. This is not the whole story, though it is the larger part of it. Some early sixth-century stone reliefs decorating tombs at Tarquinia simply use the Corinthianizing animals familiar to us from the vases.[66] Other work in stone, then and later, is not so Greek in aspect. In part it follows older local traditions for clay sculpture, as in the ash urns of Chiusi with their bust lids (Canopic); and in part it betrays a lingering orientalism, especially in the relief stelae.[67] This is not so easy to explain since direct influence at this date, and operating at this level, is not otherwise documented. It is as well to remember how localized many of these classes of monument were, often confined to a single city, possibly therefore the product of individual choice, of whatever inspiration, and not to be taken as indicative of

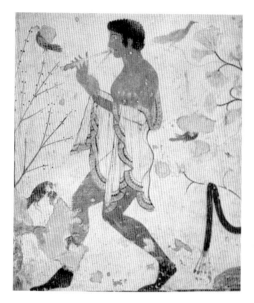

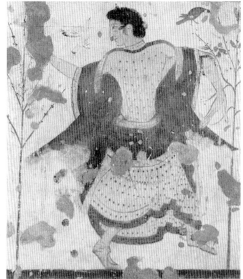

7.22a,b Painting from Tomba del Triclinio, Tarquinia

7.22c Athenian vase (London)

any more widespread practice through all Etruria. Thus, the later archaic relief *cippi* of Chiusi are heavily Greek (Ionicizing) in style and often in subject.[68]

In one medium, however, the east seems still the main source of inspiration – jewellery.[69] The most luxurious of all the crafts had been wholly eastern in design in the seventh century. Forms and techniques remain oriental (though many of them had been shared by Greek jewellers elsewhere) but there are many local forms of brooch and ornament also worked in the eastern manner. Greek subjects and patterns inevitably intrude, but it seems that, despite legendary Ionian skills in luxury products, Etruscan nobles still cultivated oriental style. Perhaps this was an area of production less readily influenced by immigrant artists, and a difficult craft such as that of the jeweller tends to be extremely conservative and resistant to outside influence once established. The Greeks offered works in more accessible techniques and materials, but also a thoroughly pervasive figure and decorative style, which eventually overtook even the jewellery, and even in luxury material such as ivory their hands are not altogether absent, as we

7.23 Gold ring (Paris, Bibl.Nat.)

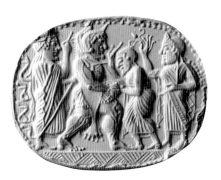

7.24a,b Carnelian scarab (Boston)

can see from decorative relief plaques, or an ivory siren from Orvieto with a wholly Ionian head.[70]

The last class of sixth-century product to be considered, before we reflect on subjects and sources, is related to the jewellery. Early in the century there began production of a series of finger rings, gold or gilt-silver, which are Phoenician in shape (a long oval bezel like a cartouche) and not intended for use as signets because the metal is too thin (and the intaglios too shallow) and many are at any rate worked in relief. Greeks too had adopted the shape and it has been assumed that they introduced it to Etruria. This might be the case, but the shape was also well known to the western Phoenicians for solid, practical rings. The decoration, other than the jewellery components of the hoops and mounts with their filigree and granulation, is Greek, with only an occasional nod to their eastern prototypes, such as a winged sun-disc. The one I show has a demonic chariot drawn by a sphinx and a stag [7.23]: the animals and eventually even versions of Greek mythological figures and scenes relate very much in style to the Pontic vases.[71]

Another jewellery type is represented by Etruscan scarabs.[72] Their form may be wholly oriental in origin, but their currency in Etruria is due entirely to Greek example and instruction. They may be treated as jewellery rather than signets, since this seems to have been their prime function, and their gold or silver mounts (rarely preserved) were probably as valuable as the stones. But the medium has a very long and distinguished history in Etruria: its opening years need discussion here, and will be followed up later in this chapter. The East Greeks (again) had learned how to cut hardstone scarabs from

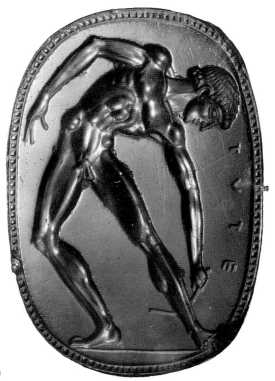

7.25 Carnelian scarab (Berlin)

Phoenicians, probably in Cyprus, as late as the second quarter of the sixth century. The type is introduced to Etruria in the second half of the century where, almost immediately, a new approach to the genre is apparent. It must have been initiated by the first Greek engravers, but in many ways it epitomizes Etruscan attitudes to the arts. Where the Greek scarab backs are comparatively rough cut and unpolished, the Etruscan show as much care and detail lavished on the beetle back as on the intaglio, and a finely polished carved surface. The edge of the beetle base (plinth) is regularly decorated, as not in Greece, and the beetle back may sometimes carry a relief figure device – a pseudo-scarab. The earliest are purely Greek in style, and surely from Greek hands, so it is an Ionian preference, not much followed in the homeland (there are exceptions), that helped set the new fashion. The stocky figures typical of one of the earliest artists (the Master of the Boston Dionysos [7.24]) are Anatolian and close to some that appear on stone relief stelae in Etruria about the same time. The relief back of the gem shows a Dionysos, the intaglio, an unidentifiable encounter of Herakles.[73] The stone is only fourteen mm long. The favourite material for the scarabs is carnelian and in Etruria it is, and remains, regularly of a deep, intense red. The Greek studios were not so fussy and it seems likely that the source used in Etruria supplied stone colour-changed by bathing (unless it was done in Etruria itself).[74] The deep red is set off marvellously by the gold mounts, emphasizing the jewellery aspect of the usage, rather than the sphragistic. The intaglios are also more visible thus, without the necessity of making an impression, and most are designed to be viewed directly and were

deliberately not cut reversed, with an impression in mind. In the Late Archaic period the figure style of the scarabs copied the sleek anatomical studies of Greek glyptic, almost excelling them [7.25].[75] The future of the craft in Etruria will be found more revealing than most about Etruscan attitudes to the products of their Greek mentors and models.

The stories of Demaratos and others indicate how the historical record long remained aware of the physical presence of Greeks and Greek artists in Archaic Etruria. Whatever political and military animosity may have been displayed by Etruscan states seems not to have had any important effect on the free movement and employment of Greek craftsmen. These could hardly all have been slaves, some may well have been rather expensive hirelings, others respected and accepted members of the community. In the archaeological record there is more to show for them in the Etruscan ports that served the major cities than in the cities themselves. Two are of particular importance, the port of Caere at Pyrgi and the port of Tarquinia at Graviscae; in both the serious archaeological record begins only with the sixth century. For a third, Regisvilla, port of Vulci, more is to be learned from recent excavations.[76]

At Pyrgi the temple area has been excavated with two major structures, one (B) Late Archaic, the other (A) of around 460 BC.[77] The dedications are to Etruscan gods, readily assimilated to Greek (there has been something to say about temple architecture already) and both temples carried architectural terracottas in a purely Greek style and of extreme intricacy. But Etruscan gods can be assimilated to eastern gods too, and although the majority of imported finds and dedications at Pyrgi are Greek, there are also three gold tablets, inscribed in Etruscan and Phoenician, announcing the dedication (just possibly of the temple itself) by a local Etruscan king to a goddess whom he was prepared to identify as the eastern Astarte, the Etruscan Uni (= Greek Hera/ Juno). With little else at Pyrgi of eastern origin at this date (around 500 BC) the occasion is hard to imagine, unless at the time the king was under a special obligation to his Phoenician allies at Carthage.[78] That Greek arts, style and mythology should flourish still in such a potentially hostile ambience is quite remarkable, but fits well with the totally hellenized arts of Caere itself and the continuing massive import of Greek goods.[79] We should perhaps wonder to what extent the Etruscans recognized that so much of importance in their visual world had been so thoroughly determined by the taste of their enemies.

The port of Tarquinia at Graviscae seems to have been more wholly Greek in character, its sanctuaries filled with Greek votives, rich and trivial, from the early sixth century on. There is a strong Ionian presence, as well as the expected flow of Corinthian and Athenian pottery, even a stone anchor dedicated to Apollo by a Greek, Aeginetan merchant mentioned by Herodotus.[80] In these coastal exchange areas the Etruscans did nothing to keep the Greeks at arm's length, and it is not difficult to imagine how easy was the passage of Greek art and artists.

It is no part of the present enquiry to attempt to define what is Etruscan in Etruscan art, and there is no room to inform the reader adequately through pictures of what there is in the record that is not Greek-inspired. But there are some general traits which are evinced by the non-Greek and non-oriental works, and which make for that oddity in Archaic Etruscan art that declares so much of it to be of local manufacture, whatever the

inspiration. There is an element of fantasy, already apparent in the seventh-century treatment of animal friezes. It is expressed in odd combinations of animal parts, distortions and a certain theatricality of pose. There is even a rather wayward feeling for the monumental in early clay heads. There is not, on the whole, much regard for any norms of design and proportion, such as are readily detectable in the arts of the east and Egypt, and are paramount in Greek art. These are all stylistic elements that will remain important if we are to understand the continuing Etruscan response to things Greek. But before we turn to the post-Archaic period there are other aspects of the Etruscans' translation of Greek art that may tell us as much or more about what they sought in it, and about why they copied or encouraged what they did. These concern their use of Greek iconography, of divine or heroic figures, the narrative of myth and depiction of the everyday.

We know so little about names, functions and stories in Etruscan religion and myth. Their concern for their dead is apparent in the record of their tombs, and the way they often prepared them for the dead, as if for life. If the furnishings from the sixth century on are so very Greek in appearance, this should not lead us to think that their attitudes to death were at all like the Greek. One Etruscan object, a bronze model liver used for divination, names at least twenty-three deities. The Etruscans found it possible to assimilate some of their gods to about two thirds of the Greek Olympians, keeping the Etruscan names (Tinia = Zeus; Turan = Aphrodite; Uni = Hera, etc.). They were presumably led by similarities of function, but not all could be accommodated and there are many other named Etruscan deities or demons. The Greek images of assimilated gods were readily adopted, with their attributes. Other deities, heroes and mythological figures simply had their names translated into Etruscan, roughly phonetically, and these served narrative, not cult. Only Herakles, as Hercle, seems to have acquired cult status too under his Greek name; he was certainly worshipped in Rome from an early date. It has been observed that the Etruscan names for Greek myth figures derive from Doric Greek forms rather than Ionic, so we might have expected them to have been adopted in the period of presumed Corinthian influence, no later than the early sixth century. But the names do not appear commonly in myth scenes until the fifth century so there must be some other explanation for their source.[81] If most were devised about the time they first appear the source should be the Doric Greek colonies of South Italy and Sicily, but this is the time of maximum conflict between Greeks and Etruscans, and there are phonetic arguments for earlier borrowing.[82] The artificiality of the whole phenomenon suggests a fairly localized situation of a Doric Greek sitting down with a literate Etruscan mirror-maker, probably in Vulci, to improve his product by adding plentiful names to the myth scenes, à la grecque. This could not account for the whole corpus of names, obviously, but it could account for a majority on the most conspicuous monuments.

The mythological scenes that appear in Etruria, apparently from Greek hands, offer no particular problems, though we shall revert to the East Greek in a moment. Those clearly executed by Etruscans do present dire problems of interpretation. Some appear already in the seventh century, some of them explicit myth copied from the Greek, but for the most part isolated figures and monsters, often divorced from their Greek narrative context. Real stories appear even on orientalizing works, such as the Odyssey

episode with Polyphemos on an ivory bucket.⁸³ Thereafter there are stray examples until near the middle of the sixth century,⁸⁴ when the problem begins to become acute. Extreme views hold either that Etruscan artists copied without understanding what they saw, or that they acquired detailed knowledge of Greek myth which they proceeded to illustrate, following Greek conventions but in ways never met in the Greek homeland.⁸⁵ There are some examples of each extreme; but for the most part the truth must lie somewhere between them. Various factors, mainly peculiar to Etruria, need to be borne in mind. The Etruscans were concerned enough about the Greek stories to devise Etruscan names for the protagonists, guided by the Greek names. If some Etruscan treatment of Greek myth is unparalleled in Greece itself, it may be that it derives, with so much else in Etruscan art, from Ionia where it was *not* expressed in our most prolific Greek medium, painted pottery, and has scarcely survived in metalwork or other painting, where we may be sure it was much practised. Pictures do not travel with commentaries, but there was at hand in Etruria an informed Greek presence, which artists might have consulted if they wished; but even Greek artists, a generation or two away from their homeland, may devise novel treatments of narrative. The problems are best explored through examples, some of them post-Archaic.

The main picture on the back wall of the mid-sixth-century Tomba dei Tori (Bulls) in Tarquinia shows an attacking warrior, a fountain house and a young rider [*7.26*].⁸⁶ It derives from Greek scenes of Achilles hiding behind the fountain house in the Trojan plain, where Polyxena is busy with her jug while her brother Troilos approaches with two horses. A Greek artist could abbreviate the scene, but here the attack with the fountain house between them is implausible and the rider seems the major figure. Although the artist may have known the details of the story they do not seem to have been much in his mind when he executed the scene. The floral extravaganza is also unparalleled in Greek art and the figures seem little more than an accompaniment to the landscape, with a suppressed story line. The story is one to which Etruscan artists often returned, by conflation, contraction and omission making some very different narrative images to the Greek. On the whole they are doing no more than Greek artists do with the same subjects, but with intentions that may not have been so closely determined by the narrative expectations of a Greek viewer.

Next, two mirrors. On a relief mirror [*7.27*],⁸⁷ of the early fifth century, the struggling group derives from Greek groups which start as Peleus wrestling with Thetis, and come to make more explicit the lifting, rape motif. But the youth here is identified by attributes and inscription (Herecele) as Herakles, who is not so engaged with anyone in Greek art, while the woman is an unknown Etruscan, Mlacuch. An Etruscan story, new or not, has attracted the participation of a Greek hero in an iconographic scheme borrowed from a different story (something a Greek artist can also do). On an incised mirror, of the later fifth century, the scheme is the Greek one of Eos (Dawn) carrying off the body of her son Memnon [*7.28*].⁸⁸ But Eos was identified as an Etruscan goddess, Thesan, and is so named here, while Memnon has to be given a version of his Greek name, Memrun: the Etruscan deity has acquired a Greek story and family. The phenomenon is paralleled in other works where the Etruscan-identified deity acts his or her Greek counterpart's role in a Greek story. But sometimes there is total incomprehension, and on a scarab of about the same date showing the same group the

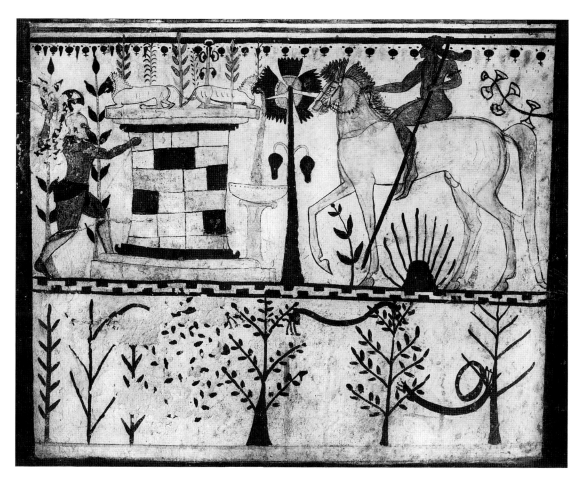

7.26 Painting in Tomba dei Tori, Tarquinia

figures are quite wrongly named after two prominent gods, Tinias (Zeus) and Turan (Aphrodite).[89] We think of myth as an essential mode of thought and communication for a culture. The Etruscans did not adopt Greek religion, but they were ready to adopt the Greek stories that accompanied figures which they had identified with their own gods and goddesses. This was not done through the medium of literature, it seems, nor, one imagines, verbal instruction; it was done mainly through the medium of art, and it is difficult to think of a more dramatic demonstration of the power of a foreign image to shape the mythology, not merely the visual experience, of a people.

Some Greek stories are better illustrated, or illustrated in more novel ways, in Etruscan art than they are in Greek art. The prime example is the story of the Seven against Thebes, some episodes of which had limited currency in Greek art, dwelling mainly on the preparations for the expedition. In Etruria we see far more of episodes in the fighting itself. Some would argue that the artists had access to details of the full story which they proceeded to illustrate according to the conventions of Greek art. This is not easy to disprove and at any rate it seems plausible although it need not imply any very

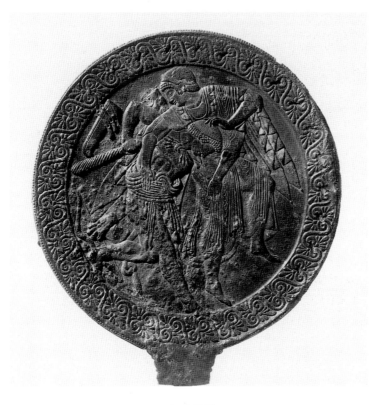

7.27 Bronze mirror (London)

7.28 Bronze mirror (Karlsruhe)

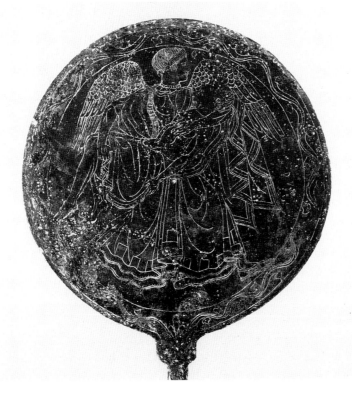

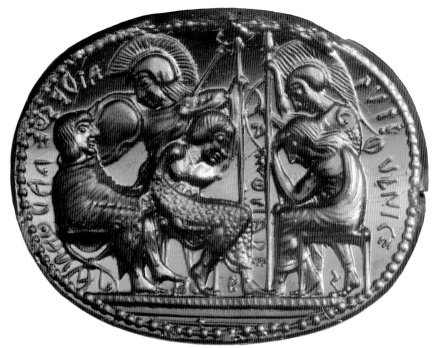

7.29 Carnelian scarab (Berlin)

detailed knowledge of Greek literary sources now lost to us. It is hard to explain the prevalence of the Theban story by referring it to Archaic Ionian originals, poorly attested in the homeland, and the interest is maintained through the fifth century and later. One example, not an action group, may illustrate the problems: it appears on a famous scarab [7.29].[90] The two seated figures facing each other derive from Greek figures of Achilles mourning. Such an Achilles may appear in scenes of the Embassy in which Odysseus tries to persuade him to return to the battlefield at Troy, and in these Odysseus may appear with legs crossed or hand on knee, like the third seated figure on the scarab. The mood of thought or dejection is enhanced by the downcast heads of the two standing warriors. But the five are named as five of the Seven who went to Thebes. The mood is appropriate since they were, with one exception, not to return, and they knew it. The scheme has been created by an artist (probably not the engraver of this scarab originally) adjusting Greek figures from a Trojan occasion to a Theban one. But not wholly appropriately; there are only five figures, and there are indications that the artist had thought of cutting a seat in a different position (making more, or less, or the same number of figures?), so he may not have embarked on the composition with any clear idea about numbers (by this time, important in the Theban story). Did he have this story in mind at all before the question arose of adding names, for which the composition does not seem to have allowed? That he did is suggested by other scarabs, and mirrors, which have elements of the group and have the appropriate names.[91] The Greek who taught the Etruscans the names taught the stories too, and the scheme for Etruscan depictions used appropriate images from other narratives, in the Greek

manner. Only the choice of subject seems a little odd, as do some of the other individual studies of the Seven which may present them, not altogether inappropriately, as, for instance athletes [7.25] (Tydeus) rather than the warriors of the story.

In the borrowing of pattern rather than figure subjects in the sixth century the Etruscan artist tended to slacken the geometry of even the floral motifs, adjusting them much in the way that he had adjusted the animal subjects in earlier years. The results can produce some decorative and suggestive fantasies.[92]

Of the everyday subjects in Etruscan art the most conspicuous are those on the tomb paintings, notably the symposion and komos (song and dance) which closely follow Greek models. Even the depiction of the laying out of the dead (*prothesis*) in the Archaic period is surprisingly dependent on Greek scenes.[93]

The association of depictions of feasting on couches (*klinai*) with death are complex. Generally, the solitary feaster is like an eastern ruler, holding court, and provides a model for some Greek heroes in the Archaic period (Achilles, Herakles) and thereafter for an indication of heroization after death. The full symposion, with several feasters, is real life, and in a funerary context might refer to the good life enjoyed before death, or, if there are other indications to support it, prospects for a good afterlife.[94] The question is bedevilled by the fact that in the Greek world the same furniture (*klinai*) was used for sleep, the laying out of the dead and the group symposion.[95] The real *klinai* in Etruscan tombs and monuments of reclining couples as [7.15,33,34], carry a funerary connotation even where the figures are shown alive and feasting. Group symposia, which are not all that common in tomb paintings, might refer to life or afterlife, but probably the former, along with athletic scenes and the like. Some more specific symbolism may be contained in scenes such as that of the diver, echoed in a very Greek painting (accompanied by a full symposion) for the tomb of a native neighbour of the Greek colony at Paestum.[96] But it remains a question whether the life scenes were adopted from Greek art in Etruria with as little relevance to local behaviour as the myth scenes must have borne to Etruscan religion. It is, however, at least likely that the more congenial aspects of Greek life – drinking, dance, athletics (but not nude athletics)[97] – were admitted by Etruscans along with the many trappings (table furniture) and iconography.

Several of these examples of Etruscan use of Greek iconography have been fifth-century and we turn now to the question of the appearance rather than content of Etruscan arts down to the time when Etruria is absorbed by Rome. The political and social situation may be recalled, after the hostilities with Greeks in the early fifth century. Etruria's continuing prosperity is less obviously signalled by Greek import or heavily hellenizing works, nor need we expect it to be. In the fourth century things start to go wrong. The Etruscans had lost their grip on Campania to the south, Roman power was inexorably spreading and Veii was sacked, the Gauls raided Rome, Greeks from Syracuse sacked the pirate stronghold at Pyrgi; Roman penetration continued and was absolute by the end of the third century, but without much disturbing the local craft traditions of the Etruscan cities.

Greek art of the first half of the fifth century had achieved the Classical revolution described briefly in Chapter One. The human figure was presented with growing realism, thanks to more careful perception and understanding of anatomy, with no lessening of concern with composition, proportion and narrative. Etruria was drawing

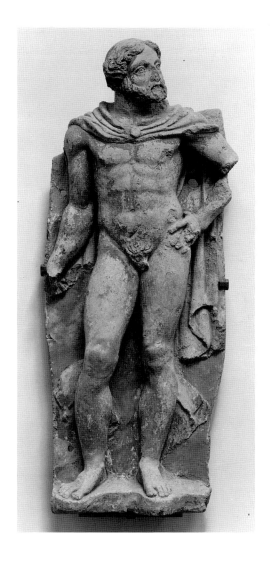

7.30 Clay figure from Orvieto (Orvieto)

back from the Greeks in these years, as we have seen, but the import of Greek goods diminished without drying up. In a new Etrusco-Greek town on the upper Adriatic (Spina), there is a strong flow of imported Athenian vases. It was possible still for an Etruscan, perhaps a merchant, to bespeak in Athens a vase carrying a gift inscription in Etruscan.[98] But Etruscan artists ignored the new developments in Greece, although they were apparent enough in the products of their Greek colonial neighbours. The Archaic idiom is maintained to at least the mid-century; only then do some of the new relaxed, realistic poses begin to be copied in the finer bronzes and clay figures. It seems, however, to be a matter of the influence of appearance rather than understanding. The figures generally remain flat-footed, however well executed technically, and it takes time for a true Classical style to be adopted with any success. When it is, the native traits of strong expression and theatricality seem almost at odds with the idealism of the Classical. Examples of anything closely resembling the Greek Severe Style (Early Classical) are rare indeed in Etruria.[99]

7.31 Bronze head from Bolsena (London)

7.32a,b Clay heads (Rome)

Later in the century Etruscan artists catch up, but often in an eccentric and dramatic way. For work which in part comes close to the Classical norm consider the strongly expressive head on the ideal body of the clay figure [7.30].[100] And the bronze head from Bolsena was not possible without the Classical revolution of Greek art, yet is totally distinct from it [7.31], and may be as late as fourth-century in date.[101] Perhaps this is Etruscan art come of age, and even the most hellenizing subjects and groups can display

7.33 Sarcophagus lid (Boston)

7.34 Clay group on ash urn (Volterra)

7.35 Pediment from Talamone (Florence)

7.36 Bronze Ficoroni cista (Rome)

7.37 Bronze goddess (London)

a robust individuality that has left behind mere copying.[102] In sculpture we can follow this through to some remarkable clay and bronze figures of the fourth century and later that are portraits, though not perhaps quite in the Greek or modern sense of the term. These very probably made a significant contribution to the new attitudes to portraiture fostered by Rome and have their roots in a form of ancestor-worship very different from that of the Greeks. And with the approach of the Hellenistic period and its new use of expression in posture, body and head, there are direct Etruscan responses, notably in clay [7.32].[103] The narrative vigour is retained for the relief decoration of burial urns, a prolific group of which is formed by the products of Volterra, often in alabaster, and the stone and clay sarcophagi of other cities with their characteristic recliners on the lids [7.33].[104] Our last look at the non-Greek yet Greek-rooted expression of Etruscan funerary portraiture [7.34][105] is a final declaration of freedom from the Classical Greek, while carrying something of the realism of contemporary Alexandrian art. The clay architectural sculpture of the period outdoes all that has gone before in ambitious composition. A pediment at Talamone presents, yet again, the Seven against Thebes, setting the figures on plaques up and down the field [7.35] in a manner practised for a while in fifth-century Greece for wall painting, then taken up by vase painters, but barely intelligible in a pediment.[106] An earlier treatment of the subject at Pyrgi also had

figures massed horizontally so there may have been a continuing tradition for this in Etruria, long abandoned in Greece where it was not used for pediments, but to be taken up again in Roman art.

One or two other genres of the fifth century and later are worth describing for what they tell of response and non-response to Greek art: bronzes, glyptic and painted pottery. Mirror backs, incised rather than in relief, continue as an important medium for work good and bad well into the third century, and offer as wide a range of mythological themes as any other medium, often with inscribed names.[107] Through them we trace in greater detail the problems posed by the scenes both on the mirrors and on other objects already discussed. In the fourth century begins production of an another important series of bronze objects decorated with comparable incised figures. These are cylindrical boxes (*cistae*) with figure-decorated walls and lid, and cast figures serving as handles and feet. The centre of production seems to have been Latin Praeneste but the style falls in with the prevailing Etruscan tradition for the technique. The example shown is the best and the most informative [*7.36*], the Ficoroni cista.[108] The style seems pure Greek and the scene, an episode on the expedition of the Argonauts, is composed in the manner we imagine employed for murals in Greece with figures set on a variable groundline. If so, it copies a manner which we also believe to

7.38 Chimaera from Arezzo (Florence)

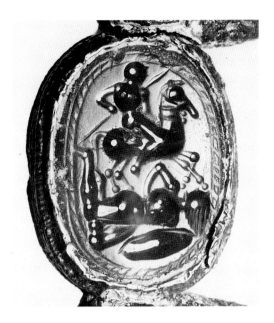

7.39a,b Carnelian scarabs (Oxford)

have gone out of fashion in Greece by the fourth century, in favour of panel pictures, though it may have been retained for objects requiring friezes, such as this. Some figures recur on other works in Italy, bronzes and vases, so the original may have been visible in Italy. Apart from its quality there is the unique feature of its artist's signature. This, in Latin, reveals that it was made by Novios Plautios, in Rome, to be given by Dindia Macolnia to her daughter. Plautius was a common name in Praeneste, where the cista was found and where the artist must have practised or learnt his craft; we would dearly like to know from whom he learned it, to become so accomplished an exponent of Greek Classical draughtsmanship, and there is other work on cistae from other hands, just as good. We have no reason to think that he could have been a naturalized Greek, and so he demonstrates how unwise it might be to assign what looks to us like pure Greek work always to Greek hands. By Plautius' time some studios in Italy were practising and teaching Greek art in a manner indistinguishable from that of the native Greek.

In other bronze production the continuing interest in furniture – lampstands and tripods – decorated with cast bronze figures and groups, provides a good range of works of broadly classical style and highly accomplished workmanship;[109] for example, an Etruscan snake-handling goddess of Greek aspect [7.37].[110] The Arezzo Chimaera [7.38] is a superb and monumental version of the smaller animal studies in bronze in which the Etruscan artists matched and sometimes surpassed their Greek models.[111]

Scarab production continued through into the Hellenistic period. In Etruria the scarab form was never abandoned although eventually flat ring stones for setting in metal hoops were also made in the same style. In Greece, from the early fifth century, the scarab had been virtually abandoned in favour of the larger scaraboid, which

allowed of a different disposition of the figure intaglio, no longer crushed into an Archaic frame. The Etruscan scarabs still have their fancy beetle backs and the figures crammed into the small oval fields. Late and sub-Archaic anatomical studies were as accomplished as any Greek [*7.25*], and went on being made for a long time before classical poses and subjects were adopted [*7.39a*]. In the fourth century, in Etruria or perhaps Latium, there was what seems almost a regression to a technique-dominated style [*7.39b*] – *a globolo* – which is thoroughly un-Greek and survives into the second century. From all this emerged the Hellenistic styles of glyptic used in Republican Rome.[112] Etruscan jewellery, meanwhile, developed with more regard to its own strong tradition in techniques and forms than to contemporary Greek.

Vase painting has proved itself a revealing craft in the Archaic period, being prolific, in widespread use in the community, and informative from its figure work about sources and influences. In the last quarter of the sixth century Athenian artists developed the red figure technique and the Etruscans proved ready customers for the vases, more ready than most Greek cities seemed to be. The black figure styles continued to be made in Etruria, pervaded more with Ionian style than Athenian, but soon the appearance of the new technique, with light on dark (red reserved in black) figures, attracted attention in Etruria and was copied through the first half of the fifth century (mainly about 480–60 BC). But the technique itself was not copied, and the figures are painted in red on a black-painted vase and not reserved in the red clay with the black background painted in, as in Athens [*7.40*].[113] The result is really just a forgery of Athenian, however carefully done; it may have fooled an ancient customer, and the fact that the attempt was made says much for the value (probably monetary too) that was set on the Athenian

7.40 Praxias Group vase (Florence)

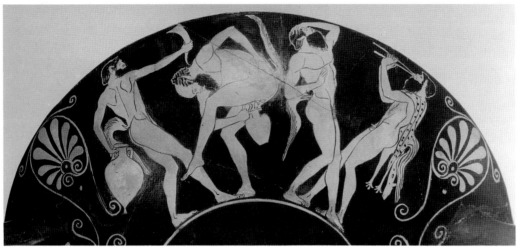

7.41a,b Athenian red figure cup (Vatican)

7.42a,b Etruscan red figure cup (Paris, Rodin)

7.43a,b Etruscan red figure cup (London)

7.44 Etruscan red figure cup (Paris, Bibl.Nat.)

7.45 Etruscan red figure stamnos (Oxford)

products. The few inscriptions on these vases (the Praxias Group) are in Greek, but in Euboean not Athenian letters, so if they were copied from Athenian vases the letter forms were adjusted to the more familiar Euboean alphabet, which was the source of the Etruscan.[114]

Before the mid-century real red figure was copied, often literally copied, as we may judge by the lucky survival of both the Athenian model (found at Vulci) and its Etruscan lookalike [7.41,42].[115] The way the Etruscan has omitted the figure being belaboured by the man with a sandal in his hand suggests that he was not thinking very hard about what he was copying. For the rest of the fifth century there was continuing production of red figure, probably at Vulci, but activity increased in the fourth century, probably under the stimulus of the new red figure schools of the Greek cities in South Italy. At Latin Falerii the fourth-century Faliscan vases may have started under more direct influence from Athens, probably immigrant in origin rather than the product of copyists.[116] As the fourth century wore on, and into the third, production spread to northerly cities, Chiusi and Volterra. One northern product is shown in [7.43][117] and does something to support the commonly held view (also in antiquity) that the Etruscans had a taste for sensuality. They are the first to show the goddesses in the Judgement of Paris naked, and though the three here are not the goddesses they show well how total nakedness may be made the more piquant by the wearing of boots and jewellery. The figures on the outside of the cup are from a different, *art nouveau* hand. There is little point here in distinguishing Athenian from South Italian sources; they were equally intelligible. But the products diverge from their models in interesting ways. The subject matter in particular adopted a native air; not merely Etruscan figures but an Etruscan view of

7.46 Etruscan red figure crater (Paris, Bibl.Nat.)

Greek ones. Only an Etruscan would have thought of the Minotaur as a baby [7.44].[118] On the stamnos [7.45] an impertinent Ganymede flashes at Zeus under the gaze of a cynical Eros perched on a rock.[119] The later vases owe more to South Italy in appearance but are very Etruscan in their treatment of Greek myth. The couple on [7.46] are identified as Admetus with Alcestis, who in the Greek story cheated premature death, but now they are threatened by two very Etruscan death demons.[120]

Tomb painting in the Classical period does not decline but, in common with sculpture, barely keeps in touch with developments in Greek art. The late fourth-century Tomba François at Vulci and the second-century Tomba del Tifone at Tarquinia [7.47] catch something of Hellenistic Greek styles in shaded drawing and painting with some appreciation of how to render figures in the round.[121] Otherwise we find more linear, though highly coloured figures which match fourth-century Greek red figure [7.48], both on walls and a few painted sarcophagi,[122] developing into a more

7.47 Painting from Tomba del Tifone, Tarquinia

prosaic narrative style[123] not unlike that met in other outlying areas of the classical world, even at much later dates. We should probably assume a readiness to continue to commission Greek artists to execute and instruct.

The illustrations to this section have naturally given a somewhat one-sided view of Etruscan art, corrected, I hope, by the commentary in the text. The influence of Greek art was strong at a certain level – fairly humble – from the very beginning, competing with that of eastern art and artists, more favoured for luxury products. From about 600 BC on Greek art was dominant and appears to have affected virtually every medium except for basic architectural forms, though it was highly influential in matters of architectural decoration. So is Etruscan art no more than a copy of Greek art in the hands of artisans who appreciated nothing more than its appearance and failed totally to absorb its essence? That they did not follow Greek views on proportion and composition is hardly surprising. Nor did any other people borrowing from Greek art that we survey in this book. Indeed, it is the deliberate or instinctive taste for distortion of natural forms and bizarre coloration that give Etruscan art its distinctive quality. On the other hand, no other people (apart from the Romans) seem to have surrendered so wholeheartedly and we have to ask what they sought to express and how the foreigners' art served their very different culture.

That the adoption of Greek artistic idiom was accompanied by adoption of any more profound Greek way of life seems highly unlikely. Drinking habits may be fairly

7.48 Painting from Tomb of Orcus I, Tarquinia

conspicuous in the archaeological and iconographic record but they are hardly as fundamental to society as some scholars may claim. The Greek iconography of the symposion had been adopted by the Etruscans, as we have seen, and it is likely that the custom of reclining to feast was adopted too, but in Etruria with wives present; and the use of the motif in funerary contexts may have had little or no relationship to the way the Greeks came to use the motif (generally much later). Everything suggests that Etruscan religion and views on death were very unlike the Greek. What is surprising is that the Etruscans seem to have had such an unformed view of their own gods that they were able so readily to assimilate them to Greek gods and adopt at the same time their Greek attributes and stories; that they had so little by way of any strong mythical tradition that they were ready to accept Greek myth wholesale and never use the narrative idiom that they had learned to express Etruscan myth, although they used it to depict peculiarly Etruscan figures, usually death demons. Had they no thinkers, no imaginative literature beyond precepts for divination?

In Greece myth served to comment on life. Is it possible that Etruscan choice of Greek scenes to cherish and their placing of them indicate some comparable understanding of their suitability? This is almost impossible to prove. Death scenes are appropriate enough to tombs, even violent death, and the subjects were well used in Etruscan painting and relief, especially on the sarcophagi and ash urns of the later period, barely noticed here, where the gorier Greek myths are strongly in evidence. But

there is no obvious use of myth to suggest heroization of the dead or to hint at a desirable afterlife. The life scenes of feasting, sport and dancing probably do little more than reflect on the life style of the dead without intimations of a good life to come, and many may indicate as much copying of Greek art as of Greek manners. That specific stories or heroes or gods could be used to express views about dynastic or civic power, as they were in Greece and were to be in Rome, is not beyond belief but, without the Greek example, it would not have been possible from the monuments alone even to suspect such a thing,[124] as it is in Greece. To the student of Greek art this failure of the Etruscans to appreciate its social potential as well as its artistic integrity must always be a disappointment. Etruscan artists had minds of their own, exercised choice, and developed an aesthetic of their own, but ultimately all depended on Greek models and Greek example.

B Rome

Rome was the intermediary for Greek art to the later western world and made her own special contributions to the tradition. This is not a subject for this book. For the following pages we must shake off the numbing weight and apparent inevitability of the Roman Imperial Achievement and its classical legacy. When Romans first met Greeks Rome was just another township, of less account probably than other towns of Latium and certainly of less account than the Etruscan cities nearby. Romans were exposed to hellenism in much the same way that the Etruscans had been. In the centuries before the establishment of Empire the Roman genius for organization, expansionist and opportunist, created a form of 'Democratic Republic' more on the modern pattern than the Greek. It depended increasingly on a well-structured civil service which could never overrule the inspiration provided by strong politicians and generals. It evolved through its ability to resolve the problems of a fairly basic class struggle, a balance achieved or imposed by good sense, some bloodshed, and the distractions of the profits offered by conquest. What we need to look for in the early history of Rome and its Republic are the sources of knowledge of Greek art in Rome and the nature of the patronage which determined what might be borrowed or copied by artists serving Rome. It was even an ancient commonplace that Greece was the cultural victor over its Roman masters, but was the Romans' choice any broader and more discriminating than, say, the Etruscans'? Was it a walk-over for Greek art? We need to remember that the Romans were not in some way derived from the Greeks, that Latin and Greek are different languages, that Roman attitudes to Greeks ranged from contempt, through indifference, to blind adulation.[125]

We deal with five roughly definable periods in the history of Roman art, the transitions not always corresponding with important historical events: the first, with Rome in a fully Etruscan mode and ruled by kings, to about the end of the sixth century, corresponding with Greek Archaic and the age of tyrants; the second, more austere, hardly less Etruscan, down to the middle years of the fourth century, the Classical age of Greece; the third, barely divided from the second, to towards the end of the third century, far more actively aware of Greek arts in Italy and of the incipient Hellenistic

style; the fourth, overwhelmed by Greek art, artists and ideas, down to the second half of the first century; finally, the early principate, the beginning of Empire, with new roles for the borrowed contemporary and earlier arts of the Greek world. For the third century on the discussion will be summary, dwelling on aspects relevant to our present enquiry, since the subject matter is essentially a chapter in the history of Greek and Roman art.

The territory of Latium, of the Latins, lay south of the Etruscan cities, around the River Tiber and inland, and to the south, approaching Campania, where Greeks had first settled on the Italian peninsula in the eighth century BC. This proximity to Greek towns should have played no small part in Latin awareness of Greek art, but it is not clear that it did, at least in early days when Campania was itself living very much in an Etruscan mode. Most Greek access to Etruria was probably conducted coastwise rather than overland, however, and the Latins may have learned more of Greeks from their presence in Etruria than from the Greek cities themselves. Thus, the early archaeology of the Latin town Praeneste and of Faliscan (akin to Latin) Falerii strongly reflects that of the Etruscan cities, with the same influx of oriental and orientalizing goods in the seventh century and the strong undercurrent of Greek forms and patterns observed in the last section; a mixture, in fact, no less apparent in some princely tombs of Campania itself (Cumae and Pontecagnano).[126] This is why this record has been considered together with that of Etruria in the preceding section. But the Latins were of a fundamentally different temper. This is clear from the dramatically warlike character of the content of their tombs, and the absence of some of the more striking features of Archaic Etruscan art – notably the painting.[127] Early Rome now presents a similar pattern to that of the better known Latin towns, with Greek import of Late Geometric Euboean pottery, through Protocorinthian to Athenian black figure.[128] It may, however, have been somewhat slower to put itself together as a city-state than even some of its Latin neighbours.[129]

From the end of the seventh century on the archaeological record becomes far richer, corresponding with the historical record of the presence of an Etruscan king, Tarquinius Priscus, who was of alleged partial Greek descent (see above, p. 228). The sixth century sees, at minimum, a Latin king, Servius Tullius, who had married into the Etruscan royal family, and a final Tarquin, the Proud, who was expelled in 509 BC, the traditional date of the inauguration of the Republic. 'Etruscan Rome' seems to have become an unacceptable term for some historians, understandably in the light of many distinctive elements of Rome's institutions, culture and behaviour; yet its sixth-century kings were mainly if not all Etruscan and its art long remains closer to that of Etruria than that of Greek Campania or of any other Greek source of artistic influence in central Italy. If the Latins' language and life remained quite distinct from that of Etruria, still the visual experience of our early Roman was mainly, indeed wholly, Etruscan, a matter of some importance to my subject and presumably not a matter of indifference to him or her. The new temples of the sixth century were Etruscan in form and decoration. There are even clay revetment slabs from the same moulds as those used for buildings in Etruscan Veii and Velletri [7.49], but these are more likely to have originated in Etruria than in Rome.[130] When Servius Tullius built a temple for Diana on the Aventine hill, to serve as a federal temple for the Latin League, its cult statue (of Diana/Artemis) was

7.49 Clay architectural relief from Rome

said to copy that in Greek Massilia (Marseilles), itself a copy of the Ephesian Artemis. The last Tarquin planned a great temple to Jupiter Capitolinus (a ground plan of over 56 x 61 m), for which the Etruscan coroplasts from Veii were invited to make the clay chariot on the roof; one of them, called Vulca, made the clay image of the god.[131] Vulca was heir to a strong tradition in Etruria, introduced or encouraged by Greek immigrant artists. His style might perhaps be judged from the near-life-size Herakles and Athena (Minerva) from the roof of a Late Archaic temple near the Forum [7.50],[132] if not from the famous Apollo of Veii. Already there is a strong admixture of pure Greek style, but no more than is detectable in Etruria. The Romans seem to have found it relatively easier than did the Etruscans to assimilate their gods to the Greek, to admit both their physical appearance and the nexus of myth that accompanied them. The progress of adaptation to Greek art, in both form and content, was somehow smoother in Rome, but it was by no means rapid and it was conducted at the speed dictated by hellenizing developments in Etruria. Perhaps it was simply more passive. We still lack clear evidence for direct Greek intervention in this process as early as the sixth century, rather than the enlightened patronage and example of hellenized Etruscans.

The spate of temple-building continued through the first years of the fifth century, to judge from literary records from which suspiciously close dates can be derived, but also from excavation of buildings which cannot always be identified. We hear of Greek artists, Damophilos and Gorgasos, providing painting and clay sculpture for the Temple of Ceres (Demeter; '493 BC'), their contribution being recorded on the building in a Greek inscription.[133] The young Republic had a troubled time but temple-building requires resources of men and money. Historians are understandably perplexed by this period and by the confident dates derived from later sources for building and reforms in Rome. There was no written Roman History until about 200 BC – by Q. Fabius Pictor, written in Greek, and lost. There were lists of magistrates and Annals relating to the early period, but anything too orderly in what is literally pre-history has to be treated

7.50a,b Clay group of Herakles and Athena from Rome (Rome)

7.51 Bronze wolf from Rome (Rome, Capitoline)

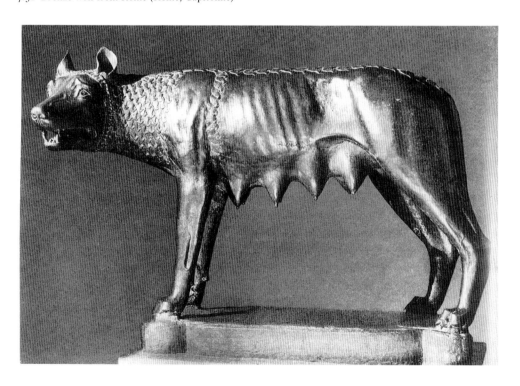

7.52 Bronze discus from Praeneste

with circumspection. If the dates are right, the Etruscan mode in Rome certainly survived the last Tarquin by many years.[134]

Apart from the temple plans (which are not Greek) and the clay sculpture and revetments (which are basically hellenizing Etruscan), there is little to show for late Archaic Rome to answer our quest.[135] The finer pottery used is Etruscan with no exceptional import of Athenian vases.[136] The famous bronze Capitoline Wolf [7.51] exemplifies the dilemma.[137] It is first attested in Rome in the 10th century AD. Pollaiuolo provided a Romulus and Remus for it in the fifteenth century, by which time its tail had been restored as well as part of its dugs. That it has anything to do with a wolf figure recorded as being set up and supplied with twins in 296 BC is improbable. Its style seems high-quality Etruscan and there can be no reason for believing it a Roman product, yet it has become a modern icon for early Rome.[138]

It would be satisfying if we could demonstrate that in the following period the Etruscan was accompanied by or gradually replaced by a mode more truly Greek, but the physical record of the following century or more is bleak in the material that might be most revealing.[139] Sumptuary legislation, revealed in the Twelve Tables, the law code drawn up in the mid-fifth century, restricted grave offerings, though we may suspect that there may have been little enough of artistic merit to put in graves anyway, in a city much concerned with internal dissent, defence and expansion. If there were indeed artisan guilds (*collegia opificum*) as early as the sixth century we can only speculate about their skills. In 390 BC a raid of Gauls from the north sacked Rome. The effect ought to have been devastating but is so far imperceptible archaeologically, and it may have involved Rome in no more than some need for local rebuilding. However, we hear nothing about restoration of destroyed temples, and the next spate of temple-building, in the early third century, seems devoted mainly to new structures.[140]

All of Latium fell under Roman rule in these years, and towns other than Rome may be more revealing. Lavinium is particularly important since the site was associated with a variant foundation story for Rome involving the arrival of the Trojan prince Aeneas,

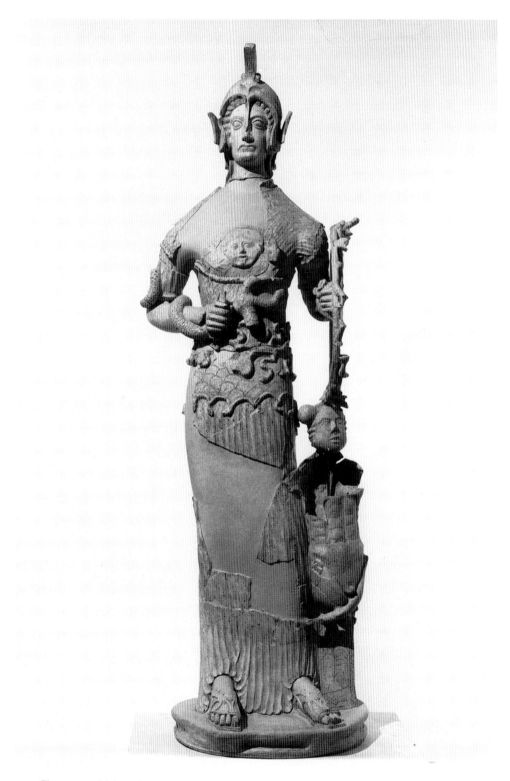

7.53 Clay statue of Athena from Lavinium

intent on creating a new home. Rome had found a Trojan rather than Greek myth-historic founder, it seems, but of course derived from Greek epic. The association with Aeneas may be an old one at the site, adopted by Rome and even grafted onto a Romulus story.[141] A sixth-century Greek had made one Latinos ruler of Etruria,[142] but the Aeneas connection with Rome (to be so well exploited by Virgil centuries later) may go back no earlier than the late fifth century and we may well suspect no little Greek mythographical help in the creation of such associations. A tomb of near the mid fifth century contained fine Etruscan armour, the strigils and oil bottles that Greeks had ordained as the essential equipment for the active life of a gentleman, and a bronze athletic discus with incised figures and decoration [7.52] strongly reminiscent of the style of the Greek makers of Caeretan Hydriae in Etruria (as [7.11]; notice too the ivy) of somewhat earlier years.[143] A sanctuary at Lavinium has yielded an important series of clay statues mainly of fifth- and fourth-century date of which I show one of the grander specimens – more than life size [7.53]. It is an Athena (= Minerva, known to have been worshipped there later), her heroic shield trimmed with snakes (as her aegis should be), clutching a triple-headed snake and accompanied by a small man-fish (Triton).[144] The iconography is distorted Greek of Archaic inspiration (whatever the date of the figure). It can owe nothing to contemporary Greek treatment of the goddess but would not have been out of place in Etruria where such styles and motifs died hard, as we have seen. It suggests strongly that what I have called the Etruscan mode continued in Latium for more than architecture, and well into the fourth century.

It is at another Latin city, however – Praeneste – that we may begin to glimpse the more fully hellenizing aspect of the later fourth and third century. The Ficoroni cista

7.54 Sarcophagus from Praeneste

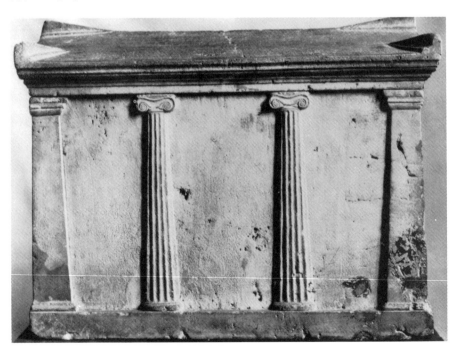

7.55 Bronze mirror from
Praeneste

[*7.36*] has been discussed already: although its Latin inscription proclaims that it was
made in Rome, its form is Praenestine. (Rome would surely not have been mentioned if
such cistae were normally made there.) It is such a fine demonstration of the quality of
work that could be done in a basically Etruscan genre that it was better considered in the
last section. But at Praeneste itself in these years we find Etruscan mirrors, Greek
strigils with Greek stamps on them, and one particularly revealing tomb which took the
shape of a Greek building decorated with Ionic columns [*7.54*], and contained a Greek
strigil with a naked woman as handle, and an Etruscan mirror.[145] Another mirror from
Praeneste [*7.55*] recalls the cista for the Greekness of the subject (satyr Marsyas and
baby Pan, Paniskos) and for its Latin inscriptions, this time announcing its maker: *Vibis
Pilipus cailavit* = *Vibius Philippus caelavit*. The Vibii were an important native family,
Philippus suggests that the craftsman was a Greek in their household, *caelavit* is the
technical term for engraving.[146]

 We return to Rome. If the presence or arrival of foreign craftsmen there, and their
effect, remain obscure, there is another aspect of the Roman's visual experience of his
city that can be documented and another source for the city's embellishment that will
prove of the greatest importance – loot.[147] The sack of Veii in 396 resulted in the
removal of treasures of the gods, and the gods themselves; a statue of Juno is mentioned,
reverently handled. This could only have reinforced the Etruscan appearance of the city
at a time when there was renewed temple-building.[148]

7.56 Bronze head from Rome (Rome, Conservatori)

7.57 *(below)* Sarcophagus of Scipio from Rome (Rome, Vatican)

Other Greek forms and objects intrude more and more as the fourth century wears on. It is difficult to know what to make of the report that statues of the Greeks Pythagoras and Alcibiades were set up during the Roman wars with the Samnites (to the south, bringing Rome into closer contact with the Greek cities), and that this was at the suggestion of the Delphic oracle. But presumably they were Greek portrait statues, and after 285 BC the Greeks of Thurii in South Italy set up a statue in Rome for a magistrate (tribune) who had helped them by passing laws against their enemies. In 338 BC there is

7.58a,b Clay altar and mould from Rome (Rome)

7.59 Clay head from Rome (Oxford)

record of the first statues set on columns and equestrian statues. Gradually, it seems, Greek statuary practices as well as appearances were being adopted. There had been a long tradition of setting up commemorative statues of famous men, starting under the kings, and this, combined with the Roman practice of keeping wax busts of their ancestors for commemorative and funerary occasions, might lead us to think that a developed local art of portraiture was flourishing. There is nothing to support this, beyond what has already been remarked about Etruscan Classical heads in clay. If the famous bronze 'Brutus' [7.56] was in fact made in or for Rome in the third century, I find it more easy to relate to something Greek-inspired, like the gift of the Thurians, than evidence for an accomplished local art.[149] Scholars' observations of nuances of style, Greek or non-Greek, have been highly subjective and accordingly contradictory. We would give much to know the appearance of or even the sculptor's name of the colossal Jupiter made from the bronze armour captured from Samnites by consul Spurius Carvilius in 293 BC. But when the Scipio who was consul in 298 was buried he was laid in his family tomb on the Via Appia in a stone sarcophagus carved with the purest Greek architectural mouldings [7.57] such as were perhaps beginning to appear on major buildings too.[150]

Other works found at Rome, in clay, in the round or relief, do not go much beyond the quality or style of contemporary Etruscan products, but they are prolific and often of fine workmanship. The small clay relief altars (arulae) are a type met all over South Italy in these years, depending on Greek models and, some of them, on Greek moulds [7.58a]. There are many in Rome, and part of a mould [7.58b].[151] With them go architectural antefixes of the same style, larger clay votive heads, more like the Etruscan, but also finer works in the round, like the Oxford head from the Esquiline [7.59].[152] For the last at least it is not difficult, but perhaps wrong, to posit a Greek hand, so accurately does it reproduce Greek fourth-century style.

Painting was regarded as a less than banausic art form in antiquity. C. Fabius Pictor, of noble family, is recorded as decorating the Temple of Salus in 304 BC – our first true Roman artist, but strongly hellenized, we may imagine. A military Fabius is involved in a painted scene from a tomb on the Esquiline of about this date, done in what seems a pure if dull provincial Greek style [7.60].[153] A century later a kinsman, Q. Fabius Pictor, was writing the first History of Rome – in Greek – in imitation of the popular Greek genre of local histories.

At a lower level of expectation, we find Rome using the poor imitations of Athenian red figure vases made by nearby, subject Faliscans, and there is no good evidence for any notable Roman production. Exceptions may be some plain black wares, 'Herakles cups' with relief medallions copying Greek coins showing the hero who was becoming of increasing importance in Rome, and *pocula*, black cups with added-colour figures and naming Latin (Roman) gods [7.61: naming Juno].[154] The way the subjects of the *pocula* generally do not match the gods to whom they are to be offered says something about the attitude to the Greek figure motifs employed. There was no market for South Italian, even Campanian, red figure.

Nevertheless, Roman attention was being drawn inexorably south, first to Campania. Here Etruscan interests had been effectively displaced after the Greek defeat of an Etruscan fleet off Cumae in 474 BC. Rome did not exactly fill the vacuum but when the

7.60 Painting from the Esquiline, Rome (Rome)

7.61 Clay cup

Samnites provoked hostilities in the fourth-third century they were crushed and Roman control in Campania was assured. The Greek cities had already begun to play a greater part in introducing Greek art and artists to Rome, some effects of which we have observed: one result was the first Greek-style silver coinage naming Romans, first in Greek, then Latin, minted in Campania and soon to be followed by minting in Rome;[155] another was the building of the Via Appia from Rome to Capua, a characteristically practical foundation for empire-building. The next quarry was the Greek Pyrrhos of Epirus, who saw himself as a new Alexander, liberating western Greeks. Rome fought him from 280 to 270 BC and soon won control of Greek South Italy. In the triumph after victory in 275 they carried off 'richly adorned statues of gold and charming Tarentine painted panels', but they left the divine statues: 'let us leave these aggrieved gods to the Tarentines', said Fabius. Such forbearance was shortlived.

The distinction between the Classical period in the hellenizing of Roman art and the following one is, at its baldest, the difference between carrying off familiar Etruscan statues and the deliberate plunder on a large scale of Greek ones. War with Carthage (the Punic Wars) brought Roman arms into Sicily, and the rich city of Syracuse, which had sided with Hannibal, was sacked in 211 BC. 'When the Romans recalled Marcellus to the war with which they were faced at home, he returned bringing with him many of the most beautiful public monuments in Syracuse, realizing that they would make a

visual impression of his triumph and also be an ornament for the city. Prior to this Rome neither had nor even knew of these exquisite and refined things, nor was there in the city any love of what was charming and elegant; rather it was full of barbaric weapons and bloody spoils; and though it was garlanded with memorials and trophies of triumphs, there was no sight which was either joyful or even unfearful to gentle and refined spectators.' We must excuse a gentle and refined and thoroughly prejudiced Greek, Plutarch, for this unflattering view of early Rome, but it is a Roman historian who summarizes the effect – 'it was from these that one can trace the beginning of the craze for works of Greek art and, arising from that, the licentiousness with which all places everywhere, be they sacred or profane, were despoiled.'[156]

The treasures of the Greeks in Italy and Sicily were only a start. In the second century the arena was Greece itself and the Hellenistic kingdoms of Asia Minor. The gold and silver vases for each triumph were reckoned in tens of thousands of pounds-weight and paraded through Rome. For the triumphal procession following a victory in west Greece (Aetolia, 189 BC) 285 bronze statues and 230 marble ones were carried. For another, after victory in Macedonia (Pydna, 168 BC), 250 wagons were needed on each of two days to carry the paintings, statues, plate and armour. The plunder culminated in the sack of Corinth in 146 BC. Spoils of victory have been, in a way, sanctioned by history, at least until recent years, but this was not to be the end of the spoliation and enrichment of Italy at the expense of Greek cities. The Romans made a point of claiming that the victors themselves and their homes were not the main beneficiaries of this behaviour. The monuments and statues went to decorate Rome itself, its temples and public places. Metellus, another victor in Macedonia (148 BC), created a portico complex in Rome with two new temples, one alleged to be the city's first in marble, and placed before them the statuary group of cavalry (apparently more than twenty-five figures) made by Lysippus for Alexander the Great to celebrate his victory at Granikos.[157] But I cite merely samples of the rich record. Archaeological evidence for it is slight, but a mid-fifth century Greek pediment which had been placed on the Temple of Apollo Sosianus has been recognized in recent years [7.62].[158] It may be from Eretria (sacked in 198 BC; its yield of statues and paintings is remarked by Livy) and certainly from Eretria is an Archaic figure from the city's temple pediment, taken to Rome in antiquity.[159]

The depredations continued throughout the history of the Republic and beyond, but in the first century BC two other factors increased the flow of material beyond the immediate spoils of war and fruits of victory: theft by Roman governors in occupied territory, and a positive interest in building private art collections. The two go together. The most notorious and ruthless of collectors is known to us through Cicero's prosecution of him (70 BC) following complaints from Sicily. But Verres had turned to Sicily only after several years of collecting in Greece and Asia Minor. 'I affirm [said Cicero] that in the whole of Sicily, in a province which is so wealthy and old, which has so many towns and so many rich family estates, that there is no silver vase, neither Corinthian nor Delian, no gem or pearl, no object of gold or of ivory, no bronze, marble, or ivory statue, no picture either painted on a tablet or woven in a tapestry, which he has not sought out, inspected, and, if it pleased him, stolen.' Another aspect of his collecting is of archaeological interest since Cicero says that he also had a workshop in Syracuse in

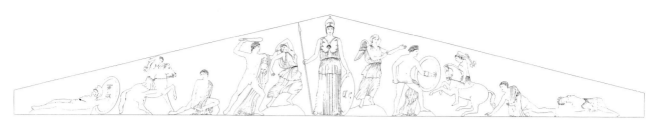

7.62 Marble pediment from Temple of Apollo Sosianus, Rome (Rome, Conservatori)

which a variety of gold objects were cannibalized for their decorative appliqués and ornaments which were then inlaid in gold bowls: a form of re-cycling art which is met at other periods and places in the classical world.

Cicero was a collector himself, and his correspondence with his friend and agent in Athens, Atticus, has a decidedly modern ring to it.[160] He had to pay for his statues and drove a hard bargain, exercising a very practical form of art criticism: 'You compare these Bacchants with the Muses of Metellus. What is similar about them? To begin with, I would never have thought that even those Muses were worth so much, and the Muses would probably have agreed with me.' Cicero was mainly concerned with interior and garden decoration. Others were more specialized and we hear of collections of gems – mainly stones, engraved or not, set in finger rings – but these were being collected also in the Hellenistic kingdoms; Pompey the Great dedicated in Rome the collection of King Mithradates (Asia Minor). Special shows were mounted in Rome in which works in public ownership were joined by loan pieces from private collections. After the sack of Corinth a particular vogue for 'Corinthian bronzes' is recorded.[161] The Art World, its jealousies, deceptions, preciosity and big spending, was born in first-century Rome. And, perhaps for the first time in the history of art, artists bent their attentions to serving it. Art for Art's sake had arrived; meaning, Art for the self-esteem of collectors and the financial profit of dealers and artists.

The Romans' satisfaction at the new sculptural decoration of their city had naturally bred a greed for more, but it need not have also generated an interest in the production of comparable works at home or a readiness to employ Greek craftsmen. Yet this is what happened, and the work of Greeks for Romans in Italy kept pace with the acquisition of works of art from Greek lands. It should be remarked, however, that the works plundered were the products of the Classical period of Greek art, the fifth and fourth centuries, as well as works in the developed Hellenistic style. It looks as though the Classical were preferred and were perhaps more numerous and accessible to the looters in Italy and Greece. Many were also associated with the names of artists whom the Romans soon learned (from Greeks) to regard as the greatest masters of the arts. From texts alone we may count in Rome two works each by Phidias and Polyclitus, four by Scopas, fourteen by Praxiteles, and many others since our roll-call of Greek artists depends very much on the texts (notably Pliny's) which also record for us the new, Roman homes for their works.[162] But the artists who now came to Rome worked in the new, not the old styles. We may well suspect that their arrival was as much at their own

initiative as at Roman invitation; craftsmen, especially Greeks, can be good businessmen and Rome was generous in matters concerning the rights of allies. No doubt many were not averse from advising or serving the trade in originals. And as good businessmen who perceived that the prevailing taste was for works in a style other than that which they were used to reproducing themselves, they saw to it that the customers' preferences were satisfied. In the Greek world there had always been a certain readiness to produce archaizing or classicizing works, but now there was a strong financial stimulus for the creation of sculpture in earlier Greek styles, both through copying and in original essays in the Classical manner.

This is a new chapter in the history of classical art, almost wholly the product of Roman patronage. It was not, however, exclusively practised in Italy. The Neo-Attic school which served the new market, whether in Greece or Italy, is perceptible first in late second-century Greece. In 166 BC Rome declared Delos a free port, administered from Athens but clearly with a strong Roman presence, served by classicizing works of sculpture, decorative and portrait. In Italy there were other studios manned by Greeks producing original works in the same consciously classicizing styles. The copying became not confined to Greek originals but of anything in the Greek style.[163] We hear of Pasiteles, a Sicilian who had gained Roman citizenship (probably in 88 BC, with fellow Sicilians), Arkesilaos and others, all Greeks.[164] They made groups and figures of Greek myth-historical subjects, but also cult statues for Roman temples. The latter were probably all carefully modelled on Greek originals. That of Venus Genetrix, made for Caesar's temple to the goddess in his new forum, was made by Arkesilaos and seems likely to have been a close copy of a well-known late-fifth-century type.[165] Of the same artist we are told that the clay or plaster models from which the works were copied or cast, could fetch even more than the finished bronzes or marbles. This is an interesting reflection on sculptural techniques, which can hardly be pursued here, but, even if exaggerated, it makes sense if we consider that such models could have served more easily than finished statues as sources for the production of further copies or versions in other studios. The new Art World did not yet admit problems of copyright.

For those who either could not afford the new 'originals' or who preferred masterpieces, even in copies, a copying industry soon emerged. In Greece itself this was by about 100 BC already serving Delos, where we find a marble copy of Polyclitus' famous Diadoumenos.[166] The result was the legion of marble copies (seldom in bronze but generally copying bronze originals) found in Italy and all over the Roman world, which serve as a major source for our study of the lost originals by famous artists.[167] The technique has been partly revealed by discovery in 1952 of debris from a copyist's studio at Baiae in the Bay of Naples. It comprised fragments of plaster casts of Greek original sculptures, mostly of well-known and much copied types. [7.63] shows a fragment of a cast from Baiae beside one of the versions of Roman copies of the same head – from the Early Classical Tyrannicide group which stood in Athens. The casts (not, it seems, the moulds) had been made in Greece and taken to Italy. Here they served as models from which copies could be made by a process similar to that of the 'pointing' well documented for sculptors from the Renaissance on. It was probably not as mechanical as 'pointing', yet it could be very accurate, at least to judge from comparison of some surviving copies with each other (not of copy with original, which is denied us in almost

7.63a Plaster head from Baiae (Baiae)

7.63b Copy of head of Aristogeiton (Madrid)

all cases). Copying from clay/plaster model to stone had been, after all, a normal process in the production of major marble statuary since the fifth century.[168] First-century Athenians complained at the way their statues were always being messed about by moulders. It was of course always open to the copyist to introduce variants or create pastiches. Inasmuch as these were intended for Roman patrons they might be deemed to reflect Roman taste, even amount to 'Roman art', but obviously no new major art form developed from these classicizing works, and real 'Roman sculpture' has to wait on different themes and settings.

Painting was the other major art attracting the copyist and encouraged by Roman patrons. Most paintings would have been made themselves from copies, even from copies of copies, which accounts for the greater divergencies in versions of paintings than there generally are in copies of sculpture, since the latter could be based on more accurate reference to the originals via casts. The Classical and Hellenistic treatment of mythical subjects is familiar from the many painted copies on Roman walls, at Pompeii, Herculaneum and elsewhere,[169] or from subjects translated into mosaic. Of no less importance were the battle paintings, a genre that goes back to Polygnotos' Battle of Marathon for the Painted Stoa in fifth-century Athens but of which little is preserved from later years beyond the famous copy in the Alexander Mosaic. Paintings were displayed at the Roman triumphs, and the victors could also commission Greek artists to paint illustrations of their successes on the battlefield. The Athenian Metrodoros was

invited to supply such paintings for Paullus' triumph after the battle at Pydna in 168 BC and there are references to comparable occasions, some even earlier.[170] These are naturally not subjects for villa walls but from such works probably stemmed the Roman tradition of historical narrative art, usually in relief works (as on Trajan's column) and invariably warlike.

In other luxury arts – jewellery, gold and silver vessels, engraved gems and cameos – Greek artists and models were no less essential to the market. The styles and subjects are reproduced endlessly too in other media: stuccoed ceilings, clay relief revetments, furniture. Plaster provided a ready medium for the creation of artists' models, and casts of finished works may also have been of some value in their own right as handsome objects. This explains the wide distribution of plaster casts from fine metalwork at and beyond the borders of empire, in Germany, Egypt, Afghanistan. In the first century BC and the early Empire there are many surviving specimens of carved gems in a pure Greek style, signed by Greek artists. The Felix who signs (in Greek) the fine gem shown in [7.64] is probably the same as one recorded as a freedman of Q. Plotius. The gem's owner is also named, in Greek, Calpurnius Severus.[171] There must have been many willing apprentices in the workshops, not of Greek birth, and the cachet supplied by a Greek name must have been due as much to the unnaturally high esteeem in which all things Greek were held by the intelligentsia and most politicians.

Without further, even summary, consideration of the Greekness of the arts of Rome in the Late Republic and Early Empire, and with no consideration of the peculiarly Roman contributions to architectural design, and their revolutionary feats of engineering for roads and aqueducts, all of which owed little or nothing to Greece, so far as can be judged, and served different intentions, we should turn to the principal subject of this section. Why did Rome respond in the way it did to Greek art? What was there in Greek art that captured Romans even more effectively than it had any other people considered in this book? How could a people temperamentally so different come to accept Greek style; and to what extent *did* they really share or understand it? *Hae tibi erunt artes* ... Virgil tells his countrymen that these are their arts – to rule nations, impose rules of peace, spare the conquered and war down the proud, *not* to model bronzes so that they seem alive, to talk smart and watch the stars.[172] For the Romans was there any alternative to an aesthetic life that was dominantly Greek, and that for long was simply left to Greeks to create for them?

Down to the fifth century the arts of Rome were essentially Etruscan, and Etruscan art, after an orientalizing phase, was by the sixth century mainly determined by the example of Greek art, as we have seen. Can we count Rome, for our present purpose, as another Etruscan city, determining its own choice of what to accept from the foreigner? It seems not; rather its choice was determined for it by whatever Etruria supplied or, in the sixth century, may have imposed. Otherwise we would have expected indications of distinctive local production, such as we find in virtually every Etruscan city. There are evident Vulcian, Chiusine, Tarquinian versions of Etruscan art in the Archaic period, as later; none Roman. Etruscan influence in the arts never quite recedes although influence in all other matters soon disappears. What Romans were left with was a hellenized figure art and repertory of subjects which they found it very easy to reconcile with the identities of Latin deities and perhaps even with Latin stories. Not merely the

7.64 Carnelian gem by Felix (Oxford)

appearance but the whole content of Greek art seems to have been accepted, almost as if there was no alternative, nothing even which might seriously modify the Greekness in favour of some Roman aesthetic vision or need. Closer contact with Greek cities and then the flood of Greek objects acquired by conquest simply confirmed the capitulation to Greek art. A Cato might mourn the passing of the old clay idols of the gods (which were as much Etruscan as anything) and with others deplore the pervasive and debilitating effect of intercourse with Greeks, but no one could provide any alternative, and Romans were not willing to accept an aniconic visual environment.[173] The people, 'plebeians', may have clung longer to forms and styles determined by Etruscan or Italic traditions, but the most influential of these were ultimately derived from Greece though stripped of Classical style. It was, however, the plebeian idiom that was eventually to prevail over the consciously classicizing.

Only in architectural design and technique[174] was there native inspiration, and we have seen elsewhere that in architectural matters Greeks could have no real influence on design, which generally depended on local cult or political practices, although they could provide models for architectural ornament. So the Corinthian became the most popular Roman architectural order, and Sulla brought columns from the Temple of Olympian Zeus in Athens for the Capitoline. From Greek example marble became the preferred material for major buildings and for the mural decoration of private homes. When Augustus boasted that he had found Rome a city of brick and made it a city of marble he was effectively claiming that it now looked as good as any Greek city, or better.

The Romans acquiesced in a vision of Jupiter in the image devised by Greeks for their Zeus, and so with their other gods, all of whom were readily assimilated to Greek gods, with only Apollo adopted directly from Greece. Greek scenes of Greek myth were as

readily adopted and their schemes used for the few Roman stories they chose to illustrate. Herakles, as Hercules, but as god rather than hero, became for the Romans more important than he ever was for Greeks, but his appearance and exploits were those of Greek cult and literature. Even under the Empire the further development of myth narrative remained primarily in Greek hands, from the sarcophagi of Asia Minor to the mosaic floors of North Africa and the east. The Greek idiom of mythological narrative and of genre scenes was readily adapted for a Roman world and in the Republic and early Empire provided a means of expressing those few other subjects that Roman life, cult and politics looked for. With Empire the conventions of Greek art could be adjusted as readily as those of Greek literature to the needs of imperial propaganda.[175] This was a role never imagined in Greece, where the only precedents were the local promotion of a hero and the assimilation of rulers to gods in the Hellenistic world. Rome went further, and allowed genre and portraiture to serve comparable purposes for a far bigger world, of different races and of different creeds.

What did the Romans understand of all that they stole, copied and commissioned? The principles that governed Classical Greek art were not immediately apparent from the works themselves and were many of them probably forgotten even by Greek artists of the day although a few Classical artists had left books about their work. The Roman Vitruvius provided explanations for Greek architecture that seem to bear little relationship to what we understand of its principles and intent in the Classical period. Greek art was always on the move, and the aspirations of the Classical, then the Hellenistic and Roman world, incessantly reformulated intentions and the means through which they were realized. But were the Romans as indifferent to the content of what they borrowed as they may have been to its aesthetic formulae? Their religion accommodated itself totally to Greek style. In other matters a sense of the appropriate seems to have operated without being obsessive. With some of the earliest probably purely Roman products, the *pocula* [7.61], we have seen that objects made as gifts to specific gods were decorated with wholly trivial Greek subjects, and it looks as though their makers and customers were totally indifferent to the impropriety. But when Cicero was ordering statues he asked for subjects suitable for a gymnasium or exercise ground. He declared the Muses we have already mentioned suitable for his library, but where would he have put the Bacchants? A statue of Mars was of no use to a man of peace! But he also had an eye for position, and asked for reliefs (without mentioning subjects) to decorate a court and ornamental well-heads. And the Roman who decorated the garden and rooms of the Villa dei Papiri near Herculaneum with copies of busts of Greek rulers, philosophers, writers and politicians, was deliberately creating a Greek intellectual environment through deployment of Greek art, as did other rich Romans for their libraries.[176] It was for Romans that Greek portrait busts were removed, in copy, from the whole statues to which they belonged, and presented as busts, often on a pillar herm. They may have been prompted in this by their traditional wax masks of ancestors, if not also by economy.

The statues for the gymnasia were probably of Greek naked athletes, but the Romans would have nothing to do with nude athletics and, Pliny tells us, called such figures Achilles.[177] A mythical or divine identity rendered nudity tolerable. This soon meant that, as the Roman ruling class got used to the idea of assimilation to gods, they would

admit naked portrait statues of themselves, borrowing the bodies of Greek statues, however inappropriate to the portrait head attached! But the point cannot be laboured. Many, probably most Greek motifs were at least roughly appropriate to the subjects or setting they occupied: but decorative in all the senses of the Latin *decor* – what is proper and becoming, what graces and adorns. The wholly inappropriate was certainly avoided for any major or public monument, but not all booty could have found an appropriate home. It is difficult to imagine the religious justification for placing the Greek Amazonomachy pediment [7.62] on the temple of Apollo Sosianus in Rome.[178] The practice with sculpture and reliefs cannot in this context be readily divorced from the practice with wall paintings and the record of the collecting of gems as *objets d'art*. The Romans were a people of a temperament wholly unlike that of the Greeks, and the copies of Greek works which became part of their visual experience could not have played quite the same intellectual or spiritual role in their Roman setting as the originals had in their Greek setting. Image and identity were adopted but hardly all nuances of message and meaning without profound translation or re-interpretation. Virgil wrote in Homeric hexameters, Horace in Greek lyric metres, but the *Aeneid* and the *Odes* are of a totally different world to that of the *Iliad* and Sappho, incomparable though they all are, in every sense of the word.[179]

This is a fairly bleak assessment of Rome's attitude to Greek art. The Romans were by no means mindless copyists and purchasers of copies, although I think there was a great deal of indifference to what was regarded more as a measure of status than a medium of communication and expression. In the first century BC many worked hard on Greek culture and their writers produced work which, whatever the inspiration, has a strong and effective Roman stamp.[180] Some, writers and artists, or patrons of art, could turn the Greek idiom to totally new purposes which served a type of state quite unknown to the Greek world. This was the achievement of the Empire. For these purposes, arguably, the Greek idiom was surely but not inevitably more effective than, say, the oriental might have been. It is worth reminding ourselves that it was not preordained that Rome should become 'classical', and if Phoenician art had won the upper hand in seventh-century Etruria, who knows what the Art of Empire might have looked like! That Greek art *was* more effective for Roman purposes is probably due to its ready appeal to all classes of men and most nations. How far this in turn was due to the realistic element in the arts, providing a more direct, less complicated appeal to any viewer, an international idiom more dependent on life than on local brands of religious symbolism, broaches problems not for this chapter. But we are left no closer to determining what and why the Romans took from Greek art, beyond the suspicion that in the years we have reviewed 'aesthetic choice' never really entered the equation to any significant degree. In effect Rome reverted to the aims and aspirations of many other early cultures in their use of art – to commemorate people and events and to demonstrate the dignity and power of gods and rulers, and while their minor arts may also reflect these aims, they mostly entertain. You have to stand back a bit from antiquity to recognize, with Kenneth Clark, 'that long slumber of the creative imagination which lasted from the end of the second century BC to the third century AD.'[181] Rome may have acquired a Greek marble veneer, but remained at heart a city of brick, and therein surely lay her strength.

8 · Europe

THOSE OF US WHO LIVE north of the Alps, far enough from the Mediterranean sun to have to regard, enviously, the cultures of the inland sea as essentially foreign to us, either enjoy or are distraught by two artistic heritages so dissimilar as to defy easy reconciliation. Much of our literature, thought, art and architecture still proclaim a classical heritage introduced fleetingly by the Romans and far more indelibly stamped by Renaissance enlightenment. But what has Stonehenge in common with the Parthenon, menhirs with obelisks, the Book of Kells with Trajan's column, Asterix with Alexander? Celtic art (I shall have to qualify the term shortly) seems a more decisive negation of the classical than even that of the steppe nomads we have met by Black Sea shores and farther east. Yet communication with the Mediterranean from south to north up river valleys and even through mountain passes was relatively easy, and the way of life not as disparate as that of the nomads compared with the urban. Northern Europe was the western home of that broad zone of the alternative style in art which ended in Siberia and North China, upon which comment has already been passed (above, p. 194). There was more in common between the extremities of that zone, over centuries, than between it and the valley civilizations of the warmer, more southerly areas that gave life eventually to the classical arts of the Mediterranean world.

This is, of course, gross simplification, but it prepares us for an inconclusive search for, not the penetration by the classical of the north in antiquity, since that can readily be documented archaeologically, but any profound effect it had on either local arts or life. The sparse record of such influence continues well into the Christian era, except for brief but vigorous periods of Romanization and even the creation of an imperial court on the Moselle (Augusta Treverorum: Trier).

Our area of study runs from the British Isles to Austria/Hungary. The Thracians, not unrelated, have been better considered with other peoples of the Black Sea, and there will be occasion to cross the Alps into North Italy for reasons which will become clear. The first major period takes us to the first half of the fifth century BC, contemporary with the Archaic Greek, and only thereafter shall we consider at all seriously what is meant by Celtic. For the earlier period the use of a term such as proto-Celtic might not be much amiss, and the transition to the main Celtic, La Tène culture was more physically than culturally abrupt. Life depended partly on agriculture, partly on animal-rearing, with no more movements of population than the purely local, required for the latter activity. Power, at least in the proto-Celtic phase, was in the hands of horse-riding aristocracies to whom princely is the quaint title bestowed by archaeologists, since no central royal authority can be distinguished. And in the main

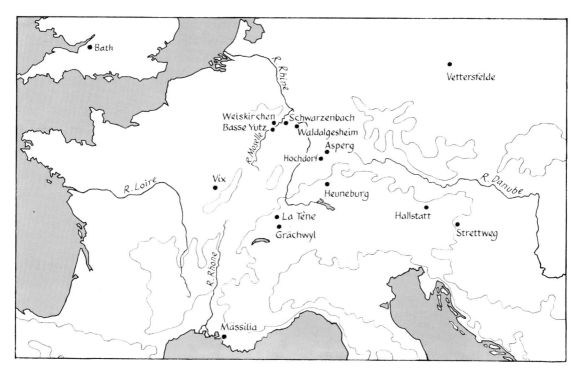

MAP 8 EUROPE

Celtic period the Celtic tribes (as Gauls) displayed a belligerence that tested the homelands of Romans, Greeks and Anatolians. But there were also in central Europe rich resources of metal, and the bronze-working capabilities of the area were as advanced technologically, if less sophisticated in product-design, than those of the east Mediterranean. Iron they were slower to adopt but no less effectively and with equally rich resources. Archaeologically the proto-Celtic culture is named after Hallstatt, the salt-mining centre in Austria, but it would be wrong to get the impression of any unity of government or of anything beyond a very general unity of material culture. Literate observations from the south about the northerners help not at all for this early period, beyond showing a general awareness of Keltoi in the north and some of their outlandish habits.

The probability is that the area was occupied by an ethnically related but essentially disunited complex of tribal units. The major centres of power that the material record of sites or artefacts can reveal may not have controlled large areas. They are revealed by a series of well-fortified hill settlements and rich chamber burials beneath tumuli, well supplied with grave goods and commonly also with a chariot – more like a four-wheeled cart than the light two-wheeler of the south. The prime period of these princely tombs is the sixth century BC and earlier fifth, and the presence in them of objects from the Greek homeland, or from western Greek colonies, or from Etruria, is the first important intimation of close contact with the south.[1]

We have to consider both the imports, which were generally luxury items, gifts to local rulers in return for privileges in trade (probably mainly metals and possibly slaves); and the effect that such goods and closer contact with production or distribution areas (mainly the south of France and Etruria) had upon local crafts. These were not, on the whole, of great sophistication. Ornament was usually geometric in character,[2] to the point that we could well think Greek Geometric had as much or more to do with styles to the north as to the east, and for some elements of Greek military equipment of the seventh century we may have good reason to look to the north.[3] The strong similarities between the figures on the famous Strettweg (near Graz in Austria) bronze cult wagon and Late Geometric Greek bronzes should, if dates are right and stylistic comparisons not moonshine, indicate influence south to north.[4] But it seems just as likely that at least the form of this derives from Etruscan wheeled stands, themselves dependent on oriental models met also in Greece. We shall find throughout this chapter that Etruria has more to do with introducing the Mediterranean to Europe than Greece.

Hammered bronzes might sometimes also carry animal figures – duck-like creatures are the commonest, and these appear also in the round as decorative additions to vessels or furniture. Human figures, cast or incised/traced on metal, are comparatively rare (which makes the Strettweg wagon so remarkable), and there is no narrative. Where this general prescription begins to break down the intrusion of southern styles can generally be demonstrated, but we should consider first the gifts from the south.[5]

The earliest major class is of Greek bronze oinochoai which have generally been called Rhodian and are to be found, and were copied, in Etruria. This immediately raises the question of the source for those found on sites in the valleys of the Rhone, Rhine and upper Danube. They appear in the west probably before the end of the

8.1 Bronze tripod from La Garenne

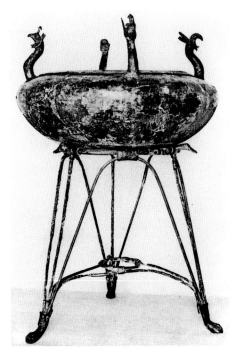

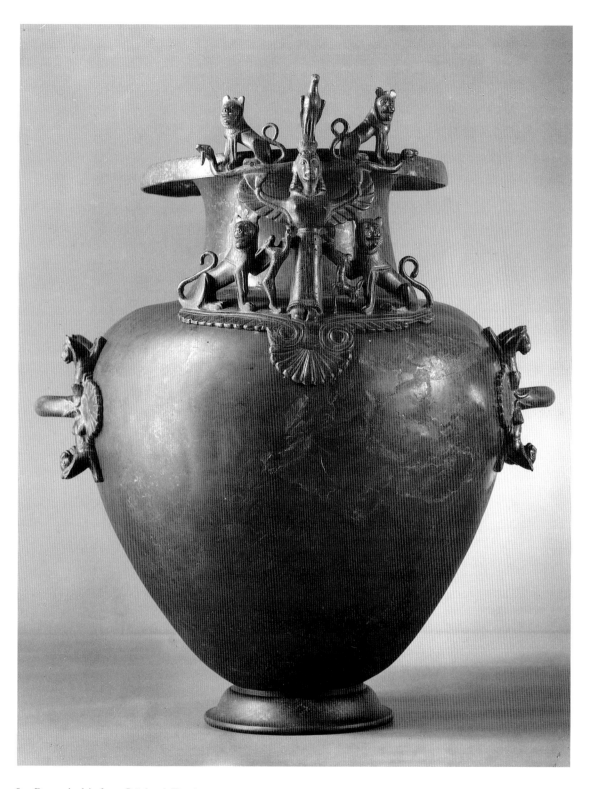

8.2 Bronze hydria from Grächwyl (Bern)

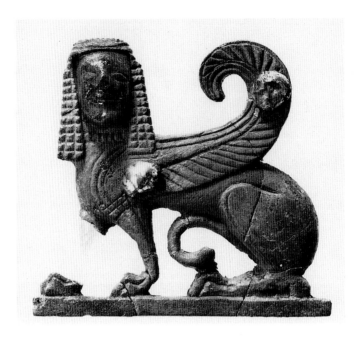

8.3 Ivory sphinx from Asperg (Stuttgart)

seventh century. Their Rhodian tag need not be taken too seriously: it used to be freely applied to other artefacts of this period (notably pottery of the Wild Goat style) because of finds in Rhodes. Herodotus tells us that of the Greeks the Phocaeans (Ionians from the mainland city north of Smyrna, whom we have met already in Chapter Three) were the first to exploit western waters, and it was they who founded Massilia (Marseilles) near the mouth of the Rhone, which was the obvious route north into France, in about 600 BC. There are earlier Greek finds in the neighbourhood. That the vases are of Phocaean origin seems not unlikely.[6]

More impressive bronze vessels carried to the same general areas are tripod cauldrons decorated with griffin protomes. This old orientalizing form had a long life in Greece, and its last years, to which the western imports belong, were monopolized by Ionian workshops. Greek examples are found in the west, but they too were imitated, in a distinctive manner, in Etruria. An example which reached a princely tomb at La Garenne (near the Seine) sported three protomes which might well be Etruscan, and one in an odd style which resembles grosser Etruscan imitations; the stand is iron, where the Greeks preferred bronze [8.1].[7] The most travelled of these cauldrons reached Sweden, but had lost its griffins by the time it was discovered.

The finds mentioned so far have been earlier than the mid-sixth century in date, and are joined by a few others of comparable interest but different origin: for example, a bronze hydria from Grächwyl in Switzerland, which seems of Spartan manufacture [8.2],[8] and at Asperg (near Stuttgart) a cauldron stand, and an ivory sphinx with amber face of late seventh-century Greek type, but perhaps of western Greek manufacture [8.3].[9]

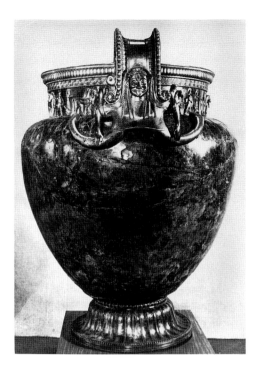

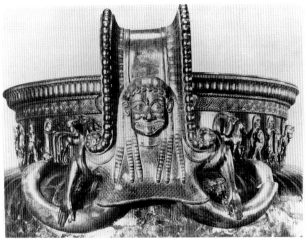

8.4a,b Bronze crater from Vix (Chatillon-sur-Seine)

8.5a,b *(below)* Gold torque from Vix (Chatillon-sur-Seine)

After the mid-sixth century and through the first quarter of the fifth – the period of some of the most spectacular of the princely tombs – the pattern of imports changes. Athenian decorated pottery begins to arrive, possibly in quantity since, although finds are relatively few, they are well scattered.[10] Some are remarkably large vases – volute craters at Würzburg (from the Marienberg) and Heuneburg that must have stood some seventy cm high. But the most impressive finds are still bronze vessels. In 1953 a princess' tomb was excavated at Vix overlooking the Seine. It contained the usual chariot but a fifth of the floor space was occupied by a Greek volute crater standing 1.64 m high, with ornately cast handles, neck friezes and a figurine on its lid [8.4].[11]

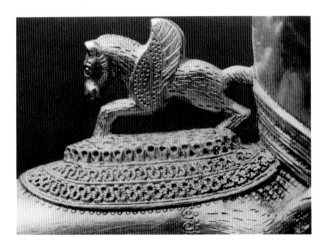

It is Spartan in style but possibly made in Greek South Italy. Its neck figures had been carefully labelled for assembly so it may have travelled in pieces. The same tomb contained three Etruscan bronze basins and a beaked jug, a gold phiale, two Athenian clay vases and a gold torque (necklet). The last is a mystery piece which has called to mind Greek work for Scythians in the Black Sea. The little winged horses are certainly a Greek motif but the rest of the gold work looks unfamiliar [8.5]: an eclectic product designed for a European by a goldsmith less than wholly Greek in his background and training.[12]

Another no less remarkable recent find (1978) is the tomb at Hochdorf, not far from Asperg: another chariot tomb with some bizarre furniture – a bronze settee on wheels for the body, nine drinking horns and dishes, three bronze basins, a gold cup, various jewellery and weapons, even a straw hat. But in the corner of the tomb was a great bronze cauldron of Greek type, eighty cm high and over a metre in diameter [8.6].[13] On its shoulder are three ring handles and three recumbent lions. The handles and two of the lions are purely Greek work; the third lion is a local replacement, not cast from its kin but a totally original conception by an artist guided only by the appearance of the other lions and with no regard for their near-oriental hauteur. It would be perverse to prefer him, but equally wrong to dismiss the creature as an inept attempt at copying. This is not copying but translation into a different and personal idiom (for it can hardly be called a typical product of sixth-century Europe). It is interesting to observe how this local intruder has been received by scholars: nicknamed 'the rat' by its finders and alternately praised for its technique and reviled for its style.[14] Anything Greek seems still to exercise a mystical claim to superiority that it is embarrassing to deny; but the European response in antiquity was probably much the same.

Both the Vix and Hochdorf vases are Greek works of the third quarter of the sixth century. Why have they travelled so far? The usual and probably correct explanation is that they were gifts from Greeks to rulers who occupied routes or sources which were important for trade or seemed potentially important. Whether they might also have served as samples of what more the Greeks might offer is hard to say; certainly, no brisk trade in Greek artefacts resulted. It is hard to determine what the real or potential trade involved, but tin is commonly suggested, even from Britain, and carried overland along the French rivers; and slaves are the usual fallback for archaeologist-historians when material remains fail. They may well have been important but there is no overwhelming evidence for European slaves in the Mediterranean area to be found in literature or in names. Perhaps the motivation in this period was on the Greek side optimistic curiosity and prospection in an area that might prove as productive for the Greeks as Spain was proving for the Phoenicians.

It is generally assumed that the vessels were regarded by their recipients as exotic status symbols, luxuriously useless, but we may misjudge native behaviour and Greek response. A feature of most of the princely tombs is the presence of one, sometimes more, large bronze vessels. The local shape is the plain conical bucket (situla), often over half a metre high, like small dustbins (trashcans). At Vix and Hochdorf the Greek vases alone took their place; elsewhere, the tripod cauldrons, or smaller straight-sided buckets (cistae) of Etruscan type, and in later years Greco-Etruscan stamnoi, though the local plain form continues in use where nothing better (i.e., exotic) was available.[15] We may

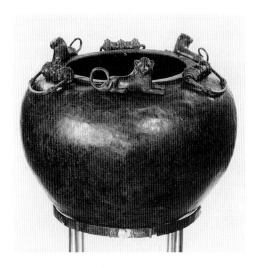

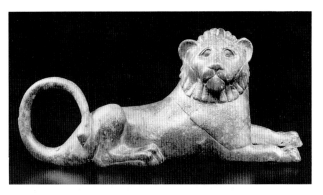

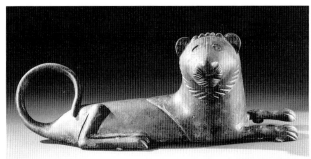

8.6a–c Bronze cauldron from Hochdorf
(Stuttgart)

assume they all could have served the same purpose. The local situlae are thought to be associated with drinking rituals or celebrations, most probably of beer or mead (hydromel), rarely wine. We have no reason to impose Greek symposiac behaviour on Europeans simply because symposion vessels were received, and they apparently preferred to sit and drink, not recline like Greeks.[16] (The only thing found in the Vix crater was a dead polecat.)

The effect of these imported goods from the Mediterranean world was negligible, except where there was call for the creation of replacement parts. Thus, at Heuneburg there was found a mould for casting a head-and-spirals attachment of Etruscan type [8.7],[17] a phenomenon to parallel the third lion at Hochdorf, no doubt. Only from one area did Greek, via Etruscan, motifs intrude with any success.[18] In North Italy, from Bologna through the Po valley and, in its later phase, round into the Balkans, there flourished a distinctive style in decorative bronzes called Situla Art after one of the popular shapes carrying this decoration: the same shape as the situlae discussed in the last paragraph, which seems to have been adopted in North Italy from Europe.[19] Most of the decoration is repoussée, in simple lines and dots rather than substantial relief. It resembles much proto-Etruscan work, and is indeed simply a local variety, and comes to admit figure and decorative motifs deriving ultimately from Greece (rather than the orient) via Etruria. This includes the animal friezes which we saw to be Etruscan versions of Greek orientalizing. The range of shapes and subjects makes it distinctive. Some subjects are taken from the south, even the reclining symposiast [8.8][20] but for the most part the idiom is used to express genre scenes and offers a vivid commentary on

8.7 Cast from clay mould from Heuneburg

8.8 Bronze plaque from Carceri (Este)

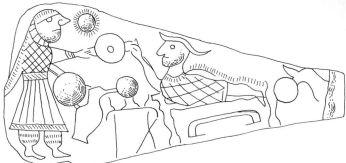

sub-Alpine life. The style crosses the Alps and informs eastern parts of the area treated in this chapter where, as a result, figure and animal scenes in the dot-and-line technique begin to offer a wider iconographic range than that of the more westerly areas of the princely tombs. I illustrate a detail from a famous situla found in Etruscan Bologna [*8.9*], but displaying the northerners' oval shields (a hallmark of the Celts), a display of situlae, a seated fiesta (on Etruscan furniture of the sort also imitated in the northern tombs, as at Hochdorf) and a typical animal/monster frieze. This is a relatively late example, of around 500 BC, and the style can be traced on into the fourth century in northern former Jugoslavia.[21] What is of some importance, however, and which justifies giving Situla Art some prominence in this chapter rather than relegating it to a position of provincial Etruscan, is the way in which many of the borrowed decorative motifs are allowed to disintegrate into new patterns or to recombine. These are traits which are important in true Celtic art, to which we must now turn.

The end of the Hallstatt, proto-Celtic, fortified sites was marked by violence and the abandonment of many of the princely towns. Power tended to shift away to north and west (the Marne area and the Moselle-Middle Rhine) and there are material changes in culture and burial practices, but it is not easy to assess how profound these changes were and there are no clear indications of invasions or the imposition of any radically different culture. The destruction of the upper elements of a hierarchy need not mean much in terms of a change in way of life for the majority of the population, and there seems to

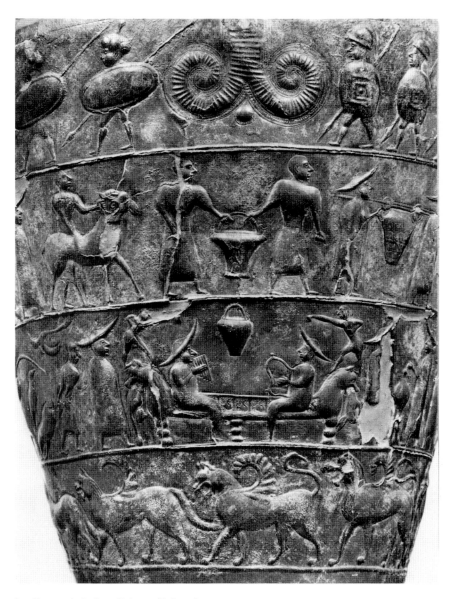

8.9 Bronze situla from Bologna (Bologna)

have been a period in which some princely settlements survived after the establishment of the new order elsewhere. At a less than princely level the changes are less dramatic, but there comes to be more association and influence from Italy than from colonial Greece, and a degree more unity best displayed in the fairly rapid development of a recognizably Celtic style in art. The route via Greek Marseilles and the Rhone gave place in importance to the Alpine passes.[22] It was as though the rather disparate and disorganized essays in expression were pulled together into an idiom that more satisfactorily answered the needs of the society the craftsmen served, its religion and life. Politically the Celts present no greater unity of purpose or government than their

predecessors, and we seem to be dealing still with relatively restricted tribal divisions, prepared to unite in the interest of foreign plunder. In terms of archaeology the culture is that of La Tène, named from the site on Lake Neuchâtel in Switzerland.

This is the point at which to reflect on the effect of the south on the north before and after this transition. The absence of literary evidence leaves the whole question of the organization and ambitions of proto-Celtic and Celtic peoples to the interpretation of the mute (therefore unbiased?) evidence of archaeology. It has proved a fruitful area for speculation and model-building. The suggestion that the Hallstatt princedoms collapsed through the inability of the bigger fish to distribute adequately the prize-gifts from the south to smaller fish, and that the creation of La Tène was wholly or largely a result of closer contacts with the south (though the early centres were farther away), is impossible to prove, and on the available evidence implausible. That contacts with other cultures may be a stimulus to new endeavours is unquestionable; it happened in orientalizing Archaic Greece. The lack of any evidence for a substantial flow of goods or materials (even slaves) in either direction leaves the role of such contacts in this area and period very nebulous. The south was rich and attractive, so it was raided and what passes as trade developed. This is demonstrable mainly by a scatter of imports, always a tiny percentage of finds, and occasional use of luxury materials from the south (coral, ivory).[23] What happened in Europe surely depended much more on local problems and their sometimes violent solutions than on the lure of Etruscan bronzes.[24] Just how superficial the effect of the south was is best judged by its impact on Celtic art, which is the main subject of this chapter and to which we turn belatedly.

No style in art, at least in antiquity, was ever quite new. The striking individuality of Celtic art has made it seem a unique creation within which various influences, that we have to disentangle (at least for the Greek thread), were woven. The rapid creation of such a strong idiom suggests innovative experiment by one or a very few workshops. Its spread suggests a degree of cultural unity in the area that did nothing to discourage the dissemination of new works and visual ideas and messages. Its success suggests that the messages exactly suited the needs, religious, functional or aesthetic, of its customers. That its elements changed little over some four centuries (unlike classical art) and is readily perceptible in European art of centuries later is a further tribute to its success, though also a dire source of disquiet when dating is in question. Classical arts (not only Greco-Roman) require forms and conventions that are subject to readily perceptible decline of purpose and stagnation in design; Celtic art, like the Animal Art of the east, does not.

Celtic art is essentially decorative, in the best sense.[25] It was not expended to any notable degree on monumental arts of statuary or architecture, or even, so far as we can judge, painting. What stone sculpture there is does not demonstrate its subtler qualities. It was best expressed in cast metal and jewellery, and this seems a judgement not reliant wholly on the accidents of survival. And it was generally practised to embellish functional objects which may have served to display wealth or status but which seem usually not to have been of a uniquely ritual character. There is a restricted range of animal and monster forms, a few human (mainly heads) and many floral or abstract (but not strictly geometric), but no serious interest in narrative, little even in the depiction of the individual, divine or human, and none at all in realism *per se*. So points of contact

8.10 Gold band from Weiskirchen (Bonn)

with Mediterranean arts may seem slight. The grammar of the art involved the translation and combination of the elements I have mentioned into flowing non-repetitive designs that respected function without being dictated by it. The recipe was the creation of European artists; the contributing stimuli came from the past, the east and the south.

The Hallstatt past contributed more in terms of some continuity of forms to be decorated than anything beyond the most basic techniques and patterns of decoration. Geometric motifs, for example, were shunned except for over-all patterning on plain surfaces, as of armour, and hammered or punched decoration was unimportant except in sheet gold. The contribution of the east is more complex, given the lack of much import and the ever-present possibility that what there is of the east could have been transmitted from the south, via the variously orientalized or even persianized arts of Greece and Etruria. Yet there is a barely definable relationship with the Animal Art of the steppes and the Scyths, not least in the treatment of animal forms and the inventive translation and combination of animal and floral elements. Slighter cultural links may also be found in shared habits of wearing trousers and sitting cross-legged. There were Scythian raids into central Europe in the sixth century (see p.200) but this is a less likely immediate source than some relatively low level shared responses of animal-rearing peoples, related in way of life (though the west wandered less) and more remotely related in blood. The Scyths were also, as we have seen, well served by Greek artists. One product of this work seems to have travelled to a Celtic site – the gold band for attachment to a drinking horn, decorated with Late Archaic stamped sphinxes, found at Weiskirchen [8.10].[26] The nature of the materials to be decorated probably explains the common interest in openwork gold sheet, to decorate clothing or utensils of horn or wood, often with classical motifs.

The other eastern element, from the fifth century on, may be Persian, and we have seen in Chapter Six the extent to which the arts of the Thracians, the Celts' eastern neighbours, were affected by Persian presence and goods, albeit slightly. The connection is perhaps reciprocated by the emphasis on the use of heads as decoration in Thracian fourth-century art, and the Thracian (Getic) contribution to what we would otherwise regard as Celtic work in much later centuries.[27]

And what from the south? Elements of the grammar of Celtic art are perhaps discernible in Situla Art, as we have seen, and may have contributed to the new style. The import of bronze vessels continues, notably the beaked Etruscan jugs, a shape which is taken up enthusiastically, and stamnoi (already remarked as successors to the

8.11 Greek clay cup repaired in gold, from Kleinaspergle (Stuttgart)

cauldrons) for which, at least in later years, a north Greek source as well as an Etruscan might be argued.[28] There is little interest in painted pottery, and when mid-fifth-century red figure Athenian cups required mending they were patched with gold plaques of Celtic pattern before deposition in the tomb at Kleinaspergle [8.11]. This early demonstration of the new style in a tomb (or rather the secondary burial in a tomb) which is still of princely aspect, is worth closer attention.[29] Its principal liquid container was a plain bronze cauldron, seventy-nine cm in diameter, *not* of southern shape. It was supplemented by a cista a cordoni of Etruscan type, two Etruscan stamnoi, and a beaked jug of Etruscan shape but local workmanship. On the handle attachments of one of the stamnoi appears a frontal satyr's head topped by tear-shaped patterns which look like horns but are really the Etruscan version of the common Greek Archaic motif of a pair of eyes; but notice how they also echo the shape of the satyr's animal ears [8.12a].[30] The beaked jug has a cast handle of a different southern type: animal heads at the top of the handle looking into the jug and at the ends of the arms along the rim, and a head with spiral or floral additions at the handle base [8.12b].[31] If the jug is to be dated not much later than the Greek clay cups (and doubts must linger) then Celtic art had very rapidly achieved the translation and synthesis of foreign forms that is its hallmark. The heads on the handle are animal in the way the ears are attached, human in nose and chin and probably to be related to southern satyr masks, as that on the stamnos. There is a vestige of the moustache, a mane-like beard, and the decoration below the main attachment is more like a mane than the palmette seen in this position on southern works. The spirals at the sides go with a palmette but also recall the so-called Hathor locks of some Etruscan frontal heads. Whatever there was of the south in this has been totally transmuted; beside it the satyr-head attachments look like what they indeed are – banal reproductions of what had been an evocative Greek decorative motif. As one enters the fourth century the beaked jugs retain their southern shapes and the animal components for their handles and along their rims; but their design amounts to a highly original artistic variation on an ancient theme [8.12c]; and the whole jug [8.13].[32]

8.12 Attachments to bronze vases

8.13 Bronze jug from Basse-Yutz (London)

Virtually all the borrowings of Celtic art from the south can be found in the handle attachments of imported vessels and in comparable decorative metalwork of Italy and Greece. From early in the fifth century there are the lion-head and satyr masks, with their accompanying spirals and palmettes; occasionally there are broader complexes of spiral and palmette, without animal addition, to serve as models. Later the more elaborate spiral and palmette complexes of southern metalwork are observed and adapted. There is an early intimation of this in the openwork gold decoration of a wooden bowl from Schwarzenbach [*8.14*] with motifs like those used to patch the Athenian clay cups.[33] Later, in the fourth century, there are works assembled as the Waldalgesheim Style, named from a princess' tomb near Bonn, from which I show a typical pattern [*8.15*].[34] Orientalizing cable and multiple cable (guilloche) patterns had been deconstructed in Situla Art,[35] and were turned into interlaces of linked discs in Celtic art.[36]

In the period of this assimilation of classical debris and the evolution of Celtic art there was opportunity enough to profit from closer acquaintance with the products of the Mediterranean world through booty. The Celts (Gauls) raided far south; they, as much as Rome, were the ruin of the Etruscan states; they sacked Rome in 390 BC and

8.14 Gold bowl from Schwarzenbach (Berlin)

8.15 Pattern from bronze vessel from Waldalgesheim

8.16 Gold plaque from Schwarzenbach (Berlin)

penetrated even as far as Sicily in armed bands; they raided Delphi a century later but were turned back by a divinely inspired snowstorm, and Celtic shields hung beside Persian ones as trophies in Apollo's temple. They were regularly repulsed and so never lingered except in North Italy (Cisalpine Gaul), and after their third-century raids into Anatolia which resulted in the state of Galatia.[37] Few may have ever returned with much loot, and though the pillagers of Delphi were said to have brought booty back to Toulouse, it seems to have had no effect on local crafts.[38] The heroic nudity of the tall blond warriors and their courage impressed the Greeks more than Greek art seems to have impressed the invaders.

The Celts succeeded as perhaps no others did in taking trivial classical ornament and moulding it into an authentic new style, since the contribution of the east and even the past to Celtic art must be judged slight. The symbolic values of what was created are important but not our concern since they are far removed from southern applications of their models, which were wholly or mainly decorative. But we have seen in other chapters how the trivial may be found significant in a new context and for a different society. The importance of the human head in Celtic art is made much of, yet, apart from any allusion to the Celts' penchant for decapitating their enemies and sometimes keeping the heads, a practice shared by many peoples, there is little to show for any special ritual or symbolic functions which heads served. And in Celtic art the strange leaf-like attachments which are often apparent and identified as indications of some

8.17 Celtic silver coin

fertility function [8.16],[39] are in fact no more than versions of the eye/horn/palmette-leaf motifs of the Greek and Etruscan bronze vase handles. Can they really have achieved so much greater significance in northern arts? Or are they simply another manifestation of Celtic art's tribute to plant and animal life?

The distinguished record of the fourth century BC continues until the Celtic world is beset by the Roman, and beyond. Much the same processes of translation of minor classical motifs continues and classical rinceaux are barely distinguishable from those adopted far to the east.[40] What the Celts continued to ignore in classical art is almost as telling as what they borrowed. They generally did not borrow classical figures for depiction of their gods and true assimilations are hard to detect although enthusiastically sought. Where, much later, the romanized Celtic world adapted the forms of classical monuments to local needs, as with the so-called Jupiter columns of N-E France and the Rhineland, it is hard to say whose the prime inspiration must have been, and European versions of classical bronze figurines seem to have had no serious role in cult or even decoration. There are hardly any further concessions of importance to Mediterranean habits in the mainstream of Celtic art. Their skills at the dismemberment and adjustment of foreign forms is nicely manifest in their treatment of the subjects of Classical and Hellenistic coinage; I show a second-century BC example dependent ultimately on Macedonian and western Greek devices [8.17].[41] The phenomenon is not all that unlike that of Asia with Greek coins [4.18]. Where and while Rome is dominant and Romans dictate style the Celtic is in a subordinate position and barely shows through. The Victories in the pediment of the Temple of Minerva Sulis at Bath in England are at least still good classical Victories, but the head they support is an unclassical hybrid of Ocean and Medusa, someone's idea of a motif that might have made sense to a Briton [8.18].[42] I show it because it is near home and because we have met this much-travelled motif already, transformed, more than five thousand miles away (p. 152).

8.18 Reconstruction of pediment at Bath

MAP 9 SATELLITE MAP OF EUROPE AND ASIA

This composite satellite map is *not* upside down since only the conventions of northern hemisphere civilizations have decided that north should be at the top. I show it because it covers all the areas of the Old World which have been considered in this book; and I show it in this way because, when we view the familiar in an unfamiliar way we often begin to see and understand things previously ignored or taken for granted. Conventional political boundaries, ancient or modern, have proved to hold little significance in these pages. In other periods and places maps have been made with Jerusalem or Delphi or Rome at their centres. We need to have the geography right, even if seriously distorted in the interests of making the spherical flat, but it is the physical interrelationships of areas that is important, matters that we tend to judge from present day experience of travel. In a sense, we should study movement in antiquity in terms of what antiquity thought was the shape of the world and its oceans, if we hope to understand ancient attitudes to places, peoples and journeys. But this is difficult to recapture and we always try to force it into the familiar patterns of our maps and charts.

Reconsider the Old World. How thoroughly peripheral Britain is, its importance for much of the past two hundred years dependent wholly on its necessary maritime ascendancy! How satisfying for a Briton that this projection makes it so much bigger than it should be in comparison with

Mediterranean lands! In the Mediterranean how close are Italy and Greece, how remote from them the Levant, but close the Black Sea! Put the book on its side so that the Mediterranean becomes a tortuous funnel for the waters of the Nile and Black Sea to the Atlantic; how utterly different seem its two shorelines – more so than when seen one above the other! How close the Nile is to Mesopotamia, and how distant Persia, which seems to be the true pivot between west and east, the focus of routes that can only be by-passed through frozen steppes or the open ocean! In Old World terms Persia seems the centre of the world, a point not altogether lost in the preceding chapters. India and Central Asia are massive; Europe could be lost in them, even with Persia. And how magnificent their history and achievements even in some periods when civilization in our west was sluggish or ill defined! How much the more remarkable that the arts of tiny Greece should have been influential over such great distances; how unremarkable that their original messages had to be constantly re-read! How ironic that the classical complexion of much of western civilization stems from the greed for Greek things on the part of central Italians, then their rediscovery of them over a millennium later, and then further diffusion into and from northern Europe into all continents!

9 · Conclusion

Conclusion, not conclusions. The diversity of the subjects and peoples considered in the preceding chapters suggests that it would be unwise to generalize or propose models for the diffusion of images, Greek or other, in antiquity or at any other time. It would be an exercise yet more hazardous and potentially misleading than those which prescribe mechanisms of trade and exchange in antiquity. We may at best describe, compare results, and occasionally observe that roughly similar conditions may produce roughly similar results, whether inevitably or accidentally. The exercise is an important one but secondary to the record and interpretation of each case.

The response of non-Greek peoples to the appearance of classical art depended in part on the nature of the means by which they came to know it, in part, as we have repeatedly noted, on their own needs. Some generalization is indeed possible about the impulses which led to the phenomena we have observed. They require some brief discussion since there is an inherent enthusiasm in the archaeologist and art-historian to detect influence on the flimsiest of evidence, and to deduce either significant migration of artists, or some profound communion of intent, shared processes of thought or of aesthetics or of religion, that go beyond the common aspirations of humanity at most times and places. I doubt whether I have been altogether successful in avoiding this temptation in these pages.

The nature of the contacts which produced the results we have surveyed can be divided roughly into three categories:

1 those that result from trade, with which we may include exchange of gifts, which may be casual or with intent;
2 those that result from an active interest on the part of either Greek or non-Greek craftsmen rather than merchants;
3 those that are consequent on other activities which are not primarily a matter of craft production, and in this category we deal mainly with emigration (including colonization), evangelism and booty.

[In the following paragraphs I use the term 'work of art' to signify any product whose form or decoration might have had some aesthetic influence on customers or other craftsmen, without regard to its originality or quality as perceived by its maker – or by us.]

1 Gifts of manufactured goods exchanged between people of status or influence, be they rulers or merchants, depend for their appeal either on their intrinsic worth (usually

precious materials) or some exotic and unfamiliar quality. The latter presumably explains the carriage of decorated Greek pottery far into the Ukraine in the seventh century BC, possibly the result of a chain of gifts; the former explains the Vix crater in a Celtic tomb [8.4]. The most that such gifts might do is predispose the recipient to acquire more, although it must be doubted whether the idea of giving 'free samples' of works of art to generate a market was seriously entertained in early days. However, any flow of specific items, such as bronze vessels into Europe, might eventually have stimulated a demand. Whatever the motives, this movement of valuables and exotica would have introduced such works of art far afield; their local importance and likely influence on local craftsmen depended on other factors.

Deliberate trade in 'export models' is most apparent in decorated Greek pottery, but only to markets already well conditioned to Greek art. This is most apparent in Italy and on the shores of the Black Sea, where there was also an even more lucrative local Greek production of luxury goods in gold and silver directed to the Scythians, for exchange or as influential gifts. The almost accidental dispersal of works of art not *per se* but for their contents might apply to the early perfumed oil vases in clay or metal travelling to Italy, but we cannot be sure. And since we do not know whether decorated clay amphorae could have been filled with materials more interesting than the vases themselves, it is not possible to judge how much more of the range of decorated pottery was accepted primarily for its contents. Probably very little, and most goods travelled either in plain pottery or probably most often in containers that have not survived (skins, baskets, sacks, wooden cases). So it is likely that most decorated pottery travelled because it looked good or for its potential function (not necessarily that of its home users). It was relatively cheap to produce in comparison with metal vases, but its value to distant customers must have been considerable for Phoenician ships to find it worth carrying to the Morocco coast for their trading posts and the local population.

Deliberate trade in luxury goods, generally gold, silver or bronze, ivory or precious stones, is more difficult to assess since in most cases the intrinsic value of the material would have been greater than the cost of its translation into a work of art, though this could have had an added value of far greater importance to some customers. It is clear, however, that the bullion value of silver vessels in particular (antiquity operating mainly on a silver standard) was often a prime reason for their travel, at least until the Hellenistic period when their fine decoration must have been as great a recommendation as their metal.

Trade for profit can therefore be judged an important means of introducing works of art, but usually only to conditioned markets, the conditioning not necessarily being dependent initially on any interest in Greek art. The Art Trade in modern terms begins in Republican Rome, as we have seen in Chapter Eight, and operated nowhere else in antiquity on this scale, if at all.

2 The motives of Greek artists themselves in the dispersal of their works could only have been profit, and a profit more effectively realized by middlemen and merchants than by the artists themselves. That their work should become popular was in their interest; that it should be imitated locally might not have been, especially if local production drove out import. This happened to the pottery trade with the Greek cities

of South Italy once the local schools for decorated red figure pottery were established in the later fifth century BC. It depended partly on the quality of local work, and Etruscan imitation of Greek wares did not affect trade at the lower end of the market, with decorated pottery, though it surely did where Etruscan skills proved supreme, as in metalwork and jewellery.

The presence of Greek artists working in the territory of a conditioned market is detectable, though we need to be cautious about determining what only a Greek could have made, a problem encountered in considering 'Greco-Persian', 'Greco-Phoenician', Thracian and some Etruscan arts. It is also not possible to judge when their presence was a matter of their own choice or of coercion. Greek potter/painters were at work in Etruria and Campania as soon as Greeks reached the coasts of Italy to settle. In Persia, and perhaps earlier in Babylon, coercion may have been the prime factor, and then for specific purposes, architectural or sculptural. The deliberate commissioning of Greek artists is well attested for Sidon, Carthage and Rome. In later years the possibilities of travel were far greater, and the record of St Thomas and of western craftsmen in India must simply reflect what may have been a very common phenomenon of the Hellenistic and Roman periods.

The motives of non-Greek craftsmen in adopting or copying classical art also clearly involved profit, but other factors too, to be mentioned below. Their work would have depended very much on observation of import, but there were other possible sources. The existence of something like pattern books in antiquity is endlessly debated, and was perhaps more likely in later periods, AD. More authentic sources could be provided, for elaborate metalwork, by plaster casts of details of decoration and scenes. Collections of such casts are found outside the classical world rather than within it – in Germany, Egypt and Afghanistan [4.58] – mainly first century AD, but the circumstances in which they are found suggest that they might as well have been kept for their decorative value as for their use as models. For casts of works of art unfired clay is the least durable medium, fired clay the most durable, but plaster was in common use after the fourth century BC and its survival depends on conditions of burial. At fourth-century BC Ur in Mesopotamia a tomb was found to contain a collection of fired clay casts and impressions of Greek coins, gems and finger rings, which might have served as models for an engraver, unless they are an early record of a collector of curiosities (above, p.39). They would have well served an engraver of Greco-Persian gems of the period. A group of fourth-century Greco-Persian gems at Taxila in India looks more like the stock of a travelling salesman or engraver.[1]

3 When Greeks settled overseas the first populations were probably mainly male – sailors, farmers, traders or soldiers, in so far as such specialization of profession meant anything in early days. This accounts for all colonial activity in the Mediterranean and Black Sea areas, as well as the purely commercial enterprises of the Archaic period in Egypt (Naucratis) and perhaps North Syria (Al Mina), and, for the soldiers, the Archaic settlement of mercenaries in Egypt and the creation of the Hellenistic kingdom of Bactria in the east as well as many new foundations – Alexandrias and Seleucias. The development of regular communities broadly on the model of homeland cities inevitably involved the establishment of local craft production by the immigrants to

serve the same purposes as they did in the homeland. If the Greeks married local women items of jewellery and dress decoration might be of native style or origin.[2] The situation would be somewhat different, however, in a place like Naucratis where there was a purely Greek town, unlike Al Mina or some of the Etruscan ports where any serious measure of Greek sovereignty was surely denied and other factors operated.[3] Mere Greek presence beside non-Greek communities would have generated in the latter knowledge of Greek art, which could have been deliberately encouraged in Italy and the Black Sea. But more casual awareness of Greek art would also have developed through exchange, gift, intermarriage, and the inevitable intercourse of neighbour societies, even if on occasion hostile to each other. Thus Greek art infiltrated the local crafts of the non-Etruscan peoples of Italy (not studied in detail in this book), without any notable commercial rather than social dimension to the process. And this process was not inevitable, but depended on the strength of local traditions and needs; so there is no such influence by a form of osmosis in Egypt, and little enough in Europe or, initially at least, in the east.

Just as Pericles held Athens to be the School of Greece, so later Greek writers saw Greece as the school of the civilized world, a role not generally acknowledged by the supposed beneficiaries. Modern scholarship studies 'acculturation', but the degree to which it was positively sought in antiquity, except by Imperial Rome and then for motives of security and finance, was probably slight, and later authors may have falsely attributed missionary aims to some peoples and persons. Little of this concerns our main subject, but there is one factor, not itself to do with art, but which can be a major medium of diffusion – religion. This is manifest in the record of Buddhism, Christianity and Islam, all evangelizing religions which carried their art with their priests, often with their armies. It was not true of Egypt, and barely true of Greece, though Rome used Imperial cult as a means of establishing or acclimatizing Imperial rule in remote areas. The Greeks did not force Olympian or Greek chthonic religions on their neighbours, and when, with Alexander, it became a matter of the conquest of non-Greeks on a large scale, they found it better (as had the Persians) to leave alone or adjust to local religious practices, even to adopt them. As a result, although a major function of Greek art was the service of religion, or the expression of religion (myth) in decoration, the religious images made their way mainly through reinterpretation locally rather than adoption of Greek religious practice. There was indeed a degree of assimilation of deities, in Italy, the Semitic world and Egypt, but we cannot say that Greek priests carried Greek art in the way that some other more strongly evangelizing religions carried *their* arts and indeed imposed them. Plutarch commented[4] that when Alexander 'civilized' Asia the folk of Bactria and Caucasus learned to revere Greek gods, but whatever cults were established would have been initially for emigrant Greeks and not imposed on the native population. Perhaps the strangest instances of the influence of religious art in our area appeared when Christian subjects, themselves wholly dependent on classical idiom, are found to have had a return influence on the arts that generated them. Images of the Virgin and Child had derived from classical versions of Egyptian Isis and Horus, but the group was then returned to serve as model for Hermes with the infant Dionysos. The assembly of Jesus and the Apostles modelled for Socrates and the Wise Men of Greece.[5]

Works of art as booty have a long history, to the present day. The Greeks were

themselves greedy enough for booty in the form of precious objects which might be used or melted down, but have no record of carrying off major monuments. True, they were offered few opportunities through conquest of non-Greek peoples until Alexander, but one senses a conscious indifference to the possession of the major arts of the foreigner unless they could be turned to bullion or were otherwise serviceable, despite their considerable dependence upon foreign example in the early Archaic period.[6] Greek works, however, seem to have been much coveted by their victors and often to some effect. The Persians had carried off statues and other works to Persepolis [2.25], perhaps partly encouraged by previous experience of gifts and of Anatolian Greek craftsmen working in Persia for Darius. The Phoenicians in Sicily and the Carthaginians removed statues from the Greek colonies [3.13] – from Himera, and Phalaris' famous bronze bull from Akragas. That many such works could be regarded as more properly belonging in their original context is shown by the way they might later be returned, by Alexander's successors to Greece, by the Romans, notably Scipio, to the western Greeks (but only from Carthage, not Rome). The Romans removed Etruscan statues, then Greek ones from the Italian cities, then from Greece itself. These we have seen to be a major factor in the adoption and continuing Roman dependence on Greek art. Sometimes the removal of statues of gods might have been regarded as denial to enemies of divine support, or acquisition of power by possession of figures deemed to symbolize the god's presence. It is interesting to notice that marble statues seem to have been as desirable as bronze, though we regard the bronzes as far more highly prized in antiquity.[7] We have had occasion to discuss the problems of the appropriateness of Greek statuary to its new context in Italy, whether the pieces were booty, bought, or deliberately copied. When statuary was installed in a permanent position, as on a temple, the question may become acute. Thus, the Amazonomachy pediment that was taken from Greece and placed on the Temple of Apollo Sosianus in Rome could have had no subject relevance to the god and his cult [7.62].[8]

We have so far considered mainly the How of the diffusion of classical art; of more moment is the Why, and for this we have to consider the attitudes and needs of the recipients. These are generally revealed by the ways in which the classical arts were employed, but we have also in some places to ask the question why, when readily accessible, they could also be ignored. We surveyed in Chapter One what classical art had to offer, mainly in terms of a realistic figural art in the service of religion, of narrative, both mythical and genre, and of decorative detail. The functions that the classical motifs had to serve generally concerned status, religion, or the exotic tastes of all levels of society. The processes commonly involved plain copying tempered by misunderstanding and reinterpretation.

Demonstrations of status and power are generally rendered more effectively by arts that are less realistic than the Greek, and certainly by arts that presented their rulers in anything other than the nude. So Greek art offered nothing here except to Rome, where adoption of Greek iconography for the gods, and the willingness of emperors to claim divinity, meant that Greek statuary types, nude and not, were accepted. For figures of gods themselves only those circumstances in which there was considerable assimilation

of Greek to non-Greek deities admitted classical forms for essentially non-classical divine figures. This happened to a minor degree in late Egypt, and earlier in the egyptianizing arts of the Semitic world. In India, where a figure type for the Buddha had been deliberately shunned, the classical example of realistic figures for a man-god may have encouraged the idea of representing the Buddha at last, and also provided the model for the standing figures, like Apollos in a priest's shirt [4.63], while the seated figures derived from eastern noble or regal iconography.

I have mentioned nudity and realism, and these were exportable and distinctive aspects of Greek art which need consideration regardless of the purposes to which they were put. The limited value of nudity as the dress of status has been observed. Generally the nude had not been shunned in the figure arts of antiquity, except in the north and west. It was readily employed for depiction of the very young, the impoverished or ascetic, the enslaved or defeated. Higher in the scale it served certain deities, expressing fertility for the female, strength for the male. The special Greek use could have made sense only to a Greek, and was perhaps barely appreciated even by the Romans, but the nakedness of Greek gods and heroes (for instance, the many eastern versions of Herakles) was accepted. Classical dressed figures were readily copied by artists in Italy, not least because their original models were at hand. Farther off, we have seen that an element of Archaic Greek treatment of dress was taken up in Achaemenid Persian court art, and may have been transmitted east. Later, more realistic Greek treatment of dress had minimal effect in Egypt, more in India where it served to represent dress types which were quite similar in appearance.

Realistic depiction of the human and animal world, let alone landscape, presents different problems. Landscape can be dismissed rapidly; only the Greeks ever came to attempt realistic landscape and only the Romans to follow them. Realistic figures are not a notable feature of near eastern art. In India there are very early and brilliant examples, but quite removed from the period of contact with the classical.[9] In Egypt we observed the plaster heads of Amarna [5.4] but also the artists' careful avoidance of sheer realism rather than something better or at least more effective. Within the conventions of Egyptian figure-drawing a remarkable range of action postures was achieved, lacking only anatomical accuracy. Greek artists of the fifth century began to seek realism for its own sake, but thereafter it became more a habit than a positive attempt for yet greater visual effect, and inevitably degenerates, finding a purpose only in portraiture. Something of Classical realism can be glimpsed in early Roman Imperial art when it is not always clear whether we have copies of Classical variants or new classicizing creations. Yet these too were semi-mechanically reproduced, whatever the visual effect they achieved. Non-Greek artists were not much impressed and shunned a world of *trompe-l'oeil*, but they probably seldom had the opportunity to view Classical realism in its most dramatic form, in major painting and free-standing sculpture in Greece itself. The strict anatomical approach (even casting from life) was soon abandoned in Greece and was never adopted by the foreigner. Portraits on most classicizing non-Greek coinage (e.g., later Parthian, Indian and Sasanian) came to depend more on inscription or head-dress than physiognomy.

Greek animal art of the Archaic period depended almost wholly on eastern example but soon adopted more fluent and realistic forms for fighting groups. In the Classical

period the depiction of animals can be as carefully observed as that of human beings, and special types of eastern monsters (notably the griffin) are devised by Greek artists. This is why the animal foreparts of eastern rhyta come to abandon their impressively formal Persian Court Style forms in the fourth century, and even the survivors of Persian creatures in eastern art adopt realistic classical details [*5.13*] which deflect attention from the emphatic pattern of anatomy which was the glory of the Court Style. Look at the realistically soft mouths of the lions on the Bactrian rhyta and the Indian Sarnath column [*4.21,42*].

The narrative arts of the classical world were exceptional, and not easily transmitted. In the near east and Egypt narrative of life – warfare, hunting, religious and court ceremonial – went far beyond anything that Greek art offered, although from the Classical period on the complex and realistic compositions of the hunt and of fighting could be adopted along with other classical forms. This started with the use by Greek artists of classical versions of hunt and fight for the coffins of the kings of Sidon [*3.7,10*], and continued to inform the arts of the east and Parthia. Narrative, or rather description, of domestic life held little appeal, but persuaded some new subjects into the repertory of near-eastern glyptic on the Greco-Persian seals, while the iconography of vinous behaviour and the Dionysiac world made good headway in India. This may have encouraged Greek stories of Dionysos' invasion of India, which was a mythical paradigm for Alexander's conquest of the east. It was a rich theme for the arts of the Hellenistic and Roman period but it was the images of a Dionysiac world that affected the east, not worship of the god or even any explicit assimilation to him.

The life of the artisan and farmer were quite well documented in the native arts of Egypt, the near east and beyond; domestic life less so, and classical arts did nothing to change tastes except where Greeks were close at hand (as with the Greco-Persian) or for the celebration of drinking, which was regarded as a noble rather than plebeian pursuit. The exception, again, is Rome and to a lesser degree Etruria, where the humane and athletic repertoire of Greek art was accepted as part of the coveted Greek culture.

Greek narrative of myth, commonly in single panels or friezes and without repetition of protagonists in the same field (until the Hellenistic period), also held little appeal. This mode was at any rate ignored in the near east and Egypt, where repetition of figures had been a regular practice in the great wall-covering compositions. For reasons which others should explain, the myths of the near east and Egypt never achieved canonical schemes in art except at the simplest level, and once the Greek idiom was observed, it was still not adopted. In Thrace there was limited acceptance, in the interests of religious display rather than narrative. In early Indian sculpture the narrative scenes remain discrete, usually in small panels, or, more often, tondos. They pile and overlap figures in a wondrously expressive manner and the Buddhist scenes at least convey an effective narrative, though much Hindu mythology was of a character that defied depiction. Scenes of the life of the Buddha were simpler and of human dimensions. For these the classical idiom of panels, and even some of the more static narrative groups, were found applicable and these inform the arts of Gandhara in the early centuries AD. These are the nearest we get to the narrative style of the Mediterranean world, and in Gandhara they are dependent upon it.[10] Only in India do we approach the effective correspondence between literature and art that is observed in the classical world, and

then best when the classical intervenes; the dichotomy elsewhere is not complete but regularly baffling, and no Gilgamesh was given an identity such as Greek artists created for a Herakles.[11]

The Semitic world, the west and the north, have been barely mentioned in the preceding paragraphs, dealing mainly with figural arts. It is different when we turn to decorative arts (not necessarily non-functional, however). Architectural ornament is fairly readily traced, applied to buildings which are not of Greek plan: the Greek temple was not an export model. Where there was Greek architecture near by, as in Italy and Bactria, or Greek masons at work, as in Persia, the influence was direct; otherwise it travelled through the use of ornament on smaller objects such as wooden chests (themselves often shaped like small buildings with gabled lids). The most important elements are the floral, encountered at a wide range of scales from gems to major architecture. Archaic Greek floral patterns, like their animal art, had been thoroughly oriental, but rapidly changing. With the Classical period more flowing forms were adopted and nature was observed more closely, although the forms of flower, leaf and tendril are woven into strictly symmetrical patterns – a form of floral geometry that was not too concerned with botanical plausibility but that was well suited to almost any field or scale. At its simplest this took the form of flame-leaved palmettes, at its most complex those networks and scrolls of acanthus, vine, convolvulus and lotus that can be observed, often in very similar forms, at either end of the Eurasian continent. Sometimes, as in the near east, they echo the familiar floral patterns which were their remote ancestors; farther afield, as in India, they are adopted because they resemble local floral subjects which had a distinct meaning. Their function as framing motifs or as all-over decoration may have carried much the same generalized message of vegetal vitality as in Greece, but it is doubtful whether even in the homeland this message was consciously read or propagated, except where the composition was concentrated into something like a Tree-of-Life (an overworked term often with unproved religious connotations) or peopled scrolls. It was elements of this type of decoration that were observed, copied and adapted in the north, by Celts and nomads, more readily than the figure arts. Their persistence mainly in the Buddhist arts of the east probably represents the best example of the *continuing* reflection of classical motifs in world art since antiquity, and the motifs were readily adopted by Islamic art. The idiom of the Classical figure arts had to be rediscovered by the Renaissance, although their developed form, with the florals, had lingered through the Byzantine and Romanesque. I generalize very broadly, of course, but the floral patterning on an Iznik plate, a Buddhist temple in Java, Tang gravestones, the cathedral of Trani, own a common ancestor in Hellenistic Greece.

The mental processes of admitting influence in the arts are more difficult to fathom than the physical processes. Straight copying of a foreign motif for its own sake, or simply because it is foreign and with no attempt to understand or convey its basic meaning or function, seems not to have been a normal practice of antiquity. Roman egyptianizing, as in Hadrian's park at Tivoli, comes close to it, but is far from being an ancient equivalent to modern Chinoiserie. Classical forms seem not to have been copied so mindlessly in antiquity, but for a purpose. That purpose, however, may easily have been very different from that of the model. There was certainly some degree of

misunderstanding where there was no commentary or commentator to explain, but the copying would not have happened aimlessly, and there must normally have been a degree of reinterpretation to justify adoption of foreign forms; and reinterpretation is a respectable creative exercise. The process is best observed with narrative figures or scenes, and some decoration. The reinterpretation of a classical scene is perhaps best studied in the case of the silver dishes [4.27,29], and of decoration in the treatment of florals and garlands in India [4.68–72]. On other eastern silverware, the cups [4.23–26], the schemes of some classical myth groups were borrowed, but it is questionable whether they were reinterpreted in terms of local story or had lost their narrative content totally and become, at best, genre scenes or classicizing without intelligible content.[12] In Italy there are certainly some examples of misunderstanding, where Greek scenes were abundantly available and accepted but sometimes lose their sense in the process of translation, and where, for many narrative scenes, there seems to have been no local model inviting any reinterpretation. In Rome the Greeks remained basically in control of interpretation of the purely Greek subjects though they might be used for new purposes.

The last paragraphs have inevitably dwelt on the effects of the major and luxury arts. But the visual experience of the ancient non-Greek was only conditioned by these arts inasmuch as they were applied to visible architecture or were closely reflected in humbler crafts – dress, furniture, pottery, coinage, and the like. Common experience of classical style is probably best traced in the cheap, mass reproduction of classical forms that we observe in clay, mould-made figurines which could be devotional or decorative. We measure it through the eventual prevalence of classical and classicizing clay figures throughout the Semitic world and Spain, throughout the Roman provinces and around the shores of the Black Sea, in adjusted forms in Egypt; even, though to a far lesser degree, in India where the Hellenistic clay dolls are adapted to succeed the long tradition of clay figures of women.[13] In the non-decorative arts we may observe the same phenomenon in the adoption of classical vessel shapes, in clay or metal, even in India, and the Hellenistic skyphos with circular handles and thumb bracket makes its mark even in China.

The question of the nationality of the artists involved in the works we have discussed has from time to time arisen, generally inconclusively. The notion that good = Greek: bad = copyist, native or provincial, can be dismissed as a basic principle though it must sometimes, even often, have been true where it was classical forms that were reproduced. The Egyptian craftsmen on Petosiris' estate made objects of Greek and Greco-Persian form, but we have none of their finished products, only pictures of them [5.17–20]. We found no reason to assume Greek hands in Greco-Phoenician glyptic, nor in Greco-Persian glyptic and metalwork, though they might have been busy and, at least in initial stages, would most readily account for Greek elements of subject and design. I have little doubt that we *are* able to detect Etruscan craftsmen groping unsuccessfully for Greek form, and Greeks for Scythian and perhaps Egyptian. I think Phidias might have winced at many Classical Etruscan figures, but a contemporary Athenian admits the superiority of Etruscan metalwork.[14] Far-flung Greek artists, as in Bactria, seemed well able to keep up with homeland fashions, but when we reach early Buddhist sculpture it is quite impossible to affirm or deny the work of Greek or Greek-

trained hands. Where, however, comparatively pure classical styles can be observed at dates far removed from that of their inspiration, we are certainly dealing with local artists successfully maintaining the classical tradition of their remote predecessors (e.g, in Gandhara [*4.87–89,91*], and in both Archaic and Classical Etruria). It is apparent even within the Mediterranean world, where the Greek east remained more 'classical' in the early centuries AD than did hellenized Rome, but here it was due to the continuing tradition of Greek craftsmen ignoring developments to the west. Observation of this phenomenon of delayed or residual classicism in other areas of the ancient world is one of the more illuminating of this exercise.

The broadest review of the places and periods considered in this book suggests that the classical arts made least headway where local idioms in the arts were long established, were profoundly different from the classical, and totally satisfying – in Egypt, with the nomads and Celts. They made most progress in what amounted to a vacuum, in Italy. In the near east and Semitic world long though tangential familiarity guaranteed a measure of success, reinforced by longish periods of Greek presence after Alexander. In India there was a far more complex reaction since Buddhism provided a market for arts of narrative and divine display that were less well served by the local idiom, and where a Greek, then Roman, presence was influential. Here, and to a lesser degree in the Parthian and Sasanian world, there is that subtle process of reinterpretation that guaranteed the long survival of classical forms in a totally alien environment. In places the influence of the classical was highly effective and, even to our eyes, highly satisfying. Plato, as vain as any Greek, could comment that 'whatever we have adopted from the barbarian we have changed into something ultimately more beautiful.'[15] The reverse also proved true. Greece and Rome need take no particular credit for this, but the phenomenon has proved the most enlightening of all in the history of art to demonstrate the diffusion of image without message.

At the end, it is impossible not to reflect on the differences between the classical arts, essentially Classical Greek art, and the arts of other peoples of antiquity. Such comparisons can make a difference to our own views about Classical art and any special qualities it may claim or that we have claimed for it. Hereafter the reflections are largely personal, the result of working for some years towards this book, and have been partly aired already in Chapter One.

There can be little doubt that Greek artists entertained the notion of progress in the arts, of rendering their works functionally more effective, and that this contributed to the rapidity of change. It has been argued that the Greeks had no concept of progress, but I do not think this can be upheld in the arts, and it explains the pattern of rapid change from the fifth century on.[16] Cultural factors which were not bound to the visual arts led them to the strange and novel idea that their role was to copy nature (= man) or even improve on nature by idealizing, generalizing. It is debatable whether the resultant Classical idiom did indeed provide a more effective image of men and gods. Relevant to the enquiry would be the question why no other cultures adopted this solution and why indeed some seem to have shunned it deliberately, and why their arts did not change so much or so quickly. What they did borrow from the classical world was not the Classical

tradition in its original, fifth-century form. Perhaps the artists of any essentially humanist society, not obsessed by the gods they have created even in human shape, turn naturally to the human body as a point of reference for all their work, rather than the animal or vegetable world or any inspired distortions of the human, and are willing to treat it realistically. This was certainly true of Classical Greece, the western Renaissance, and to some degree of the Buddhist east, but not at all of other arts we have surveyed.

In Greece the new, Classical approach was certainly relatively short-lived although it superficially determined the classical arts for centuries to come, and provided Rome with the Art of Empire. '. . . totalitarian art must be a form of classicism: the State which is founded on order and subordination demands an art with a similar basis' is a fairly austere observation but tells part of the story.[17] If the Romans had not 'liberated' Greek art (rather than just bought it, like Lord Elgin) we would have had a hard time in trying to understand the Classical revolution, which we still have largely to judge through copies made for Romans, while the survival of the classical tradition itself might never have happened, leaving Rome more etruscanized or even celticized than hellenized. Perhaps we owe more to the continuing classical tradition of the Greek homeland and Greek east, even via imperial Byzantium, than to imperial Rome. Even so, that tradition moved steadily farther from its origins, towards virtual abstraction, while Christianity provided a motive to set it on a new course. Yet the culture that was the natural heir to the humanity of classicism had to await the Renaissance before it turned again to what appeared to be its source. Meanwhile vestiges of classical art lingered like cobwebs in every corner of the Old World.

ABBREVIATIONS

AA	*Archäologischer Anzeiger*
AJA	*American Journal of Archaeology*
AKGP	H. Kyrieleis (ed.), *Archaische und klassische griechische Plastik* (1986)
ARV	J.D. Beazley, *Athenian Red-Figure Vase-Painters* (ed.2, 1963)
BASOR	*Bulletin of the American Schools of Oriental Research*
BABesch	*Bulletin antieke Beschaving*
BAVA	*Beiträge zur allgemeinen und vergleichenden Archäologie*
BCH	*Bulletin de Correspondance Hellénique*
Berlin Kongr. 1988	*Akten des XIII internationalen Kongress für klassische Archäologie, Berlin 1988* (1990)
BIFAO	*Bulletin de l'Institut français d'archéologie orientale*
Boardman, *ABFV*	J. Boardman, *Athenian Black Figure Vases* (1974)
Boardman, *ARFV* I	idem, *Athenian Red Figure Vases. Archaic Period* (1975)
Boardman, *GSAP*	idem, *Greek Sculpture. Archaic Period* (1978)
Boardman, *GSCP*	idem, *Greek Sculpture. Classical Period* (1985)
BSA	*Annual of the British School at Athens*
CAH	*Cambridge Ancient History* (2nd ed.)
CRAI	*Comptes-Rendus de l'Académie des Inscriptions et Belles-Lettres*
CVA	*Corpus Vasorum Antiquorum*
GCNP	J.-P. Descoeudres (ed.), *Greek Colonies and Native Populations* (1990)
GGFR	J. Boardman, *Greek Gems and Finger Rings* (1970)
GO	J. Boardman, *The Greeks Overseas* (1980)
GRBS	*Greek, Roman and Byzantine Studies*
JdI	*Jahrbuch des Deutschen Archäologischen Instituts*
JHS	*Journal of Hellenic Studies*
JRAS	*Journal of the Royal Asiatic Society*
Kraay, *ACGC*	C.M. Kraay, *Archaic and Classical Greek Coins* (1976)
Kraay/Hirmer	C.M. Kraay and M. Hirmer, *Greek Coins* (1966)
LIMC	*Lexicon Iconographicum Mythologiae Classicae*
MEFRA	*Mélanges de l'Ecole française de Rome. Antiquité*
Mitt.	*Mitteilungen*
OJA	*Oxford Journal of Archaeology*
RA	*Revue Archéologique*
REA	*Revue des Etudes Anciennes*
RM	*Römische Mitteilungen*
Simon/Hirmer	E. Simon and A.& M. Hirmer, *Die griechischen Vasen* (1976)

NOTES

Abbreviations used throughout the book are listed above. Titles listed in the General Bibliographies of each chapter are abbreviated (in the notes for that chapter only) by author and date or brief title, as indicated in each General Bibliography.

1 Greek Art

GENERAL BIBLIOGRAPHY

J. Boardman (ed.), *The Oxford History of Classical Art* (1993) – with reading lists.
J. Boardman, *Preclassical Style and Civilisation* (1967)

J.J. Pollitt, *Art and Experience in Classical Greece* (1972)
——, *Art in the Hellenistic Age* (1986)
M. Robertson, *A History of Greek Art* (1975)

NOTES

1 Painting on wood may have been largely for home use, and did not travel, but we cannot be sure. The painting styles on wood seem to have remained outline, not silhouette like black-figure on vases.
2 On classical nudity see L. Bonfante, *AJA* 93 (1989) 543–70; N. Himmelmann, *Ideale Nacktheit in der griechischen Kunst* (1990).
3 J.J. Pollitt, *The Ancient Greek View of Greek Art* (1974) esp. 9–31. E. Gombrich, *Art and Illusion* (1959) ch. 4, suggests that the

turn to imitation (*mimesis*) was prompted by the desire to explore the How and the Why in narrative, but the deliberate turn towards total realism seems to have come first with free-standing sculpture, with the presentation of effectively real humanoid gods or evocations of ideal humanity (much the same thing); total realism can easily drain narrative of its message (before film), just as accurate perspective denies the artist freedom to adjust emphases.

4 Naples, Archaeological Museum, from Pompeii; cf. Boardman *GSCP* 205; copy of the Doryphoros, in which, we are told, Polyclitus expressed his Canon.

5 We may suspect a tendency (but no more) to make athlete statues under six-foot, heroic ones over. The apparent *proportionate* difference is clear in the figures of mortals, heroes and gods in the Parthenon East Frieze. On reconstructing proportions see E. Berger et al., *Der Entwurf des Künstlers Bildhauerkanon in der Antike und Neuzeit* (1992). The attempt to make lifesize human replicas, as at Madame Tussaud's, came first, while painting on walls was still sub-Archaic (Polygnotan) though experimenting with anatomical realism. Realistic narrative scenes require realistic depiction of setting also, and this was ignored by Greek artists until later in the fifth century, for stage painting or panels.

6 A. Stewart, *Greek Sculpture* (1990) 40–2, 336, underestimating the possibilities with bronze.

7 K. Clark, *Moments of Vision* (1981) 25.

2 The Near East and the Persian Empire

GENERAL BIBLIOGRAPHY

J.M. Cook, *The Greeks in Ionia and the East* (1962)
——, *The Persian Empire* (1983)
A. Farkas, *Achaemenid Sculpture* (1974)
C. Nylander, *Ionians in Pasargadae* (1970)
E. Porada, *The Art of Ancient Iran* (1965)
M.C. Root, *The King and Kingship in Achaemenid Art* (1979)
C.G. Starr, *Greeks and Persians in the fourth century* (1979) (ex *Iranica Antiqua* 11, 12).

GO 35–109
CAH III,1 (1982) chs. 12 (V. Karageorghis; Cyprus), 18 (J.M. Cook; East Greece and islands); III, 3 (1982) chs. 36a,c (T.R.G. Braun, Greeks in near east; V. Karageorghis, Cyprus), 39a (J.M. Cook, East Greece).
CAH IV (1988) part 1 (Persian Empire); *Plates to CAH III* (1984), ... *IV* (1988)
Achaemenid History I– (1987–) ed. H. Sancisi-Weerdenburg et al. = *AchHist*

NOTES

1 After *OJA* 9 (1990) 174, fig.1, augmented. Dr Moorey tells me that a Protogeometric Greek vessel is reported from T. Hadar on the north-east shore of the Sea of Galilee.

2 The view that these early contacts were initiated by easterners seems not supported by the archaeological evidence; see J. Boardman, *OJA* 9 (1990) 169–90, and for Al Mina in general, *GO* ch. 3. Some essays which try to redress the east-west balance in favour of the former throughout early history appear in *Greece between East and West* (edd. G. Kopcke and I. Tokumaru, 1992), notably its Introduction (S.P. Morris). M.E. Aubet's claims for Tyrian control of north Syria in the ninth century are flimsy and ignore the other sources for the history of the area: *The Phoenicians and the West* (1993) 39–41, 101. We may hope that a balanced view will eventually be achieved and agreed, but this seems unlikely. My approach in this book, dictated by its subject, may not help matters. I have come to regard Greece before the

fifth century as basically an extension of the near east, with constant fluctuations of interests and traffic in which only those scholars with ulterior motives seek positive 'decisions' for one side or the other.

3 Oxford, Ashmolean Museum 1937.409; *GO* 41–2. I had once thought that these could have been made by Greeks at Al Mina. The exterior decoration and shape, with the fine walls, are Greek; the striping inside is Cypriot. On Greek Geometric pottery in Cyprus see now L.W. Sorensen, *Acta Hyperborea* 1 (1988) 12–32.

4 London, British Museum WA; C.L. Woolley, *Carchemish* II (1921) pl. 24; *GO* 51, fig. 20. The shield may look eastern but the gorgoneion at the centre is of purely East Greek type and unlikely to be of other than Greek manufacture.

5 On Greeks and Babylon, *CAH* III.3, 21–4.

6 *CAH* III.3 1–3, 20; J.A. Brinkman in *Daidalikon* (Studies R.V. Schoder, 1989) 53–71 for a full study of the use of the word in the near east.

7 The fortifications of Smyrna, J.M. Cook and R.V. Nicholls, *BSA* 53/4 (1958/9) 1–137.

8 Ankara Museum, from Gordion; E. Akurgal, *Phrygische Kunst* (1955) pl. 14a; see *GO* 84–95.

9 Ankara Museum; *GO* 94, fig. 106, cf. 107; K. Bittel, *Antike Plastik* 2 (1963) 7–22.

10 Sardis Museum; *GO* 95, fig. 109; G.M.A. Hanfmann and N.H. Ramage, *Sculpture from Sardis* (1978) no.7, figs. 20–50.

11 A. Åkerström, *Die Architektonischen Terrakotten Kleinasiens* (1966); pl. 79 = [2.7], drawing M. Welker.

12 *GO* 97, fig. 110, for the siege mound that topped the walls (also above, n.7).

13 *GO* 93, fig. 105; M. Mellink in *Mélanges Mansel* I (1974) 537–47.

14 Ankara Museum; *GO* 92, fig. 104; *Anatolia* 3 (1958) pl. 1.

15 Once New York, Metropolitan Museum 66.11.27, now returned to Turkey; D. von Bothmer, *Bull.Metr.Mus.Art* Summer 1984, 35, no.45, and cf. nos. 46–9; and in *Artibus Aegypti* (Studia B.V. Bothmer, 1983) 15–23.

16 *BCH* 3 (1879) pls. 4–5; *GO* 100, fig. 117.

17 The inscriptions are published piecemeal. See especially R.G.Kent, *Old Persian* (1950) 144; F. Vallat, *Syria* 48 (1971) 54–9 (Elamite and abridged Akkadian); W. Hinz, *JNES* 9 (1950) 1–7 (Elamite, translating the Ionian-Sardian stone-workers as 'captives'); *Cambridge History of Iran* II, 807–8.

18 A very good corrective by A.Kuhrt in *Proc.Camb.Phil.Soc.* 1988, 60–76.

19 The march of Xenophon's Ten Thousand through eastern Anatolia in 400 BC, told in his *Anabasis*, reveals a land of ruggedly independent tribes and, on the coast of the Black Sea, independent Greek colonies where even the creation of new Greek cities could be contemplated.

20 Fine reconstructions in F. Krefter, *Persepolis. Rekonstruktionen* (1971) (Beil. 26 = [2.12]); and cf. L. Trumpelmann, *Persepolis. Ein Weltwunder der Antike* (1988). *Plates to CAH IV* ch.1 for the site.

21 See too the basis from Susa, *Mem.Miss.Iran* 30 (1947) pl.5.1. There seems to have been a separate or at least parallel source for Greek architectural bead-and-reel in early archaic half-round mouldings decorated with broad, near-circular leaves with plump outlines. These naturally reduce to hemispheres with double vertical dividers, assimilated to the in-the-round pattern of globes and dividers (one, two or more) on lathe-turned wood or on bronze furniture derived from wooden forms. In architecture it naturally borders other florally-derived patterns, such as egg/leaf-and-dart, where it is also commonly seen in the east. For the pattern on earlier Greek bronze work see P. Jacobsthal, *Greek Pins* (1956) 153–9.

22 For the architectural sources at Pasargadae see Nylander (1970) and *Archeologia Classica* 43 (1991) 1037–52 (claw chisel). I am indebted to Professor Nylander for photos used in

[2.13,15,16] = Nylander (1970) figs. 36, 48a, 24. On the architecture in general, Cook (1983) ch.15; Porada (1965) 142–56; *Plates to CAH IV* esp. chs. 2, 3. The claw chisel may not in fact be a Greek invention but had been used in Egypt on softer stone than marble; see O. Palagia, *OJA* 13.2 (1994).

23 H. von Gall, *Baghdader Mitt.* 19 (1988) 557ff., pls. 22–6, 564, fig. 4 = *[2.17]*; Porada (1965) 138–9.

24 Cf. J. Boardman, *Antiquaries Journal* 39 (1959) 215 for this and related Ionic architectural features.

25 *Persepolis* I, pl. 70c.

26 Pasargadae: *GO* 104, fig. 120; Nylander (1970) fig. 44. *Persepolis* I, pl. 193b = *[2.19b]*. There is a problem about the date of the figures at Pasargadae from 'Palace P' which might be of Darius' reign, giving the Greek style greater priority. See Farkas (1974) 24–5; Nylander (1970) 128. Farkas gives the fullest account of sculptural borrowings from Greece. The sculptors at Persepolis signed their work with marks resembling those on seals and masonry at Sardis; see below, n. 44.

27 M.C. Root's sensible analysis of how the patterns relate properly discounts exaggerated claims about Greekness but offers no other source and makes no allowance for the way the patterns had to be adapted: *The King and Kingship in Achaemenid Art* (1979) 9–15.

28 Farkas (1974) 78–9. Cf. E. Schmidt, *Persepolis* III (1970) pls. 19, 41, 50, 57, 63, 71 = *[2.20]*, for the tomb façades at Naqsh-i Rustam and Persepolis. The same style on the latest of the façades, unfinished: W. Kleiss and P. Calmeyer, *Arch.Mitt.Iran* 8 (1975) 81–98.

29 *Plates to CAH IV* pl.22; *Cahiers Del.Franç.Iran* 4 (1974) fig. 20, drawing by H. Gonnet; H. Luschey, in *Akten des VII Int. Kongr. für iranische Kunst und Archäologie 1976* (1979) 207–17. The statue is probably of the earliest fifth century.

30 See especially *Mem.Miss.Iran* 30 (1947) 75, fig.43, with the palmettes in lotuses springing between linked circles, and the palmette friezes; and the lotus and palmette friezes, 79, fig.48 = *[2.22]*. J.V.Canby, *Arch.Mitt.Iran* 12 (1979) 315–20 on date and technique. A. Nunn, *Die Wandmalerei und der glasierte Wandschmuck im alten Orient* (1988) for the history of the whole genre.

31 Hinz, op.cit. (n. 17) on line 37.

32 Farkas (1974) 93.

33 He is called Phocaeus (Pliny, *HN* 34, 68) which could indicate either. Most scholars prefer Phocaea, in Ionia, a city abandoned in the face of the Persians in the mid-sixth century, but his other work is said by Pliny to be mainly in Thessaly, which suggests a central Greek home (Phocis) and one which tended to favour the Persians.

34 Hinz, op.cit. (n. 17) 6, on line 41.

35 *[2.23]* = New York, Metropolitan Museum of Art 45.11.17, Rogers Fund; perhaps a 'portrait' of a Persian, cf. *[2.35]*. *[2.24]* = M.Roaf and J.Boardman, *JHS* 100 (1980) 204–6 and *GO* 105, fig.121; G.M.A.Richter, *AJA* 50 (1946) 15–30 for other pieces; C. Nylander and J. Flemberg, *Anadolu* 22 (1981–3) 57–68.

36 Dr Moorey has drawn my attention to an object that has been generally disregarded in discussion of Greek art in Persia: a limestone pillar decorated in relief with what must be Late Archaic Greek gorgon-like figures and a lion, found in the Hellenistic and later town of Persepolis at Istakhr: E.F. Schmidt, *The Treasury at Persepolis and other discoveries* (OIC 21; 1939) 120, fig. 87. On loot from Greece, K. Tuchelt, *AA* 1988, 427–30.

37 Tehran Museum; *GSCP* 51 figs.24–6; W. Gauer, *JdI* 105 (1990) 31–65.

38 P. Amandry gives an excellent short account of the character of 'Persian art' in *Mélanges K. Michalowski* (1966) 233–8.

39 Cook (1962) 199–202 on the Anatolian satrapies; and *CAH IV* ch.3e (M.Mellink).

40 On Persian coinage *Plates to CAH IV* pl. 307; P. Calmeyer, *Arch.Mitt.Iran* 12 (1979) 303–13.

41 *CAH* IV ch.7d (C.M.Kraay) for early Greek coinage, and *Plates to CAH IV* ch.15 (M.J. Price).

42 E.G. Starr, *Num.Chron.* 1976, 219–22; M.C. Root, *Num. Chron.* 1988, 1–12.

43 E. Porada, *Iraq* 22 (1960) 228–34; L. Woolley, *Ur X*, nos. 701–832.

44 J.Boardman, *Iran* 8 (1970) 19–45 (pl. 1.6 = *[2.26a]*, Geneva, Mus. d'Art et d'Histoire 20564; pl. 2.12 = *[2.26b]*, Boston, Museum of Fine Arts 95.80); *RA* 1976, 45–9. For the masons' marks in Persia see M. Roaf, *Sculpture and Sculptors at Persepolis* (= *Iran* 21, 1983), listed on p. 160. The masons' marks found at Sardis are broadly similar: R. Gusmani, *Kadmos* 27 (1988) 27–34.

45 See note 13.

46 *Plates to CAH IV* pl.81; *CAH* IV 222–3, 478–9; *GO* 106–7, fig.122 with refs. I am indebted to Professor Mellink for the photo.

47 London, British Museum B 287; *Xanthos* I (1958), II (1963); C. Bruns-Özgan, *Lykische Grabreliefs des 5. und 4. Jdts v. Chr.* (1987).

48 Istanbul Museum, from Daskyleion; *GO* 109, fig.127, refs. on 274, n.319; H. Metzger, *RA* 1975, 209–20; subjects, H. von Gall, *Anadolu* 22 (1981–3) 143–65; M. Nollé, *Denkmäler von Satrapensitz Daskyleion* (1992). From Sardis, G.M.A. Hanfmann, *RA* 1976, 35–44.

49 Ankara Museum 19367; E.Akurgal in *AKGP* I, 9–14.

50 Paris, Louvre; P. Amandry, *Antike Kunst* 2 (1959) 50, pls. 26.2, 27.2–3; Porada (1965) 168 and pl.50. On Anatolian production of this Greco-Persian (mainly Persian) plate see P.R.S. Moorey, *Iranica Antiqua* 23 (1988) 231–46.

51 On the Greco-Persian series see *GGFR* ch.6; J.Boardman, *Intaglios and Rings* (1975) ch.3: *RA* 1976, 50–2.

52 *Anabasis* 3, 2, 25.

53 The Persians were fond of dancing: Athenaeus 434e.

54 *[2.32a]* = Oxford 1885.491, from Nymphaeum (*GGFR* pl. 838); *[32b]* = Berlin F 307, from Athens (*GGFR* pl. 895); *[32c]* = Rome, Villa Giulia, from Bolsena (*GGFR* pl. 881); *[32d]* = Berlin F 183, from Ithome (*GGFR* pl. 890); *[32e]* = Oxford 1892.1482, from Greece (*GGFR* pl. 853); *[32f]* = Oxford 1921.2, with later Arabic inscription added (*GGFR* pl. 880); *[32g]* = Malibu, Getty Mus. 81.AN.76.88 (*RA* 1976, 50, fig. 8); *[32h]* = Oxford 1892.1487, from Spezia (*GGFR* pl. 859).

55 M.C. Root in *AchHist* VI, 19–26, figs. 4, 5 for our *[2.33]*; = *PFT* Seals 857 and 142.

56 London, British Museum, Walters no. 524, from the Punjab; *GGFR* pl. 856. The sealing from Ur, ibid., 235, fig. 278.

57 Kraay/Hirmer, figs.621–74; Kraay, *ACGC* ch. 12; J. Zahle in *AchHist* VI, 145–60, for Lycia.

58 *[2.35]* = satrap Tissaphernes, late 5th cent. (Kraay/Hirmer, fig. 621, cf. figs.622–3); G.M.A.Richter, *Greek Portraits* (1984) 40–2, 67; H.A. Cahn, *Rev.Et.Gr.* 17 (1989) 101–6.

59 J.W. Betlyon, *The Coinage and Mints of Phoenicia* (1982).

60 V. von Graeve, *Der Alexandersarkophag* (1970) and *Istanbuler Mitt.* 37 (1987) 134, fig. 3 = *[2.36]*. R.R.R. Smith, *Hellenistic Sculpture* (1991) 90–2.

61 According to a Greek, Diodorus 17, 69, 2–4.

3 The Semitic World and Spain

GENERAL BIBLIOGRAPHY

M.E. Aubet, *The Phoenicians and the West* (1993)
D.B. Harden, *The Phoenicians* (1963)
R.J. Harrison, *Spain at the Dawn of History* (1988)
S. Moscati, *The World of the Phoenicians* (1968)
S. Moscati (ed.), *Phoenicians* (1988)
G. Nicolini, *Les Ibères* (1973)

R.M. Pidal (ed.), *Historia de España* III (1954)
P. Rouillard, *Les Grecs et la péninsule ibérique* (1991)

GO 210–5
CAH III.2 ch. 32 (W. Culican)

NOTES

1 A good, brief survey of the fluctuating scholarly views in W. Burkert, *The Orientalizing Revolution* (1992) 1–6; and most recently on the archaeology, S. Morris, *Daidalos* (1992).
2 Athens, NM 1488; the provenance is not recorded, but probably Piraeus; C.W. Clairmont, *Gravestone and Epigram* (1970) 114–7, no. 38, pl. 19.
3 For the fluctuating effect of Egyptian art in Phoenicia in the Iron Age see G.E. Markoe, *BASOR* 279 (1990) 13–26.
4 On these matters see, briefly, J. Boardman, *OJA* 9 (1990) 169–71. The case for Sardinia is being vigorously argued: M. Balmuth (ed.), *Papers in Sardinian Archaeology* II (1986); D. Ridgway in *Studies in Sardinian Archaeology* (Papers presented to M. Balmuth, edd. R.H. Tykot and T.K. Andrews, 1992) 355–63, and J.M. Davidson, ibid., 384–93. We may expect that when the current Sardomania settles down it will have proved to have made some contribution to our understanding of the Mediterranean world in this period.
5 *CAH* III.², 523–30; V. Karageorghis, *Kition* (1975).
6 On Attic black figure found in the area see J. Perreault, *BCH* 110 (1986) 145–75.
7 C.L. Woolley, *JHS* 58 (1938) 6, 136–43.
8 J. Boardman, *Archaic Greek Gems* (1968) ch.3; *GGFR* 139–42, 153–4.
9 J. Boardman in *Cyprus and the East Mediterranean in the Iron Age* (ed. V. Tatton-Brown, 1989) 44–9, fig. 3 = [*3.2*] (Cyprus, private; *GGFR* pl. 329). In like case is a cylinder seal in Berlin (VA 2145) bought in Baghdad, with an Archaic-Greek-derived Perseus and Gorgon, and a fish. It might be Cypriot; see J. Boardman, *Island Gems* (1963) 135, K2, and now W. Burkert, *The Orientalizing Revolution* (1992) 85–6 (but the Gorgon does not have bird claws – they would be reversed!); better, W. Lambert in *Monsters and Demons in the Ancient and Medieval Worlds* (Papers E. Porada; edd. A.E. Farkas et al. 1987) 48, pl. 11.22.
10 Paris, Bibl.Nat. 1973.1.489; P. Bordreuil, *Cat. des sceaux ouest-sémitiques inscrits* (1986) 42, no. 37; J. Boardman, forthcoming. See also the summary Classical stones from eastern sources mentioned in *GGFR* 209, and gold finger rings of the later fifth century which may relate to the gems discussed in the text here, ibid., 221, 419 (de Clercq Group).
11 Paris, Bibliothèque Nationale 1082bis; *GGFR* pl. 420. The scarab series is discussed briefly by the writer in *Tharros* (edd. R.D. Barnett and C. Mendleson, 1987) 98–105; and the Greek myth scenes on them in *Praestant Interna* (Festschrift U. Hausmann, 1982) 295–7; on the point of the colour see also in *Jewellery Studies* 5 (1992) 30–1.
12 Beirut Museum; *Les Phéniciens* (edd. A. Parrot/M.H. Chehab/S. Moscati, 1975) 107–8, fig. 111.
13 B. Kanael, *Biblical Archaeology* 26 (1963) 40–2 figs. 2–4; Kraay/Hirmer, figs. 681–5. Ibid., figs. 681–2 for the falcon, with its long tail and insignia, but Athenian 'owl' coins may have prompted the frontal head.
14 Beirut and Istanbul Museums. E. Kukahn, *Anthropoide Sarkophage in Beyrouth* (1955), and an important series of articles by M.-L. Buhl, the latest, with remarks on origins, being in *Acta Archaeologica* 58 (1987) 213–21; and on finds not in Phoenicia itself, in *Atti II.Congr.Int.di Studi Fenici e Punici* (1991) 675–80. See also J. Elayi, *Iranica Antiqua* 23.1 (1988) 275–322; R.A. Stucky, *Antike Kunst* 32 (1989) 147–50. Moscati (ed. 1988) 292–6.
15 This is apparently thirteenth-century in date but was reused for Ahiram in about 1000 BC; see *Plates to CAH III* pl. 136b and

CAH III.2, 463. However, R. Wallenfels has argued that neither the sarcophagus nor the inscription can be earlier than the mid-ninth century, and may be even later: *Journal of the Ancient Near Eastern Society* 15 (1983) 79–113.
16 I. Kleemann, *Der Satrapen-Sarkophag* (1958); R. Fleischer, *Der Klagefrauensark.* (1981); A. Schmidt-Doumas, *Die lykische Sark.* (1985); A. Stewart, *Greek Sculpture* (1990) pls. 466–7 (Lycian), 539 (women), 588–94 (Alexander); J.J. Pollitt, *Art in the Hellenistic Age* (1986) 38–45; V. von Graeve, *Der Alexandersarkophag* (1970); H. Gabelmann, *AA* 1979, 163–77 on dating and identifications; R.R.R. Smith, *Hellenistic Sculpture* (1991) 190–2 (Alexander); W. Messerschmidt, *Boreas* 12 (1989) 64–92 (Alexander). Photos, German Institute, Istanbul, W. Schiele [*3.7–9*]. On these sarcophagi and the Phoenician, I. Hitzl, *Die griechische Sarkophage der arch. und klass. Zeit* (1991).
17 R.A. Stucky, *Tribune d'Echmoun* (1984). I am indebted to Professor Stucky for the photo. On the date, W. Fuchs in *Canon* (Festschrift E. Berger, ed. M. Schmidt 1988) 150; on interpretation, E. Will, *Syria* 62 (1985) 105–24.
18 Beirut Mus., from temple of Eshmun; Moscati (ed. 1988) 285. Cf. L. Ganzmann et al., *Istanbuler Mitt.* 37 (1987) 103–12; on the Cypriot, A. Hermary, *Antiquités de Chypre. Sculptures: Louvre* (1989) 69.
19 A useful general acccount of Greek influence in classical Phoenicia by R.A. Stucky in *Ras Shamra. Leukos Limen* I (1983) 167–72. J.-F. Salles in *Topoi* 1 (1991) 48–70 expresses dissatisfaction with J. Elayi's *Pénétration grecque en Phénicie sous l'empire perse* (1988).
20 *GO* ch. 5. Carthage has yielded nothing certainly earlier than the mid-century, so far; see H.G. Niemeyer, *Das frühe Karthago* (1989), and on the nature of early settlements, in *GCNP* 469–87. On Phoenician interest in land, C.G. Wagner and J. Alvar, *Rivista di Studi Fenici* 17 (1989) 61–102.
21 For Sardinia see above, n.4. On the early Greek pottery there, matching that from Carthage, P. Bernardini in *Atti II Congr. Int. di Studi Fenici e Punici* II (1991) 663–73. Early Phoenician inscriptions in Sardinia (especially the Nora stone) might be important evidence for the eastern contacts if they could be closely dated; cf. *CAH* III.2, 486; M.G. Amadasi Guzzo and P.G.Guzzo date them palaeographically *c.* 830–730 in *Los Fenicios en la Peninsula Iberica* (edd. G. del Olmo Lete and M.E. Aubet, 1986) II, 59–71; Aubet (1993) 179–81.
22 Pseudo-Skylax 112: 'Phoenician merchants bring them myrrh, Egyptian stone, . . . (unexplained item), Attic pottery, and jugs.'
23 Tunis, Bardo Museum. *GO* 216, with references. They are found also in Sardinia and Ibiza (cf. *Archivo Español* 57 (1984) 167–70).
24 Motya, Whitaker Museum. V. Tusa in *AKGP* II, 1–11; G. Falsone, *Studi e Materiali, Inst.Arch., Univ. Palermo* 8 (1988) 9–28. That Motya and western Sicily were more exposed to Greek Archaic forms also may be shown by the stone relief sphinxes in Motya Museum, J.I.S. Whitaker, *Motya* (1921) 278, figs. 56–7.
25 Cicero, *In Verr.* 2, 35, 86–7.
26 The destruction of Motya in 397 BC might have been the occasion of the burying and therefore fine preservation of the marble.
27 Kraay/Hirmer, 300–1, figs. 205–11 (206 = [*3.14*]). Cf. A.C. Tusa in Moscati (ed., 1988) 204–5.
28 But see below, n. 74.
29 For the razors, C.G. Picard, *Karthago* 13 (1967) – Greek subjects: no. 13 – Hermes(: Isis); no. 22 – lion: hippocamp; no. 23 – youth in Greek dress but with Punic adorant gesture(: palm); no. 37 – our [*3.15*] (drawing from *CRAI* 1905, 326); no. 38 – youth seated: Herakles seated; pl. 36 top right (from Utica) – youth fights bull: Skylla. Picard associates no. 37 with Hannibal's successes in Italy in the later third century.

30 Carthage Museum; *Karthago* 17 (1976) pl. 8. 6 (C.I.S. I 5519); Moscati (ed. 1988) 62.

31 A. Lézine, *Architecture punique* (1962) for a detailed study. Ionic seems especially favoured in the fourth century.

32 C.G. Picard, *Catalogue du Musée Alaoui* 1, Cb.658. C. Picard in *Karthago* 17 (1976) 67–138 and 18 (1978) 5–116, gives a full survey of the motifs on Carthage stelai. On the architecture of Punic stelai, M.T. Francis in *Atti II Congr. Int. di Studi Fenici e Punici* (1991) II 863–74.

33 Carthage Museum; *Karthago* 17 (1976) pl. 9. 1 (C.I.S. I 4044).

34 For the painted stelai-niches in Sicily (mainly from Lilybaion), most of which may be neo-Punic, in the period of Roman domination but retaining Punic motifs, see E. Gabrici, *Monumenti Antichi* 33 (1929) 41–60; Moscati (ed., 1988) 452–3; A.M. Bisi, *Archeologia Classica* 22 (1970) 93–130; *Africa* 5/6 (1978) 32–3. Several depict the death-feast in Greek form, a normal intimation of heroizing for the dead by this date and of eastern origin. The feast is seen also on a Carthage stele, Picard, *Alaoui* Cb.917. For relief stone stelai from Lilybaion with Greek-style subjects (girls with thymiateria) see A.M. Bisi, *Karthago* 14 (1967/8) 227–34. A painted tomb at Cagliari in Sardinia offers Greek gorgoneia beside orientalizing florals and an Egyptian winged cobra: Moscati (ed. 1988) 451.

35 Turin Museum. Harden (1963) pl. 44. For comparable examples, Doric and Ionic, see Moscati (ed., 1988) 325 (Sardinia) and 672, no. 522.

36 Tunis, Bardo Museum. References in H. Benichou-Safar, *Les tombes puniques de Carthage* (1982) 130–5. Moscati (ed. 1988) 62.

37 Tunis, Bardo Museum. The type and subject recurs in Spain: J. Almagro-Gorbea, *Corpus de las Terracottas de Ibiza* (1980) 271–3 for discussion.

38 Ibiza has proved a major source and the material has been studied: A.M. Bisi, *Rivista di Studi Fenici* 1 (1973) 69–89, 2 (1974) 201–44; 6 (1978) 161–226; and in *Los Fenicios* (see n. 21) I 285–94. Almagro-Gorbea, op.cit., pls. 1, 68 (our [*3.22*]), Madrid 36170), 69 (a near copy, Barcelona 8538). For the dress of [*3.22*] see M. Pilar San Nicolas Pedraz, *Archivo Español* 56 (1983) 67–108. [*3.21*] = Moscati (ed. 1988) 534.

39 Lézine, op.cit. (n. 31) ch.1. The Ma'abed shrine manages to combine Persian/Mesopotamian merlons with Greek Ionic dentils and an Egyptian cavetto moulding; it appears to be of the Persian period – see *Archéologie et Histoire de la Syrie* 2 (1989), edd. J.-M. Dentzer/W. Orthmann) 22–4, 459–60, for other references.

40 Restored height 23.65 m; A. Di Vita, *RM* 83 (1976) 273–85, fig. 4 = [*3.23*]; F. Rakob in *Die Numidier* (edd. H.G. Horn and C.B. Rüger, 1979) 119–71 for classical architecture in Numidia.

41 Harden (1963) 110–1, pl. 115; L. Poinssot, *CRAI* 1910, 780–7; S. Gsell, *Hist.anc. de l'Afrique* VI (1927) 251–61; C. Poinssot, *Les Ruines de Dougga* (1958) 58–61. Rakob, op.cit., 148.

42 Harrison (1988) ch. 7 for these Greek towns and Ullastret; also M.A. Martin Ortega, *Ullastret* (1985); M. Picazo, *Ceramica aticas de Ullastret* (1977).

43 For Phoenicians in Spain see W. Culican, *CAH* III.2 512–35; articles in H.-G. Niemeyer (ed.), *Phönizier im Westen* (1982), and *idem*, *Jb.Röm.-germ. Zentralmuseums* 31 (1984) 3–94, and in *RA* 1988, 201–4. Harrison (1988) is the most useful general guide to the early period and its archaeology. There are important articles in *Los Fenicios* (n. 21). Articles in *The Hellenic Diaspora* (ed. J.M. Fossey, 1991) esp. 81–160 argue strongly for a dominant influence of Greeks, not Phoenicians, a point of view rather favoured by Spanish scholars. For the record at Cadiz, M.C.M. Ceballos and F.J. Lomas, *Dialoghi di Archeologia* 1992, 129–54.

44 The literature grows apace. A full survey by J. Fernandez Jurado in *Huelva Arqueologica* 10/11 (1988–9; Tartessos y Huelva). P. Cabrera and R. Olmos, *Madrider Mitt.* 26 (1985) 61–73; A full and thoughtful earlier discussion of the evidence by B.B. Shefton in *Phönizier im Westen* (ed. H.G. Niemeyer, 1982) 337–70 and now in *Kölner Jahrbuch* 22 (1989) 208–13. For a

balanced view of the early Greek role in Spain see H.-G. Niemeyer, *Hamburger Beiträge* 15–7 (1988–90) 269–306, and a fuller study by Rouillard (1991).

45 Herodotus 1, 163.

46 Shefton, op.cit. (n. 44, 1982) 350–1, refers. There is not much to support any positive Etruscan role as intermediary for Greek subjects in Spain. Cf. J. Remesel and O. Musso (edd.), *La Presencia de Material Etrusco en la Peninsula Iberica* (1991).

47 Thus, the Etruscans learned their alphabet from Greeks, and it has generally been held that the Spanish learned from the Phoenicians, including, in the S-W and Celtiberia, a syllabary with Cypriot traits; A. Arribas, *The Iberians* (1964) 87–96 for a useful brief discussion. But T. Judice Gamito argues that Greeks introduced literacy to S-W Spain, in *The Hellenic Diaspora* (see n. 43) 81–108.

48 *CAH* III.2, 530–1; G. Nicolini, *Techniques des ors antiques* (1990) for fine pictures; Greek influence comes later (*idem*, *Rev.Et.Anc.* 89 (1987) 365–76) and is commensurate with reception of other Greek classical styles.

49 A local vase with an Archaic Greek graffito from Huelva demonstrates a probable Greek presence: J. Fernandez Jurado and R. Olmos, *Lucentum* 4 (1985) 107–13.

50 P. Rouillard, *Madrider Mitt.* 31 (1990) 178–85; C. Briese and R. Docter, *Madrider Mitt.* 33 (1992) 25–69. The phenomenon but not the product matches the imitation of Euboean in Cyprus and Etruria (our [*2.2;7.1*]) in these years.

51 For Punic settlement in Morocco see now F.L. Pardo, *Archivo Español* 63 (1990) 7–41.

52 Harrison (1988) ch. 5; A.M. Bisi, *Rivista di Studi Fenici* 8 (1980) 225–35; B.B. Shefton, *Kölner Jahrbuch* 22 (1989) 212.

53 J. Fernandez Jurado and P. Cabrera Bonet, *Rev.Et.Anc.* 89 (1987) 149–56, and articles ibid., 161–8 (C. Sanchez Fernandez), 179–91 (C. Campenon). The chunky little Athenian black 'Castulo cups' are export wares that are easily packed and carried, named from the finds in Spain.

54 A. Arribas et al., *El Barco de el Sec* (1987); a useful series of articles and discussion in *Rev.Et.Anc.* 89 (1987) 3/4, 1–146, especially 134–8, 140 (B.B. Shefton). The Punic graffiti on pottery are of personal names; the Greek refer to marketing in Athens.

55 Barcelona, Museo Arqueologico; A. Arribas, *The Iberians* (1964) pls. 12–13; M. Blech and E. Ruano Ruiz, *Madrider Mitt.* 33 (1992) 70–101.

56 Pidal (ed., 1954) 458–67 for examples.

57 The case against this 'Phocaean' sculpture is well put by W. Trillmich in *GCNP* 607–11; and for the Phoenician content, M. Almagro-Gorbea, *Rivista di Studi Fenici* 10 (1982) 231–72. The main sources are Pozo Moro (for which see *idem*, *Madrider Mitt.* 24 (1983) 177–293) and Porcuna (Obulco). For discussion and illustration of the sculptures, rather stressing their Greekness, see J.M. Blazquez and J. A. Gonzalez Navarrete, *AJA* 89 (1985) 61–9 and Navarrete's *Escultura Ibérica de Cerillo Blanco (Porcuna)* (1987); I. Negueruela, *Rev.Et.Anc.* 89 (1987) 319–38, but ibid., 403–4 (J. Marcadé). See also Harrison (1988) ch. 8, who uncharacteristically (in view of his very balanced presentation) thinks the sculpture could be Greek-made because of its 'perfection'.

58 Navarrete, op.cit., nos. 5, 15.; cf. also no. 30, an orientalizing lion hugging a palmette.

59 *Madrider Mitt.* 22 (1981) pl. 17.

60 P.A. Lillo Carpio and M.J. Walker in *GCNP* 613–9, fig. 1 = [*3.27*].

61 J.M. Blazquez, *AJA* 92 (1988) 503–8. The date is insecure.

62 Madrid, Museo Arqueologico; W. Trillmich, *GCNP* 610, pl. 63, 3; *Estudios de Iconographia* 2 (Coloquio sobre el Puteal de la Moncloa; 1986) 183–203.

63 Madrid, Museo Arqueologico. For the major figures cited see Pidal (ed., 1954) ch.3, 474–9 for [*3.29*] (Cerro de los Santos), 479–96 for the smaller figures, 558–74 for [*3.30*] (Dama de Elche);

M.R. Bremon, *Archivio Español* 64 (1991) 83–97.

64 B. de Grino Frontera, *Rev.Et.Anc.* 89 (1987) 339–47 on identifications; A.M. Bisi, *Prakt.II Int.Congr.Class.Arch.* I (1985) 41–7 for references.

65 M. Almagro-Gorbea, *Berlin Kongr. 1988* 113–27 for a good survey of Hellenistic influence in Spain and its Punic sources.

66 See *Ceramiques gregues e helenistiques a la peninsula Iberica* (edd. M Picazo and E. Sanmarti, 1985) esp. 71–81 (V. Page).

67 Examples of the pottery in Nicolini (1973) 99–117; Pidal (ed., 1954) ch.4; L. Pericot, *Ceramica Iberica* (1979). There are Greek ornamental motifs on late vessels without figures (e.g., *ibid.*, figs. 84–5, ivy leaves). For a discussion of the Greek associations see R. Olmos, *Mediterranean Archaeology* 2 (1989) 101–9 and 3 (1990) 7–25.

68 K. Raddatz, *Die Schatzfunde der iberischen Halbinsel* (Madrider Forschungen, 1969) 69–79, pls. 73–8; Arribas, op.cit., pls. 73–4; Nicolini (1973) 128–9, figs. 126–7; M. Almagro-Gorbea, *Berlin Kongr. 1988* 120–1. [*3.31,32*] = Raddatz, pls. 74a, 76a: Barcelona, Museo Arqueologico. Photos, German Institute, Madrid, P. Witte.

69 Madrid, Museo Arqueologico 28.453; Raddatz, op.cit., pls. 63–4; B. de Grino and R. Olmos in *Estudios de Iconografia* I (1982) 1–111 for the fullest study. Cf. R.R. Comas in Remesel and Musso (edd.) op.cit. (n. 46) 587–95.

70 Madrid, Museo Arqueologico 28.440; Raddatz, op.cit., pl. 29. 1 (from Mogon), the silver band shown here, and compare the chalice from Santisteban, ibid., 253, fig. 21 and pl. 60. 1, from the same hoard as the phiale [*3.33*].

71 Useful recent surveys by M. Almagro-Gorbea in *The Celts* (ed. S. Moscati, 1990) 386–405, and by M.E. Aubet-Semmler in Moscati (ed., 1988) 226–42. See also F. Burillo, *Celtiberos* (exhibition, Saragosa, 1988).

72 Raddatz, op.cit., pl. 7 (fibula). For a probable Celtiberian gold fibula of great complexity and including strongly orientalizing animal motifs, see R. and V. Megaw, *Celtic Art* (1989) 122, fig. 177; *Archivo Español* 59 (1986) 207–10.

73 On the limited hellenization, F.G. Millar, *Proc.Camb.Phil.-Soc.* 209 (1983) 55–71, and for engaging reflections on Greek attitudes to easterners and others, A. Momigliano, *Alien Wisdom* (1975).

74 The equation of the Phoenician god Melqart with Greek Herakles can be exaggerated. Some Herakles images were modelled on and later became a model for eastern heroes, mainly lion-fighters, but the easterners never accepted the whole Herakles corpus of myth, or indeed any significant part of it, for any deity, in the way the Etruscans did for both heroes and gods. The Pillars of Hercules were perhaps both the Straits of Gibraltar and the pillars before the Temple of Melqart at Cadiz. The temple bore reliefs of some of Herakles' labours and life (listed in the first century AD by Silius Italicus 3, 32–44), but the choice shows that there the equation was a Roman idea, not Phoenician (*LIMC* V Herakles no. 1751).

4 The East after Alexander the Great

GENERAL BIBLIOGRAPHY

L.I. Albaum and B. Brentjes, *Wächter des Goldes* (1972)
F.R. Allchin and N. Hammond, *The Archaeology of Afghanistan* (1978)
M.A.R. Colledge, *Parthian Art* (1977)
A.K. Coomaraswamy, *La sculpture de Bharhut* (1956) = *Bharhut*

O.M. Dalton, *The Treasure of the Oxus* (1926; 1964)
E. Errington, and J.Cribb, (edd.), *The Crossroads of Asia* (1992) = *Crossroads*

D. Faccenna, *Butkara I* (1980–1)
A. Foucher, *L'Art Gréco-buddhique du Gandhara* (1905, 1918; addenda 1951)
G. Frumkin, *Archaeology in Soviet Central Asia* (1970) for a review by sites and maps.
R.N. Frye, *The History of Ancient Iran* (1984)
R. Ghirshman, *Iran* (1954)
——, *Iran: Parthians and Sassanians* (1962)
A. Grünwedel/E. Waldschmidt, *Buddhistische Kunst in Indien* I (1932)
J. Hackin et al., *Nouvelles Recherches Archéologiques à Begram* (1954)
J.C. Harle, *The Art and Architecture of the Indian Subcontinent* (1986)
G. Herrmann, *The Iranian Revival* (1977)
F.L. Holt, *Alexander and Bactria* (1988)
H. Ingholt, *Gandharan Art In Pakistan* (1957)
M. Lerner and S. Kossak, *The Lotus Transcendent* (1991)
J. Marshall and A. Foucher, *The Monuments of Sanchi.* = *Sanchi*
J. Marshall, *Taxila* I–III (1951) = *Taxila*
J. Marshall, *The Buddhist Art of Gandhara* (1960)
A.K. Narain, *The Indo-Greeks* (1957)
L. Nehru, *Origins of the Gandharan Style* (1989)
Oxus: '2000 Jahre Kunst am Oxus-Fluss in Mittelasien'. Museum Rietberg (Zürich 1989) = *Oxus*
U.A. Pope, *Survey of Persian Art* (1938)
E. Porada, *The Art of Ancient Iran* (1965)
J. Rawson, *Chinese Ornament: the lotus and the Dragon* (1984)
T. Talbot Rice, *Ancient Arts of Central Asia* (1965)
J.M. Rosenfield, *The Dynastic Arts of the Kushans* (1967)
M. Rostovtzeff, *Social and Economic History of the Hellenistic World* (1941)
B. Rowland, *Art and Architecture of India* (1977)
V. Sarianidi, *The Golden Hoard of Bactria* (1985)
W.W. Tarn, *The Greeks in Bactria and India* (1951; 1985 with introduction by F.L. Holt).
F. Tissot, *Gandhara* (1985)
J.P. Vogel, *La Sculpture de Mathura* (Ars Asiatica 15, 1930) = *Mathura*
R.E.M. Wheeler, *Rome beyond the Imperial Frontiers* (1954)

Cambridge History of Iran III.1, 2 (1983)
CAH VII.1 (1984) ch. 6 (D. Musti); VIII (1989) ch. 11 (A.K. Narain)

NOTES

1 For Alexander and his conquests see *CAH* VI (1994); R.L. Fox, *Alexander the Great* (1973); A.B. Bosworth, *Conquest and Empire* (1988).

2 The coins are five-shekel pieces (decadrachms in Greek terms). See *Crossroads* no.2 for references. W.B. Kaiser, *JdI* 77 (1962) 226–39, figs. 1–4; N.Davis and C.M. Kraay, *The Hellenistic Kingdoms* (1973) 29, figs. 10–12; M. Mitchiner, *Indo-Greek and Indo-Scythian Coinage* I (1975) 8–9, 20, takes the dress and headdress as Persian, prefers BA[ctra] to BA[bylon] for the monogram. Related coins show an Indian (?) archer, chariot group and elephants; P. Calmeyer, *Arch.Mitt.Iran* 12 (1979) 308–9 doubts some identifications of figures. A. Stewart, *Faces of Power* (1993) for an iconographic study. The painter Apelles had shown Alexander with a thunderbolt, according to Plutarch (*de Iside* 360D); and he appears thus again, with eagle and aegis but naked, on a Hellenistic gem (Kaiser, op.cit., fig.9). And Plutarch (*Alex.* 16, 4) has him wearing a helmet with feathers at Granikos. [*4.1*] is an electrotype of a London coin, and a drawing by the writer.

3 Plutarch, *de Alexandri Magni Fortuna aut Virtute* 1. 328c.

4 Frye (1984) is probably the best historical guide, with some

5 Peter Hopkirk's *Foreign Devils on the Silk Road* (1980) gives a stirring popular account of exploration before the 1920s, when access became severely restricted by the Chinese.

6 On new city types in the east, P. Leriche in *La Ville Neuve* (ed. J.-L. Huot, 1988) 109–25. Sites on the Persian Gulf reviewed by R. Boucharlat, *RA* 1989, 214–30.

7 A. Kuhrt in A. Kuhrt and S.Sherwin-White, *Hellenism in the East* (1987) ch.1; and S. Sherwin-White and A. Kuhrt, *From Samarkhand to Sardis* (1993) for a vigorous reassessment of the early Seleukid empire. Observe, ibid., pls. 14–5, the combination of Greek Ionic capitals with Persepolitan bases in a temple on Failaka Island (off Kuwait in the Persian Gulf) a Seleukid foundation; also *Cambridge History of Iran* III.2, 1032 with pl. 51b.

8 Bern, Merz Collection = *GGFR* pl. 965. For some simple terracottas showing the *kausia* worn see R. Ghirshman, *Terrasses sacrées de Bard-e Nechandeh et Masjid-i Solaiman* (MDAI 45; 1976) pls. CXI–CXIII. On the hat, C. Saatsoglu-Paliadeli, *JHS* 103 (1993) 122–47.

9 [*4.3*] = once Evans Coll. from Naxos; *GGFR* pl. 981. [*4.4*] = once Harari Coll. (*RA* 1976, 53, fig. 16).

10 On these later Greco-Persian gems see *GGFR* 320–22; *RA* 1976, 52–4.

11 Missouri Univ. 65.149; A. Krug, *Muse* 14 (1980) 36–42, fig. 1.

12 Colledge (1977) 89–90, fig. 39A; W. Kleiss, *Arch.Mitt.Iran* 3 (1970) 145–7, fig. 11 (=[*4.6*]) and pl. 66; a good photo of the figure in *Arch.Mitt.Iran* 2 (1969) pl. 16.2 27–8, and drawing in *Arch.Mitt.Iran* 17 (1984) 245, fig. 20. The head is cut in the round and quite finely finished.

13 For good general accounts of the arts of Parthian (and Sasanian) Persia see the General Bibliography above, especially Colledge (1967; 1977; and in Kuhrt/Sherwin-White, op.cit. (n. 7), ch.6), Herzfeld (1941), Porada (1965), and Herrmann (1977) for well illustrated comment. Schlumberger's (1960) account of contexts and influences is only slightly dated. K. Wiedemann in *Jahrbuch des Römisch-German. Zentralmus. Mainz* 18 (1971) 146–78, on style and chronology. A good essay on mainly non-archaeological evidence for Greek influence in Parthia by E. Bickerman in *La Persia e il Mondo Greco-Romano* (Rome 1966) 87–117. M. Rostovtzeff's essay on Dura and Parthian art in *Yale Classical Studies* 5 (1935) 157–304 is still worth reading.

14 I quote A. Perkins, *The Art of Dura-Europos* (1973) 119; where also (p.125) 'Last to appear at Dura and least influential is the art of Rome.' The Zeus Theos at Dura is crowned by a pair of the familiar classical flying Victories, ibid., pl. 14.

15 Temple of Gareus at Uruk; 1st cent. AD. Cf. Colledge (1977) 76, fig. 37, and his ch. 2 generally for architecture in Parthia.

16 H. Dodge in *Architecture and Architectural Sculpture in the Roman Empire* (ed. M. Henig, 1990) 108–20 on Roman architecture in the east.

17 W. Andrae, *Hatra* (1908/12) pl. 6.

18 Cf. R.R.R. Smith, *Hellenistic Royal Portraits* (1988) 103–4, pl. 59.1.

19 Colledge (1977) pl. 11d.

20 Iraq Mus. 68072; height 17.5 cm. P. Bernard, *Journal des Savants* 1990, 3–68; W.I. Al-Salihi, *Mesopotamia* 22 (1987) 159–67.

21 Iraq Mus. from Hatra. Cf. M. Colledge, *The Parthians* (1967) pls. 60–5.

22 For the sculpture of Hatra see D. Homès-Fredericq, *Hatra et ses sculptures parthes* (1963); F. Safar and M.A. Mustafa, *Hatra* (1974). In general, T.S.Kawami, *Monumental Art of the Parthian Period in Iran* (1987); H.E. Mathiesen, *Sculpture in the Parthian Empire* (1992). On some of the classical motifs, A. Invernizzi, *Mesopotamia* 24 (1989) 129–76.

23 J.M.C. Toynbee, *Sumer* 26 (1970) 231–5, thought to see a version of a portrait of Trajan, doubted by A. Invernizzi,

Mesopotamia 21 (1986) 21–51. For later, though slight, intrusion of Roman sculptural types see M. Colledge, in *Pagan Gods and Shrines of the Roman Empire* (edd. M. Henig and A. King, 1986) 221–30.

24 For a good review of the Parthian style in sculpture and the issue of frontality see S. Downey in *Dura-Europos* III 1.2, 283–93 and her study of the varieties of Herakles figures in ibid. III 1.1. Also Kawami, op.cit., ch.8 on Herakles; and on frontality, M. Pietrzykowski, *Berytus* 33 (1985) 55–9.

25 On the gradual abandonment of Greek carving techniques see M. Colledge, *East and West* 29 (1979) 221–40.

26 Tehran Mus. 2452; height 40 cm. Colledge, op.cit., on technique, and (1977) pl. 9c; R.R.R. Smith, *Hellenistic Sculpture* (1991) fig. 281. The crown is an eastern version of the turreted crown that may be worn by the goddess Tyche (Fortuna) when she serves to personify a particular city. This is presumably the intention here also. It has been suggested that it portrays Musa (?), a slave sent to King Phraates IV (37–2 BC) by Augustus, whom he made his queen. The notion is attractive and she might have seemed a suitable subject to serve as a city Tyche in the classical manner, but it is quite unprovable: F. Cumont, *CRAI* 1939, 330–9, with pls. 1–2, argued the case, and Josephus, *Ant.* 18, 40, tells about Musa (name not quite clear). Tyche has a distinguished history even farther east as we shall see.

27 Tehran Mus. 2401; height 1.96m. Smith, op.cit. (n. 26) fig. 274, cf. 275. A valuable comparison with Parthian work at Palmyra by E. Seyrig, *Syria* 20 (1939) 177–83. The head was made separately, and some think it not intended for this figure.

28 For a good assessment of Parthian/Greek sculpture see R.R.R.Smith, *Hellenistic Royal Portraits* (1988) 101–2 (Shami), 117–119, and *Hellenistic Sculpture* (1991) 225–6; J.J. Pollitt, *Art in the Hellenistic Age* (1986) 284–9.

29 Ghirshman, op.cit. (n. 8) pl. LXX. 1–2; Kawami, op.cit. (n. 22), pl. 54.

30 Reconstructed reliefs; Royal Ontario Museum, Toronto, 983.61.2,5; Herrmann (1977) 67–72; E.J. Keall et al., *Iran* 18 (1980) 1–41; J.E. Vollmer et al., *Silk Roads.China Ships* (1983) 34–44.

31 [*4.16,17*] = Mithradates I (about 171–38 BC), Gotarzes II (about AD 38–51). Colledge (1977) pls. 38h–39f for a good selection; generally, D. Sellwood, *Introduction to the Coinage of Parthia* (1971).

32 The Bokhara coins, Albaum/Brentjes (1972) figs. 82–3. The regional debasement of style: A. Simonetta, *South Asian Archaeology 1979* 356–68. The archer motif in the east, P. Calmeyer, *Arch.Mitt.Iran* 22 (1989) 125–30.

33 This is particularly true of the paintings at Kuh-i Khwaja, a site by Lake Hamun in the Seistan desert of south Afghanistan, which had been attributed to the Parthian period but are possibly all later though the site has Parthian structures. See Herzfeld (1941) 291–7, pls. 101–4; T.S. Kawami, *Met.Mus.Journal* 22 (1987) 13–52; G. Azarpay, *Sogdian Painting* (1981) 83–4. They seem to owe more to the hellenizing arts to their east than to the west.

34 London, British Museum WA 56–9–9.74–5; Herrmann (1977) 63 (as Eros); P. Calmeyer in *Misc. in hon. L. Vanden Berghe* (edd. L. de Meyer et al. 1989) II, 605–21, pl. 2b,c. For other examples of the type, all west Parthian, see B. Musche, *Vorderasiatischer Schmuck zur Zeit der Arsakiden und der Sasaniden* (1988) 72–6, pl. 11, esp. 6.2.2, and pls. 12–3 for Erotes.

35 P.D. Harper, *Mesopotamia* 22 (1987) 341–55. A treasure from Nihavand, between Hamadan and Isfahan, seems 4th to 2nd century in date and includes fine silver, mainly of western origin. A useful discussion, with comparable pieces, by A. Oliver in *Silver for the Gods* (Toledo, 1977) 72–83.

36 Toledo Museum of Art 88.23. Harper, op.cit., 350–1; S.E. Knudsen and K.T. Luckner, *Antike Welt* 22.2 (1991) 115–8, also for lists. A.C. Gunter and P. Jett, *Ancient Iranian Metalwork in the*

Arthur M. Sackler Gallery and the Freer Gallery of Art (1992) no.
10; the completion of the animal forepart's body in relief on the
horn is an older eastern conceit. M. Pfrommer, *Metalwork from
the Hellenised East: J. Paul Getty Museum* (1993) no. 66. J.
Boardman (ed.), *Oxford History of Classical art* (1993) pl. XXIV.
37 M.E. Masson and G.A. Pugachenkova, *The Parthian Rhytons
of Nisa* (1982). For a reassessment of the Greekness of the rhyta
see P. Bernard, *Journal des Savants* 1985, 25–118. Cf. M.
Pfrommer, *Studien zu alexandrischer und grossgriechischer Toreu-
tik* (1987) 172, calling them Seleukid. On the ivory furniture from
Nisa, which looks more Persian with some Greek touches, see P.
Bernard, *Syria* 47 (1970) 327–43.
38 *Oxus* no. 6; dated earlier in I.R. Pichikyan, *Oxos-Schatz und
Oxos-Tempel* (1992) 48–9, but the lion head is Hellenistic, not
Court Style.
39 V.M. Masson in *La Persia e il Mondo Greco-Romano* (Rome
1966) pls. 1 (silver), 2 (marble; the archaising statue, fig.
2 = [*4.22*]).
40 It is seen, however, on silver bosses from the European
Scythian area. On Parthian plate: P. Harper, *Mesopotamia* 22
(1987) 350, fig. 96; Pfrommer, op.cit. (n. 37), 26–36 for several
examples on eastern phalerae of the first century BC/AD.
41 For a clay example from Alexandria close to ours in shape and
with a relief myth scene upon it see J. Vogt, *Expedition Ernst von
Sieglin* II.3 (1924) pl.20.
42 Pope (1938) pl.137b. Cf. the poorer specimen with compar-
able florals, probably from Olbia, New York 22.50.2 (*Bull.Met.-
Mus.Art* 42.1 (1984) no.87); and the finer gilt silver bowl from
Nihavand, Persia (Pope (1938) pl.137a).
43 Once in Berlin, also with wave pattern at the rim; K.
Weitzmann, *Art Bulletin* 25 (1943) 312, fig.25.
44 Weitzmann, op.cit., 289–324.
45 St Petersburg, Hermitage Mus.; diameter 15.5cm. Weitz-
mann, op.cit., figs. 1, 5–8; K.V. Trever, *Pamyatniki Greko-
Baktriiskogo Iskusstva* (1940) pls. 15–7.
46 Freer Gallery of Art 45.33 (formerly Kevorkian Coll., New
York); diameter 19.1 cm; Gunter/Jett, op.cit. (n. 36), no. 23;
Weitzmann, op.cit., fig. 13.
47 St Petersburg, Hermitage Mus.; diameter 14.5 cm; Weitz-
mann, op.cit., figs. 9–12; Trever, op.cit., pls. 18–21.
48 With shorter animal ears, less satyric, it becomes called
Karttimukha, an alias of the Indian wargod Skanda, with many
appearances in Central Asia: e.g., a silver emblema from
Pendzikent (B.I. Marshak, *Sogdiiskoe Serebro* (1971) fig. 33); or
the clay heads as J.C. Harle and A. Topsfield, *Indian Art in the
Ashmolean Museum* (1987) no. 35. It may owe something to satyr
masks, as *Crossroads* no. 118. The resemblance to Archaic Greek
gorgon masks (leonine human) is accidental, since these lost their
animal features in the 5th century BC.
49 Unknown whereabouts; diameter 21 cm; P. Denwood, *Iran* 11
(1973) 121–7. For the technique, see below, n. 52.
50 E.g., *Crossroads* nos. 97–8.
51 For these later examples: Dalton, pls. 29–32, 34–5; *Ars
Orientalis* 2 (1957) 56–7, pl.2, pl.8; *Acta Iranica* 1 (1974) pl. 21;
P. Harper in *Misc. Vanden Berghe* (ed. L. de Meyer and E.
Haerinck) II (1989) 847–66; B. Brentjes, *Iranica Antiqua* 25
(1990) 173–82; Gunter/Jett, op.cit. (n. 36), no. 25.
52 London, British Museum WA; diameter 22.6 cm. Dalton
(1964) no. 196, pl.27, from Badakshan; often described as being
from the Oxus treasure itself; *LIMC* III Dionysos in per.or.
no.223, pl.417. On the technique, see P. Harper, *Bull.Met.
Mus.Art* 23 (1964/5) 188–9, who declares it not pre-Sasanian in
the east; and F. Baratte, *Revue du Nord* 66 (1984) 221–30, for
Roman usage.
53 Naples, National Museum 25840; Dalton (1964) 50, fig. 75;
M.-L. Vollenweider, *Die Steinschneidekunst* (1966) pl. 23.1,
attributed to Sostratos, mid-1st century BC; *LIMC* III Dionysos/
Bacchus no.223, pl.451.

54 Washington, Freer Gallery of Art 64.10; diameter 21.9 cm; R.
Ettinghausen, *Arts in Virginia* 8 (1967–8) 39, and *From Byzan-
tium to Sasanian Iran and the Islamic World* (1972); *LIMC* III
Dionysos in or.per. no.128, pl.417; Gunter/Jett, op.cit. (n. 36), no.
16. The replica, found in the Urals, is in the Historical Museum,
Moscow. I discuss these dishes more fully in *Classical Art in
Eastern Translation* (Myres Memorial Lecture, 1993).
55 Tarn (1951), 22–3. They had other Sasanian silver: P.O.
Harper, *Silver Vessels of the Sasanian Period* I (1981) pl. 11b (the
Burnes plate; lost) and Cab Med. CH 2881, ibid., pl. 22.
56 Paris, Bibl.Nat., Babelon 360; H.von Gall, *Das Reiterkampf-
bild* (1990) 56–9.
57 New York, Met.Mus. 63.152; diameter 21 cm; P.O. Harper,
Bull.Met.Mus.Art 23 (1964/5) 186–95; K. Weitzmann (ed.), *The
Age of Spirituality* (1972) no. 145; Ettinghausen, op.cit. (n. 54,
1972) pl. 11. 38, and pl. 11. 39 for a version with the horses alone;
N. Yalouris, *Pegasus: The Art of the Legend* (1975) for the later
history of the Pegasus group.
58 W. Vogelsang in *Eastern Approaches* (ed. T.S. Maxwell, 1992)
1–15, and especially most of his *The Rise and Origins of the
Achaemenid Empire* (1992) for Persian occupation of and debt to
the east and north-east. On the Bactrian landscape, J.-C. Gardin,
CRAI 1980, 480–501.
59 Expressed as a threat in Herodotus 6, 9. Inhabitants of
Branchidae near Miletus had been sent to Sogdiana, north of
Bactria, where they were found by Alexander; see Narain
(1957) 2–3.
60 See Holt (1988) for a description and account of early Bactria,
Alexander and the immediate aftermath. On Alexander's eastern
satrapies see K.W.Dobbins, *Persica* 11 (1984) 73ff.
61 For the early coins found in Bactria and the imitation owls see
P. Bernard and O. Guillaume, *Revue Numismatique* 22 (1980)
9–17; M. Mitchiner, *Indo-Greek and Indo-Scythian Coinage* I
(1975) 21–2; *Crossroads* 5–6.
62 Others, such as Narain (1957, 4–5) place Sophytes before
Alexander's arrival, and take him for 'a Greek with the semblance
of an Iranian name.' Mitchiner, op.cit. (n. 61) 23; R.B.
Whitehead, *Num.Chron.* 1943, 60–76, pl. 3.7–8.; Holt (1988) 96ff.
63 For the Persians and Greeks in Bactria see *CAH* IV, ch. 3c
(H.-P. Francfort); VII.1, ch.6 (D. Musti); below, n. 65.
64 N. Davis and C.M. Kraay, *The Hellenistic Kingdoms, Portrait
Coins and History* (1973) ch.5. On the later series, O. Bopearach-
chi, *Numismatic Chronicle* 1990, 79–103. [*4.31*] is in Kabul
Mus.
65 In Bactria itself the local language is written in Aramaic script
before the Greeks, in Greek script after; see I. Gershevitch,
Cambridge History of Iran III.2 (1983) ch. 36.
66 A good survey of the site and finds by C. Rapin in *GCNP*
329–42. On the sculpture, see below, and Smith, op.cit. (n. 26)
224–5. A.D. Narain questions dates in *India and the Ancient
World* (ed. G. Pollet; Eggermont Jubilee vol., 1987) 116–30.
67 P. Bernard, *Berlin Kongress 1988* 51–4, 58–9. Bernard has
conducted the excavations and produced exemplary reports
68 For its Corinthian capitals see P. Bernard, *Syria* 45 (1968)
111–51 (fig.4 = [*4.32*]).
69 I. Kruglikova, *Drevnyaya Baktriya* 1 (1976) 89, fig. 52; *CRAI*
1977, 407–27.
70 P. Bernard, *CRAI* 1990, 358–70; 1992, 275–311.
71 Dalton (1964) – including much material *not* from the hoard;
Plates to CAH IV 52.
72 London, British Museum WA 123905; height 29.2 cm; Dalton
(1964) no.4; *Plates to CAH IV* pl.235.
73 This seems unlikely; it is argued by Pichikyan, op.cit. (n. 38)
who places both treasures before 330 BC; answered by K. Jettmar
in *Oxus* 171.
74 For the satyr, P.Bernard, *Studia Iranica* 16 (1987) 103–15;
LIMC VII s.v. Oxos. For this and other Takht-i Sangin finds,
B.A.Litvinsky and I.R.Pichikyan, *JRAS* 1981–2, 133–67; and

the exhibition catalogue, *Oxus* (1989). For Tillya Tepe, mainly later, Sarianidi (1985); see also the next section for finds at this site.

75 *Oxus* no.9, width 11.8 cm. A gilt bronze plaque from the site carries heraldic panthers in relief in what may be a deceptively Archaic Greek style, but taken for an import by B.A. Litvinsky and I.R. Pichikiyan, *East and West* 42 (1992) 69–84.

76 *JRAS* 1981/2, pls. 1, 11–2; *Oxus* no.5.

77 J.-C. Gardin in *Berlin Kongress 1988* 187–93.

78 St Petersburg, Hermitage Mus. diameters 24.7, 24 cm; Trever, op.cit. (n. 45) pls.1–5. P. Goukowsky suggests that the war-elephant bearing a turret ('Elephant and Castle') was a Greek innovation, not Indian: *BCH* 96 (1972) 473–502. On these phalerae, Pfrommer, op.cit. (n. 36), publishing others with animal-fights.

79 Cf. Oliver, op.cit. (n. 35), no.37, for an Eros from the Nihavand find; ibid., no.52 for a western (Asia Minor) example.

80 St Petersburg, Hermitage Mus.; diameter 9.2 cm; Trever, op.cit. (n. 45) pl.10, from between Omsk and Tobolsk.

81 *JRAS* 1981/2, pl.10; gilt bronze from Dushanbe, *Oxus* no.26.

82 *Taxila* pl. 209a; Wheeler (1954) pl. 24b. The genre persists in Sasanian; for its history in the east, P. Harper, *Royal Imagery on Sasanian silver vessels* (diss. 1977).

83 Polybius 11, 34.

84 For possible archaeological evidence of the invasion of the Yueh-Chi see P. Bernard, *CRAI* 1987, 758–68.

85 *[4.41]* Calcutta, India Mus.; *[4.42]* Sarnath Mus. Harle (1986) 22–4; J. Irwin, articles in *Burl.Mag.* 115–8 (1973–6) and *South Asian Archaeology 1979* 313–40. These 'Indo-Persian' columns may have less Persian about them than is generally held though the addorsed animals atop those which are used architecturally (but not free-standing) recall Persepolis. The bell-shaped capitals have nothing really in common with Persian bell-shaped bases, and the member can appear inverted at the base of the Indian columns too. They resemble tent-post terminals over which canopies are to be draped and are more likely a translation into stone of a wooden form, as so much else in early Indian architecture, but adjusted and embellished for a monumental setting. The vertical tongue patterns on the capitals do resemble Persepolis, however, while an upper flaring member resembles the Greek sofa capital (see below). It is odd that they are then used free-standing but this is determined by their special function. The lions on *[4.42]* are very Persian but with realistic touches (the mouths) as on Greek-inspired works (the ivory rhyta from Nisa).

86 Patna Mus., from Pataliputra, the Mauryan capital; height 86.5 cm; Rowland (1977) 72, fig. 23; M. Wheeler, *Early India and Pakistan* (1959) pl. 49, taken as Persian. The Greek type: C. Llinas in *Hommages G. Roux* (1989) 63–78. A very similar Hellenistic one with flame-palmette decoration from Rhamnous in Attica: *Ergon ...Arch.Etaireias* 1989, 7, figs.7–8. They are found topping Indo-Persian columns on reliefs at Bharhut and Sanchi (2nd cent. BC on), and relate to shallower bracket-capitals in wood (*Bharhut* pls.11–4). They carry palmette-like patterns at Mathura and on Begram ivories: Hackin (1954) figs. 514–5. The double scrolls on Persian columns are not on splaying members, and the lower scrolls are at any rate not the rule in India.

87 Conveniently discussed in Rowland (1977) chs.6–7; Harle (1986) ch.1. A.K. Coomaraswamy, *La sculpture de Bharhut* (1956) for comprehensive illustration. Sanchi is selectively illustrated in most handbooks, comprehensively only in J. Marshall and A. Foucher, *The Monuments of Sanchi*. Bodh-Gaya has a smaller complex preserved: A.K. Coomaraswamy, *Ars Asiatica* 18 (1935). R.E. Fisher, *Buddhist Art and Architecture* (1993) gives a useful account of Buddhist art in the service of its religion.

88 The pillars of the vedika have tenons above to fit into the upper rails; the stone construction long follows the principles of woodwork rather than using clamps or dowels, which are not seen in India much before the second century AD.

89 The stepped battlement pattern (merlons) soon loses any allusion to its original function, and becomes a persistent though sporadic decorative pattern in eastern art: e.g., in gold, *Taxila* pl.194c; alternating with lotuses on *Bharhut* pls. 41–51, *Sanchi* pls. 57, 59, with palmettes on *Mathura* pl.59a. It appears realistically on architecture here and there at Sanchi (e.g. *Sanchi* pls. 12 (on a stupa), 22, 31, as if made of wood or bricks and sometimes streamlined into triangles), otherwise decoratively on model or relief stupas, and as pure pattern. It has a long life yet farther east – on a model stupa in Urumchi Museum, in its true role on representations of western cities on some Dun-Huang paintings, etc.

90 Calcutta, India Mus. *Bharhut* pl.17.43; M.L. Carter, *Ars Orientalis* 7 (1968) 137–40, pl.7, fig.16 – a detailed study. Identified as a Saka (Scythian) by P.G. and D. Paul, *East and West* 39 (1989) 130, 137. He is generally said to be holding a vine sprig: it is surely ivy, the leaf and certainly the flower.

91 The head recurs on a figure with a horned lion at Sanchi: Carter, op.cit., 139, fig.1.

92 Vidisa Mus., from Vidisa. For such figures see *Mathura* and *Bharhut* passim (heavily stylised on pl.15.37 and perhaps misunderstood on pl.18.46). For Yaksas, e.g., Rowland (1977) fig. 24; ibid., figs. 29, 30 (Bharhut) and fig. 45 (the Didarganj yaksi); Harle (1986) 29–30, figs. 13–5 (fig. 13 = *[4.45]*). In elaborate form at Pitalkhora, *Ancient India* 15 (1959) pl. 51; Harle (1986) 51, fig. 33. The motif appears also far to the east: D. Barrett, *Sculptures from Amaravati in the British Museum* (1954) pl. 17. A slightly different treatment at Sanchi, as R.E. Fisher, *Buddhist Art and Architecture* (1993) 39, fig. 25.

93 E.g., Harle (1986) figs. 13, 33; Foucher (1918) I, frontispiece; *East and West* 31 (1981) 133–4. On statues of Kushan rulers, *Mathura* pls. 2 (at side), 34b.

94 J.J. Pollitt, *Art in the Hellenistic Age* (1986) 175–84.

95 Foucher (1918) II, esp. 215–227; in Japan, 667, fig.548.

96 *Bharhut* on the gate pl.2.3–4; cf. pl.4.9, behind the lions, pls. 6.19, 39.120. It is popular as a torana (gate) acroterium, *Mathura* pls.5b, 6. It is not clear how far these are locally inspired florals assimilated to the Greek style of palmette, or already dependent on the Greek pattern. The folded leaves of the ferns (also on the side of the capital *[4.43]*) could have been suggested by the drooping lower leaves of a Greek palmette but look more realistic.

97 E.g., *Bharhut* pls.41–51; Nehru (1989) pls. 95–6.

98 *Bharhut* pls.8.24, 9.27, 11.31, 25.65.

99 Usually on representations of stupas and in two rows, unsupported: *Bharhut* pls.6.18, 8.24, 11.30, 23.59, 25.65.

100 Grünwedel (1932) fig. 27; *Ars Asiatica* 18 (1935) pl. 53.2. Cf. *Bharhut* pl. 16.34, profile view, and *Mathura* pl.38a, where the near horses turn their heads back. They pull the chariot of Surya, the sun god, and recall classical groups of the Sun (Helios/Sol) in his chariot. But in the early Vedic hymns Surya has seven horses, as often in later Indian art.

101 For Sanchi 2 see *Sanchi* III; Grünwedel (1932) figs. 18–21, 28. For Bodh-Gaya, ibid., figs. 24–7 (the chariot), 44, 46; Rowland, figs. 38–9. The railings as Oxford 1983.24 (Harle/Topsfield, op.cit. (n. 48), no.10) could be as early for the lion type and folded-leaf ferns; and P. Pal, *Indian Sculpture. Los Angeles Museum* I (1986) 175–6, S53.

102 E.g., Oxford X. 201; height 21.3 cm; Harle/Topsfield, op.cit. (n. 48), no. 7. This is a most elaborate version of a familiar type for the period.

103 *Sanchi* 117, 217, Inscription no.400. Kharoshti masons' marks at Bharhut (*Sanchi* 103) might suggest that the masons were recruited from Gandhara where the carpentry traditions are strongly apparent once these are translated into surviving stone.

104 Rowland (1977) 109, fig. 55; E.C.L. During Caspers restores it as a table leg, vel sim., *S.Asian Arch. 1979* 341–53. Fully discussed in *Amadeo Maiuri* (ed. C. Belli, 1978) 229–38 (= article by Maiuri in *Le Arti* 1939). The ivory figures at Begram are

slightly different (Hackin (1954) figs. 234–5, and cf. our [*4.61*]); this is the style of the earliest group of paintings in the Ajanta caves.

105 See n. 103; and cf. the strange lion-capital with Kharoshti inscription, *Mathura* pl.24a.

106 Air photographs in *Plates to CAH IV* pl.33; M. Wheeler, *Civilisations of the Indus Valley and beyond* (1966) 121, cf. 122, a site near Charsada. Important recent essays on Taxila by F.R. Allchin, G. Fussman and S.R. Dar in *Urban Form and Meaning in South Asia* (edd. H. Spodek and D.M. Srinivasan, 1993). Cf. the summary of dating by K. Karttunen in *Arctos* 24 (1990) 85–96.

107 Indo-Greek coinage: Narain (1957). On the profound effect of Greek coinage in India and the east see D.W. MacDowall in *Aus dem Osten des Alexander-reiches* (Festschrift K. Fischer, 1984) 66–73. The use of Greek coin names can be traced well into Central Asia (*stater* = Satera; *drachma* = Trakhma).

108 In general on the Greeks in India see Tarn (1951), Narain (1957); *CAH* VIII ch.11 (A.K. Narain). For Persians in India, *CAH* IV, ch.3d (A.D.H. Bivar).

109 J.N. Farquhar, *Bulletin of the J. Rylands Library* 10 (1926) 80–111 and 11 (1927) 20. Amphilochos, whose Hellenistic tombstone in Rhodes records his craft practice on the furthest Indus, was perhaps an architect: W. Peek, *Griechische Vers-Inschriften* I (1955) no. 904.

110 *Cambridge History of Classical Literature* I (1985) 657.

111 A recent review of the problems, A.D.H. Bivar and M.C. Bridge, *S.Asian Stud.* 5 (1989) 149f.; S.J. Czuma, *Kushan Sculpture* (1985)39–43; *Crossroads* 17–8 (J. Cribb).

112 Rosenfield (1967); e.g., Harle (1986) fig.50.

113 Kushan pottery seems to owe more to Indo-Greek tradition than Roman or nomad; see J.-C. Gardin in *Aus dem Osten des Alexander-reiches* (Festschrift K. Fischer, 1984) 110–26.

114 A late example reached Tadzikistan: *Oxus* (1989) no. 45. They have been collected by H.-P. Francfort, *Les palettes de Gandhara* (1979), but see the review by K. Parlasca (*Gnomon* 1981, 694–7) who studied their western models in *Das Römischen-Byzantinische Agypten* (Akten Kongress Trier, 1979; 1983) 151–60. An indication of their early demise is the sole late specimen to depict Buddha: Francfort, no. 96. See also *Crossroads* 152–8.

115 British Museum EA 1936.12–23.1; diameter 12.3 cm; Francfort, no. 6; *Crossroads* no.154.

116 London, Victoria and Albert Museum IS 3–1958, from Taxila (Sirkap); diameter 12 cm; Francfort, no. 41; *Crossroads* no.156.

117 Oxford, Ashmolean Museum EA 1993.24; width 11.2 cm. Lerner/Kossak (1991), no. 24 for the palette with the whole Herakles group.

118 *Taxila* pl. 191, 98; Rowland (1977) 146, fig. 90.

119 London, Victoria and Albert IS 13–1948; *Crossroads* no.137 q.v. for references to similar figures. Indianized Psyche/Aphrodites from Tillya Tepe, our [*4.92*]. The lotus bases strangely echo the egg-and-dart mouldings which top many classical bases, and were also derived from overlapping leaf patterns.

120 Private Coll., discussed by the writer in *Crossroads* no.140, and forthcoming. For the earring, from Dushanbe, see *Oxus* no.23. The closest Indian versions are hovering sirens at Mathura, which have lion forelegs and human arms: *Mathura* pl.8a.

121 Oxford, Ashmolean Museum Ant 1892.1499; diameter 25 mm; *GGFR* pl.998; J. Boardman and M.-L. Vollenweider, *Cat. of Engraved Gems and Finger Rings, Oxford* I (1978) no.280; *Crossroads* no.1. I find it hard to believe that the inscription was cut later than the gem, as has been suggested; its reading remains obscure; cf. also A. Stewart, *Faces of Power* (1993) 321–3.

122 For Gandharan glyptic see the survey by P. Callieri, *Atti Acc.Naz.Lincei* 44 (1991) 243–54, and promised works by the same author.

123 Sarianidi (1985) fig.109.

124 E.g., Trever, op.cit. (n. 45), pl.38; Sarianidi (1985) pl.74; *Journ.Asiatique* 263 (1975) 219–22. Cf. E.E. Kuz'mina in *Le Plateau Iranien* (Colloques int. du CNRS 567, 1976) 201–14.

125 J. Bouzek, *Berlin Kongress 1988* 316; cf. idem, *BCH* 109 (1985) 589–96.

126 *GGFR* 318–9.

127 Sarianidi (1985) fig.108.

128 *Taxila* 2 (1951) ch.31. A unusual bronze ring of Greek shape with Kharoshti inscription and a device related to the Greco-Persian but indianized: Lerner/Kossak, no.16.

129 *Ai Khanoum* 7 (1987) nos.1245–54, F4–5; no.1253 is a sealing on a jar with a classical motif; no.1002 is closer to late Greco-Persian.

130 J.L. Davidson in *Aspects of Indian Art* (ed. P. Pal 1972) 1–14; see also below. D. Whitehouse, *Journal of Roman Archaeology* 2 (1989) suggests the generation after AD 100, arguing from the glass but has to posit production, perhaps in the Yemen, for pieces roughly matched in the Roman world only much later. The bronze balsamaria, as our [*4.59*], may not be as late as claimed by Coarelli (see n. 133) and the dates proposed on the basis of the classicizing and some of the Indian material, studied in Hackin (1954), are mainly first-century; there is only a bare hint of Buddhism in the finds: ibid., 83–7.

131 J. Hackin et al., *Rech. arch. à Begram* (1939) and (1954).

132 Hackin (1954) chs. 2–4 (O. Kurz), [*4.58*] = figs. 291, 302; the plaster fragments include part of a life size foot which could only have served a studio copying major statuary.

133 Paris, Musée Guimet 19073; height 11 cm; *Crossroads* no.115; on the examples at Begram, F. Coarelli, *Archaeologia Classica* 13 (1965) 168–79; on the type in general, K. Majewski, *Archaeologia* (Poland) 14 (1963) 95–126 and J.C. Balty, *Jahrbuch des Römisch-German. Zentralmus. Mainz* 20 (1973) 261–4. The Begram examples are unusually fine and could be very early, even late Hellenistic (cf. Balty).

134 Hackin (1954), 54–7 (O. Kurz), with telling comparisons with scrolls at Pompeii (so, before AD 79); Davidson, op.cit. (n. 130) but deriving them from the Indian rhizomes at Bharhut etc. (see above), which is incorrect. On bead-and-reel in India, R. Morton Smith, *East and West* 25 (1975) 439–51.

135 Hackin (1954) fig. 46. There is a bronze in Indian style of the woman with the swan, London, Victoria and Albert Museum IS 8–1989 (cf. *Crossroads* 111). The ivories are (were?) in Kabul Museum but there is a good selection of the Begram finds in Paris, Musée Guimet.

136 Notably Wheeler (1954). A statement of the Roman case by H. Buchthal in *Proceedings of the British Academy* 1945, 151–76, well illustrated. Detailed discussion of eastern relations with Rome in *Aufstieg und Niedergang Röm.Welt* II 9,2 (1978). A good essay by B. Rowland in *Art Bulletin* 31 (1949) 1–10; D. Schlumberger, *Syria* 37 (1960) 131–66, 253–318, for Bactria, largely based on his work at Surkh Kotal; Nehru (1989) passim for discussion of the problem and arguments *pro et contra*.

137 J. Bouzek and S. Deraniyagala, *BCH* 109 (1985) 589–96; J. Bouzek, *Berlin Kongress 1988* 316–7; *Archiv Orientalni* 61 (1993) 13–28. Pliny, in the mid-first century AD, had heard of Herakles being worshipped in Ceylon and its king dressed as Bacchus (*HN* 6.89).

138 L. Casson, *The Periplus Maris Erythraei* (1989). The Greeks called the Indian Ocean the Red Sea. X. Liu, *Ancient India and Ancient China* (1988) for an account of the commodities carried; on sources, I. Puskas in *India and the Ancient World* (ed. G Pollet; Eggermont Jubilee volume, 1987) 141–56. Important essays on Roman contacts and finds in south India in *Rome and India* (edd. V. Begley and R.D. De Puma, 1991). See also below, Chapter Five, nn. 19, 20.

139 Dio Chrysostom, *Disc.* 32. 36,40.

140 *HN* 6.101.

141 *HN* 6.52, citing Varro.

142 By the Sasanian period there is much more of apparently Italian/Roman in the east.

143 E.H. Warmington, *The Commerce between the Roman Empire and India* (1928) remains a valuable source; Wheeler (1964) 161–2.

144 London, British Museum Coins; *Crossroads* no.197.

145 Rosenfield (1967) 72, lists the pantheon and illustrates types, with discussion. There is less correspondence than one might expect with the types of deities on Indo-Greek coins, for which see N. Davis and C.M. Kraay, *The Hellenistic Kingdoms* (1973) figs. 129–74 passim. A good survey by J. Cribb and O. Bopearachchi. in *Crossroads* 74–88.

146 *Crossroads* no.35. The reverse shows the king sitting on a curule chair, a type reserved in Rome for senior magistrates. An iron example was found at Taxila: *Taxila* 544, pl. 170s (I am indebted to David Bivar for pointing this out to me).

147 P. Turner, *Roman Coins from India* (1989), reviewed by S.E. Sidebotham in *Gnomon* 1992, 732–4; Wheeler (1954) ch. 12, and copies of coins of the Emperor Tiberius were made in clay as amulets (pls. 22–3; Turner, op.cit., 37–41; *Rome and India* (n. 138) 39–45). A coin of Nero travelled far north, beyond the Oxus: Albaum/Brentjes (1972) fig. 108.

148 D.W. MacDowall and N.G. Wilson, *Num.Chron.* 1970, 234–40; but this, they argue, should be post AD 98/9. Dr R. Nagaswamy draws my attention to the relief from Amaravati where what seem to be curly-haired, tunic-wearing foreigners offer basins of what might be coins to a ruler: C. Sivaramamurti, *Amaravati Sculptures in the Madras Government Museum* (1956) 119, 234–5, pl. 25.2.

149 Warmington, op.cit. (n. 143), ch.2.

150 Warmington, op.cit. (n. 143), 86, 139, 266; F. Grosso in *La Persia e il Mondo Greco-Romano* (1966) 157–76.

151 His dates have been long disputed, but an accession of about AD 100 seems generally acceptable; see above, n. 111.

152 L. Courtois, *Arts asiatiques* 9 (1962/3) 107–13, 'pseudo-stéatites verdâtres ou légèrement brunatres à polis gras'. For the schists see D.C.R. Kempe, *Journal of Archaeological Science* 13 (1986) 79–88. On sculptors' stone in India see R. Newman, *Stone Sculpture of India* (1984), and on Gandharan, *Crossroads* 264–77 (C.L. Reedy).

153 The gilding preserved on a relief loaned to the Sackler Gallery, Washington, appears on both dress and flesh parts, so there was in this case at least no colour contrasts.

154 The most accessible account of early Indian sculpture of the schools of Gandhara and Mathura can be found in Harle (1986) part 1; Rowland (1977) is more fully illustrated for this period; Ingholt (1957) for the richest illustration of Gandharan. S.J. Czuma, *Kushan Sculpture* (1985) has an excellent account, and cf. *Crossroads*. A convenient repertory of decorative forms and possible derivations in G. Combaz, *L'Inde et l'Orient classique* (1937), and an important repertory of figures and forms in Tissot (1985). Origins are studied in Nehru (1989). There seem problems over the nature of the earlier aniconism: S.L. Huntington, *Ars Orientalis* 22 (1992) 111–56. On the Buddhas: Harle (1986) 76–7; J.E. van Lohuizen de Leeuw, *S.Asian Arch. 1979* (1981) 380–99; J. Cribb, *S.Asian Arch. 1981* (1984) 231–44; *Crossroads* 46–8 (F.R. Allchin and C. Fabrègues).

155 M. Carter explores the case for an early Gandharan seated Buddha (bronze), *Marg* 39.4 (1988) 22–38.

156 This may be barely apparent on the BODDO coin of Kanishka I [4.62] but it is implicit in the heavier treatment of the true right leg. If the Bimaran casket is indeed of the mid-first century AD (*Crossroads* no.191) its Buddha owes something, however remotely, to Polyclitus.

157 Rowland (1977) 127, fig. 66. Once in the Guides Mess, Hoti-Mardan, improved with boot polish.

158 For Hellenistic archaizing see M.D. Fullerton, *Athenische Mitteilungen* 102 (1987) 259–78, and M.A. Zagdoun, *La Sculpture archaïsante* (1989); for Roman, Fullerton, *The Archaising Style in Roman Statuary* (1990).

159 Peshawar Mus. Ingholt (1957) pl. 411; Marshall (1960) fig. 40. A near replica is a large fragment in London, British Museum EA 1900.4–14.13 (ibid., fig. 41; *Crossroads* no.131), where the man wears a chiton under the himation. See *Crossroads* for discussion (Boardman) and forthcoming.

160 Compare especially the style and subjects of the relief in the Victoria and Albert Museum (IS 3–1971; Rowland (1977) 132, fig. 71; *Crossroads* no.130). The series is commonly, and misleadingly, referred to as the Buner Reliefs, but are from somewhere in the Peshawar valley. A good account of them by B. Rowland, *Archives of the Chinese Archaeological Society of America* 10 (1956) 8–17; and Marshall (1960) chs. 5–6. Cf. Czuma, op.cit. (n. 154) nos.87–90; *Crossroads* 125–8.

161 On the Parthian element, B. Goldman, *East and West* 28 (1978) 188–202.

162 London, British Museum OA 1889.10–16.1; height 17.8 cm Marshall (1960) fig. 47; *Crossroads* no.129. The companion relief is in New York.

163 E.g., Ingholt (1957) pls. 388–9, 393–4; *Crossroads* no.128.

164 Marshall (1960) fig. 50. The figures are again arranged in couples, more animated than those just mentioned, and like family groups, with children; see next note.

165 Paris, Musée Guimet 17210, photo F. Tissot; height 17.2 cm; Marshall (1960) pl.31, fig.49. This has no boxed column, but, from the slab from Hadda mentioned in the preceding note, it can be seen that they were not disposed in the manner of the Peshawar valley reliefs, but in longer continuous friezes, interspersed with columns; they also have copings above the figures.

166 As argued by A.D.H. Bivar in *Pakistan Archaeology* 26.1 (1991) 61–72. Parallels with earlier first-century AD work at Palmyra support a relatively early date, pre-Kushan, for some of the first Gandhara reliefs: cf. C. Fabrègues, *Bull.Asia Inst.* 1 (1987) 37–41. Other parallels with work at the other end of the Parthian empire and beyond are remarked in this section.

167 Marshall (1960) figs. 53–62.

168 E.g., Ingholt (1957) pls. 129–31. Buchthal, op.cit.(n. 136), 163–8, figs. 37–46.

169 E.g., by A.C. Soper in *AJA* 55 (1951) 301–19.

170 This has been argued by D. Ahrens, *Die römischen Grundlagen der Gandharakunst* (1961); H.C. Ackermann, *Narrative Stone Reliefs from Gandhara in the Victoria and Albert Museum* (1975). Portraiture in the Roman manner has also been detected in Kushan art but may not go beyond family or ethnic characterizations: O. Stary-Majewski, *South Asian Studies* 6 (1990) argues for it, and cf. Rosenfield (1967) xii–vi. The identification of a portrait of Livia on a Begram plaster relief seems doubtful: E.A. Voretzsch, *RM* 64 (1957) 8–45, pl. 5.

171 K. Walton Dobbins, *East and West* 23 (1973) 279–94, reviews, rather optimistically, the evidence of excavation for dating Gandharan art.

172 V. Dehejia, *Art Bulletin* 72 (1990) 374–92 on narrative modes in Indian art, well defined.

173 London, British Museum OA 1970.7–18.1; height 53.9 cm; *Crossroads* no.134; F.B. Flood, *South Asian Studies* 5 (1989) 17, fig. 1; ibid., for a discussion of Herakles figures in Gandhara.

174 *Pace* Buchthal, op.cit. (n. 136) 158 with figs. 17–19, which make my point well.

175 Thus, M. Taddei, *Archaeologia Classica* 15 (1963) 198–218, on echoes of classical scenes with Philoktetes in groups with Buddha; idem, *East and West* 14 (1963) 38–55, figures lifting beam/trophy/club; J.C. Harle, *South Asian Archaeology 1983* 641–52, on Herakles and the horses of Diomedes.

176 A.C. Soper argues this forcefully in *AJA* 55 (1951) 301–19, esp. 305–6.

177 Strabo 2. 3. 4 (99).

178 London, British Museum OA 1940.7–13.1; height 20.9 cm; *Crossroads* no. 132. The motif studied by Ackermann, op.cit.(n.

170) 40–3; cf. Ingholt (1957) figs.374–80; C.A. Bromberg, *Bull. Asia Inst.* 2 (1988) 67–85; J. Burgess, *Journal of Indian Art and Industry* 8 (1900) pls. 21, 23.

179 See G. Koch and H. Sichtermann, *Römische Sarkophage* (1982) 499–500, pls. 501, 509, 512, 539–41, et al.; N. Asgari, *AA* 1977, 329–80 on their production in Asia Minor. It is the essential combination of details that connects this series with the Gandharan. The hanging grapes occurred on Hellenistic altars with garlands in East Greece.

180 The bracket figures with busts of deities, some winged, may have served this purpose on first-century AD Gandhara stupas; cf. Lerner and Kossak (1991) no.35, with references. This would have encouraged the copying of classical figure supports.

181 Ingholt (1957) 29–30, pls. 494–5; Rowland (1977) 135, fig. 73; *Crossroads* no.193. The inscription also names the slave Agisala as architect, who used to be taken for a Greek – Agesilaos. The idea is generally now discounted but Bivar, op.cit. (n. 166), 72, n. 12, defends it.

182 E.g., no hanging fruit and the exceptional animation of the putti.

183 London, British Museum OA 1880–357, from Jamalgarhi; height 10.2 cm; *Crossroads* no. 203. Cf. Tissot (1985) pl.15 (cf. 13.6–10, 14), figs.79–84.

184 E.g., Koch/Sichtermann, op.cit. (n. 179) pls. 338, 484–5. Palmyra: M. Colledge, *The Art Of Palmyra* (1976) pls. 13–4. They are not boxed, like the Gandharan, but there is some analogy at Palmyra where they appear flanking two-tiered reliefs which stand at the foot of niches in temples. The acanthus friezes are also shared in the west, at Hatra [*4.6*].

185 Rowland (1977) 135, fig. 74; Nehru (1989) 87–8; *Crossroads* no.191–2.

186 *Taxila* pl. 73a and cf. pl. 120a; *Taxila Guide* (1960) 138.

187 They share some features with Bactrian Corinthian that might not be expected in newly adopted forms: P. Bernard, *Syria* 45 (1968) 123–4, the rigid leaves without the usual classical whorls (oeillets). And cf. *Taxila* pl. 135hh.

188 E.g., Ingholt (1957) pls. 15, 76, 102, etc.

189 London, British Museum OA 1951.5–8.1; Rawson (1984) 55, fig. 33.

190 Tissot (1985) pl.16.1. I discuss the phenomenon in *Classical Art in Eastern Translation* (1993).

191 The spirals are oddly recalled in the spiral bracelets growing in the Bharhut tendrils.

192 *Taxila* pl. 17, no.12; photo in A.N. Khan, *Buddhist Art and Architecture in Pakistan* 47, 3 (Taxila Mus.).

193 E.g., Ingholt (1957) pl. 461, and 462 with rosettes in the loops; Marshall (1960) pl.55, fig.80.

194 Boston, Museum of Fine Art, Asiatic Art 39.36; Tissot (1985) figs. 65–6, cf. pl.11.6, 9.

195 M. Squarciapino, *La Scuola di Afrodisias* (1943), pl. 30b = [*4.72b*], from the Arch of Severus. For peopled scrolls of this type in the west see J.M.C. Toynbee and W.B. Ward-Perkins, *Papers of the British School at Rome* 5 (1950) 1–43.

196 See below, under Central Asia, and Rawson (1984) passim.

197 There is bead-and-reel at Bharhut, *Bharhut* pl. 4.10. On the eastern use of the motif and its architectural use by Greeks see above, Chapter Two, n. 21.

198 *Bharhut* pl. 6.19, cf. 39.20; and cf. Sanchi, Grünwedel (1932) fig. 20, and often on Mathura sculpture, *Mathura* pls.9c, 13a, 15a; also on the capital [*4.43*] side. Palmettes remain a pattern for the sofa capitals (as ibid., pl.22c) which remain the common crown to Indo-Persian columns (pls.20, 23b, also inverted as bases on 54) and are seen on the Begram ivories, Hackin (1954) fig.165, with the same column types.

199 London, British Museum OA 1939.1–19.18; height 19 cm; *Crossroads* no.135. Similar examples of the group and dress, Foucher (1918) II figs. 365–6, 379–80, and for Vajrapani 329–30.

200 But for a truly monumental fortified crown for Hariti see the

relief from Swat, G. Gnoli, *East and West* 14 (1963) 29–37, fig. 6, where she seems to have no other Tyche attributes; on this cf. also *idem* in Maxwell, op.cit. (n. 58), 30–7; and M. Taddei in *Aus dem Osten . . .* (above, n. 113) 157, fig. 2. A remarkable Tyche/Hariti with cornucopia and attended by two babies is seen on a gem of late Hellenistic type bought in Kabul, where the recumbent figure below may be a river god, recalling the Orontes with the original Antioch-Tyche figures. But above her are two elephants on lotuses, such as serve the Hindu goddess of good fortune, Laksmi: F. Widemann in *Technology and Analysis of Ancient Gemstones* (edd. T. Hackens and G. Moucharte; PACT 23, 1989) 173–8, fig. 1, who takes the recumbent figure for a 'roi écrasé'.

201 Cf. Ingholt (1957) figs. 340, 342; *Crossroads* no. 142.

202 London, British Museum OA 1950.7–26.2, from Takht-i Bahi; height 27.3 cm; Rosenfield (1967) pl. 78; *Crossroads* no.136. For other Haritis see Foucher (1918) II 145–69; Ingholt (1957) pls. 340–5.

203 Rosenfield (1967) 97, 246–8.

204 Karachi Mus.; height 11.5 cm; Ingholt (1957) pls.347–8; Nehru (1989) pl.124.

205 R.E.M. Wheeler, *Charsada* (1962) pl.41. Charsada (Pushkalavati, Lotus City) resisted Alexander for a month (Arrian 4, 22) and was later laid out on a Greek grid plan, like Taxila (Sirkap).

206 Ingholt (1957) fig.392.

207 London, British Museum OA 1990.10–13.1, from Mardan District; height 12.7 cm; J. Allan, *JHS* 46 (1966) 21–3; *Crossroads* no.133. It carries flanges, like the early reliefs, so might itself be quite early. Another, far poorer relief fragment, shows a warrior (?) emerging from the horse's neck: N.A. Khan, *East and West* 40 (1990) 215–9.

208 Ingholt (1957) pl. 391; *Mathura* pls. 8a, 58b; *Crossroads* no.126.

209 E.g., *Mathura* pl.9.

210 Ingholt (1957) pl. 443. The helmet is worn by other figures on reliefs, sometimes in Roman-style armour; e.g., Tissot (1985) fig. 268, cf. 265, pl. XLII.5. The peak seems converted to a diadem on our [*4.51*].

211 *Butkara I* I.2, pls. 289–93; I.3, pls.343–5, 378a.

212 Indian examples: e.g., Ingholt (1957) pl. XX.2, with sunshade, XI.2, separate. The flying dress for Nereids and the like on Roman sarcophagi: Koch/Sichtermann, op.cit. (n. 179), pls. 238–40, 242, 244; the motif goes back to the fifth century BC for divine riders and fliers.

213 E.g., the woman of the flying couple: Rowland (1977) 240–1, fig. 180; or in a painting at Bamiyan in Afghanistan, *Rivista Istituto Nazionale* 2 (1953) 210, fig. 28.

214 London, British Museum OA 1880.182, from Jamalgarhi; height 23 cm; *Crossroads* no.125; cf. Ingholt (1957) pls. 381–7; *LIMC* III Atlas, p. 16.

215 Such as the famous statue of Kanishka: Harle (1986) fig.50; *Mathura* pl.1. The seated figure, ibid., pl.2, has the splaying classical zigzag folds at the side hems of his cloak, and another, pl.15 (Foucher (1918) II, 537, fig.496), a fine cluster between his legs; remarked above. An important essay on the relationship between Gandharan and Mathura sculpture, J.E. Van Lohuizen-de Leeuw in *Aspects of Indian Art* (ed. P.Pal, 1972) 27–43.

216 I explore these possibilities in *BCH* Suppl. 14 (1986) 447–53 (fig.6 = [*4.80*]: Delhi, National Museum J 555); and the general subject in *Monsters and demons in the ancient and mediaeval worlds* (Papers . . . Porada; edd. A.E. Farkas et al. 1987) 73–84. On the makara, *Mathura* 69 – 'De quadrupède il devient bipède, de crocodile il se change en poisson'; S. Darian, *East and West* 23 (1973) 317.

217 Calcutta, India Mus.; Rowland (1977) 159, fig. 103; Harle (1986) 68, fig. 48.

218 Mathura Mus., from Maholi. Good studies by M.L. Carter in *Ars Orientalis* 7 (1968) 121–46 (fig. 2 = [*4.82*]), and *Bulletin of the Cleveland Museum* 69 (1982) 246–57. Rowland (1977) 158, fig.

192; Harle (1986) 68, fig. 49; Ingholt (1957) pl. 398.

219 Begram – Hackin (1954) fig. 235 (but not on the other ivories, it seems); *Bharhut* pl.19.48; Ingholt (1957) figs. 353–6, 398, 441; A.-M. Loth, *La Vie publique et privée dans l'Inde ancienne* IX (1972) Les Bijoux, pls. 45–8

220 H. Hoffmann and P.F. Davidson, *Greek Gold* (1965) 9, fig. D; *LIMC* II Aphrodite no.779, pl.78; in per.or. no.111, pl.164 (Amman). Nisa – Herrmann (1977) 46. Cf. Taxila – Ingholt (1957) pls. 353–6.

221 Le Comte de Mesnil du Buisson, *Le Sautoir d'Atargatis* (1947).

222 Private coll.; height 16.8 cm, of leaded brass; *Crossroads* no.102, cf. 103–4; F.B. Flood, *South Asian Studies* 5 (1989) 1–17.

223 Private coll.; height 8.6 cm; *Crossroads* no.111.

224 London, British Museum WA; height 25 cm; C.H. Read in *Essays ... William Ridgeway* (ed. E.C. Quiggin, 1914) 261–5; Dalton (1964) pl.25, no.194. Its less Mesopotamian, Gandharan counterpart can be seen in Ingholt (1957) pl. 396 (muzzle, ears, acanthus neck) and cf. the muzzle on pl. 394. In *Cambridge History of Iran* III.2, 1095, pl. 100c, it is compared by D. Shepherd with bronze throne legs of griffin heads and necks (ibid., pl. 100 b) which are taken for Sasanian, yet look perfectly classical in form. For the throne legs see now *Splendeur des Sassanides* (Brussels, 1993) nos. 28–9.

225 Karachi Mus. 1832; Ingholt (1957) pl. 508.

226 M.Z. Tarzi, *CRAI* 1976, 381–410.

227 Tarzi, op.cit., 402–4; C. Mustamandy in *Aus dem Osten ...* (above, n. 113) 176–80.

228 London, British Museum OA 1880.7–9.19, 32; D. Barrett, *Sculptures from Amaravati in the British Museum* (1954) pls. 4, 39–41.

229 Ortiz Collection, Vandoeuvres; height 58 cm; second/third century AD. G. Ortiz, *The George Ortiz Collection* (London 1994) no. 173.

230 A general survey, B.A. Staviskij, *La Bactriane sous les Kushans* (1987).

231 On Buddhism among Iranians, R.E. Emmerick in *Cambridge History of Iran* III.2 (1983) 949–64.

232 Schlumberger, op.cit. (n. 136) for a summary of results and significance.

233 Sarianidi (1985) has lavish illustration of the material: figs. 69 (cameo), 71 (gem); also *idem* in *Persica* 11 (1984) 1–35. On the gold work, G.A. Pugachenkova and L.I. Rempel, *Bull. of the Asia Inst.* 5 (1991) 11–25. The subject of the gem is three of the Seven against Thebes drawing lots before the gates of Thebes; cf. *Die antiken Gemmen ... in Wien* (E. Zwierlein-Diehl) I (1973) nos.284–6, II (1979) nos. 696–7; not the Herakleidai.

234 Sarianidi (1985) figs. 77–9.

235 Sarianidi, op.cit., figs.99, 80, 19.

236 Albaum/Brentjes (1972) fig. 108, from Chairabad-Tepe, 30 km north of Termez.

237 From Termez. Albaum/Brentjes (1972) pls. 105–6. Restored here from a complete example from the same mould, now in Italy: A. Frova, *Archaeologia Polona* 14 (1973) 155–74, suggesting manufacture in Asia Minor, first century AD. The shape is an *askos*, inspired by the form of a wineskin and translated also into metal (there is a silver example from Taxila).

238 Albaum/Brentjes (1972) fig. 103; *East and West* 21 (1971) 75.

239 E.g. the clay Herakles from Tajikistan, *Oxus* (1989) no. 44, the knot and pattern of his lionskin apparent, the lion head turned to a cap, but the club, pose and nudity in place.

240 Nehru (1989) pl. 53.

241 R. Morris makes a good critique of the dating of Khalchayan and Dalverzin-Tepe in *Journal of the American Oriental Society* 103 (1983) 557–67. Nehru (1989) 32–7 finds lingering Bactrian influence still. Cf. also G. Frumkin, *Archaeology in Soviet Central Asia* (1970), especially for Pendzikent where there is a relief with a version of a *ketos* and Skylla, pl. 27 and fig. 19; and Azarpay,

op.cit.(n. 33), 83–4.

242 G. Azarpay, *Iranica Antiqua* 23 (1988) 349–60; *eadem*, op.cit. (n. 33), 141–3; Albaum/Brentjes (1972) pl. 146.

243 An account of the Chinese sources in Narain (1957) ch.6.

244 A useful account of the routes and relations with India and China is to be found in X. Liu, *Ancient India and Ancient China* (1988). For artistic exchange east-west, Rawson (1984) and a brief but well-documented account of trade, U. Hermberg, *Gewürze, Weihrauch, Seide: Welthandel in der Antike* (1971); W.Raunig, *Bernstein – Weihrauch – Seide* (1971). For the Achaemenid Persians and Central Asia, H.-P. Francfort in *CAH* IV ch.3c.

245 K. Jettmar, *Zwischen Gandhara und den Seidenstrassen* (1985).

246 Liu, op.cit. (n. 244) observes that materials reaching China from India may have come from the west but were not valuable enough to have formed part of a regular West-to-China trade.

247 Hermberg, op. cit. (n. 244), 39 refers and illustrates.

248 V. Guguev, I. Ravich and M. Treister, *Bulletin of the Metals Museum* 16 (1991) 32–50.

249 Pomponius Mela 3. 7. 60.

250 *HN* 6.54.

251 K. Jettmar, *The Art of the Steppes* (1967) ch. 8.

252 *CRAI* 1990 531–5, figs. 7–8; J. Rawson, *Bull. of the Asia Inst.* 5 (1991) 140, fig. 5.

253 Oxford, Ashmolean Museum EA 1963.28, from near Gilgit; height 27.5 cm; *Crossroads* no.95, cf. 96. Cf. K. Jettmar, *South Asian Archaeology* 1977, 921–5; Albaum/Brentjes (1972) fig. 33; R. Brentjes, *Arch.Mitt.Iran* 25 (1990) pl. 23.1.

254 Urumchi Museum; *CAH* IV, 181–2, fig.8; *Arts asiatiques* 42 (1987) 35, fig. 8; the bronze rings found with it are cauldron rims. The figure is remarkably large – 42 cm high and said to weigh 4 kilos. The hands hold hollow tubes

255 Rawson (1984) 56; R. Whitfield and A. Farrer, *Caves of the Thousand Buddhas* (1990) nos. 115–24 ([4.97] = nos. 115, 117, 122: British Museum MAS 699, 707 from Loulan, as third cent. AD; MAS 391 from Khadalik, as sixth cent. AD).

256 E.g., A. Stein, *On Ancient Central Asian Tracks* (1933) 89, fig.44, 104. Cf. his excellent summary of the geography in *Geogr.Journal* May/June 1925, 1–55.

257 Talbot Rice (1965) 212–4; M. Bussagli, *Central Asian Painting* (1979) 18–29.

258 Delhi, National Mus.; Rowland (1977) 186, fig. 126; details, Bussagli, op.cit., 24–5. One inscribed painting records payment to an artist called Ti-ta, from which Stein and others have improbably argued a Roman Titus; see M. Bussagli, *Rivista Istituto Nazionale* 2 (1953) 184, who expresses proper doubts.

259 Urumchi Museum.

260 Bussagli, op.cit. (n. 258), 192.

261 A. von Le Coq, *Von Land und Leuten in Ost-Turkistan* (1928) 162ff. on western motifs (pl.43, the apsaras; 165–6 on cornucopiae). The architectural details – idem, *Buried Treasures of Chinese Turkestan* (1928, 1985) 136, pl.42; Grünwedel/Waldschmidt (1912) 146, fig.335, cf. 64, fig.124; 170, fig.319, the apsaras. Apsaras at Bamiyan, Rowland (1977) fig.120. On the afterlife of Corinthian capitals in Bactria, B.J. Staviskij, *East and West* 23 (1973) 265–77. Apsara is a term of convenience for these and their earlier kin at Bharhut and Sanchi; there are various flying spirits in Indian literature, some musical or birdlike, seldom exactly identifiable with images except in a generic way. I have not seen R.S. Panchamukhi, *Gandharvas and Kinnaras in Indian Iconography* (1951), but these might be better names for some of these flying attendants; see also *Wörterbuch der Mythologie* V (1984) s.v.

262 Notably architectural elements in the fifth-century Buddhist reliefs at Yungang (Shanxi province, west of Peking): Rawson (1964) 58–62.

263 From Datong, fifth cent. AD. Rawson (1984) 64–5, cf.23–39, 54–62.

264 A useful account of Buddhist art in China in M. Sullivan, *The Arts of China* (1973) 101–17, 126–31. Emmerick, op.cit. (n. 231), suggests that Buddhism may have reached Khotan in the first century BC.

265 A convenient account of Dun-Huang in Whitfield/Farrer, op.cit. (n. 255), a British Museum exhibition catalogue; pl. 113 top for some apsaras, who have been adopted as the tourist mascots for the site. B. Gray and J.B. Vincent, *Buddhist Cave Paintings at Tun-Huang* (1959). The flying apsaras survive for centuries in this basic form in the Buddhist arts of China, Korea and Japan.

266 China: J. Rawson in *Pots and Pans* (ed. M. Vickers, 1986) 33, fig.2. India: Talbot Rice (1965) 143, fig.128; *Oxus* no.204, pl.33; *Crossroads* no.101. Classical elements in Chinese jewellery: V.C. Xiong and E.J. Laing, *Bull. of the Asia Inst.* 5 (1991) 163–73; some Greek and Roman objects in China, K. Parlasca, *BAVA* 2 (1980) 297–308.

267 Cleveland Museum of Art 88.69; *Bulletin* Feb. 1989, 37–8, 41, with a beaker and bottle in the same style.

268 Ningsia region; Wu Zhuo, *Bull. of the Asia Inst.* 3 (1989) 61–70. Cf. the dancers with the arc-flying dress on silver jugs, *Silk Roads. China Ships* (ROM Toronto, 1983) 70–3.

5 Egypt and North Africa

GENERAL BIBLIOGRAPHY

C. Aldred et al., *L'Egypte du crépuscule* (1980)
B. Bothmer, *Egyptian Sculpture of the Late Period* (1960)
P. du Bourguet, *Coptic Art* (1971)
A.K. Bowman, *Egypt after the Pharaohs* (1986)
G. Grimm, *Kunst der Ptolemäer- und Römerzeit im Ägyptischen Museum Kairo* (1975)
Koptische Kunst. Christentum am Nil (Ausstellung, Villa Hugel, Essen, 1963) = *Essen 1963*
I. Noshy, *The Arts in Ptolemaic Egypt* (1937)
H. Schäfer, *Principles of Egyptian Art* (trans. J.Baines, 1974)
W. Stevenson Smith, *The Art and Architecture of Ancient Egypt* (1981)

GO ch.4
CAH VII.1 ch. 5 (E.G. Turner).

NOTES

1 London, British Museum E 1056; the Tanis stele. On such groups, J. Quaegebeur, *BIFAO* 69 (1971) 191–217 (pl. 1, the London stele).
2 St Petersburg, Hermitage Mus. 3936, of gabbro. *Egyptian Antiquities in the Hermitage* (ed. A.B. Piotrovsky, 1974) no. 131; Aldred et. al. (1980) fig. 326. On the *dikeras*, double horn, see D.B. Thompson, *Ptolemaic Oinochoai and Portraits in Faience* (1973) 32–3. Bothmer (1960) 126, thinks this may be of the deified Arsinoe, posthumous.
3 Cairo Mus. C.G. 701, of red granite; Grimm (1975) pls. 14–15, no. 13, taken for a Greek; and in *Alexandrien* (ed. N. Hinske, 1981) pl. 12; V. Strocka in *Eikones* (Fest. H. Jucker, 1980) 177–80, pl. 60. Cf. Grimm (1975) pls. 16–19, no. 14, a possible Mark Antony in Egyptian style.
4 E.g., a back three-quarter view of a standing figure in a fifteenth-century tomb (Rekhmire); A. Mekhitarian, *Egyptian Painting* (1954) 51.
5 For the Amarna period see *CAH* II.2 ch. 19 (C. Aldred).
6 His name and title, Director of Sculpture, was inscribed on a ivory lid found in the large house which accommodated the workshop. Other sculptors' names of the period are known – Men

and his son Bak 'whom the king himself instructed' (cf. L. Habachi, *Kairo Mitt.* 20 (1965) 86–91 for the family).
7 Berlin, Eg. Dept. 21.261,2. G. Roeder has the fullest study of the heads, in *Jahrbuch der Preussischen Kunstsammlungen* 62 (1941) 145–70. He thought they had been cast from clay models, created in the 'life class', rather than from live or dead figures. For first reports of the sculptor's house and workshops see L. Borchardt in *Mitt. der Deutschen Orient-Gesellschaft* 50 (1912) 29–35, and 52 (1913) 28–50; also 55 (1914) for the use of a resinous, waxlike material for modelling rather than clay. There is a negro face in plaster, perhaps from Amarna, in Cambridge (EGA 5503.1943). H. Schäfer, *Zeitschrift für Ägyptische Sprache* 52 (1915) 81–7, and (1974) 58, and 330–2 for sculptural techniques. It is perhaps worth observing that the Egyptians could never have matched the classical Greek rendering of realistic features and poses without adopting the techniques of copying from models used and perhaps invented by Greek artists in the fifth century, abandoning their Archaic, Egyptian, techniques. To the end, for major sculpture in hard stone, the Egyptians abjured metal tools though they used them freely in work on soft stone. They were well aware of a range of sculptors' tools for softer stones, and it now seems that even the claw chisel, long thought a Greek invention of the sixth century BC, was in use in Egypt earlier: see O. Palagia, *OJA* 13 (1994). On problems of death masks and portraiture in antiquity and early Roman practice see H. Drerup, *RM* 87 (1980) 81–129; J. Bazant, *Annali (Napoli)* 13 (1991) 209–18.
8 V. Webb, *Archaic Greek Faience* (1978). Many Egyptian subjects were adopted for faience, but not exclusively in Greek workshops in Egypt rather than, say, Rhodes.
9 Basel, Cahn Coll. On Archaic Greeks in Egypt and at Naucratis see *GO* 111–41; figs. 146–51 (faience), 162–3 (the Karnak vase), 164 ([5.5]; for which also B. Kreuzer, *Frühe Zeichner* (Freiburg, 1993) no. 51). One cartouche on the last appears to name the Pharaoh Apries who reigned 589–70 BC; stylistically the vase looks of about 530–10 BC. A. Möller, *Naucratis* (forthcoming) on Naucratis and trade. For Herodotus on Egypt, A.B. Lloyd, *Historia* 37 (1988) 22–53.
10 *Antike Kunst* 24 (1981) pl. 10. 1–2.
11 For these see *GO* 136, figs. 158–61. [5.6] = Berlin, Staatliche Museen 19553, from Abusir; height 27 cm; O. Masson et al., *Carian Inscriptions from N. Saqqara and Buhen* (1979) 64. [5.7] = Cairo Mus. JE 35268, from Saqqara; height 9.5 cm; K. Parlasca in *Wandlungen* (Fest. Homann-Wedeking, 1975) pl. 10b,c.
12 G.T. Martin, *The Tomb of Hetepka* (1979) pl.1; J.P. Hemelrijk, *Caeretan Hydriae* (1984) 201–2.
13 Paris, Louvre CA 3825; L. Kahil, *RA* 1972, 271–84; *GO* 140, fig. 166. The Amazon vase, ibid., fig. 165. For an ingenious attempt to explain what the Amazon might have meant in Nubia see H. Hoffmann and D. Metzler in *Genres in Visual Representations* (edd. H.G. Kippenberg et al. 1990) 172–93.
14 F. von Bissing, *Zeitschrift der Deutschen Morgenländischen Gesellschaft* 84 (1930) 226, pl. 1; *Führer durch das Berliner Äg.-Museum* (1961) pl. 56.
15 *GO* 159, fig. 200; A. Fakhry, *Annales du Service* 40 (1940) 793ff., and pl. 109 for a ceiling in the tomb with a Greek wave pattern.
16 *GO* 153–9. It was suggested by S. Stucchi that Cyrenaica provided an alternative and in some ways easier route to Nubia from the Mediterranean: *Mediterranean Archaeology* 2 (1989) 73–84.
17 A rock painting of a leaping quadriga in classical style in Central Sahara (south Algeria): A. Müller-Karpe, *BAVA* 2 (1980) 359–80.
18 Vandoeuvres, Ortiz Coll.; height 0.17. Photo, Y. Lehmann. Probably of Spartan origin. J.D. Beazley, *BSA* 40 (1939/40) 83–4. G. Ortiz, *The George Ortiz Collection* (London 1994) no. 117.

19 J. Pirenne, *Le Grèce et Saba* (1955).

20 Minor finds, as pottery and glass, are plentiful. The bronze statue of a seated female figure recalling the Indian version of Tyche at Taxila [*4.75*] is more remarkable: J. Pirenne, *La Royaume Sud-Arabe de Qataban et sa Datation* (1961) 57–61, pl. 4a,b; *Corpus des Inscriptions et Antiquités sud-arabes* I.2, 366–7, F72; *AJA* 59 (1955) 214, pl.61. Also the bronze horse at Dumbarton Oaks, with its dedicatory inscriptions, in a lively classical style, probably second cent. AD, and very finely cast: J. Ryckmans, *Dumbarton Oaks Papers* 29 (1975) 287–303. A relic of the return trade from India is a bronze figurine from the Yemen: *Archaeology* 16.3 (1968) 187–9.

21 There are a few hardstone statues of Egyptians in Persian dress: Bothmer (1960) pls. 60–1; *Plates to CAH IV* pl. 58.

22 London, British Museum 73.8–20.389, said to be from Canosa, Italy; Thompson, op.cit.(n. 2), no. 1, pls. 1–2, 60, 62. There is a dedicatory inscription on it to the Good Fortune (*agathe tyche*) of Arsinoe; or it may be that the queen is assimilated to Tyche. It bears also a sacred pillar and a horned altar of the type referred to below, n. 31.

23 K. Parlasca, *JdI* 91 (1976) 135–56 for exported examples and full references.

24 E.g., Grimm (1975) pls. 108–10; Aldred et al. (1980) fig. 196, for a glazed clay rhyton with lion forepart.

25 H.P. Bühler, *Antike Gefässe aus Edelsteinen* (1973), esp. 8–10; G. Grimm in *Alexandrien* (ed. N. Hinske, 1981) pl. 16 for an onyx animal-head rhyton from Egypt, and another of the same origin which travelled to China in antiquity.

26 Cairo Mus. JE 38093, from Tukh el-Qaramus; Grimm (1975) pls. 96–7, no. 57. For comparable rhyta in clay or 'black glaze' see A. Adriani, *Bull.Soc.Roy.Arch.Alex.* 33 (1939) 350–62. Material from a bronze-worker's studio in the south part of the Delta has objects of Egyptian form (nails with figure-heads) and models over which jewellery could be hammered, but all the subjects are Greek and in Greek style (including a few popular hellenized Egyptian subjects, such as Bes): A. Ippel, *Der Bronzefund von Galjub* (1922); R.A. Higgins, *Greek and Roman Jewellery* (1961) 11, 157–8, 171.

27 J.J. Pollitt, *Art in the Hellenistic Age* (1986) 280; B.S. Ridgway, *Hellenistic Sculpture* I (1989) 95–7.

28 Noshy (1937) is a dated but still useful guide to the architectural elements.

29 Imitations of Athenian – T.V. Buttrey in *Actes IX Congr.Int.-Num. 1979* (1982) 137–40; G. Goyon, *BIFAO* 87 (1987) 219–23, for a small coin with an Athenian owl which has also made some concessions to the Egyptian falcon (as too on the Greco-Phoenician gem, *GGFR* pl. 418). Pharaonic – A.O. Bolshakov, *Revue d'Egyptologie* 43 (1992) 3–9.

30 E.g., the great Nile mosaic at Praeneste, and Hadrian's Canopus-Serapeum at his villa at Tivoli: *Oxford History of Classical Art* (ed. J. Boardman, 1993) nos. 174, 263.

31 G. Soukiassian, *BIFAO* 83 (1983) 317–33 has a slightly more involved explanation.

32 The best account remains that of the excavator, G. Lefebvre, *Le Tombeau de Petosiris* (1923–4). A brief description with bibliography in *Lexikon der Ägyptologie* 4 (1982) s.v. 'Petosiris', by S. Nakaten, who promises a fuller study.

33 Lefebvre, pls. 12–13; contrast pls. 35–6, 46–9.

34 Lefebvre, pls. 19–22.

35 It would be foolish to insist on detail, but this is no mere copy of a Greek scene, misunderstood. The bull's head is raised for sacrifice, appropriate for a Greek sacrifice to an Olympian god rather than a hero, but an Egyptian probably would not make any such distinction between heroic and divine. Note that the saucer and bowl held by a woman and man in the scene are more Persian than Greek. The scene recalls the earlier Greek sacrificial procession with bulls on the wooden plaque from Saqqara, our [*5.8*].

36 Lefebvre, pls. 7–8; Aldred et al. (1980) fig. 218 (as of wood!). See also for these vessels M. Pfrommer, *Studien zu Alexandrinischer und grossgriechischer Toreutik frühhellenistischer Zeit* (1987) passim, but I do not think the incense burner carried in one scene (ibid. 12, 29, KT4) is a version of the classical rather than a long-familiar eastern type.

37 Lefebvre, pls. 7–8; Aldred et al. (1980) fig. 155, for a good photo.

38 *Pace* Adriani, op.cit., 361. Heichelheim thought the scenes were simply traditional ones modernized, but they are totally modernized and must represent current and local practice, not a mindless copy of old models; cf. M. Rostovtzeff, *Social and Economic History of the Hellenistic World* (1941, 1986) III, 1620.

39 Lefebvre, pl. 11. C. Picard, effectively answering P. Montet, saw the significance of these scenes of metalworking and carpentry: *BIFAO* 30 (1931) 201–27.

40 A relief in Berlin (2214) is in a comparable style but without the strong Greek features: H. Schäfer and W. Andrae, *Die Kunst des alten Orient* (1942) pl. 452; Noshy (1937) pl. 18. At Hermoupolis the Egyptian temple of Thoth had been completed through Greek royal patronage in Petosiris' day. Later, the third Ptolemy built a Greek temple there for himself and his divine wife: A.J.B. Wace et al., *Hermoupolis Magna, Ashmunein* (1959). There was also a Hellenistic Egyptian writer, astrologer and mathematician called Petosiris; the name is common and scholars are unwilling to associate him with the Petosiris burial, but they seem to have had something in common. The tomb inscriptions include some very odd moral texts, and it was much visited by later Greeks who left graffiti, naming Petosiris as *sophos*, 'wise': Lefebvre, 21–5 and ch. 3.

41 Grimm (1975) gives a good brief account of such reflections of Greek art in Egyptian.; pl. 12 for the stele; pl. 13, a Greek dedication to Serapis, where the naiskos stele is better shaped but given Egyptian naked caryatids on the side pilasters; the altar shown on it is of the 'horned' type of Alexandria and Petosiris.

42 Grimm (1975) pls. 74–5; cf. also K. Parlasca, *Studi Miscellani* 28 (1991) 113–27.

43 For the arts and especially sculpture of Greek Egypt see Pollitt, op.cit. (n. 27) ch. 12; R.R.R. Smith, *Hellenistic Royal Portraits* (1988) ch. 9 and *Hellenistic Sculpture* (1991) ch. 11.

44 A major source here is Bothmer (1960). Cf. also K. Mysliewiec, *Royal Portraits of the Dynasties XXI–XXX* (1988).

45 Brussels, Musées Royaux, of black diorite; Smith, op.cit. (1988), pl. 47, no. 73.

46 Earlier, however, Egyptian statues of collaborators could be shown dressed in a Persian manner; see Bothmer (1960) pls. 60–1.

47 Plaster casts of statue heads were still being used in Egyptian studios in the later period, e.g., for the last of the Pharaohs: Munich AS 5339, Schäfer/Andrae, op.cit. (n. 40) pl. 224; *Das Menschenbild im alten Ägypten* (ed. L. Stege, 1982) no. 36; and for Ptolemy II, *Egyptian Antiquities in the Hermitage* (ed. A.B. Piotrovsky, 1974) no. 132.

48 Leiden, Rijksmuseum van Oudheden F 1960/3.1. B.H. Stricker, *Oudheidkundige Mededelingen uit het Rijksmuseum van Oudheden te Leiden* 40 (1959) 1–16, for male figures; 41 (1960) 18–30, for female (pls. 19.2, 20=[*5.22*]). For such hellenized figures of Isis, *LIMC* VI Isis nos.2–8, pls. 502–4. An example holding a double cornucopia, like a Ptolemaic queen, cf. [*5.2*], is Cambridge E 27.1981; it is not inscribed.

49 Berlin, Eg. Dept. 10.100, 'the Green Head', of greywacke; Bothmer (1960) pls. 118–9, no. 127. Comparable examples, ibid., pls. 97–104.

50 Brooklyn Mus. 58.30, of diorite; Bothmer (1960) pls. 123–4, no. 132.

51 Alexandria, Greco-Roman Museum 1332, of limestone; Bothmer (1960) pls. 88–9, no. 95.

52 Cairo Mus, 26/3:44/2, from Hermoupolis; Grimm (1975) pl.

85, no. 47, with Hadrianic hairstyle. See the sequence, ibid., pls. 80–9.
53 Cairo Mus. CG 33269, from the Fayum; Grimm (1975) pls. 90–1, no. 52. A basic study of the Fayum portraits is K. Parlasca, *Mumienporträts und verwandte Denkmäler* (1966).
54 Berlin, Eg. Dept. 11.651,2 from Memphis; K.-H. Priese (ed.) *Ägyptisches Museum* (1991) no. 132.
55 Hamburg, Museum für Kunst und Gewerbe 1989.427; height 16.1 cm. R.A. Higgins, *Greek Terracottas* (1967) 132–3; a useful catalogue and discussion in C. Ewigleben and J. von Grumbkow, *Götter, Gräber und Groteske* (Hamburg, 1991) – [5.29] is pl. 72.
56 C. Bonner, *Studies in Magical Amulets* (1950); P. Zazoff, *Die antiken Gemmen* (1983) ch. 13; a useful account in E. Zwierlein-Diehl, *Magische Amulette ... Köln* (1992).
57 On classical architecture in Roman Egypt, D.M. Bailey in *Architecture and Architectural Sculpture in the Roman Empire* (ed. M. Henig, 1990) 121–37; cf. P. Pensabene, *Studi Miscellani 28* (1991) 29–85.
58 Z. Kiss, *Etudes sur le Portrait Impérial romain en Egypte* (1984) 69–71.; H. Meyer, *Antinoos* (1991) for a full study.
59 Cairo Museum JE 63609; S. Gabra, *Peintures à fresques et scènes peintes à Hermoupolis-ouest* (1954) pl. 15; idem et al., *Rapport 1941*, 98–100, pl. 46; K. Lehmann, *Journal of Roman Studies* 52 (1962) pl. 10.1. For the epigrams, P. Graindor, *BIFAO* 32 (1932) 97–119.
60 Trieste, Museo Civico 5620; *Essen 1963* no. 80; du Bourguet (1971) 88 (colour), 95.
61 Oxford, Ashmolean Museum Ant 1970.403. *LIMC* VI Leda no. 52.
62 Moscow, Pushkin Museum; du Bourguet (1971) 77 (colour).
63 Dusseldorf, Kunstmuseum 13062, from Achmim; *Essen 1963* no. 302.
64 Paris, Louvre E 29302, from Antinoopolis; du Bourguet (1971) app. pl. 7.
65 Cf. K. Weitzmann, *Age of Spirituality* (1979) on no. 167 and 514, fig. 69.

6 The countries of the Black Sea

GENERAL BIBLIOGRAPHY

A THRACE

Gold der Thraker (Mainz, 1980)
R.F. Hoddinott, *Bulgaria in Antiquity* (1975)
I. Marazov, *Ritonite v drevna Trakiya* (1978) on rhyta (in Russian).
I. Venedikov (and T. Gerassimov), *Thracian Art Treasures* (1975, 1979)

GO 232–45, 246–7
CAH III,1 13–18 (Greek colonies; A.J., Graham); IV ch. 3f (under Persia; A. Fol and N.G.L. Hammond); VI ch. 9e (Z. Archibald); *Plates to CAH III* ch. 11 (G. Mihailov); and *Plates to CAH IV* 78–94 (T. Taylor).

B SCYTHIA

M. Artamonov, *Treasures from the Scythian Tombs* (1969)
J. Boardman, *Pre-Classical* (1967) ch.6.
From the Lands of the Scythians (New York/Los Angeles exhibition cat., 1975) = *Lands*

E. Minns, *Scythians and Greeks* (1913)
B. Piotrovsky et al., *Scythian Art* (1987) = *S.Art*
R. Rolle, *The World of the Scythians* (1989)
R. Rolle et al., *Gold der Steppe. Archäologie der Ukraine* (1991). Important essays and illustration.
T. Sulimirski, *The Sarmatians* (1970)

GO 256–64
CAH III,2 ch. 33a (T.Sulimirski and T. Taylor); VI ch. 9f (Bosporan Kingdom; J.G. Hind); *Plates to CAH III* ch. 12 (T. Sulimirski).

C COLCHIS

O. Lordkipanidze, *Archäologie in Georgien* (1991)
O. Lordkipanidze and P. Leveque (edd.), *Le Pont-Euxin vu par les grecs* (1990)
Vani I (1972)- ; site publication, in Georgian with Russian summaries.

Reports in *BCH* 98 (1974) 897–948; *Arch.Reports for 1983/4* 91–101; ... *1990/1* 79–86 (D. Kacharava); ... *1992/3* 82–112 (J.G.F. Hind).

NOTES

1 For the approach to the Black Sea and colonies see *GO* 238–55. For earlier Greek presence, before about 700 BC, the literary evidence is feeble (and confined to the south coast) and the archaeological evidence non-existent: see J. Boardman, *OJA* 10 (1991) 387–90.
2 For the history of Persians in Thrace, J.M. Balcer, *Historia* 37 (1988) 1–21.
3 Published in the exhibition catalogue, *Sindos* (I.B. Vokotopoulou et al., Athens/Thessaloniki, 1985). On the Greek pottery, M.A. Tiverios, *Makedonika* 15/16 (1986) 71–87. Cf. *CAH* IV, 250.
4 On Persian influence in Thracian art see P. Alexandrescu, *Dacia* 27 (1983) 45–66, and 30 (1986) 155–8; T. Taylor in *Plates to CAH III* 78–90. It is interesting to contrast the Greek horse type of the Duvanli rhyton with the Persian horse type of the Borovo rhyton: *Gold der Thraker* nos. 182 and 288.
5 Venedikov (1979) pls. 169–74. Standards: D.M. Lewis in *Pots and Pans* (ed. M. Vickers, 1986) 76; M. Vickers, *Rev.Et.Anc.* 91 (1989) 256. The style of the figures is generally not unmistakably Attic, nor much of the subsidiary decoration, to judge from contemporary pottery; Attic weight standards had been imposed over much of her empire.
6 A.Fol et al., *The New Thracian Treasure* (BM 1986); idem, *Der thrakischer Silberschatz aus Rogozen Bulgarien* (1989); essays in *The Rogozen Treasure* (ed. B.F. Cook, 1989).
7 Rogozen NIM 22304; diameter 13.6 cm; Fol, op.cit., no. 4; B.B. Shefton in Cook (last n.) 82–90.
8 Rogozen NIM 22453; height 14.3 cm; Fol, op.cit., no. 154.
9 Ibid. no. 155.
10 Lovech, Historical Mus.; G. von Bülow, *Treasures of Thrace* (1987) 104. The plaques – *Gold der Thraker* nos. 267–84; R. Pittioni, *Bemerkungen zur religionshist. Interpretation des Verwehrfundes von Letnitsa* (Öst. Akad. 1977); Venedikov (1979) pl. 280–92.
11 J. Bouzek, *Eirene* 24 (1987) 85–92, gives a good general account. For Thraco-Getic as a title for the purer local style see T.F. Taylor in *The Archaeology of Contextual Meanings* (ed. I. Hodder, 1987) 117–41.
12 Venedikov (1979) pls. 231–2, 236; the helmets, ibid., pls. 237, 239–42, and Bouzek, op.cit., 84–7, figs. 17–18; P. Alexandrescu, *Dacia* 28 (1984) 85–97.
13 P. Zazoff, C. Höcker and L. Schneider give a good account of the stylistic problems of the plate, painting and architecture discussed in the following paragraphs in *AA* 1985, 595–643 (well illustrated). On related problems, L. Schneider, *RA* 1989, 227–51.
14 A rhyton of this style with the scene of Agamemnon, Telephos and Orestes reached Kerch: S. Reinach, *Antiquités du Bosphore Cimmerien* (1892) pl. 36. 1–2. See also below, n. 58, for a Thracian

phiale carried east over the Black Sea by a Greek.

15 The Panagurishte hoard: Hoddinott (1975) 85–91; *Gold der Thraker* nos. 361–9; Venedikov (1979) pls. 123–32. For a general study of Black Sea rhyta, especially the Thracian, see Marazov (1978).

16 Rousse, Historical Mus. II–361; *Gold der Thraker* no. 292; Marazov (1978) 151–3, figs. 135–6; *Das Altertum* 26 (1980) 11, fig.7; von Bülow, op.cit. (n. 10) 110–1.

17 Plovdiv, Archaeological Mus. 3199 (a) and 3197 (b); I. Venedikov, *The Panagyurishte Gold Treasure* (1962) no. 3 (a) and no. 1 (b), and (1979) pl. 129; B. Svoboda and D. Končev, *Neue Denkmäler antiker Toreutik* (1956) 129, fig. 2(b); Zazoff et al., op.cit., 613–4.

18 Athenian, to N.M. Kontoleon, *Balkan Studies* 3 (1962) 185–200.

19 Plovdiv, Archaeological Mus., from Golemata Mogila; *GGFR* 230, 425, pl.672. Cf. Venedikov (1979) pls. 206–9. See also Skylas' ring from Thrace, below, n. 33.

20 Lovech, Historical Mus.; Venedikov, pl. 283, cf. 292; von Bülow, op.cit. (n. 10), pl.85; Pittioni, op.cit. (n. 10), fig. 3, cf. figs. 1–2.

21 From Vurbitsa; Z.H. Archibald, *OJA* 4 (1985) 167, fig. 2; cf. 165–85 for discussion, and Venedikov (1979) pl. 230.

22 Sofia, Archaeological Mus. 3555; length 32 cm; *Thracian Treasures from Bulgaria* (BM 1976) no. 356; Venedikov (1979) pl. 245; von Bülow, op.cit. (n. 10), pl.58.

23 A. Vassiliev, *Das antike Grabmal bei Kasanlak* (1959); Venedikov (1979) pls. 84–9.

24 In the Tomba del Tifone at Corneto, on pillars: O. Brendel, *Etruscan Art* (1978) 420, fig. 319.

25 Zazoff et al., op.cit. (n. 13), 628–39; A. Fol et al., *Sveshtari* (1986).

26 For local production of fine jewellery in the colony Odessos, see A. Minchev, *Berlin Kongr.* 1988 463–4.

27 For a general account of Scythia in our period see Sulimirski in *CAH* III.2, ch. 33a. For a recent Russian view of the historical and social development of the area, a useful summary by K. Marchenko and Y. Vinogradov, *Antiquity* 63 (1989) 803–13. T. Talbot Rice, *The Scythians* (1957) is a rather dated account, but see Rolle (1989), and there are useful introductions in most of the art books and exhibition catalogues, notably Artamonov (1969), *Lands*, *Gold der Skythen* (Munich, 1984), *L'Or des Scythes* (Brussels, 1991). Minns (1913) is the classic work, but severely dated.

28 S.I. Rudenko, *The Frozen Tombs of Siberia* (London, 1970).

29 [*6.12*]= St Petersburg K 830, from Kelermes. [*6.13*]= St Petersburg Kr 1895 10/2, from Koulakovsky kurgan, Crimea. Artamonov (1969) pls. 22–4, 78.

30 See E. Porada, *The Art of Ancient Iran* (1965) ch. 10.

31 *GO* 258, fig. 299; from Melgunov's Barrow; Artamonov (1969) pls. 1–3. On the juxtaposition of Animal Style and Mesopotamian see P.R.S. Moorey, *Iran* 23 (1985) 21–37.

32 The furniture (Melgunov's); axe, bowls, scabbard and sword, furniture attachments (Kelermes); rhyton (Seven Brothers): see Artamonov (1969) pls. 6–19, 34, 36–9, 40–6, 117, 119; *S.Art* pls. 24–7, 32–40, 41; *Lands* pl. 8, no. 17. The sword in a Greek scabbard (Chertomlyk) – Artamonov (1969) pls. 183–4, *Lands* no. 67, *S.Art* pl. 220.

33 Skylas was killed in Thrace where, near Istria, a gold ring bearing his name has been found; its device, a seated woman in a rather provincial Greek style but of appropriate date: Rolle (1989) 123–7.

34 Artamonov (1969) pls. 140–1 for the amphora; pl. 144, the corselet (*Lands* nos. 84–5).

35 A. Leskov, *Grabschätze der Adygeen* (1990) figs. 30–1, 45–8, 50–8. The black figure closely matches one of the Maikop finds, *Lands* 158, no. 11. There is also sixth-century Greek pottery, an island skyphos, Leskov, fig. 41.

36 St Petersburg, Hermitage Mus. The Kelermes finds: *GO* 260–1, figs. 303–5; Artamonov (1969) pls. 20, 25–6, 29–33 (the mirror); *S.Art* pls. 45–50; M.I. Maximova, *Sov.Arch.* 25 (1956) 215ff. (the rhyton). On the dating of the Kelermes complex see G. Kossack, *Gnomon* 1991, 437 (part of an important review, 435–43, of recent Scythian literature).

37 St Petersburg, Hermitage Mus. KO 120 and 2498/1; lengths 31.5 and 31.7 cm: Artamonov (1969) pls. 62–4, 264–5; *Lands* nos. 18, 77; *S.Art* pls. 16, 213.

38 Berlin, Staatliche Mus. Misc. 7839; length 41 cm; *GO* 261–2, fig. 306; *Lands* 153–5; A. Greifenhagen, *Schmuckarbeiten in Edelmetall* I (Berlin, 1970) pls. 41–4, and in *Antike Welt* 13.3 (1982) 3–9. There is evidence for Scythian raids into Europe at about this date. It has been suggested that the objects were made in the Danubian Scythian area rather than farther east: S.A. Skory, *Sov.Arch.* 1990.1, 34–41.

39 St Petersburg, Hermitage Mus. SBr IV 8, from Seven Brothers tumulus; length 8.3 cm; *S.Art* pl. 107.

40 Other Kul Oba plaques: Artamonov (1969) pls. 116, 118, 120 (Scythian), 121–2; *S.Art* pls. 100, 106, 108 (Scythian); *Lands* no. 48.

41 Kiev Museum A3C–2288, from Ilyichovo barrow, Crimea; height 10.1 cm; *S.Art* pl. 70; A. Leskov, *Treasures from the Ukrainian Barrows* (1972) pl. 13. Cf. also the plaque with a dog, ibid., pl. 38 (Kakhova, Kherson district).

42 St Petersburg, Hermitage Mus. K–O 11; height 13 cm; *S.Art* pls. 184–7.

43 St Petersburg, Hermitage Mus. K–O 97; height 10.3 cm; *S.Art* pls. 193–5. For the series of Kul Oba cups: Artamonov (1969) pls. 226–9, 232–3, 239–46; *Lands* no. 81; *S.Art* pls. 184–95. Solokha: Artamonov (1969) pl. 151. Chastiye: Artamonov (1969) pls. 195–6, 198; *S.Art* pls. 171–3. Gaimanova: V.I. Bidzilya, *Archeologiya* (Kiev) 1 (1971) 44–56; I.B. Brashinsky, *V poiskach Skiphskich Sokrobishch* (1979) pl. 18.

44 Plain bronze versions are found; and cf. *Crossroads of Asia* (edd. E. Errington and J. Cribb, 1992) no. 96.

45 Kiev Museum A3C–2358, from Gaimanova Mogila; height 9.7 cm; *Lands* pl. 29, no.172; *S.Art* pls. 166–70.

46 St Petersburg, Hermitage Mus. Dn 1913 1/40; height 13 cm; *S.Art* pls. 157–60.

47 M. Andronikos, *Vergina* (1984) 101–3. For the lion with spear see W.L. Brown, *The Etruscan Lion* (1960) 151; Boardman, *GGFR* 413 and index. Brown refers to the horned lions with wings on coins of Panticapaeum: Kraay/Hirmer, pls. 440–1.

48 Scythian style: e.g., Artamonov (1969) pls. 65–6, 145, 323–5, 329–30; *S.Art* pls. 66–7, 155–6, 219. Mesopotamian: (Melgunov's) Artamonov (1969) pls. 6–8, *S.Art* pls. 32–5, with its matching sword. Persian: Minns (1913) 255, fig. 173 (Oxus Treasure).

49 Artamonov (1969) pls. 181–2; *S.Art* pls. 224–5; Minns (1913) 285, fig. 206; *Lands* no. 186. The subject has been thought Achilles on Skyros; see *LIMC* Achilleus no. 182. On *gorytoi* W. Rätzel, *Bonner Jahrbücher* 178 (1978) 163–80.

50 Thessaloniki Mus.; length 46.5 cm; Andronikos, op.cit. (n. 47), 180–6; V. Schiltz, *RA* 1979, 305–10. Part of the matrix is said to have been used for a separate appliqué plaque, *Taisei Gallery Auction* I (5.11.1992) no.166.

51 St Petersburg, Hermitage Mus. Dn 1863 1/447; length 54.5 cm; Artamonov (1969) pls. 183–5; *S.Art* pls. 220 (sword), 221–2 (scabbard); *Lands* nos. 67–8.

52 *S.Art* pls. 150–4; *Lands* no. 170.

53 St Petersburg, Hermitage Mus.; Artamonov (1969) pls. 208–9; Minns (1913) 203, fig. 98. *S.Art* pls. 150–4 (Tolstaya).

54 Solokha, with barbarians fighting, Artamonov (1969) pls. 160–1 and fig.87. Dort Oba (Crimea), with animals, ibid., pls. 193–4.

55 St Petersburg, Hermitage Mus. Dn 1863 1/166; height 70 cm; Artamonov (1969) pls. 162–76; *S.Art* pls. 265–8; Minns (1913)

19–62, figs. 46–9 (drawings), 288–9. For the site and its finds see now A. Alexeev et al., *Chertomlyk* (1991).

56 M. Robertson, *JHS* 85 (1965) 82–6; 87 (1967) 133–6; *History of Greek Art* (1975) 486. The style is associated with the name of the painter Pausias of Sicyon, where mosaics in this style have been found. On its development, M. Pfrommer, *JdI* 97 (1982) 119–90.

57 St Petersburg, Hermitage Mus. Dn 1913 1/48; diameter 21.8 cm; Artamonov (1969) pls. 157–8; *S.Art* pls. 162–3; *Lands* no.70. Compare the decoration of the gold stand from the Bratoljubovsky Kurgan, Rolle et al. (1991) 366–8, no. 120d.

58 Artamonov (1969) pls. 207, 210; *S.Art* pls. 164–5; *Lands* no. 83; Minns (1913) 204, fig. 99 (drawing). Other oddly composed phialai, of silver: Seven Brothers, Minns, 209, fig. 107; and a Thracian example (compare Rogozen) found in the Kuban, Minns (1913) 231, fig. 136, and G. Tsetskhladze, *OJA* 13 (1994), with an inscribed reference to an Apollo of Phasis in Colchis. The latter was presumably acquired by a Greek and dedicated to Apollo for its seemingly appropriate decoration of stag heads and snake at omphalos.

59 Artamonov (1969) figs. 58–9, 156–7, pls. 317, xxii; *S.Art* pls. 110–1; Minns (1913) 219, fig. 121.

60 A. Leskov, *Grabschätze der Adygeen* (1990) figs. 191–7. The eyes are inlaid with amber. The style of the frieze is Early Classical and the whole assembly need not be much later. On the site, G. Kossack, *Gnomon* 1991, 438–41. The Maeotians of this area may have been a long-settled people, not nearly related to Scythians or Persians; cf. *CAH* III.2, 572.

61 *Lands* no. 168. Cf. the bronze bowls from Uljap, Leskov, op.cit., figs. 59, 61–6.

62 *Antike Welt* 4.1 (1973) 49, fig. 11.

63 St Petersburg, Hermitage Mus.; Artamonov (1969) pls. 177–9.

64 St Petersburg, Hermitage Mus. Dn 1868 1/8; height 41.4 cm; Artamonov (1969) pl. 186; *S.Art* pl. 144; *Lands* no. 69; Minns (1913) 166, fig. 54.

65 St Petersburg, Hermitage Mus. Ak–B 28; height 14.4 cm; Artamonov (1969) pl. 272; *S.Art* pl. 229; *Lands* no. 61; Minns (1913) 391, fig. 287.

66 Kul Oba: Artamonov (1969) pls. 236–8; *S.Art* pl. 179; Minns (1913) fig. 92.

67 Artamonov (1969) pl. 206; *S.Art* pl. 180; Minns (1913) 199, fig. 92.

68 St Petersburg, Hermitage Mus. Dn 1863; *S.Art* pl. 233; cf. *Antike Welt* 4.1 (1973) 37ff., figs. 7, 14, 15, 17.

69 Artamonov (1969) fig. 109; *S.Art* pl. 233; Minns (1913) 157, fig. 44.

70 But notice the early, Assyrianizing example with apparently Scythian traits, from Ziwiye: E. Porada, *The Art of Ancient Iran* (1965) 132–4, pl. 37.

71 Kiev Museum A3C–2494; diameter 31 cm; *S.Art* pls. 118–21; *Lands* no. 171; *Antike Welt* 4.1 (1973) 48–52; B.N. Mozolevskii, *Sov.Arch.* 1972.3, 268–308 for the find.

72 Artamonov (1969) pl. 295; *S.Art* pls. 255–6; Minns (1913) 429, fig. 320 (drawing).

73 St Petersburg, Hermitage Mus. Dn 1913 1/1; width 10.2 cm; Artamonov (1969) pls. 147–8, 150; *S.Art* pls. 128–9; *Lands* no. 71.

74 St Petersburg, Hermitage Mus. Dn 1897 2/14; height 47 cm; *S.Art* pl. 161; *Lands* no. 60; Minns (1913) 290, thought the quality of production indicated Greek work.

75 From Alexandropol; Minns (1913) 155, fig. 42; cf. Artamonov (1969) figs. 133–4.

76 The triangular plaque from Karagodeuash: Artamonov (1969) pl. 318; *Lands* no. 74; Minns (1913) 218, fig. 120. Cf. the plaque from Merdzhana (Kuban), *S.Art* pl. 232.

77 Cf. the textiles from Pazyryk, as *Lands* no. 115. But gold plaques of this type seem barely represented with Scythian objects at, for example, Ziwiye in the seventh century; cf. the gold goat

plaque, A. Godard, *Le Trésor de Ziwiye* (1950) 49, fig. 39, and Sotheby 10.7.1989 lot 64 (similar, and a lotus plaque: 'Ziwiye?'). Herodotus (1. 203) remarks animals *painted* on clothes in the Caucasus area.

78 Roughly comparable plaques from the early burials at Kelermes seem totally un-Greek: Artamonov (1969) pls. 51, 54, from tombs with the rhyton and mirror, our [6.14,15]. Very much earlier evidence for the practice in this area may be apparent in the Maikop plaques (3rd millennium BC?), *Lands* no. 1.

79 Artamonov (1969) figs. 35, 43–51, pls. 94–6, 106–11, 217 (Kul Oba, winged boar); *S.Art* pls. 74–83. Also Leskov, op.cit. (n. 60) pls. 33–4 (running youth). There is possibly an earlier, 'Greek' group, from Maikop (Kuban), I am not convinced about the homogeneity of (or possibly the authenticity of part of) the Maikop hoard. There are examples of this in various museums, from a 'find' including an assortment of obviously genuine objects, purchased from a dealer early in this century: see *Lands* pp.157–60; A. Greifenhagen, *Schmuckarbeiten in Edelmetall* I (1975) 55, pl. 33.2. Greifenhagen puts them all in the fifth century. The griffin plaques look pure Archaic Greek, without the Classical manes, and take with them the stag plaques, whose antlers are decidedly odd having no 'Animal Style' elements and long parallel branches (though this can be paralleled). These are cut-outs, but seem not pierced for sewing as are almost all other such dress plaques. They also all look very fresh. With them probably go the paired lotuses and the four-cup-spiral ornaments, which are matched at Ephesus. Other Maikop finds are closely matched now at Uljap, notably the gold rhyton (*Lands* 157, no. 6 and Leskov, op.cit. (n. 60) figs. 187–90), the black figure (see above, n. 35) and details of the gold plaques.

80 Nymphaeum: Artamonov (1969) pl. 94 and Minns (1913) 208, fig. 106.19 (there is a third element below, possibly animal). Seven Brothers: *S.Art* pl. 85. In Classical versions the human head is helmeted – Chertomlyk and Kul Oba: Artamonov (1969) fig. 106 and Minns (1913) 158, fig. 45; Kherson district: *Lands* no. 183.

81 Artamonov (1969) figs. 67–71; cf. Greifenhagen, op.cit. (n. 79), pl. 27.

82 Artamonov (1969) figs. 80–1, 93–5, 100, 102–3, 106, 115.

83 Artamonov (1969) pls. 216 (maenad head), 218 (Herakles and lion), 219, 225, 247 (running hares), 248 (lion).

84 Obvious imitations are from Dort Oba, Artamonov (1969) figs. 136–7.

85 Leskov, op.cit. (n. 60), pl. 25.

86 Minns (1913) 168, fig. 58.

87 Artamonov (1969) fig. 114, pl. 235; *S.Art* pl. 257.

88 Artamonov (1969) fig. 81; *Lands* no. 72; *S.Art* pl. 142. Cf. Rolle et al. (1991) 179, no. 99, a diadem from near Sachnovka; and the fine relief group from Kul Oba, *S.Art* pl. 196.

89 Minns (1913) 169, fig. 62. Contrast the native version of a seated Scythian, ibid., 182, fig. 75bis.

90 *Lands* no. 81; *S.Art* pl. 199; and see below, n. 95.

91 Kul Oba: Artamonov (1969) pl. 204; *S.Art* pl. 198.

92 Great Bliznitza: Artamonov (1969) pl. 308; *S.Art* pl. 208; with human head, Kul Oba, ibid., pl. 203. Cf. the later standard from Alexandropol, Minns (1913) 154, fig. 40.

93 St Petersburg, Hermitage Mus.; Artamonov (1969) pl. 234.

94 St Petersburg, Hermitage Mus.; Artamonov (1969) figs. 145–9, 150, pls. 286–90, 310–1. For a locally inspired variant see the earring pendant of a goddess on a lion-legged throne from the Tolstaya tomb, *Sov.Arch.* 1972.3, 303, fig. 39. This is surely not a Europa on the bull, as suggested in *Antike Welt* 4.1 (1973) 36–7, fig. 12.

95 D.S. Raevsky, *Sov.Arch.* 1970.3, 90–101. The same author suggests that the plaque showing two Scythian archers, back to back and shooting, reflects an eastern ritual of shooting arrows to the four points of the compass. This is possible, but relates to cult, not myth; see *Sov.Arch.* 1981.3, 44–51.

96 E.g., the frontlet [6.32]. Also, in a decorative frieze, Kul Oba,

Reinach, op.cit. (n. 14) pls. 2, 3. The subject is discussed by M.W. Stoop in *Floral Figurines from South Italy* (1960) and M. Maaskant, *BABesch* 64 (1989) 21–6. The Pontic snake-legged woman seems to me a local variant on this archaizing *Rankenfrau* who is met in both west and east. Cf. also H. Jucker, *Das Bildnis im Blätterkelch* (1961) 195–208; G. de Luca, *Istanbuler Mitt.* 40 (1990) 157–66; M. Pfrommer in *Hermogenes* (edd. W. Hoepfner et al., 1990) 73–6; and for her later history, W. Veit, *Pantheon* 48 (1990) 4–27.

97 For some Etruscan versions see A. Brown, *Antike Kunst* 17 (1974) 24–9; and later, S. Haynes in *Festschrift J. Inan* (ed. N. Basgelen et al. 1989) 247–57.

98 St Petersburg, Hermitage Mus. K–O 70, from Kul Oba; height 3.3 cm; *S.Art* pl. 203. The same figure on a small plaque from Krasnodar, *Treasures of the Nomadic Tribes in South Russia* (Tokyo exhib. 1991) no. 46.

99 For all this see especially T. Sulimirski, *The Sarmatians* (1970), and a fine exhibition, *Treasures . . .* (last note).

100 For stories of a seventh-century Greek who may have visited the northern shores of the Black Sea and Central Asia see J.D.P. Bolton, *Aristeas of Proconnessus* (1962).

101 St Petersburg, Hermitage Mus.; Minns (1913) 58, fig. 11; Sulimirski (1970) pl. 34.

102 *GO* 64–5. Figurines of two-headed animals in Colchis derive from Persia rather than Geometric Greece; Lordkipanidze (1991) pl.22.

103 Tbilisi Mus.; *GO* 254, fig. 294; O. Lordkipanidze, *Arch. Polona* 14 (1970) 89–94 and (1991) pl. 26.4.

104 A useful summary of the results by O. Lordkipanidze, the excavator, in *Greek, Roman and Byzantine Studies* 32 (1991) 151–95. Rather differently interpreted by A. Wąsowicz in *Archeologia* (Warsaw) 43 (1992) 15ff.

105 J.M. Cook, *The Persian Empire* (1983) 79, 186. Iberia (roughly east Georgia and north Azerbaijan) was somewhat isolated from Colchis by the Surami ridge.

106 Lordkipanidze (1991) pl. 40.2–3.

107 Lordkipanidze (1991) pl.25; *BCH* 98 (1974) 900–3.

108 Tbilisi Mus.; *Vani* I pls. 37–8, 230 for the Greek-style plaque; pls. 187–9, 231 for the derived animal style; pls. 56, 204 for patterned; Lordkipanidze (1991) pl. 50. The torques with the plaques are puzzling since they seem to have no Colchian antecedents and it is possible that they are of some Anatolian type yet to be recognized at home. But cf. the diamond-shaped centrepiece with relief lions on a gold bracelet from Ziwiye: E. Porada, *Art of Ancient Iran* (1965) pl.39. *Vani* VI presents overall studies of the gold objects from the sites, but see the earlier volumes for fuller illustration, also Lordkipanidze (1991).

109 *Vani* I pls. 224–5.

110 Tbilisi Mus.; *Vani* I pls. 61 (feline and rams), 211 (pegasi and rams). Compare the spoon with a sphinx, pl. 212 and the ladle, pl. 57.

111 *Vani* I pl. 39 and III pls. 85–90; Lordkipanidze (1991) pl. 51.9–10. An exactly similar pair has been found in the fifth-century Sazonkin Barrow on the lower Volga (Sulimirski (1970) pl.6) though with a loop attachment on one horse's head, not the Colchian rosette and bar. The horsemen carry *gorytoi*. The most elaborate pair are from Akhalgori in Colchis (T. Talbot Rice, *Ancient Arts of Central Asia* (1965) 23, fig.12; Lordkipanidze (1991) pl.54.1–2) with strong Persian influence (horse foreknots and battlement pattern). The type does not seem certainly of Persian origin but cf. the model gold chariot from the Oxus treasure, O. Dalton, *Oxus Treasure* (1964) pl. 4.

112 *Vani* III pls. 130–3; M. Lordkipanidze, *Kolchidskie perstni-petsati V–III bb. do n.e.* (1975).

113 Vani Mus.

114 *Vani* I pl. 169; Lordkipanidze (1991) pl.32.1.

115 Vani Mus. and site; *Vani* II, pls. 18–21.

116 *Vani* I pls. 144–9.

117 Lordkipanidze, op.cit. (n. 104) 189–93, pls. 15–6.

118 *Vani* I pls. 131–43; a bronze Nike, pl. 143; Lordkipanidze (1991) pl.35; *BCH* 98 (1974) 926–8. The eagles are like those from Pella attributed to a couch-*kline* (*Treasures of Ancient Macedonia* no. 75) or could be from a throne back, so there may be more variety of objects in the Vani bronze find.

119 *Vani* VIII pl. 57. 1–2.

120 From Sairkhe (200 km from the Black Sea) where there are rich finds from fourth-century and later graves: D. Nadiradze, *Sairkhe Drevneischii Gorod Grusii* (1990) pl.46. The leaf pattern derives ultimately from Egypt.

7 Italy

GENERAL BIBLIOGRAPHY

A. Andren, *Architectural Terracottas from Etrusco-Italic Temples* (1940)

Die Aufnahme fremder Kultureinflüsse in Etrurien und das Problem des Retardierens in der etruskischen Kunst (Mannheim 1981). = *Aufnahme*

L. Bonfante (ed.), *Etruscan Life and Afterlife* (1986). Esp. chapters on history of subject, history, architecture, life.

O. Brendel, *Etruscan Art* (1978). Good art history with lacunae for some media.

G. Colonna (ed.), *Santuari d'Etruria* (1985)

M. Cristofani, *I Bronzi degli Etruschi* (1985)

G.M.A. Hanfmann, *Roman Art* (1964)

S. Haynes, *Etruscan Bronzes* (1985) Comprehensive.

M. Henig, *A Handbook of Roman Art* (1983)

R. Ling, *Roman Painting* (1991)

M. Martelli (ed.), *La Ceramica degli Etruschi* (1987)

J.J. Pollitt, *The Art of Rome c. 753 B.C. – A.D. 337* (1983). Testimonia in translation.

B.S. Ridgway, *Roman Copies of Greek Statues* (1984)

D. and F.R. Ridgway (eds.), *Italy before the Romans* (1979). Range of important archaeological essays.

Roma Medio Repubblicana (exhibition catalogue, Rome 1973) = *Roma Med.Rep.*

H.H. Scullard, *The Etruscan Cities and Rome* (1980). History.

M. Sprenger and G. Bartolini, *The Etruscans* (1983). Full range of pictures and comment.

S. Steingräber, *Etruscan Painting* (1986). Illustrated corpus of tombs.

S. Stopponi, *Case e palazzi d'Etruria* (1985)

GO 198–210

CAH IV ch. 13 (D. Ridgway on early Etruria); VII.2 (various authors on early Rome).

Arch. Reports for 1973–4 42–59 (D. Ridgway); . . . *for 1979–80* 54–89 (D. Ridgway and T.J. Cornell); . . . *for 1985–6* 102–33 (T.C.B. Rasmussen and T.J. Cornell).

Bibliography for 1978–90 by F. Ridgway in *Journal of Roman Archaeology* 4 (1991) 5–27

NOTES

1 On the archaeology of colonization see *GO* ch. 5, and for the literary record *CAH* III.3 chs. 37–8 (A.J. Graham). It is from time to time fashionable for ancient historians to decry the trade motive, and insist on need for land. This ignores the geography of the earliest settlements in Italy (and in the Black Sea). The latest essay in this vein is G. Cawkwell, *Classical Quarterly* 1992, 289–303, who invokes a lengthy and profound climatic change leading to famine and search for new homes; a change which presumably left the rest of the Mediterranean unaffected and had

to be repeated in the seventh century in East Greece only when the Milesians started *their* colonizing!

2 *GO* 200; the comparison was from an angry correspondent. 'Only through the originality of incompetence can it [Etruscan art] be distinguished from the art of the Greeks' was Bernard Berenson's opinion, *The Passionate Sightseer* (1960) 118–9, and similar harsh views have been expressed by hellenists; they are prejudiced but this does not mean that they are altogether wrong. A useful corrective by J.P. Small in *Boreas* 14/15 (1991/2) 51–65.

3 There are many books on Etruscan art. Brendel (1978) is a thoughtful account, well illustrated, but somewhat old-fashioned and with some major gaps, stronger on art history than archaeology. A fine series of pictures with commentary in Sprenger/Bartolini (1983).

4 E.g., F.C. Woudhuizen, *Talanta* 14/15 (1982/3) 91–117; M.B. Polisensky, *The Language and Origins of the Etruscans* (1991). A sensible account of how Herodotus has misled us over this by R. Drews in *Historia* 41 (1992) 14–39; and a full assessment of the literary record in D. Briquel, *L'Origine lydienne des Etrusques* (1991).

5 *CAH* IV, 721–6 (J.H.W. Penney).

6 A good account of the early period by D. Ridgway in *CAH* IV, ch. 12.

7 D. Ridgway in *Ancient Greek and Related Pottery* (Copenhagen 1989) 489–505, esp. 496–7; *Miscellanea Ceretana* 1 (1989) 32, fig. 60 for the Caere find.

8 The return trade in other than raw materials is not inconspicuous in the archaeological record, though not spectacular, mainly to Euboea and dedications at Olympia and Delphi: F.W. von Hase in *Aufnahme* 9–24 summarizes.

9 Most recently on the Lyre Player seals, J. Boardman, *AA* 1990, 1–17. M. Martelli repeats her case for Rhodes as the centre of production (*Atti II Congr.Int.Stud.Fenici e Punici* 1991) 1049–51, but all the archaeology of the seals (material, decoration, shape, mounts, distribution) is against this view. I venture to predict that when a Lyre Player seal *is* found in the Phoenician west it will be with Euboean pottery. W. Röllig's proposal to call all Levantines 'Phoenicians' is unhelpful (in *Greece between East and West* (above, Chapter Two, n. 2) 93) although it conveniently disguises linguistic and palaeographic problems about distinguishing Phoenician and Syrian/Aramaean. Archaeologically and historically the royal Phoenician cities (Tyre, Byblos, Sidon) and towns such as Al Mina, dependent on inland sites such as Tell Tayinat and the cities beyond, are as different as their overall proximity and shared general culture permit.

10 On the process of borrowing see M. Cristofani, *Annali ... Claudio Faina* 4 (1990) 61–73.

11 The story in Pliny, *HN* 35, 152, where it is said that they *introduced* the craft to Italy, which is untrue. On Demaratos see now D. Ridgway in *Greece between East and West* (above, Chapter Two, n. 2) 85–92. On the local attitude to the son, Livy 1, 34.

12 D.W. Ridgway in *Studies in honour of T.B.L. Webster* II (edd. J.H. Betts et al. 1988) 104; C. Ampolo, *Dialoghi di Archeologia* 9/10 (1976/7) 337–40; C. de Simone in *Aufnahme* 91–2. The second is painted but it is not altogether clear that it was pre-firing (which has then suggested a potter's signature, which is by no means necessary) and the piece is lost. The medium is described as *minio*, and red post-firing dipinti are a feature of non-Attic wares.

13 Especially the crater from Pescia Romana, Martelli (1987) no. 3.

14 Cerveteri Mus.; *Miscellanea Ceretana* 1 (1989) 14–5, figs. 10–12.

15 Cf. Ridgway, op.cit. (n. 11) 89 for refs.

16 Vulci Mus. 75871; Martelli (1987) no. 7.2.

17 Philadelphia, University Mus.; Martelli (1987) 19, fig. 2, from Narce.

18 Rome, Villa Giulia 74916; Martelli (1987) no. 20; the Cumae Group.

19 Cerveteri Mus.; Martelli (1987) no. 37. Cf. eadem, *AA* 1988, 285–96, and *Prospettiva* 48 (1987) 2–11, 50 (1987) 3–14, for some other vases in this general style.

20 Rome, Capitoline Mus. 172; Martelli (1987) no. 40; *GO* 193, fig. 227; B. Schweitzer, *RM* 62 (1955) 78–106; Simon/Hirmer, pls. 18–19; Jeffery, *LSAG* 239. Caeretan potters seem particularly taken with figure scenes, cf. [7.5]; there is another blinding of Polyphemos on a pithos, in a private collection in New York.

21 E.g., Martelli (1987) pls. 42–4.

22 Useful monographs are: M. Bonamici, *I Buccheri con figurazioni graffite* (1974); G. Camporeale, *Buccheri a cilindretto di fabbrica Orvietana* (1972); T. Rasmussen, *Bucchero pottery from Southern Etruria* (1979). Cf. Brendel (1978) 77–82, 137–41.

23 Cf. M. Martelli, *Miscellanea Ceretana* 1 (1989) 45–9.

24 For good studies on these problems see I. Strøm, *Problems concerning the origin and development of the Etruscan Orientalising Style* (1971); F.W. von Hase, *Hamburger Beitr. Arch.* 5 (1975) and *AA* 1974, 85–104, on jewellery. And in *Atti II Congr.Int.Stud. Fenici e Punici* (1991) essays by Strøm (323–31) and M. Cristofani (67–75).

25 On the problem of the carriage of orientalia from the east to Italy see J. Boardman, *OJA* 9 (1990) 170–90, esp. 180–2.

26 For a survey of Phoenician and Punic settlement in Sardinia and Sicily see E. Acquaro, *Gli insediamenti Fenici e Punici in Italia* (1988).

27 W.L. Brown, *The Etruscan Lion* (1960) remains an excellent account of oriental influences in Etruria. The ivories are collected by Y. Huls in *Ivoires d'Etrurie* (1957), and see M.E. Aubet, *Los Marfiles orientalizantes de Praeneste* (1971). Bronze strips with animal friezes, *Acta Archaeologica* 34 (1963) 135–84; and situlae, J.M.J. Gran Aymerich, *MEFRA* 84 (1972) 7–59.

28 I. Strøm in *GCNP* 87–97.

29 For the silver vessels see G. Markoe, *Phoenician Bronze and Silver Bowls* (1984) 131–5, 274–89 (E 1–4, Praeneste), 364 (Comp. 10, kotyle from Vetulonia); also *Studi Etruschi* 37 (1970) pls. 24–7 (Marsiliana) and 41 (1973) 97–120 (M. Martelli) on the Chiusi silver (Markoe, Comp. 12). For the bronzework, articles by I.J. Winter and G. Falsone in *Bronze-working Centres of Western Asia* (ed. J. Curtis, 1988) 193–250. A full study of the most important tomb, F. Canciani and F.W. von Hase, *La Tomba Bernardini di Palestrina* (1979). On the presence of eastern silverworkers in Etruria, G. Markoe in *Greece between East and West* (see Chapter Two, n. 2) 61–84.

30 A summary of evidence for foreign craftsmen by F. Canciani in *Aufnahme* 53–9.

31 M. Cristofani and M. Martelli (eds.), *L'Oro degli Etruschi* (1983) pls. 1–117.

32 But there was some Greek influence on behaviour too, arms and armour becoming Greek in aspect rather than European/oriental from about 650: P.F. Stary in *Aufnahme* 25–40.

33 On the question of survival and revival of motifs in Etrusco-Corinthian vase painting see J.G. Szilagyi in *Aufnahme* 67–74. A comprehensive study, *idem, Ceramica Etrusco-Corinzia figurata* I (630–580 B.C.) (1992).

34 Greek Geometric pottery patterns and shapes were adopted by native peoples of Sicily and parts of South Italy, the influence being generally from Corinth, thanks to the influence of Syracuse. In the seventh century important local styles in pottery developed in some of the colonies, most clearly attested in Naxos, Megara Hyblaea and Syracuse, but apparent everywhere, and these were influential. But most of the Italic peoples retained a strong cultural and archaeological identity well into the fifth century, and indeed until they are absorbed by Rome. So, of course, did the Etruscans, but their world was more profoundly shaped by Greek presence and example. For the Italic peoples in this period see E.T. Salmon in *CAH* IV, ch. 14; for the archaeology *GO* 189–98.

35 Rome Villa Giulia, from Vulci; Martelli (1987) nos. 58; A. Giuliano, *Prospettiva* 3 (1975) 4–8; *GO* 203.

36 J.G. Szilagyi, *Studi Etruschi* 50 (1984) 3–22, pls. 1–2 for the Corinthianizing amphora with an Ionian frieze, pl. 4c for the olpe.

37 Florence Mus. Arch. 71015, from Pescia Romana; *Prima Italia* (exhib. Rome 1981) no. 64. For a study of the polychrome vases, J.G. Szilagyi, *Wiss. Zeitschrift Univ. Rostock* 16 (1967) 543–53.

38 Some Greek shapes too are copied in the native bucchero. A rarity derives from a Western Greek type of column crater: *Neuerwerbungen 1952–65, Badisches Landesmuseum, Karlsruhe* (1966) no. 16. The Corinthian crater import seems to have been mainly directed to Caere: J. de la Genière, *BCH* 112 (1988) 83–90.

39 There are those who believe that the Athenian vases were imported solely as tomb furniture, cheap substitutes for the metal vases used in life. This is negated by finds in settlements and traces of wear and repair (surely not all from transit) on the vases. Cf. too inscriptions which may imply pre-tomb use for other purposes: M. Martelli, *Studi Etruschi* 55 (1987–8) 342–4. The pre-burial history of a fine Attic cup by Oltos from a tomb, but bearing an Etruscan dedicatory inscription to the Dioskouroi with their Etruscan name (Tinas cliniar: sons of Tinia = Zeus) is obscure; see M. Cristofani, *Prospettiva* 53–6 (1988) 14–16. Useful studies on Greek vases in Etruria and trade by N. Spivey and A.W. Johnston in *Looking at Greek Vases* (edd. T. Rasmussen/N. Spivey, 1991) chs. 6, 9.

40 An idea revived by B. Ginge in *Proc. 3rd Symp. on Ancient Greek and Related Pottery* (Copenhagen 1988) 201–10. But clay analysis reveals Attic clay, not Italian, and there could be no reason to export clay to a clay-rich area for their production. The analysis – J. Boardman and F. Schweizer, *BSA* 68 (1973) 270–1, no. 5. On the problems of 'Tyrrhenian' and the possibility that they are not mainstream Athenian products rather than, as it were, provincial Attic, see T.H. Carpenter, *OJA* 2 (1983) 279–93; 3 (1984) 45–56; a view disputed by J. Kluiver, *BABesch* 67 (1992) 75–80.

41 Boardman, *ABFV* 64–5.

42 Reassembled by M. Cristofani, *Monuments et Mémoires, Fondation Piot* 63 (1980) 1–30.

43 For possible Etruscan traders, A.W. Johnston in *Il Commercio etrusco arcaico* (ed. M. Cristofani et al. 1985) 249–55. M. Gras, *Trafics tyrrhéniens archaïques* (1985), review by F.-W. von Hase, *Hamburger Beiträge* 15–7 (1988–90) 347–64.

44 Munich, Antikensammlungen 837, from Vulci; Martelli (1987) no. 102. These are called Pontic because early scholars noted the figures of Scythian riders on them and wrongly deduced that they must have been made by Greeks in the Black Sea (Pontus). See P. Ducati, *Pontische Vasen* (1932); L. Hannestad, *The Paris Painter* (1974) and *Followers of the Paris Painter* (1976); J. Lund and A. Rathje, in H.A.G. Brijder (ed.), *Ancient Greek and Related pottery* (1984) 352–68.

45 London, private; height 32.4 cm; *CVA* Castle Ashby 1–2, pls. A, 1–3. R.M. Cook and J.M. Hemelrijk, *Jahrbuch der Berliner Museen* 5 (1963) 107–20.

46 Malibu, J. Paul Getty Museum 83.AE.346; J.M. Hemelrijk, *Caeretan Hydriae* (1984) no. 23.

47 Toledo Museum of Art 1982.134; Martelli (1987) no. 130. N.J. Spivey, *The Micali Painter* (1987), for the main practitioners and comment on relationship to Pontic (43, no. 2, on [7.12]). One unusual vase (Florence 496780; P.B. Pacini/A. Maggiani, *Boll.-d'Arte* 30 (1985) 49–54) shows what seems to be a youth working on a major sculpture of a bronze(?) horse; it also carries garbled copies of a Greek potter's signature and a *kalos* name.

48 For a general survey of the pottery record in the seventh and sixth century, summarized here, see *GO* 198–207.

49 A. Hus gives a good general account for all periods in *Les bronzes étrusques* (1975). Fine pictures and commentary in Cristofani (1985).

50 Munich, Antikensammlungen Tripod B. The main monuments are the Monteleone and Castel San Mariano chariots, the Loeb tripods. See Brendel, 146–51, 157–64; Sprenger/Bartolini, pls. 101–11 (pl. 103 = [7.13]); U. Höckmann, *Die Bronzen aus dem Fürstengrab von Castel San Mariano* (1982); Krauskopf, op.cit. below (n. 85), pls. 7–13 (Loeb tripods).

51 See especially Cristofani (1985) pls. 4.1–3, 23–47; Haynes (1985) 139–77 passim. For copies of a Greek bronze oenochoe type, B.B. Shefton, *RM* 99 (1992) 139–62.

52 London, British Museum 48.6–19.11 (Br 598); Haynes (1985) no. 56.

53 Sprenger/Bartolini (1983) pls. 118–23, 125.

54 Rome, Villa Giulia Mus.; Brendel (1978) 230–1; Sprenger/Bartolini (1983) pls. 114–5; M.-F. Briquet, *Le sarcophage des époux de Cerveteri du Musée du Louvre* (1989).

55 Viterbo Museum, from Acquarossa; A. Andren, *Architectural Terracottas from Etrusco-Italic Temples* (1939–40) (pl. 24, 53 = [7.16]); Å. Åkerström, *Opuscula Romana* 1 (1954) 191–231; M. Torelli, *Ostraka* 1 (1992) 249–74. The revetments from Murlo are the more important of recent finds, similar to the example shown here but with a greater iconographical range; cf. *CAH* VII.2, 40–4.

56 Brendel (1978) 129–33; Sprenger/Bartolini (1983) pls. 49–53.

57 Vatican Mus., from Vulci; A. Hus, *Recherches sur la Statuaire en pierre* (1961) pl. 24, 18. Brendel (1978) 125–9; Sprenger/Bartolini (1983) pls. 46–7, 58–9; later, pls. 60–1.

58 Orvieto, Mus. Civ. 1307; A. Andren, *Antike Plastik* 7 (1967) 10–24, pls. 1–8; M. Cristofani, *Annali ... Claudio Faina* 3 (1987) 27–39. The central parts of the legs are restored. A nice discussion by L. Bonfante in *Source* 12 (1993) 49–50.

59 Florence Mus. Arch.; M. Martelli, in *Studi per Enrico Fiumi* (1979) 33–45, especially pl. 11.

60 An important conspectus, fully referenced and well illustrated, for Etruscan tomb painting is Steingräber (1986).

61 Steingräber (1986) no. 175.

62 Steingräber (1986) no. 176; and the chronological lists ibid., 388. For a new early tomb painting, at Magliano, *Arch.Reports for 1985–6* 116, fig. 21.

63 London, British Museum, Hinks, no.5; Sprenger/Bartolini (1983) pl. 74. The subject is probably a Judgement of Paris, continued on other slabs: S. Haynes, *RM* 83 (1976) 227–31. For the various plaque series from Caere see F. Roncalli, *Le Lastre dipinte da Cerveteri* (1965).

64 Tarquinia, Tomba del Triclinio (Banquet); Steingräber, no. 121; Brendel (1978) 270–1; Sprenger/Bartolini (1983) pls. 150–7. [7.22c] is from a cup by Epiktetos, London, British Museum E 38; Boardman, *ARFV* I, fig. 75.

65 Greek letters had been detected beneath the painting in the Tomba del Barone at Tarquinia, but may in fact be Etruscan (the alphabet being copied from Greek with minor deviations). For Etruscan vase painting in this mural style see *Arch.Reports for 1985–6* 109, fig. 11. For muralist hands, G. Camporeale, *RM* 75 (1968) 34–53, and M.A. Rizzo in *Pittura Etrusca al Museo di Villa Giulia* (1989) 179–86.

66 Brendel (1978) 119–20; S. Bruni, *I lastroni a scala* (1986); and cf. Vulci stelae, ibid., 123–4.

67 Brendel (1978) ch. 7, and 125–34.

68 Brendel (1978) 279–81; J.-R. Jannot, *Les reliefs archaïques de Chiusi* (1984).

69 R.A. Higgins, *Greek and Roman Jewellery* (1961) chapter 13; Cristofani and Martelli, op.cit.(n. 31), pls. 118–98.

70 *Studi Etruschi* 30 (1962) pl. 4c. The plaques – M. Martelli in *Il Commercio etrusco arcaico* (ed. M. Cristofani et al. 1985) 207–48.

71 Paris, Cab.Med. 2615. For these rings see J. Boardman, *Antike Kunst* 10 (1967) 5–16, and the rest of the article for other ring shapes made both in Greece and Etruria. [7.23] = ibid., pl. 2, BII8.

72 Comprehensive treatment by P. Zazoff, *Etruskische Skarabäen* (1968). On origins, J. Boardman, *Archaic Greek Gems* (1968) esp. 173–4.

73 Boston, Museum of Fine Art LHG 35ter; *GGFR* pl. 408.

74 On the colour see J. Boardman, *Jewellery Studies* 5 (1992) 29–31.

75 Berlin, Staatliche Museen F 195; length 14 mm; *Antike Gemmen in deutschen Sammlungen* II, no. 238.

76 Cf. *Arch.Reports for 1985/6* 112.

77 A good summary by F.R.S. Ridgway in *GCNP* 511–30; also Colonna (ed. 1985) 127–41. An exceptionally fine Athenian red figure phiale from Pyrgi: M.P. Baglione in *Ancient Greek and Related Pottery* (Copenhagen 1988) 17–24.

78 There was another port, called Punicum, some six miles from Pyrgi, but, for all its suggestive name, we do not know its origins or history.

79 Herodotus knows Caere as Agylla, and it might be that there was a substantial Greek settlement in the city, with its own name. This might explain the record of a 'Caeretan' treasury dedicated at Delphi (Strabo 220).

80 M. Torelli, *Parola del Passato* 26 (1971) 44–67; 32 (1977) 398–458; *CAH* IV 669; and Colonna (ed. 1985) 141–4. The anchor dedicated by Sostratos: also *GO* 206, fig. 245; Herodotus 4, 152; he may also account for the SO graffiti and dipinti found on many imported vases of the same date; for which see also Johnston, in *Il Commercio* (above, n. 70) 265, a Laconian storage jar so inscribed from Vulci.

81 C. de Simone, *Die griechischen Entlehnungen im Etruskischen* II (1970) 304–34. Names for objects were borrowed earlier and are mainly names of pot shapes (and their contents – oil), which indicates that Greek vases were not acquired primarily as tomb furniture, as some have suggested.

82 H. Rix in *Aufnahme* 96–106; who also believes that the same names could have been picked up at different times and places, but the variants in translation to Etruscan seem hardly greater than those in spellings of Greek names in Greece.

83 Sprenger/Bartolini (1983) pls. 34–5; Krauskopf, op.cit. below (n. 85) 8–9, pls. 2–3. See above, n. 20, for an earlier Etruscan Polyphemos.

84 Krauskopf, ibid., 4–25.

85 The case for Etruscan knowledge is argued by E. Simon and R. Hampe in *Griechische Sagen in der frühen etruskischen Kunst* (1964), and cf. I. Krauskopf, *Der thebanische Sagenkreis und andere griechische Sagen in der etruskischen Kunst* (1974).

86 At Tarquinia; Steingräber (1986) no. 120; Sprenger/Bartolini (1983) pl. 78. It is much discussed: e.g., A. Giuliano, *SE* 37 (1969) 3–26; Brendel (1978) 165–8.

87 London, British Museum Br 542; Haynes (1985) no. 71; Sprenger/Bartolini (1983) pl. 165 top; *LIMC* V Herakles/Hercle no. 331.

88 Karlsruhe, Badisches Landesmuseum 78/40; *LIMC* III Eos/ Thesan no. 39, cf. nos. 36–8; H. Jucker, in *Studies ... von Blanckenhagen* (1979) 53–62.

89 Chiusi Mus.; *LIMC* III Eos/Thesan no. 41. For this see also S. Haynes in *Atti XVII Conv. Studi Etr. e Ital.* (1989) 300–9, also for the Greek origin of the winged women in Chiusine funerary art.

90 Berlin, Staatliche Museen F 194; *Antike Gemmen in Deutschen Sammlungen* II, no. 237; discussed also by E. Zwierlein-Diehl in *AA* 1969, 525–8; and Krauskopf, op.cit. (n. 85), 43.

91 The story of the Seven and the use of Greek myth in Etruria in general is well explored by Krauskopf, op.cit. (n. 85), though she is inclined to rely too much on vase painting as the prime medium of transmission and perhaps to undervalue an Etruscan artist's ability to 'improve' a narrative scene without deliberately rewriting the story or using some source unknown to us. It is remarkable too how much more we have learned of Greek iconography in recent years. Thus, her observation of Etruscan novelties on the Loeb tripods includes: Peleus seizing Thetis from behind, our [*7.13*], now known on more than one Greek monument (the Kavalla vase she cites, n.183, but also Corinthian

and Athenian vases); Thetis' mutant animal head at her neck is an Ionian mannerism (as J. Boardman, *Archaic Greek Gems* (1968) pl.15, no. 237); and it is by no means clear that Achilles should be thought to be killing the riding Troilos rather than dragging him off his horse.

92 On Etruscan treatment of the Greek eye-cup motif see B.B. Shefton in *Aufnahme* 117–23. This is carried a stage further in North Europe, as we shall see.

93 J. Boardman, *BSA* 50 (1955) 357–8; Jannot, op.cit. (n. 68) 368–80; A. Rathje detects oriental elements, *Acta Hyperborea* 1 (1988) 81–90.

94 The realistic furnishing and decoration of many Etruscan chamber tombs suggests that Egyptian art might have proved a more effective model for this aspect of their afterlife preparations than Greek!

95 On the furniture, J. Boardman in *Sympotica* (ed. O. Murray, 1990) 122–31. On Etruscan symposia, ibid., ch. 21 (A. Rathje) and 337–8; Jannot, op.cit. (n. 68), 362–8. Kline/symposion/death associations in Etruria may have more to do with Anatolian and East Greek practice than the better documented Athenian.

96 J.G. Pedley, *Paestum* (1990) 89–94, pls. VII, VIII.

97 The Etruscans, like the Romans, seem to have shunned public nudity for respectable occasions, and for a class of Athenian vases aimed for the Etruscan market and carrying scenes of athletes and symposia, the painters dressed the males in loincloths: the Perizoma Group, Boardman, *ABFH* 112, fig. 219; L. Bonfante, *Source* 12.2 (1993) 47–55.

98 Found in Populonia, the inscription discussed tendentiously by D. Gill in *Antiquity* 61 (1987) 82–7. Philologists accept the probability that it is a gift inscription rather than a maker's, but may have been misled by some archaeologists' enthusiasm for signatures. Remarks about the possibility of moving potters' clay to Etruria wilfully ignore the obvious circumstance in which clay *might* be moved – when there are no local resources: not the case in Etruria. See also F. Lissarrague, *REA* 89 (1987) 267, n. 40 and M. Harari in *Prakt. XII Int. Congr. Class. Arch.* (1985) I, 147, suggesting it may be an Etruscan imitation of Athenian, not an import at all.

99 For a good study of the classical in Etruscan art see T. Dohrn, *Die etruskische Kunst im Zeitalter der griechischen Klassik* (1982); for the Severe Style, pls. 7–9; and cf. M. Sprenger, *Die etruskische Plastik des V. Jdts und ihr Verhaltnis zur griechischen Kunst* (1972); P.J. Riis in *Prakt. XII Int. Congr. Class. Arch.* (1985) 250–5.

100 Orvieto, Mus. dell'Opera del Duomo; under half lifesize; Sprenger/Bartolini (1983) pls. 198–9.

101 London, British Museum Br 1692; height 25 cm; Cristofani (1985) pl. 118; Sprenger/Bartolini (1983) pl. 204; Haynes (1985) no. 150.

102 This perhaps clearest in much of the funerary statuary: M. Cristofani, *Statue-cinerario chiusine di età classica* (1975).

103 Rome, Villa Giulia, from Falerii and Pyrgi respectively. Sprenger/Bartolini (1983) pls. 241, 243.

104 Boston, Museum of Fine Art 86.145; Sprenger/Bartolini (1983) pl. 208 (cf. 209) for these reclining couples, as in bed, a short-lived style alongside the more familiar single figures or pairs propped on one elbow, like symposiasts, as our [*7.15*]. Brendel (1978) chs. 28–30; and a good essay by G.M.A. Hanfmann, *JHS* 65 (1945) 45–57. The Volterran reliefs: G. Cateni and F. Fiaschi, *Le urne di Volterra* (1984); *Corpus delle urne etrusche di età ellenistica* (1975–); M. Martelli (ed.), *Caratteri dell'ellenismo sulle urne etrusche* (1977); L.B. van der Meer, *Etruscan Urns from Volterra* (1978).

105 Volterra, Mus. Etrusco Guarnacci, from Volterra; Sprenger/ Bartolini (1983) pl. 288; M. Nielsen, *Acta Hyperborea* 4 (1992) 89–141.

106 Florence, Mus. Arch.; Brendel (1978) 425–7 and fig. 324 for a similar pediment with Dionysos discovering Ariadne, at Cività Alba; O.W. von Vacano, *Gli Etruschi a Talamone* (1985) chs.

12–18; B. v. Freytag, *Das Giebelrelief von Telamon* (1986); Andren (1940) 227–34. *La Coroplastica templare etrusca fra il IV e il II Secolo a.C.* (Atti XVI Convegno di Stud. Etr. e Ital., 1988; 1992).

107 G. Pfister-Roegen, *Die etruskische Spiegel des 5.Jhdt vor Chr.* (1975); U. Fischer-Graf, *Spiegelwerkstätten in Vulci* (1980); J.D. Beazley, *JHS* 69 (1949) 1–17, an important essay on the world of the Etruscan mirror. *Corpus speculorum etruscorum* 1981–.

108 Rome, Villa Giulia Mus., from Praeneste; T. Dohrn, *Die Ficoronische Ciste* (1972) for the fullest study; Brendel (1978) 354–9; Haynes (1985) no. 172. G. Foerst, *Die Gravierungen der praenestinischen Cisten* (1978). *Le Ciste Prenestine – a corpus*, 1979–.

109 Cristofani (1985) esp. pls. 4.6–10, 5.1–4, 7.4, 48–71, 82–4, 87–9, 96–103, 106.

110 London, British Museum Br 1449, from near Vesuvius; ibid., pl. 106.

111 Florence, inv. 1; height 65 cm; Brendel (1978) 326–7, fig. 248; Cristofani (1985) pl. 121, and *Prospettiva* 61 (1991) 2–5.

112 Oxford, Ashmolean Museum 1921.1234 and Pr. 282; J. Boardman and M.L. Vollenweider, *Catalogue of the Engraved Gems* I, nos. 220, 260. Zazoff, op.cit. (n. 72); W. Martini, *Die etruskische Ringsteinglyptik* (1971).

113 Florence, Mus.Arch. Vagnonville 14, from Chiusi; Martelli (1987) no. 140.

114 J.D. Beazley, *Etruscan Vase Painting* (1947) 195–9; J.G. Szilagyi, *Archaeologia Polona* 14 (1973) 95–115.

115 Beazley, op.cit., 25–6, with pl. 4.2–3. The Greek cup is in the Vatican, by the Oedipus Painter (*ARV* 451, 1); the copy in Paris, Musée Rodin 980. For the phenomenon see B.B. Shefton in *Wiss. Zeitschrift Univ. Rostock* 16 (1967) 529–37, with other examples suggesting a long time lag between model and copy; also M. Harari in *Prakt. XII Int. Congr. Class. Arch.* (1985) I, 146–50.

116 Beazley, op.cit., chapter 4; B. Adembri in *Ancient Greek and related pottery* (Copenhagen 1987) 7–16, and in *La Civiltà dei Falisci* (XV Convegno di Std. Etr. ed Italici, 1990) 233–44.

117 London, British Museum F 478; Beazley, op.cit., 113, Clusium Group no. 2; M. Harari, *Il Gruppo Clusium* (1980) pl.3.

118 Paris, Cabinet des Médailles 1066; Beazley, op.cit., 54–5, Settecamini Painter no. 3, pl. 10.3.

119 Oxford, Ashmolean Museum 1917.4; Beazley, op.cit., 56–7, pl. 13A.

120 Paris, Cabinet des Médailles 918; Beazley, op.cit., 133–5, Alcsti Group no. 1, pl. 30.i.

121 Tomba del Tifone, Tarquinia; Steingräber (1986) no. 118; Brendel (1978) 419–20. *La Tomba François di Vulci* (ed. F. Buranelli, 1987).

122 Tomb of Orcus I, Tarquinia; Sprenger/Bartolini (1983) pl. 217.

123 Sprenger/Bartolini (1983) pls. 218–24.

124 The possibility is explored by G. Camporeale, *II Congresso Internazionale Etrusco* (1989) 905–24; M. Torelli, *La società etrusca* (1987).

125 On the Romans' view of Greeks, E. Rawson in K.J. Dover (ed.), *Perceptions of the Ancient Greeks* (1992) ch.1. More broadly, E.S. Gruen, *Culture and National Identity in Rome* (1993).

126 For Etruscans in Campania see the excellent and not much dated survey by M. Frederiksen in Ridgways (1979) 277–311 (rather than his *Campania* (1984) which is better for other periods).

127 Knowledge of the Latin towns depends very largely on excavations of the last 25 years. For valuable summaries see T.J. Cornell in *Arch. Reports for 1979–80* 71–88, and ... *for 1985–6* 123–33; also in T. Cornell and J. Matthews, *Atlas of the Roman World* (1982), a volume whose coffee-table appearance belies its quality. The new view of early Roman history in *CAH* VII.2, chs. 2–3.

128 For the eighth-century Greek finds in Latium, E. La Rocca, *Dialoghi di Archeologia* 8 (1974/5) 86–103, and *Parola del Passato*

32 (1977) 376–97; and for Rome, *Arch.Reports for 1979/80* 83–5.

129 The recent literature on early Rome is abundant, somewhat repetitive. Some of the early articles are the clearest (e.g., in Ridgways (1979) 187–235); for more recent accounts see *CAH* VII.2. There is an important assembly of material for this section in the exhibition catalogue of 1973, *Roma Med.Rep.*, and C. Fayer, *Aspetti di vita quotidiana nella Roma arcaica* (1982) gives a good, illustrated survey.

130 Rome, Antiquarium Comunale; Andren (1940) pl. 104.371; T.N. Gantz, *Opuscula Romana* 10 (1974–5) 1–22, studies these and associates them with the artist Vulca; see below. On earlier revetments in Rome with Corinthianizing animals and monsters (Minotaurs) see E. Rystedt in *Munuscula Romana* (Conference Lund 1988; 1991) 29–41.

131 Pliny, *HN* 35, 157; he also made a Herakles. On Vulca, A. Andren, *Rend.Pont.Acc.* 49 (1976–7) 63–83.

132 Rome, Conservatori Mus.; *GO* 209–10; A.S. Mura, *Parola del Passato* 32 (1977) 62–128. On Etruscan coroplasts in Rome, M. Cristofani, *Prospettiva* 9 (1977) 2–7.

133 Pliny, *HN* 35, 154, recording also that the Roman author Varro had declared all earlier work in Rome to be of Etruscan style. He gives the Doric name, Damophilos, not Ionic Demophilos (the name of a later fifth-century painter in Sicily; could there be confusion?). Some Greek marble chests, with gable roofs and apparently of Greek make, reach north Italy in these years, one being found on the Esquiline in Rome (G. Colonna, *Parola del Passato* 32 (1977) 141–9; *CAH* VII.2, 127, fig. 35).

134 The historical problems are best explored through the accounts in *CAH* VII.2, in places contradictory; see especially pp. 16–27, 248–60.

135 Cf. M. Cristofani, *RM* 99 (1992) 123–38.

136 There was a rich cache of red figure of the later sixth century (as well as earlier pottery) at Sant'Omobono near the Forum, as there was in most Etruscan towns, except, interestingly, nearby Veii. On import of Attic to Etruria and Rome see J.C. Meyer, *Analecta Rom.Inst.Dan.* 9 (1980) 47–69; but the statistics need careful handling; see also below, n. 139.

137 Rome, Conservatori Mus. S 1181; Sprenger/Bartolini (1983) pl. 177; Brendel (1978) 250–3, figs. 175–6; Cristofani (1985) no. 114.

138 Wolves suckling humans are met in art in Etruria in the fourth century, which may be when the story was attached to the foundation story of Rome; cf. *CAH* VII.2 57–60 with fig. 16; *LIMC* IV Faustulus no. 14.

139 The falling off in import of Athenian pottery matches that of Etruria. See *CAH* VII.2 131–2 and 287 for contradictory views on Meyer's figures (above, n. 136).

140 *CAH* VII.2, 405–8.

141 *CAH* VII.2, 56–61 for discussion of this.

142 Ibid.; pseudo-Hesiod: M.L. West, *Hesiodic Catalogue of Women* (1985) 130–1.

143 G. Colonna, *Parola del Passato* 32 (1977) 150–5, the mirror, fig. 10.

144 Sopr. Arch. del Lazio, Lavinium inv. P 77.38; *Arch.Reports for 1979/80* 86–7, figs. 18–19; F. Castagnoli, *Il culto di Minerva a Lavinium* (1979); *Enea e Lazio* (exhib. 1981) D 61; M. Torelli, *Lavinio e Roma* (1984) 19–20, fig. 9.

145 Rome, Museo Barracco 173; *Roma Med.Rep.* nos. 418 (tomb), 419, 420.

146 Rome, Villa Giulia 24898; ibid., no. 428.

147 For this and all subsequent references to literary evidence for material brought to Rome and building there the reader will find no difficulty in tracing testimonia (translated) in J.J. Pollitt (1983). I use his translations here, with thanks. He also provides a valuable and succinct conspectus of the development of Roman art vis-à-vis its history.

148 When Pliny (*HN* 34, 34) reports an unfriendly Greek as saying that the Romans conquered Etruscan Volsinii (264 BC) for

the sake of two thousand statues, the reflection is more on the practice than the motivation.

149 Rome, Conservatori Mus. 1183; Cristofani (1985) no. 124; Brendel (1978) 399–401. I find it easier to relate to the first firmly dated portrait of a Roman, on the gold coin of T.Quintus Flamininus, struck in Greece in 196 BC. On Republican portraiture see the useful surveys by U.W. Hiesinger and J.D. Breckenbridge in *Aufstieg und Niedergang der Römischen Welt* I.4 (1973) 805–54 (fig. 1 for the Flamininus coin), and for the rich series on gems, M.-L. Vollenweider, *Die Porträtgemmen der röm.Rep.* (1972). On the wax and plaster heads and busts see H. Drerup, *RM* 87 (1980) 81–129.

150 Vatican Mus. 1191; *Roma Med.Rep.* no. 370; it takes the form of a Greek altar, combining Ionic dentils with Doric triglyphs-and-metopes, a mix which also appears in western Greek architecture.

151 Rome, Conservatori Mus.; *Memoirs American Acad. Rome* 2 (1918) pl. 17; *Roma Med.Rep.* 72–96 (no. 88, the mould).

152 Oxford, Ashmolean Museum S. 1; ibid., no. 282.

153 Rome, Musei Comunali 1025; *Roma Med.Rep.* no. 283; *CAH* VII.2 13, fig. 2, 412; Henig (ed. 1983) pl. 1.

154 Once in Gotha. The 'Genucilia Group' of small plates, usually decorated with profile women's heads like the poorest South Italian Greek products, have been taken for Roman but are probably Faliscan. See V. Jolivet in *Contributi alla ceramica etrusca tardo-classica* (ed. F. Gilotta, 1985) 55–66; and for the black *pocula* and stamped wares, J.-P. Morel, *Ceramiques campaniennes.Les Formes* (1981) 48–9 and in *Roma Med.Rep.* 43–58 (no. 14 = [7.61]).

155 *CAH* VII.2 415–8 reviews the coinage; the mint for the ROMANO coins is still debated, cf. F. Van Keuren in *La monetazione di Neapolis* (Atti VII. Conv.Int.Stud.Num. 1980; 1986) 421, 424.

156 For these passages and full testimonia for the later depredations see Pollitt (1983) 32–3 et seqq.

157 Pollitt (1983) 45–6. The naming of the temple architects, Greeks from Sparta, Sauras and Batrachos (Lizard and Frog), sounds like a tale for tourists.

158 Rome, Conservatori Mus.; Boardman, *GSCP* (1991) figs. 134, 134a; E. La Rocca, *Amazzonomachia* (1985) and see below, n. 177.

159 Boardman, *GSAP* fig. 205.1. There are few other original Greek marbles from Rome which presumably arrived in antiquity: e.g., the Ludovisi throne (*GSCP* fig. 46, not necessarily from South Italy as generally assumed), the 'Esquiline stele', the Albani relief (ibid., fig. 153), another pediment with Niobids (ibid., fig. 133).

160 Pollitt (1983) 76–9 for the principal passages.

161 The term probably became more generic for bronze statues, statuettes and perhaps furnishings of Greek (rather than Etruscan or South Italian) style; Pollitt (1983) 79–80. It seems also to have been used to refer to elaborately inlaid metalwork; cf. A.R. Giumlia-Mair and P,T.Craddock, *Das schwarze Gold der Alchemisten* (1993). Nero is supposed to have found five hundred bronze statues still to loot from Delphi (Pausanias 10, 7, 1).

162 See especially J.J. Pollitt's useful essay on the impact of Greek art in Rome in *Transactions of the American Philological Association* 108 (1978) 155–74.

163 Cf. M. Marvin in *Roman Art in Context* (ed. E. d'Ambria, 1993) 161–88.

164 Testimonia in J.J. Pollitt, *The Art of Ancient Greece* (1990) 120–3 and Pollitt (1983) 88–9; *idem*, *Art in the Hellenistic Age* (1986) 133.; A. Stewart, *Greek Sculpture* (1990) 306–7.

165 Boardman, *GSCP* fig. 197; the 'Aphrodite Fréjus'.

166 For late Hellenistic Delos, A. Stewart, *Greek Sculpture*

(1990) 226–8. Stewart sees the classicizing tendencies as a primarily Greek phenomenon; Smith (e.g., *Hellenistic Sculpture* (1991) 258–61) as mainly promoted by Roman patronage. J.J. Pollitt, *Art in the Hellenistic Age* (1986) ch. 8, presents a balanced view of the various influences. Without Roman stimulus the tendency might have had a limited appeal, unless it is thought that, by the late Hellenistic period, Greek art, essentially an art of change, had nowhere to turn except back.

167 The problems of copies are central to all studies of Greek sculpture. See Boardman, *GSCP* 15–18 and ch. 16; fig. 186a for the Delos Diadoumenos. A far-reaching study of the problem in B.S. Ridgway, *Roman Copies of Greek Sculpture* (1984) which is indulgent of the possibility of much originality in the copying period, and a more conservative approach in M. Bieber, *Ancient Copies* (1977). The copying of statues was a practice known earlier in the Greek world, but, it seems, only when more than one version was required for a set or for distribution, as our [2.25], for whatever purpose, not for the market or for collectors.

168 Casts in Oxford of Baiae Mus. 174.479 and Madrid 176. The same process was presumably employed for copies of works already in Italy. Where verifiable, the Baiae pieces are all from works known to have been still in Greece. C. von Hees-Landwehr, *Der Fund von Baia* (1982), and *Die antiken Gipsabgüsse aus Baiae* (1984); Boardman, *GSCP* 18, figs. 3–5.

169 R. Ling, *Roman Painting* (1991) for a full study which does not dwell much on the Greek originals (best considered in M. Robertson, *History of Greek Art* (1975)).

170 Pollitt (1983) 45, 51–2.

171 Oxford, Ashmolean Museum 1966.1808; *GGFR* pl. 1015; M.-L. Vollenweider, *Die Steinschneidekunst und ihre Künstler in spätrep. und Augusteischer Zeit* (1966) for the artists; 44, for Felix.

172 *Aeneid* 6, 847–53, freely paraphrased.

173 We might wonder whether the 'Republican values' so valued by some at the approach of Empire were of as little historical validity as the 'Victorian values' nostalgically mourned by some today.

174 The special quality of Roman concrete derived from the admixture of volcanic ash – *pozzolana*, *pulvis puteolanus*, from Puteoli in Greek Campania. But, whoever first perceived its value, its exploitation was a wholly Roman achievement. As was the use of the arch, not unfamiliar in the Greek world but aesthetically unacceptable, it seems.

175 P. Zanker, *The Power of Images in the Age of Augustus* (1988).

176 R.R.R. Smith, *Hellenistic Royal Portraits* (1988) 70–1; Pollitt (1983) 91.

177 *HN* 34, 18; Pollitt (1983) 93. So did the women of England when they dedicated their Achilles to Lord Wellington in Hyde Park.

178 It has indeed been thought to have come from an Apollo temple, at Eretria, but there, given the date, context and associations with Athens, its Theseus theme can readily be accommodated, as not in Rome. It has been suggested that the Niobid pediment that also came to Rome, but apparently not to a temple, was from the same temple at Eretria, appropriately again since Apollo was a protagonist. See E. La Rocca in *AKGP* II 52–7. He sees the choice as an Augustan compliment to Athens through the figures of Theseus and Athena.

179 J. Griffin, *Virgil* (1986) 7–8, remarks that the local languages of Italy 'simply withered away' before the 'formal perfection' of Greek, but how the Latin language survived through the conscious creation of classical (i.e., hellenized) literature.

180 Or do I say this because the Romans are in a way more British than the Greeks? Would it be fair to compare Roman reception of Greek art to that of some Japanese collectors of European art?

181 K. Clark, *Moments of Vision* (1981) 70.

8 Europe

GENERAL BIBLIOGRAPHY

R. and V. Megaw, *Celtic Art* (1989)
T.G.E. Powell, *The Celts* (revised 1980)
B.B. Shefton in *Kölner Jahrbuch für Vor- und Frühgeschichte 22* (1989) 207–20, on early import and influence from the south.

The Celts (edd. S. Moscati et al. 1991) = *The Celts*
Die Kelten in Mitteleuropa (edd., L. Pauli et al. 1980) = *Die Kelten*
Les Princes Celtes et la Méditerranée (edd. J.P. Mohen et al. 1988) = *Les Princes*
Trésors des Princes Celtes (edd. J.-P. Mohen et al. 1987) = *Trésors*

NOTES

1 Useful accounts of the princely tombs and sites: the exhibition catalogue *Trésors*, and its accompanying colloquium *Les Princes*.
2 Persistently so on the pottery; cf. K. Spindler, *Die frühen Kelten* (1983) 252–64, for a survey.
3 A.M. Snodgrass in *The European Community in Prehistory* (Studies, C.F.C. Hawkes; ed. J. Boardman et al. 1971) 31–50. The Marmesse corselets (*Trésors* 47–9) are dated ninth/eighth century (with no context) and exhibit surprisingly detailed anatomical forms.
4 Megaws (1989) 33–4, fig. 19; Strettweg, *Trésors* 60–1.
5 Fully discussed in a valuable survey article, Shefton (1989).
6 They are studied by B.B. Shefton in *Marburger Studien zur Vor- und Frühgeschichte* 2 (1979). For Marseilles and nearby Greek finds see *GO* 214, 216–9.
7 Châtillon-sur-Seine Mus.; Shefton (1989) 214–5; *GO* 219–21; C. Rolley, *Bull. Arch. et Hist. du Chatillonais* 1988, 7–10 for the La Garenne griffins.
8 Bern, Musée d'Histoire 11620; *GO* 222–3, fig. 263; *Trésors* 244–6.
9 Stuttgart, Württembergisches Landesmuseum; *GO* 223, fig. 264; H. Zürn and H.V. Herrmann, *Germania* 44 (1966) 74–102, pl. 12.
10 Shefton (1989) 216–7.
11 Châtillon-sur-Seine Mus.; *GO* 220–1, fig. 261; R. Joffroy, *Trésor de Vix* (1954); *Trésors* 207–31.
12 Châtillon-sur-Seine Mus.; *Trésors* 225 and 41–3 on the technique and possible origin. Celtiberian Spain has been suggested as a source, and the distinctive wavy filigree is used there on Phoenician gold, but the association is disputed; see K. Raddatz, *Die Schatzfunde der iberischen Halbinsel* (1969) 173.
13 Stuttgart, Württembergisches Landesmuseum; *Trésors* 95–188 for the find, 155–9, 178–9 for the cauldron.
14 For its superior technique, J. Biel in *Les Princes* 159; 'comically poor workmanship', Megaw in *Settlement and Society* (edd. T.C. Champion and J.V.S. Megaw 1985) 168, yet 'more expertly cast', Megaw (1989) 42; 'fällt qualitativ ... so stark ab', 'unbeholfener, keltischer Nachguss' (Spindler, op.cit. (n. 2) 335).
15 E.g., *Trésors* 59, 68, 241 for examples of the large situlae (heights from 26 to 88 cm, average about 60 cm); 65, 192 for cistae; 94 for a cauldron at Apremont nearly as large as the Hochdorf example. On the ability of the Vix crater to be filled with liquid and not burst see J.G. Griffith, *Festinat Senex* (1988) ch. 2, esp. 11–12.
16 This may have been a general north European practice. The Germanic Cimbri, related to the Celts but pressing them in the second/first century BC, sent the emperor Augustus a most holy bronze cauldron, and their mantic women used to cut the throats of prisoners into a large cauldron (twenty-amphora capacity):

Strabo 293–4. On drinking habits in the Celtic world, Shefton (1989) 217–8, n. 48, and, perhaps over-emphasizing similarities to the south, B. Bouloumié in *Les Princes* 343–83. Ibid., 12–13, remarks on analyses.
17 *Trésors* 26, fig. 21; W. Kimmig and O.-W. von Vacano, *Germania* 51 (1973) 72–85. It is not clear whether it was intended for casting in bronze.
18 The gaunt life-size stone figure that marked a tumulus at Hirschlanden reflects native Italian sculptural styles, plus no little local ingenuity. Its use may be paralleled in the classical world (*kouroi*) but this need not imply any functional influence from the Greek world: Megaws (1989) 45, fig. 40; *Trésors* (1987) 46; Powell (1980) 167, fig. 120, has the back view; Spindler, op.cit. (n. 2), 172–85, for related stelai and fragments. At best it might be an isolated immigrant idea that did not catch on. The much quoted use of mud brick in fortifications at Heuneburg, following a Mediterranean practice not wholly suited to northern climates, may be in like case but involved more commitment of labour. It too did not catch on; cf. *GO* 223–4, fig. 265.
19 L. Cerchiai in *Les Princes* 102–8.
20 Este, Mus.Naz. Atestino 4845; length 7.6cm; O.-H. Frey, *Die Entstehung der Situlenkunst* (1969) pl. 67.18.
21 Bologna, Mus.Civ.; W. Lucke and O.-H.Frey, *Die Situla von Providence* (1962) no. 4, pls. 16–20; J. Kastelic, *Situla Art* (1965) pls. 12–25. See Frey (last n.) for a full survey of origins. J. Boardman in *The European Community* (see above, n. 3) 123–40 on Mediterranean motifs in Situla Art; Megaws (1989) 34–9, 263. The cistae *a cordoni* (with horizontal relief bands) entered Europe from Etruria via the same route, probably earlier, but note that relief-decorated buckets were not unknown in seventh-century Greece (Boardman, op.cit., 124–30). There are relevant essays in *Etrusker nördlich von Etrurien* (ed. L. Aiguer-Foresti, 1992).
22 On the increased commerce with North Italy at the turn of the sixth/fifth centuries, R. De Marinis in *Les Princes* 45–56.
23 J.P. Mohen in *Les Princes* 220–7.
24 On archaeologists' speculations about these matters see Megaws (1989) 48–9, 263–4. A useful survey of the period of transition by L. Pauli in *Settlement and Society* (above, n. 14) 23–43. A carefully 'modelled' account of the period, now rather outdated, in P.S. Wells, *Culture Contact and Culture Exchange* (1980).
25 The reader is referred here to Megaws (1989) as the most accessible, balanced and well illustrated recent account of Celtic art. See also the briefer survey in *Die Kelten* 76–92 by O.-H. Frey. There are numerous picture books.
26 Bonn, Rheinisches Landesmuseum A 336; *Die Kelten* 78, fig.3 and no. 25; Megaws (1989) 66.
27 This is a fruitful area for discussion, by others. F. Fischer in *Les Princes* 21–32 may see too much Persian influence. The animal handles are all explicable in Greco-Etruscan terms. He says that the raised head of the handle animal is a Persian feature, but it is Greek too (however derived) – cf. the famous hydria from Paestum (C. Rolley, *Greek Bronzes* (1986) 145, fig. 126). The animal-head-terminal bracelets are also a Greek form, certainly derived from the east, but ignoring the common eastern *omega* outline, which is also absent in Celtic art. From later years, the notable case history is that of the Gundestrup bowl, found in a Danish bog, decorated with Celtic figures and gods, but also much Thracian/eastern imagery and probably a product of east Europe in the second/first century BC; see Megaws (1989) 174–7, 271.
28 B.B. Shefton, in *Convegno ... Magna Grecia 1984* (1985) 399–410.
29 Stuttgart, Württembergischs Landesmuseum. Conveniently in *Trésors* 255–63; the cups, 259–61; fully in W. Kimmig, *Das Kleinaspergle* (1988).
30 The stamnoi and the associations of the decoration of their handles are exhaustively explored by Shefton in Kimmig, op.cit., 104–53.

31 *Trésors* 258, no. 233. On the translation of head-and-palmette motifs, V. Kruta in *Les Princes* (1988) 81–92.

32 London, British Museum P + RB. I illustrate a handle and jug [*8.12c,13*] from Basse-Yutz, on the Moselle, one of a pair. These, and a jug from Dürnnberg, are prime examples of the developed early Celtic style; the former were also accompanied by two Etruscan bronze stamnoi. Megaws (1989) 69–74 (satyr heads), 76–80 and pls. III, IV, and in *GCNP* 579–605.

33 Berlin, Staatliche Museen; *The Celts* 135–6; *Die Kelten* no.26; Jacobsthal (1944) no. 34. For these earlier floral styles, also well expressed on helmets, Megaws (1989) 102–12; *Die Kelten* (1980) 86; V. Kruta, *Etudes Celtiques* 15 (1976–8) 405–24.

34 Megaws (1989) 108–21; E.M. Jope in *European Community* (see n. 3) 165–80; the pattern, fig. 36a (Jacobsthal (1944) PP 353).

35 Boardman, op.cit. (n. 3) 130–1.

36 Megaws (1989) 56, fig. 51, where they are taken for linked Celtic triskeles. Similar nodes are fashioned from classical palmette hearts and the eyes of spirals (ibid., figs. 49, 50) et saepe.

37 *CAH* VII.1, 114–7 (Delphi), 422–5 (Anatolia). On later Greeks' views of Celts in literature, J.-J. Hatt, *Ktema* 9 (1984) 79–87.

38 The Tektosages; Strabo 188.

39 Berlin, Staatliche Museen; gold sheet from Schwarzenbach; Megaws (1989) 70, fig. 74; *The Celts* 136. Note too the way the faces lurk as 'Cheshire cats' in floral bands – Megaws (1989) 103–4, 120–1, 135–44, 265–6.

40 Megaws (1989) 192–9.

41 Powell (1980) pl. XII.2; D. Nash, *Coinage in the Celtic World* (1987) 110, pl. 17.160; Megaws (1989) 177–81, 203–5.

42 Bath Museum; B.W. Cunliffe in *Pagan Gods and Shrines* (ed. M. Henig, 1986) 1–14.

9 Conclusion

NOTES

1 *GGFR* 318–9. Note that we may consider [*4.54*] to be the work of a Greek engraver in the east.

2 This might have been the case with early Greek settlers in Italy: see J.N. Coldstream, *OJA* 12 (1993) 89–107.

3 There was probably no Greek production at Al Mina at any period, although some Geometric cups were once thought by the writer to have been made there. These *were* however made probably in non-Greek areas of Cyprus.

4 *Mor.* 328 D-E.

5 The phenomenon well discussed by J. Balty in *Mélanges Lévèque* I (edd. M.-M. Mactoux and E. Geny, 1988) 17–32.

6 The only notable exception was perhaps the tent of the Persian King Xerxes, captured at Plataea (Herodotus 9, 82) and allegedly (Pausanias 1, 20, 3) the model for the Periclean Odeion in Athens, though there are other precedents for such multi-pillared halls in Greece (as at Eleusis). See W.K. Pritchett's important study of booty in the Greek world in his *Greek States at War* VI (1991) 193–7; and M. Miller, *Athens and Persia in the Fifth Century B.C.* (forthcoming). Greeks also seem to have been little interested in carrying off each other's monuments (as opposed to precious objects for which they were always ready) until the Hellenistic period; Pritchett mentions Kleomenes taking statues from Megalopolis (and the Bithynian Prusias from Pergamon).

7 I think this is not entirely a question of survival. In modern times the copying of a model in marble would possibly cost more than casting in bronze, but labour costs are relatively far higher than they were in antiquity when the value of the material used counted for more.

8 See above, Chapter Eight, n. 178.

9 I think of the bronze from Mohenjo-Daro, more realistic than she may look and a brilliant rendering of pubescent girlhood, and limestone torsos from Harappa: Rowland (1977) 35–6, figs. 3–5; Harle (1986) 17, fig. 3 (the girl).

10 A neat comparative study of narrative conventions, from the classical to India, by D. Schlinghoff in *BAVA* 3 (1981) 87–213.

11 It is this that renders exercises in identifying near eastern iconography/myth in Greek art almost futile; the Greeks almost always re-interpreted the images they borrowed, as the Indians did the classical.

12 R. Olmos has some interesting comment on the movement of myth scenes and their intelligibility in *REA* 89 (1987) 283–95, mainly *à propos* of Spain.

13 Cf. *Crossroads of Asia* (edd. E. Errington and J. Cribb, 1992) 117.

14 Critias in Athenaeus 28b–c.

15 *Epinomis* 987 D,E. He also observed the beauty and long life of Egyptian artistic forms ('ten thousand years') — *Laws* 656 D,E.

16 E.R. Dodds argued against this in *The Ancient Concept of Progress* (1973) ch. 1, except 'during a limited period in the fifth century was it widely accepted by the educated public at large'. See also A. Tulin in *Hermes* 121 (1993) 129–338 on Xenophanes and the idea of progress.

17 Thus K. Clark in *The Romantic Rebellion* (1976) 32, *à propos* of David's *Death of Marat*. Recall and observe the arts of twentieth-century communism and fascism.

INDEX